HISTORY
of
ITALIAN ART

HISTORY
of
ITALIAN ART

VOLUME ONE

Preface by Peter Burke

Translated by
Ellen Bianchini and Claire Dorey

POLITY PRESS

English translation © Polity Press 1994.

First published in Italy as *Storia dell'Arte Italiana* © Giulio Einaudi Editore, 1979.

This translation first published in 1994 by Polity Press in association with Blackwell Publishers.

Editorial office:
Polity Press
65 Bridge Street
Cambridge CB2 1UR, UK

Marketing and production:
Blackwell Publishers
108 Cowley Road
Oxford OX4 1JF, UK

238 Main Street
Cambridge, MA 02142, USA

ISBN 0-7456-0694-6 (vol. I)
ISBN 0-7456 0695-4 (vol. II)
ISBN 0-7456 1364-0 (2-vol. set)

A CIP catalogue record for this book is available
from the British Library and from the Library of Congress.

Typeset in $10\frac{1}{2}$ on 12 pt Sabon
by Graphicraft Typesetters Ltd., Hong Kong.
Printed in Great Britain by Hartnolls Ltd, Bodmin, Cornwall

This book is printed on acid-free paper.

Contents

Illustrations

———⦿———

Publisher's Note

In this edition references to English-language sources have been given where possible. In some foreign works not readily available in English, references to the Italian editions used by the authors have been retained.

Preface

————————⚬⚬⚬⚬⚬————————

The *History of Italian Art* is one of a number of ambitious projects associated with the Italian publisher Einaudi. Giulio Einaudi, who founded the publishing house, is the son of Luigi Einaudi, the first president of the Italian Republic, and a flamboyant personality who likes to do everything on a grand scale. In the 1970s, he embarked on a series of large-scale projects. The *Einaudi Encyclopaedia*, for example, is not the usual kind of reference work but rather a fourteen-volume collection of essays, sometimes by distinguished intellectuals such as Roland Barthes and Leszek Kolakowski, on themes running from 'Abacus' to 'Zero'.

However, even the *Einaudi Encyclopaedia* looks relatively modest and compact when it is placed alongside the multivolume histories from the same publisher; for the *History of Italian Art*, published in twelve volumes between 1979 and 1982, is only the second part of a trilogy. The first part takes the form of a *History of Italy*, which appeared in six volumes (1972–6), followed by no fewer than eighteen supplementary volumes (nine of them dealing with major themes in Italian history and nine with the history of different regions). The third part of the trilogy is a *History of Italian Literature* in another twelve volumes (1982–91).

All three projects have a distinctive style. For example, all of them emphasize social factors. The academic editors include a number of leading Italian Marxists, such as Ruggiero Romano and Alberto Asor Rosa, who ensured that the relation between the history of

Italian culture and economic, social and political trends would be explored in depth and in detail. One of the volumes of the *History of Italian Literature*, for example, is entitled 'Production and Consumption', while the *History of Italian Art* includes a similar volume on 'The Artist and the Public'. Another model for these projects has been the so-called 'Annales School' of French historians, especially their emphasis on a 'total history' which reveals the connections between activities as different as painting, politics, philosophy, and so on.

The teams of scholars recruited to write all three histories – like the *Encyclopaedia* – include a number of foreigners as well as Italians. The French are particularly prominent in this respect. It is some indication of the prestige of the project that the late Fernand Braudel should have agreed to write a long chapter for the *History of Italy* on the theme of 'Italians outside Italy'. Another member of the *Annales* group, the distinguished French medievalist Jacques Le Goff, has also participated in a number of these Einaudi projects, while Nicole Dacos has contributed an essay on 'Italian Art and the Art of Antiquity' (below, pp. 113–213). English scholars, a remarkable number of whom specialize in the study of Italy, are also relatively prominent in this series of projects. The *History of Italy* contains long contributions by Philip Jones and Stuart Woolf, while the *History of Italian Art* includes an essay by Francis Haskell on the dispersal and conservation of works of art (below, pp. 214–69).

Another common feature of these volumes is their concern for long-term trends. The first volume of the *History of Italy*, subtitled 'The specific characteristics' (*I caratteri originali*), in homage to the French historian Marc Bloch and his *Caractères originaux de l'histoire rurale française* (1931), is concerned, in a Braudelian manner with trends over the very long term. The volume includes an essay by Carlo Ginzburg – an author who has long been associated with Einaudi – dealing with 'folklore, magic and religion' in Italy over a period of more than 1,000 years. Ginzburg has also participated in the *History of Italian Art*. In collaboration with the art historian Enrico Castelnuovo, he is the author of a highly original exploration of the theme of 'Centre and Periphery' in Italian art, in other words the problem of provincialism, once more a study of changes over the long term (below, pp. 29–112).

The interest in concepts and methods, the welcome given to new ideas, and the interdisciplinary approach are indeed characteristic features of the Einaudi projects. They may be illustrated by the perceptive essay by Salvatore Settis, in the now controversial area of

iconography (vol. II, pp. 119–259); by the iconoclastic piece by Giovanni Previtali, who undertakes to rethink the periodization of Italian art (vol. II, pp. 1–118); or by Anna Maria Mura's discussion of art and its public in terms of semiotics and reception theory (below, pp. 270–324).

It should be clear that despite their scale, the aim of the collective trilogy on Italian history, art and literature is not to be complete, scientific or objective, but rather to present a moving object from a diversity of viewpoints. Even a rigorous selection like the one submitted here, offering ten essays in the place of twelve volumes, still gives an impression of that diversity. In Italy, the three projects, launched with great publicity, were a great stimulus to scholarly debate. It is not too much to expect that this selection will have a similar effect in the English-speaking world.

Peter Burke

ONE

The Italian Artist and his Roles

PETER BURKE

WHAT is an artist? If the question is a historical one, there is no point in looking up a dictionary. A static definition is useless because the social roles, and hence the identities of painters and sculptors – I shall be saying little about architects – have changed a good deal in the last 800 years. The public has looked at artists, and artists have looked at themselves, in very different ways. Their recruitment and training, their position in society, the opportunities open to them, the pressures on them have all varied in different periods.

This essay attempts to sketch the history of Italian artists. It is a sketch for *une histoire de longue durée*, from the twelfth century to the twentieth; or if you like your dates more precise, from 1178 (when Antelami signed and dated a relief of the *Deposition of Christ* for Parma cathedral), to 1978. The main theme will be the historian's favourite, the relative importance of change and continuity. What is attempted here will be a sketch rather than a finished picture, not only because of the space allotted, but also because of the state of research in this area. Little is known, and in all probability little can be known, about Italian artists in the twelfth and thirteenth centuries. For the period 1300–1800 we are much better informed, thanks to the work of Wackernagel and Antal, Haskell and the Wittkowers, to mention only the best-known studies.[1] Yet even here much remains to be discovered, and we are still in danger of seeing the career of the ordinary artist in terms of the best-known,

an illusion which can be corrected only by quantitative methods, by the prosopographical approach.[2] As for the period after 1800, although by far the best-documented, it is, from the point of view of the social historian of Italian art, still virtually *terra incognita*.[3]

So much for the basic problems involved in making a study of this kind. On the other hand, there is probably no country in the world where so much information was recorded about the lives and personalities of artists between the fifteenth and the eighteenth centuries as Italy. One thinks inevitably of Vasari, but also of his many imitators and continuators, painters and antiquarians, who were concerned to show that their century and their city (Rome or Venice, Bologna or Genoa) was a worthy rival and successor to Vasari's Florence; Giovanni Baglione, Carlo Ridolfi, Giovan Pietro Bellori, Raffaello Soprani, Carlo Cesare Malvasia, Gianbattista Passeri, and Lione Pascoli, to name only the most celebrated.[4] Even the faces of a good many seventeenth-century artists are known to us, thanks to the famous collection of self-portraits in the Uffizi, assembled, and sometimes commissioned, by Cardinal Leopoldo de' Medici and his agents, including another biographer of artists, Filippo Baldinucci. There are also vivid literary self-portraits, such as the *Commentari* of Ghiberti, the autobiography of Cellini, and, in the nineteenth and twentieth centuries, the memoirs of artists such as Hayez, de Nittis, Costa, Fattori, Duprè, Carrà, Severini or de Chirico.[5] Thanks to all this material, it ought to be possible at least to make a beginning.

This sketch of the social history of the Italian artist presents five main figures, types or roles. There is the artist as craftsman; the artist as courtier; the artist as entrepreneur; the artist as civil servant; and finally the artist as rebel. As a useful simplification, one might say that these five roles have been dominant in turn between the twelfth and the twentieth centuries, although at any one time two or more roles have usually coexisted, and some artists acted out more than one of them. For reasons of space, I shall pass over two relatively small groups of artists who do not fit into this typology; clerical artists, like the Dominican Fra Angelico, the Jesuit Andrea Pozzo, and the Theatine architect Guarino Guarini; and women artists, like Properzia de' Rossi, Sofonisba Anguisciola and Rosalba Carriera.[6]

The artist as craftsman

In the Middle Ages, the main role which the men whom we call artists were expected and trained to fill was that of craftsman. The

distinction between *belle arti* (fine art) and *arti meccaniche* (mechanical arts) did not yet exist, and Sacchetti, for example, could refer to 'Buonamico dipintore' as 'buono artista della sua arte' in the sense of 'buono artigiano nella sua mestiere' (a good artist in his craft).[7] This role was fairly unspecialized. A painter might find himself painting not only panels but also beds, chairs, saddles, armour, *cassoni*, birth trays or inn signs, as well as frescoing walls, selling his work, and training his apprentices. Sculptors were even more involved in entrepreneurial activities than painters because of the cost of their raw materials, bronze or marble. A fifteenth-century Florentine sculptor would probably be expected to arrange for the quarrying of marble from Carrara as well as for turning that marble into a statue.[8]

Like other craftsmen, painters and sculptors kept workshops (*botteghe*), where works were both made and sold. The *bottega* was composed of a small group of men working more or less in collaboration. Hence paintings and sculptures were usually anonymous, and when they were signed, the function of the signature was probably to guarantee the product rather than to express the pride of an individual creator. It is likely that 'Giotto signed those major products of his workshop which he himself had not painted. These were the works that were in need of the protection of a signature to prove their provenance.' The same system operated in Venice as late as the sixteenth century.[9] It was the *bottega* rather than the individual which had a style.

This *bottega* was often a family business in the case of painters and sculptors as in that of tailors or smiths. Jacopo Bellini worked with his sons Gentile and Giovanni and his son-in-law Mantegna. The della Robbia terracotta sculpture business involved Luca, his nephew Andrea, and no less than five of Andrea's sons. However, outsiders would often be taken into the *bottega*, and indeed into the family, of a successful craftsman. Fathers would apprentice their children to him, particularly fathers who themselves exercised some craft. Peasants were unlikely to be able to afford the fees for apprenticeship, while noble families sometimes objected to their young men becoming mere painters or sculptors. Condivi records that when the young Michelangelo abandoned 'le lettere' for Ghirlandaio's *bottega*, 'his father and uncles, who hated that craft, looked askance on him and often beat him severely, because to them (ignorant as they were of the excellence and nobility of the art), it seemed shameful to have it in the family.'[10]

The apprentices (known as *garzoni* or *discepoli*) were usually under fourteen years of age and might be only seven. They would learn

their trade by copying drawings from the workshop collection, draw-ings which were used as patterns, elements (like figures or buildings) which could be combined in different ways according to need. They would also do odd jobs like grinding the colours until they were ready to assist the older men in the more difficult tasks. When their apprenticeship was over, the young men could remain in the *bottega* as *lavoranti* (journeymen), or they could set up shop on their own. To reduce expenses and provide a kind of insurance against illness it was not uncommon for painters to form a temporary association or *compagnia*, sharing profits and expenses, as, for example, Fede di Nalduccio and Lando di Stefano agreed to do in Siena in 1384. This partnership was made for a year. Fede, who owned the *bottega*, was to deduct his expenses, and the remaining profit was to be shared between the two men.[11]

Although it was the fundamental unit of production, the *bottega* was not, of course, autonomous. Its members had to join a guild (*arte, fraglia*), which was a federation of *botteghe* within a given city with its own officials (*camerlenghi, gastaldi* etc.) and its own regulations. For example, it was normal practice for painters' and sculptors' guilds, or the guilds of which they formed a part (like the *Medici e Speziali* at Florence, to which the painters belonged), to order their members not to use inferior materials, not to steal *discepoli* or *lavoranti* from one another, and not to work on the feast-days ordained by the Church. The guild would also prevent 'forestieri', outsiders to the city, from working within it without paying a spe-cial fee, and they might give or lend money to members who were sick or in prison. Thus subscriptions to a guild represented a form of insurance. Religious and social functions were also performed by guilds or by separate associations (*confraternite, scuole, compagnie*), which often had an occupational basis. Members of these associa-tions were generally expected to attend the funerals of other mem-bers and to walk in procession on the feast of their patron, often carrying a lighted candle. For painters, this patron was St Luke, because he was said to have painted the portrait of the Virgin Mary, a tradition which goes back to the sixth century or even earlier.[12]

The artistic autonomy of the *bottega* was also limited by the desires of the customers. Contracts between painters and sculptors and these customers were often drawn up by a public notary, and these con-tracts frequently specify not only the subject, the materials, the delivery date and the price, but also the number, size and colouring of the figures. For example, in a contract for an altarpiece drawn up in 1503, it was agreed that the painter, Cosimo Rosselli, should paint

Christ 'crucified, with angels at each side with chalices to catch his glorious blood, well ornamented as is customary: at the foot of the said cross the figure and image of St Mary Magdalen on her knees, her hair in disorder, embracing the cross with devotion', and so on.[13] The emphasis on custom (*come s'usa*) is typical. Within this system, an artist had little need of book-learning because his subjects were selected by the client from a traditional, mainly religious repertoire of themes which more or less coincided with the pattern-books in the *bottega*. Hence the painter was considered a hand rather than a brain, and might be paid by the square foot, as was the case when Duke Borso d'Este paid Francesco Cossa for his frescoes in Palazzo Schifanoia in Ferrara *c*.1470.[14]

This system of organizing the arts, dominant in the Middle Ages, long outlasted them. In seventeenth-century Genoa, an attempt was made (unsuccessfully, it is true) to enforce the old guild statutes against a noble painter who had not served his time as a *garzone*.[15] In Venice, which was particularly conservative in this respect, the traditional system of *bottega* and *fraglia* still flourished in the middle of the eighteenth century. The family business of the Guardis was organized on similar lines to that of the Bellinis some three hundred years before. The father, Domenico, worked with his three sons, Antonio, Francesco and Nicolò, while his daughter Cecilia married into another family of painters, the Tiepolos. It has been pointed out that the elder brother Antonio succeeded his father in 'absolute control' of the family *bottega*, so that Francesco could only 'express his own personality' after Antonio's death.[16] If one looks at the contracts between painters and their clients in chronological order, it is to find 'no important difference between a contract drawn up in medieval times and one of 1750'.[17]

Even in the nineteenth century, this traditional system of organization was not completely defunct. Massimo d'Azeglio, for example, studied painting in Rome about the year 1820 in the studio of a certain Martin Verstappen, 'agreeing to be a pupil in the traditional manner of Giotto, Masaccio and their like'. (D'Azeglio's family, incidentally, objected to Massimo's choice of career for the same reason that Michelangelo's family had given: a nobleman should not sell pictures.)[18] More recently still, Carlo Carrà (born in 1881) was apprenticed at the age of twelve to a painter-decorator, and Giacomo Manzù (born in 1908) was apprenticed to an engraver. It is easy to underestimate continuity in social history.

Of course, these examples show traditional customs surviving in a changing world. The guilds had gradually lost their power. In

Florence, for example, Cosimo de' Medici emancipated artists from
their guild in 1571. Even in Venice, where guilds remained stronger
than elsewhere, there were changes. In 1682, the *depentori* were
allowed to form their own *scuola*, separate from the *doradori*, the
cartoleri and other craftsmen with whom they had been associated.[19]

The years 1571 and 1682 mark minor victories in a long cam-
paign: the campaign by painters and sculptors to be considered as
a special kind of people, unlike ordinary craftsmen. Around 1100 an
inscription was placed on the façade of Modena cathedral: '*Inter
scultores quanto sis dignus onore / Claret scultura nunc wiligelme
tua*' (Among sculptors how greatly you are worthy of honour. Now,
Wiligelmo, your sculpture shines forth).[20] A hundred and sixty years
later the pulpit in the baptistery at Pisa was inscribed with similar
sentiments: '*Anno milleno bis centum bisque triceno / Hoc opus
insigne sculpsit Nicola Pisanus / Laudetur digne tam bene docta
manus*' (In 1260 Nicola Pisano carved this noble work. May so
greatly gifted a hand be praised as it deserves). In the early fourteenth
century Nicola's son Giovanni Pisano described himself in an in-
scription as '*dotatus artis sculpturae prae cunctis ordine purae*'
(endowed with the pure art of sculpture above all others).[21] In the
fifteenth century, painters, according to Sant' Antonino, archbishop
of Florence, were demanding payment not according to the square
foot or the hour, but according to their skill. They were refusing to
be considered as mere 'hands'.[22] Vasari's *Vite*, which it is scarcely
anachronistic to call an exercise in public relations on behalf of
artists, abounds with stories to show that they are something better
than mere craftsmen. Fra Filippo Lippi, he claims, was captured by
the Moors and made a slave, but he was released when it was
discovered that he could draw. Donatello smashed a bust made for
a Genoese merchant who haggled over the price and tried to calcu-
late it in terms of the number of days the sculptor had worked on
it. The 'divine' Michelangelo was, according to Vasari, sent by God
– as a kind of secular Messiah – to rescue the arts from decline.
Stories like these should be interpreted as myths which had the
social function of justifying or legitimating the numerous attempts
made by painters and sculptors of the fifteenth and sixteenth cen-
turies to escape from their traditional status as craftsmen.

But if artists were not craftsmen, what were they?

The artist as courtier

One obvious alternative to the role of craftsman was that of courtier.
An early example is that of Giotto, who was the *familiaris* of the

king of Naples, in other words a member of his household. In the fifteenth century the painter becomes something of a familiar figure at court; one thinks of Leonardo at Milan (though he was many things besides a painter), of Mantegna at Mantua, of Cosimo Tura at Ferrara. In the sixteenth and seventeenth centuries, as republics declined in Italy, courts grew more numerous and more and more artists became courtiers, especially in Rome and in Florence. Bramante, Raphael, Michelangelo, Bernini, Maderno, and Algardi were only a few of the many artists at the court of Rome, while Vasari, Bronzino, Allori, Buontalenti, Giambologna, Tacca and Foggini were among the painters and sculptors active at the court of the Grand Dukes of Tuscany. Courts remained important centres of patronage until the days of Pius VII, or even later. Victor Emmanuel II was interested in historical paintings, and handed out commissions to artists such as Federico Andreotti, Giuseppe Bellucci and Annibale Gatti. There is a sense in which it is useful to speak of the 'court' of Mussolini, and the official, flattering portraits of the Duce and his 'new order', like Manlio Giarrizzo's *Il Duce a Littoria* (1934), which received the Premio del Partito Nazionale Fascista, are reminiscent of nothing so much as the court portraits of Cosimo de' Medici.

To enjoy the protection and the favour of a prince (or indeed of a great noble) had many advantages for an artist in the sixteenth or seventeenth century. It meant the opportunity to work on ambitious large-scale projects and to escape from the claims of the guilds. In 1540, for example, Paul III issued a *motuproprio* declaring that Michelangelo, Pierantonio Cecchini and other sculptors at the court of Rome were free from any claims by the local guild, the *ars scalpellinorum* as the document calls it, because sculptors were '*viri studiosi et scientifici*' (learned and knowledgeable men), who were not to be counted '*inter artifices mecanicos*'.[23] To turn courtier also meant economic security. When Mantegna became court painter at Mantua, he was given a monthly salary and free lodgings, corn and wood. Salvator Rosa gained 9,000 scudi in nine years at the court of the Grand Duke of Tuscany, and Bernini did very well at the court of Rome. Not the least advantage of working at court was the relatively high status it conferred. The artist was no longer a mere shopkeeper. Michelangelo, who was extremely conscious of his noble origin, once reminded his nephew that 'I was never the kind of painter or sculptor who kept a shop. I was always taught to avoid this for the sake of the honour of my father and my brothers.'[24] The court artist could dress splendidly and live in a fine house, like Raphael's or Federico Zuccaro's house in Rome, or Giulio Romano's

in Mantua. He might end his days as a knight, like Crivelli, Sodoma, Bandinelli, Vasari, d'Arpino, Pietro da Cortona, Bernini or Borromini; or even a baron, like Solimena or, later, Camuccini; a count, like Gentile Bellini, Mantegna, Titian and Arcimboldo; or a marquis, like Canova. He might be given a splendid funeral, like Michelangelo, Agostino Carracci, or Bernini.[25]

On the other hand, courtier status meant servitude. It meant playing the role of 'humile et fedel servo' (your humble and faithful slave), as Giulio Romano described himself to Federigo Gonzaga; 'devotissimo servitore' (your most devoted servant), as Pietro da Cortona signed a letter to Cardinal Francesco Barberini, or 'servitore humilissimo' (your most humble servant), as Guercino wrote to one of his patrons, adding for good measure 'riverentemente le bacio le mani' (I kiss your hands with reverence). These phrases were of course clichés in this period. No single one of them can be taken at its face value. All the same, together they express or symbolize an unequal relationship which was necessarily tinged with servility. Courtiers had to pay court to princes, and lesser courtiers had to pay court to greater ones. Like other men of ability in early modern Europe, a gifted painter or sculptor had to decide (to use the language of La Fontaine), whether to be a dog or a wolf. The wolf lives in freedom and poverty. The dog lives in comfort, but he wears a collar. It might be the collar of the Order of Santiago (which Bandinelli long coveted and did at last obtain), or a golden chain (like the one which Pietro da Cortona received from Pope Alexander VII), but it was a collar and chain all the same. Bernini, for example, was forbidden to accept outside commissions without his master's permission. The pope might decide to lend Bernini to the king of France, but the decision was the pope's, not the artist's. The myth of the artist as hero, from Vasari to Pascoli, presents Charles V picking up Titian's brush, Julius III asking Michelangelo to sit down, and Innocent X holding a canvas for Pierfrancesco Mola.[26] The reality was not always so flattering. Princes expected their commands to be carried out quickly and withdrew their favour when there were delays. On some occasions, Cosimo de' Medici would give Cellini 'molte infinite carezze' (infinite caresses), and treat him 'con piacevole accoglienza' (giving him a warm welcome), but on others he would show 'severità', and call him 'malvenuto'.[27] If Cellini sometimes sounds paranoid, convinced as he is that enemies or 'traitors' have been poisoning the mind of the prince in his absence, he may simply have been hypersensitive to ambiguities in his status.

The patronage of artists was of course part of a much wider web

of patrons and clients. It involved middlemen, friends of friends. We find Michelangelo writing to Cardinal Bibbiena in 1520 to get papal patronage for Sebastiano del Piombo; or Vasari getting Ammanati commissions from Cosimo de' Medici; or Gianbattista Agucchi, a clerical bureaucrat as well as a dilettante, getting Domenichino a commission for frescoes at the Villa Aldobrandini; or the Roman art dealer Maestro Valentino introducing Caravaggio to Cardinal del Monte. The middlemen might be rewarded for their services. In Rome these patronage networks often involved clerics and artists who came from the same city, or at least the same region. Thus Salvator Rosa was helped by Cardinal Brancacci, 'suo paesano' (his compatriot), as Pascoli points out. Pietro da Cortona was helped by Cardinal Sacchetti, a fellow Tuscan. The Genoese painter Baciccia worked for the Jesuit General Oliva, who also came from Genoa. Most obvious of all in the early seventeenth century was the Bologna network, headed by Pope Gregory XV and his nephew Cardinal Ludovisi. Guercino, who also came from Bologna, was encouraged by Gregory's election in 1621 because (as Passeri remarks) 'as a compatriot of his he hoped for some favour.' Guercino was in fact summoned to Rome by the pope the same year. Gregory made Domenichino, another Bolognese, papal architect, while Algardi, who also came from Bologna, was 'protected' by Cardinal Ludovisi.[28]

Like the rest of the patron–client network, the patronage of artists was involved in the struggles for power between rival factions. This is especially clear at Rome. Caravaggio worked for the Aldobrandini faction, the Francophile party of Clement VIII, while Annibale Carracci worked for the pro-Spanish Farnese, and received no commissions from Clement.[29] Similarly Bernini worked for the pro-French Barberini, while his great rival Borromini was associated with the Spanish faction and even dressed like a Spaniard. Algardi had his great opportunity when Pope Urban VIII died and Barberini artists, like Barberini policies, were out of favour with his successor, Innocent X.

Of course courtier-artists never dominated their profession in numerical terms. There were not places at court for more than a minority of the painters and sculptors working in Italy, and many would not have known how to behave in this unaccustomed environment. Domenichino succeeded despite his 'lack of polish' (as Passeri called it), but courteous manners and a ready wit were assets to ambitious artists. Giotto was apparently famous for his repartee ('un bel motto' of his is recorded in Sacchetti, novella LXXV), and it may have been this which recommended him at the court of

Naples. Raphael could behave in the courtly style which was recom-
mended by his friend Baldassare Castiglione; for Vasari comments
on Raphael's 'cortesia' and his 'gracious affability', contrasting this
with the manners of 'the majority of craftsmen until now', men who
tended to have 'an element of wildness'. However, as opportunities
at court opened up, more and more artists could be found – if we
may trust contemporary biographies on this point – who were cap-
able of living up to Raphael's standards. Federico Zuccaro, whose
writings, like the decorations of his house, show his grand ideas
about the status and mission of the artist, was described as 'of most
noble aspect and regal manner'. Scipione Gaetano, one of the most
fashionable portrait painters of the later sixteenth century, 'looked
like a prince'. Algardi was 'of noble appearance', and also a fluent
talker. Pietro da Cortona, despite his relatively humble origin, was
'majestic in his carriage'. Guido Reni was 'cortese', 'spent gener-
ously' and showed 'great-mindedness'. Mola lived 'nobilmente', and
was 'affable and charming in conversation'. Bernini behaved like a
prince: 'when he gave orders, a look was sufficient to terrify.'[30]
 It is likely that some artists were prevented from making a suc-
cessful career at court by lack of an appropriate education. A *bottega*
training was simply not the appropriate preparation for this envi-
ronment, where self-confidence was essential and where the clients
no longer asked for something 'come s'usa', but, on the contrary, for
something that was new. Artists needed a classical education if they
were to handle with success the subjects from classical mythology
and ancient history which princes and nobles increasingly required
from them. True, the patron could always call in humanist advisers
to draw up a 'programme' full of literary allusions which the artist
could then execute. Thus the Mantuan humanist Paride da Ceresara
acted as an intellectual middleman between Isabella d'Este and
Perugino, while the writer Annibale Caro devised the programme
for a cycle of paintings carried out by the Zuccaro brothers in the
Villa Farnese at Caprarola.[31] However, for artists with noble pre-
tensions this was not good enough. The painter or sculptor needed
to be able to devise his own programme. The mythological diction-
aries compiled by Cartari, Ripa and others must have made life
easier for artists from the later sixteenth century onwards; one would
dearly love to know whether these books did in fact become part of
the essential equipment of the *bottega*.[32] The long-term solution,
however, could only be for the artist to be given a wider education
than had previously been customary. As Alberti put it in the 1430s,
when the suggestion was still an unusual one, 'I should like the

painter to be learned, as far as possible in all the liberal arts.' Algarotti made a similar point in the 1760s, as if public opinion had not changed very much in the meantime: 'Most people think that Ripa's "Iconology or Images" is the only book of any use to painters', whereas artists needed to be familiar with Homer and Virgil, Leonardo and Vasari.[33]

Some artists could meet these educational standards. Although he came from a family of craftsmen, Vasari was lucky enough to be given access to a nobleman's education. Bandinelli boasted of knowing some Greek and of spending his leisure hours reading Livy and Tacitus, Horace and Virgil.[34] Agostino Carracci was a learned painter: 'There was no branch of knowledge', his admiring biographer tells us, 'which was unfamiliar to him, for he was well acquainted with the maxims of philosophy and the aphorisms of medicine, and spoke with authority about mathematical proofs, astrological observations, and about the different parts of cosmography, and was well acquainted with politics, history, orthography and poetry.'[35] Salvator Rosa studied with the Padri Somaschi, and was therefore able to fulfil his own requirements: 'Painters need to be learned, acquainted with the sciences, and have a good knowledge of mythology, history, and different periods and their customs.'[36] Bernini, like Rosa, was a man of literary culture, whether he had received a formal literary education or not. He devised his own programmes, and, indeed, wrote comedies which were so full of *concetti* that 'the literary men who listened attributed some to Terence, others to Plautus and similar authors who were never read by Bernini.'[37]

What could an artist do who lacked the opportunities available to these men? And how could he learn the vocabulary, grammar and syntax of the classical language of art? In an academy. In the sixteenth and seventeenth centuries, noblemen and scholars liked to meet in formal discussion groups called 'academies', and artists began to imitate them. In typically pretentious style, Bandinelli referred to his 'academy' in the Belvedere in Rome. In Agostino's engraving of 1531, we see a group of artists, presumably Bandinelli's pupils, drawing classical statues by candlelight.[38] This is not so very different from the *garzoni* studying in the *bottega*, especially if the *bottega*, like that of Neroccio de' Landi, who died in Siena in 1500, contained (as the inventory reveals) such objects as 'an ancient head in relief' and 'another head of a child in ancient marble'.[39] However, some later academies offered a fuller programme. In Florence, the Accademia di Disegno (founded in 1561 by Cosimo de' Medici)

offered lectures on geometry and anatomy. In Rome, the Accademia di San Luca (founded 1593) allowed the young men to listen to lectures on art theory as well as to draw casts of classical statues. In Bologna the less formally organized Carracci academy, which lasted from about 1582 to about 1619, was a place where young artists could listen to lectures on perspective, anatomy and *invenzione*, as well as studying classical sculpture, drawing from the nude, and having their efforts criticized by the Carracci brothers. Thanks to this kind of training, such artists as Domenichino (a prizewinner at the Carracci academy), and Sacchi (a prizewinner at the Accademia di San Luca), were able to appear at court without embarrassment.[40]

The artist as entrepreneur

From the fourteenth century onwards, we find Italian artists who claimed that painting and sculpture were *arti liberali* and were not content with the status of craftsmen. Some were unwilling to become courtiers, others were unable. What other roles were open to them? They could try to become independent professional men, assimilating themselves either to the entrepreneur or the bureaucrat.

An artist with a large *bottega* could accept large-scale commissions which he would direct and inspire rather than carry out in person. Giotto is an early example of the artist as entrepreneur, not only in the obvious sense of hiring out a loom to a poor weaver at a profit of 120 per cent a year, but also in the sense that he ran a large *bottega* with many assistants in Florence, and probably also in Naples. Ghiberti was another artist with a large *bottega*. He had twenty-one assistants when he was working on the first of the bronze doors for the baptistery in Florence, and he became a fairly rich man, owning land and paying 34 florins in tax in the *catasto* of 1451. Another mid-fifteenth-century Florentine, Bernardo Rossellino, has been described as a leading 'contractor' for monuments and buildings rather than a sculptor or architect. Perugino had a large *bottega* and, Vasari tells us, 'became extremely rich'. In Venice too there was a succession of artist-entrepreneurs, including Giovanni Bellini (who was assisted by Carpaccio, Palma Vecchio, Belliniano, Bastiani, Mansueti and Montagnana, among others), and Titian (who was assisted by his brother Francesco, his son Orazio, his cousins Cesare and Marco, Girolamo Dente, Jan Stephan van Calcar, etc.).

Some courtier-artists might also be described as entrepreneurs, notably Raphael and Bernini. Raphael's *bottega* included Gianfrancesco

Penni, Giovanni da Udine and Giulio Romano, and it was enlarged about 1518, when he was decorating the Vatican *logge*, to include Pellegrino da Modena, Perino del Vaga and Polidoro da Caravaggio. Some of these artists specialized in particular tasks. Giovanni da Udine, for example, concentrated on grotesques and animals. It is not altogether fanciful or anachronistic to speak of 'Raphael Enterprises Limited'.[41]

Bernini had what was probably the largest *bottega* of all. For the Baldacchino at St Peter's (a commission worth 200,000 scudi), his assistants included, besides his brother Luigi, Bolgi, Cordier, Duquesnoy, Fancelli, Ferrata and Speranza. For St Peter's Chair (which was worth over 100,000 scudi), Bernini was assisted by Artusi (who specialized in bronze-casting), Ferrata, Morelli and Raggi. Ferrata and Raggi had *botteghe* of their own, so that one needs to think of Bernini as subcontracting the job rather than as working with *discepoli* in the traditional sense. For the tomb of Alexander VII, the division of labour within Bernini Enterprises reached its climax. Among the artists employed on this commission were Cartari, Lucenti, Maglia, Mazzuoli, Morelli and (especially for the allegories) Rinaldi.[42]

The increasing scale of commissions helped turn the artist into an entrepreneur; so did the growth of an art market. The medieval painter or sculptor did not always work with a specific client in mind, but would sometimes make a work first and sell it afterwards. In Sacchetti's *Trecentonovelle* (no. lxxxiv), we are told about a 'dipintore di crocifissi' (painter of crosses): 'he always had four or six finished or unfinished pieces in the house.' It was reasonable to expect that the demand for crucifixes would be a steady one, and it was easy to adapt an unfinished work to the requirements of an individual customer. This customer might be a firm who bought in order to sell again, as Francesco di Marco Datini, the merchant of Prato, and his associates did in the fourteenth century, buying paintings in Florence to sell in Avignon. The letters from Avignon to the firm's representatives in Florence ask repeatedly for paintings, 'if you think it is a bargain', or 'at a price you consider less'; 'if you don't find good things at a good price, leave them . . . these are things to buy when the master who made them is in need of money.'[43] The idea that a painting is a commodity could hardly be expressed more forcibly.

References to the market in works of art multiply from the fifteenth century onwards, especially in Florence, Venice and Rome. The growing interest in classical sculptures, which were already worth

forging by 1500, probably encouraged the growth of an art market, and so, no doubt, did foreign interest in Italian art, since a man like Francis I of France could not easily buy straight from the *bottega*. Either he had to import the artist, as in the cases of Leonardo, Rosso, Cellini and others, or he had to import the work of art, making use of the services of a middleman like Gianbattista della Palla, who bought works by Pontormo and Michelangelo to supply to the king.[44]

It should be noted that the specialist art dealer was late in making his appearance. Francesco di Marco Datini was a merchant who dealt in a wide range of commodities; della Palla was a Florentine nobleman. Artists too could engage in dealing as a sideline or even as their main activity. Jacopo Strada, for example, a Netherlander living in Italy, active as a goldsmith, painter and architect, spent a good deal of his time travelling Italy in search of classical statues, medals, and other objets d'art for customers in Central Europe like J. J. Fugger and the Duke of Bavaria. His son performed similar functions for Ferdinando de' Medici and Rudolph II.[45] The Venetian Marco Boschini, now best known for his books, like *La carta del navegar pittoresco* (1660), was a dealer in jewels and works of art who also painted. Pietro da Cortona sold paintings by Titian to the Grand Duke of Tuscany as well as carrying out work of his own.[46]

Other artists sold only their own produce, but it might be argued that the growth of an art market encouraged if it did not force them to think in a businesslike way. 'Il Cavalier d'Arpino', so Bellori tells us, 'knew how to drive a good bargain and sell his merchandise'.[47] The same might be said of Salvator Rosa, who had his own means of drawing attention to his work. When he was young and poor, Rosa 'was forced, in order to survive, to sell some fine pictures he had made to the dealers'. He is said to have acted in the Roman carnival for publicity reasons, 'in order to be more widely known'. At all events, he did become well known and successful thereafter.[48]

In the seventeenth and eighteenth centuries it is clear that some artists were suffering from the pressures of the art market, pressures which were no less strong, if less direct, than those of patrons. Successful artists found themselves identified with a particular kind of painting, which they were asked to reproduce again and again, forcing them into a kind of mass production. A discriminating French visitor to Rome in the middle of the seventeenth century commented on seeing a picture 'que l'on me voulait vendre pour Guide'. Guido Reni, whose works were often copied, was apparently prepared to retouch these copies and allow them to be sold as originals.[49]

Canaletto was, as the Président de Brosses remarked, 'gâté par les anglais'. The constant demand by English tourists for the same views of Venice encouraged him to work to a formula.[50] These are two relatively early examples of a situation in which more and more successful artists, in Italy as elsewhere, were to find themselves involved in the nineteenth and twentieth centuries, as the art market became more and more important.

As the art market increased in importance, so, naturally, did the exhibition. Paintings were displayed in public on occasion in the sixteenth, seventeenth and eighteenth centuries, notably in Rome and Venice. In Rome, the major annual occasions were the feast of St Joseph (19 March) in the Pantheon, and the feast of the beheading of St John the Baptist (29 August) in the cloisters of San Giovanni Decollato. In Venice, the major occasion was the feast of San Rocco (16 August), when paintings were hung outside the Scuola di San Rocco. However, these displays had other functions than that of selling the paintings. They were organized primarily to honour the saints on their festivals, and might include more old masters from private collections than new works. They offered artists an opportunity to publicize their work rather than to sell it. Salvator Rosa, who was not backward in exhibiting his work in Rome ('ne andava di quando in quando esponendo a pubblica vista'), would say that he had made his pictures 'per uso suo', though he might sell them when the exhibition was over. It was only very slowly that the exhibition turned into an institution for selling works of art made without a specific patron in mind, and in Italy the development of a formal system of juries, catalogues and published criticism occurred only in the nineteenth century, later than in France.[51]

From 1805, for example, there were annual exhibitions of the work of the students at the Brera. In 1810, there was an exhibition of recent works of art on the Campidoglio at Rome, lasting for fifteen days. Later in the century, annual exhibitions of local artists were organized by local societies, of which the first to be founded, in 1842, was the Società Promotrice delle Belle Arti in Torino, a kind of company which sold shares at 20 lire each and had over 2,000 members by 1872.[52] In Rome, the Società Promotrice degli Amatori e Cultori organized some important exhibitions in the 1850s. After unification, these local exhibitions were supplemented by others on a national scale, the first in Florence in 1860, the second in Parma in 1870, the third in Milan in 1872. From 1895 on, the Biennale at Venice (founded by the municipality), showed works by both Italian artists, and also sold them, for 10 per cent commission.

During the first Biennale, 220,000 visitors went to see 516 works of art, of which 186 were sold.[53] By that time, of course, exhibitions of all kinds had become commonplace; small and large, public and private, group and one-man shows.

The institutionalization of the exhibition went with the institutionalization of art criticism, in the sense of published professional comment on works of art designed both to persuade people to go and look at them and also to tell them what to like. In a sense art criticism goes back at least as far as the Renaissance, when judgements – often unfavourable ones – on paintings and sculptures were made public. When Perugino was working at the church of the Servi in Florence, so Vasari tells us, his old-fashioned style 'was criticized by all the new artists . . . they mocked him without mercy in sonnets and public insults.' Bandinello was another artist who suffered from criticism of his work, some of it in sonnet form, criticism which, as Benvenuto Cellini summarized it, was certainly sharp enough: 'if the hair of Hercules were removed, there wouldn't be enough head to hold his brain; and you can't tell whether his face is that of a man or a cross between a lion and an ox, and that he is not watching what he is doing, and that the head is badly joined to the neck.'[54] Aretino was perhaps the first Italian art critic in the sense of a professional writer who regularly gave his verdicts on new works of art, verdicts which (although delivered in letters to individuals) were intended to be made public.[55]

What was new in the nineteenth century in Italy was that art criticism became an institution in the sense of appearing at regular and short intervals in newspapers and magazines. The rise of exhibitions encouraged the rise of art criticism, and no doubt the critics in turn did something to make the exhibitions a success.[56] Some of the journalists knew little about art, some of them seem to have expected payments from the artists they reviewed as well as from their newspaper, and many considered it their mission to uphold traditional artistic standards against innovation; it was, for example, a critic in the *Gazzetta del Popolo* of Turin who coined the contemptuous term 'Macchiaioli' (much like 'impressionist') in a review of 1862. It is not surprising to find that artistic innovators were critical of the critics, from Pietro Selvatico in 1842, noting with what appears to be weary resignation 'how nice it would be for artists if only honest and enlightened men wrote for the papers', to Boccioni's denunciation of 'criticism which is superficial and is never disinterested'.[57] Critics could either launch or stifle young artists at a time when their success depended less on catching the eye of an

individual patron, as had been the case before 1800, than on becoming known to a wider public of dealers and customers.

The artist as civil servant

If craftsmen were gradually turning into entrepreneurs in the course of the seventeenth, eighteenth and nineteenth centuries, courtier-artists were slowly being transformed into civil servants. A managerial role like *capomaestro* was, of course, traditional in architecture for obvious reasons, but from the Renaissance on, artists were given other official positions. Giovanni Bellini was appointed painter to the Venetian state in 1483, a post later held by Titian. This was the republican equivalent of the post of court painter, giving Bellini a retaining fee and exemption from guild regulations (which would have limited the number of his assistants), and involving him in large-scale enterprises in the Palazzo Ducale. Raphael was appointed *commissario delle antichità* by Leo X, a job which one might have expected to have been given to a papal official rather than an artist. The academies of Florence and Rome had their heads or *principi*, posts which were primarily honorific but also involved managerial functions such as mediation between other artists and the prince, and the formulation of official artistic ideals. Among his patrons, Zuccaro played the role of courtier, but among his colleagues, that of bureaucrat, not altogether unlike the role of a later Segretario Generale del Sindicato delle Belle Arti.[58]

At the same time as the rise of the official academies, the workshops of court artists seem to have been coming under closer control, as part of the policy of centralization pursued by the new 'absolute' monarchies. In Rome, Bernini's assistants were paid by the papal treasury, not by Bernini himself.[59] A more formally bureaucratic organization of the arts could be seen in the Galleria dei Lavori in the Uffizi under the grand-dukes of Tuscany. Goldsmiths, sculptors and painters worked in *botteghe* in the palace under the supervision of a *sopraintendente dei lavori* and *capomaestri*. In 1687, the *capomaestro dei scarpellini* was given authority over his workers, 'if they fail to obey him or to work as well as they should or as much as he wishes and commands, he can dismiss them.'[60] The traditional workshop was turning into an art factory.

In the nineteenth century, the bureaucratization of art and artists went further. One reason for this was that governments, starting with the papacy, were more concerned than before to preserve and

display their artistic heritage, and called in artists to advise them about this. In 1802, for example, Pius VII made Canova Ispettor Generale delle Belle Arti for Rome and the Papal States, charged to ensure that no work of art left the area without permission. In 1814, the same pope made Camuccini Ispettor alla Conservazione delle Pubbliche Pitture in Roma; one of his tasks was the reorganization of the Pinacoteca Vaticana.[61] The opening of public museums and galleries of course involved the employment of a considerable number of officials, from directors to janitors, but artists were rarely involved. However, many official posts for artists were created by the foundation of new academies and the reform of old ones in the late eighteenth and early nineteenth centuries: administrative posts, like that of secretary to the Accademia della Brera of Milan, held by Giuseppe Bossi from 1801 to 1807 (which was certainly no sinecure), and teaching posts, professorships of painting, sculpture and architecture.

The unification of Italy replaced the patronage of individual princes by the more impersonal patronage of the state, exercised through ministries and committees, to judge competitions, beginning with Ricasoli's competition for the best painting of the battle of Magenta, which was won by Fattori in 1860. Government patronage of the arts in Italy, from 1860 to 1945 or beyond, has not yet been studied in the detail which it deserves (from the point of view of political or social history, if not from that of the history of art), so that we are in no position to say whether successful artists were generally chosen for their abilities or for their political conformism.

The academies were reformed to give artists a professional training, because they were now considered as professional men. They were given a training by specialist teachers, modelled on that given in schools and universities, in place of their traditional training on the job. The curriculum of the new and reformed academies resembled that of the earlier academies (public and private) in some ways, such as the practice of drawing from plaster casts of classical sculpture and from the nude model, together with the study of anatomy and perspective. However, the new system was more formal and the scale of operations was very much larger. In the early 1870s, there were about 1,300 students at the Brera and about 700 at the Accademia Albertina at Turin. The majority of the students, incidentally, were studying *ornato*, which suggests that they were expecting to make a career in industry as craftsmen or designers.[62]

In the nineteenth and twentieth centuries, then, the ladder of artistic success was no longer what it had been. It was no longer enough to

enter the studio of a leading painter and to attract the attention of a noble dilettante and patron, as it had been in the sixteenth, seventeenth or eighteenth centuries. The obvious thing to do now was to study at one's local academy, to pass examinations, to win medals and *pensioni* (which might carry exemption from military service), to be victorious in competitions for public commissions (the Monumento Cavour, perhaps, or the Monumento Vittorio Emmanuele), to be praised by the critics, to hold successful exhibitions, to design coins or banknotes, to sit on the Commissione Giudicatrice for some Esposizione Nazionale, or perhaps to become a professor of art with a salary from the Ministero della Pubblica Istruzione.[63] It was a comfortable, orderly, bourgeois existence – but it was not one which attracted all aspiring young artists. For those whom it did not attract, another role existed: the artist as rebel.

The artist as rebel

The tradition of the eccentric artist is, of course, an old one in the Italian literature of art. Eccentricity is one of Vasari's favourite themes, for example in his lives of Masaccio, Donatello, Uccello, Leonardo, Piero di Cosimo, Parmigianino, Pontormo, Beccafumi, Michelangelo and others. In these lives, eccentricity took different forms: solitude, or absent-mindedness, or carelessness about money matters, or melancholy, or irritability, or idleness – Aristotele di San Gallo's friends, although poor, 'were more interested in joking and enjoying themselves than in working'. Patrons and clients of this period sometimes complained, as the Marquis of Mantua did, of artists who 'hanno del fantasticho', and cannot be relied on.

Since details about the private life of artists were so rarely recorded before this time, we are in no position to say whether there had always been artists who were eccentric by the standards of the world around them, or whether capriciousness, in particular, was one means of expressing a new claim for higher status, a demand to be taken more seriously by patrons. Whichever it was, we must be on our guard against an anachronistic interpretation of these eccentricities as 'bohemianism' in the sense of a self-conscious rejection of bourgeois society.

The same warning applies to modern interpretations of the eccentricities of artists in the seventeenth and eighteenth centuries: Caravaggio, for example, described by his patron, Cardinal del Monte, as 'hare-brained', with a taste for low life and a liability for getting

himself involved in brawls; or Borromini, who was, as Baldinucci put it, 'of melancholy humour', and finally committed suicide; or Salvator Rosa, who referred to his 'unconventional temperament', and his need for liberty, satirized the papal court and the Accademia di San Luca, and on occasion refused commissions; or Canaletto, who was described by an English client, McSwiney, as 'whimsical', because he varied his prices from day to day.[64] These men were reacting with irritation to the pressures of the patronage and market systems within which they had to work – Rosa at least was doing this, for he wrote to his friend G. B. Ricciardi in 1652 about 'la repugnanza' he felt for painting battle scenes: 'I have virtually vowed to make no more of such pictures.'[65] However, not even Rosa was trying to construct an alternative system. It is their attempt to change the system which makes certain groups of Italian artists in the nineteenth and twentieth centuries (notably the Macchiaioli and the Futurists) into 'rebels' in a stronger sense of the term, or even revolutionaries.[66]

The features of the old artistic regime to which the revolutionaries objected included the academies, the critics, the dealers and the government.

Criticisms were increasingly made in the nineteenth century of traditional academic methods of art education, especially the emphasis on the study of classical antiquity. Lorenzo Bartolini, who became professor of sculpture at Florence in 1839, caused a furore by forbidding his pupils to imitate classical statues. He told them to study nature instead; to discourage the idealization of nature, he brought a hunchback into the academy to act as a model. At much the same time Pietro Selvatico denounced the imitation of classical statues by students of painting in the academies.[67] Criticisms were also made of conventional academic subject-matter. At the Academy of Naples in 1859, Michele Cammarano denounced the subject of a competition for landscape painters (Landscape with hermit in a cave), as 'the kind of absurd thing which is made in the Academy', and Giuseppe de Nittis got himself expelled from the same academy a little later, in 1863.[68] The Macchiaioli were opposed to academies in general, much like the Futurists some fifty years later. The Futurist critique of 'il formalismo accademico' echoes Adriano Cecioni's attack on 'il convenzionalismo accademico' a generation before.

With the attack on the academies went an attack on the art critics, who often judged revolutionary works by the standards of academic tradition. Artists had been expressing their unhappiness with art critics since at least the early nineteenth century. Hayez wrote with a certain envy of the artists of the sixteenth century that 'Those

artists could cultivate art with greater freedom, unhindered, as in our day, by the fear of criticism.'[69] The Macchiaioli were more outspoken in their opposition. Cecioni attacked certain art critics by name as well as denouncing 'il sistema' which forced journalists who knew nothing about art to publish their views about exhibitions. Indeed, he was opposed to anyone who 'writes about art without being an artist'. The Futurists held similar views. 'Outsiders who keep away from the site', said Carrà, and the Futurist Manifesto declared art critics 'useless and harmful'.[70] Not only the brief dominance of the professional critic, but the long dominance of the layman, whether prince, humanist or dilettante, was now called into question.

With the attack on the art critics went an attack on the commercial system of the arts which treated painting and sculpture as commodities and forced the artist to act the entrepreneur, to do what his ignorant public wanted. 'What then is the poor artist to do?' asked Selvatico. 'Either swallow the bitter pill without complaining and follow the absurd wishes of his client, or die heroically of starvation waiting for time to do him justice?' Nino Costa was one of those who refused to swallow the pill. He disliked art dealers and sometimes refused commissions because he did not care for the client. Fattori expressed a similar opposition to the art market. 'I have never wished', he wrote, 'to make art into a trade or submit to the demands of dealers, who ruin art and artists alike.' Or again: 'If the artist is obliged to please either the client or the dealer, he is a machine operated by someone else.'[71] Cecioni expressed in no uncertain terms his contempt for the artists who were prepared to work within this system: 'people who invest in the royal family . . . people who work for the market', people who produced 'bourgeois art, fashionable art'; 'the subject which sells, the colour, the chiaroscuro which sells'. He was equally scathing in his comments on the public, who, he wrote, treated art as no more than interior decoration, and 'after having calculated what matches the apartment, decides on what kind of picture to buy before visiting the exhibition'. Hence, he concluded, Italian art is in decadence.[72] From the historical point of view, this argument is open to criticism; the public had behaved in this way in the fifteenth and sixteenth centuries, when art was far from decadent. Cecioni's argument was, however, a vigorous expression of new attitudes on the part of the artist. Now that (in contrast to the Renaissance) there were different styles to choose from, artists wanted to make their own choice, not to have a style thrust upon them.

The Macchiaioli were also opposed to the current involvement

of art with the state. They disliked artist bureaucrats, 'people who do what the government wants' (as Cecioni put it) as much as they disliked artist entrepreneurs. They opposed the political intrigues and the favouritism of the Salon system. 'The government demands excellence in art but confides the task of rewarding the artist to those incapable of recognizing excellence . . . The king's acquisitions are the works which have been recommended most highly, so the artist who succeeds is not the one who has done well but the one who has the best recommendation.'[73] What the rebels wanted was freedom from political as from economic pressures. 'I believe it necessary to leave the artist free to produce the beauties of nature as he feels and sees them.' The artist must be free to produce 'l'arte per l'arte'.[74]

In short, in the middle of the nineteenth century there emerged in Italy something like an organized opposition to the artistic establishment. 'It was a conspiracy', Fattori reminisced; 'we declared war on classical art.' 'For the first time in Italy', so it has been suggested, 'an artistic movement developed like a modern political party, with its programme, its strategy and its tactics.'[75] The rebels were in fact involved in politics as well. Costa and Fattori took part in the revolution of 1848; Abbati, Costa and Signorini fought in the 1859 campaign; Costa helped to organize the 1866 insurrection in Rome. These men opposed the old regime in politics as in the arts. Much the same can be said of the Futurists, who were interested in revolutionary political and social ideas, whether socialist or anarchist. Severini, for example, read Proudhon (as Signorini too had done in his time), and also Marx, Engels, Labriola, Bakunin, Nietzsche. Carrà read Stirner, Marx, Labriola, Nietzsche and Kropotkin.[76] The way in which the Futurists promoted their ideals was even closer to a political campaign than the methods of Costa and Cecioni had been. It involved the signing of manifestos, the organization of demonstrations, the hiring of halls and theatres (for the famous *serate futuristiche*), the distribution of leaflets and the publication of interviews in newspapers (Boccioni, for example, was interviewed by the liberal Modena paper *Il Panaro* in 1911). Looking back on all this, Carrà commented on Marinetti's 'extraordinary talent for publicity', and added that 'the Futurist movement quickly took on what I would call an "American" character, producing an enormous number of manifestos and books.'[77]

Organized opposition needs institutions. The artistic opposition began in cafés and went on to found societies, journals and exhibitions.

Where the artists of the old regime associated in academies, the rebels met in cafés. Caffè Michelangelo in Florence, for example, where, in the 1850s, the Macchiaioli (in between 'jokes' reminiscent of Aristotele di San Gallo's friends some three hundred years before) formulated their opposition to academic art; Caffè Greco in Rome, an old haunt of artists, frequented by Costa in the middle of the nineteenth century; Caffè Manciola in Milan in 1909–10, where Boccioni, Carrà and Russolo drafted the Futurist Manifesto; or Caffè Aragno in Rome in the 1920s, where Giorgio de Chirico and his friends could be found.[78]

Cafés were excellent places for formulating ideals. But for spreading these ideals, other institutions were necessary. Societies, for example. Costa founded the 'Gold Club' to encourage expeditions to the countryside to paint from nature. He helped found the Circolo degli Artisti Italiani; and, most important of all, he founded In Arte Libertas, a group of artists exhibiting in Rome. The statutes of In Arte Libertas, drawn up in 1890, expressly rejected 'every intervention by the government, by the municipality or by aristocratic patrons', and declared that the society would pay nothing to the press for its criticisms. The first exhibitions held by the society were in fact attacked by the critics.[79] A few years later, in 1905, also in Rome, Giacomo Balla organized a *Mostra dei Rifiutati* on the French model.

Since the critics were hostile, the rebels founded their own journals. To explain the ideas of the Macchiaioli to the public, Martelli and Signorini founded the *Gazzettino delle Arti di Disegno* in 1867. The journal disappeared after twelve months, to be followed by *Il Giornale Artistico*, which lasted no longer. It was only in the early twentieth century that a more or less continuous tradition of avant-garde journals developed in Italy. One thinks of *Leonardo*, founded by Papini and Prezzolini, which lasted from 1903 to 1907; of *La Voce*, founded by Prezzolini, which lasted from 1908 to 1916; or *Lacerba*, founded by Papini and Soffici, which lasted from 1913 to 1915. With these journals the avant-garde became established.

This brief survey of eight centuries of artistic life in Italy suggests that being an artist has meant very different things in different periods, and also that there has never been a golden age when the artist was free from social pressures, however different the forms they have taken. To be successful in his own day, whether as craftsman or courtier, entrepreneur or civil servant, it was usually necessary for the artist to yield to these pressures, whether with a good grace or (like Michelangelo or Salvator Rosa), with a bad one. In

some cases – but only in some – it seems that the necessity of
yielding to pressures spoiled a good artist's work. Yielding to his
patrons was bad for Guercino, yielding to the market was bad for
Canaletto.[80] Other artists, including some of the greatest, like Raphael,
and Bernini, do not seem to have felt any problem at all, whether
because they were blessed with sympathetic patrons or because play-
ing the courtier was not a strain for men of their character.

Can we speak of the 'evolution' of the artist over eight hundred
years? Looking back over the whole period, it does seem that in
each successive century artists found the pressures of the particular
system within which they were working more intolerable, until some
of them tried to break with it in the middle of the nineteenth cen-
tury. Since that time, rebellion has become more frequent, more
radical, more self-conscious, better organized, and more successful.
Successful, indeed, to the point of destroying itself. What has hap-
pened to the revolutionary artists in our own century is what not
infrequently happens to revolutionaries; they enjoy an apparent
success which may really be something more like failure, because it
involves the incorporation of the opposition as one group among
others within the system which they were trying to overthrow. In
1900, for example, In Arte Libertas was amalgamated with the Roman
Società Promotrice. A few years later, the Futurists organized their
more violent opposition to the system, but their friend Marinetti got
them into the Biennale. After the First World War, the avant-garde
became fashionable, and another ladder to artistic success was set
up alongside the old ones.[81] The aspiring artist might now attend an
academy purely to enjoy 'the novelty and the pleasures of student
life', as Carrà put it; he claimed to have learned nothing at all at the
Brera. 'It never occurred to me', confessed Severini, 'to go to the
Academy to frequent the regular courses of painting.'[82] The years of
bohemian- or student-style poverty would be followed by recogni-
tion by the avant-garde, followed in turn, after a certain time-lag, by
commercial success, bringing with it the usual temptations, to which
some succumbed. Even for the rebels who did not succumb to temp-
tation, a problem remained (and in fact remains): how can an artist
revolt against tradition once there is an established tradition of the
new?

NOTES

1 F. Antal, *Florentine Painting and its Social Background* (London, 1947);
 M. Wackernagel, *The World of the Florentine Renaissance Artist* (1938;

English translation, Princeton, 1981); F. Haskell, *Patrons and Painters* (1963; second edn, New Haven and London, 1980); M. and R. Wittkower, *Born under Saturn* (London, 1963).

2 P. Burke, *The Italian Renaissance: Culture and Society in Italy* (1972; third edn, Cambridge, 1986).

3 For example, there is no good description of the status of artists in nineteenth-century Italy comparable to J. Lethève, *La Vie quotidienne des artistes français au XIXe siècle* (Paris, 1968), or a sociological study of the contemporary art world such as B. Rosenberg and N. Fliegel, *The Vanguard Artist* (Chicago, 1965).

4 G. Baglione, *Vite* (Rome, 1942); C. Ridolfi, *Meraviglie* (1648), ed. D. Hadeln, 2 vols (Berlin, 1914); G. P. Bellori, *Vite* (1672) ed. E. Borea (Turin, 1976); R. Soprani, *Vite de' pittori genovesi* (1674) 2 vols (Genoa, 1768); C. C. Malvasia, *Felsina pittrice* (Bologna, 1678); G. B. Passeri, *Vite* (Rome, 1678); L. Pascoli, *Vite*, 2 vols (Rome, 1730–6).

5 L. Ghiberti, *I commentari*, ed. O. Morisani (Naples, 1957); B. Cellini, *Vita*, ed. E. Camesasca, 2 vols (Milan, 1954); S. Rosa, *Lettere inedite*, ed. A. de Rinaldis (Rome, 1939); F. Hayez, *Le mie memorie* (Milan, 1890); G. Duprè, *Pensieri sull'arte e ricordi autobiografici*, second edn (Florence, 1880); G. de Nittis, *Notes et souvenirs* (Paris, 1895); G. Fattori, 'Note autobiografiche', in M. de Micheli, *Giovanni Fattori* (Busto Arsizio, 1961), pp. 81–96; G. Costa, *Quel che vidi e quel che intesi* (Milan, 1927); G. Severini, *Tutta la vita di un pittore* (Milan, 1946); C. Carrà, *La mia vita* (Rome, 1943); G. de Chirico, *Memorie della mia vita* (Rome, 1945).

6 On Properzia, L. M. Ragg, *The Women Artists of Bologna* (London, 1907). For Italy there seems to be no equivalent to R. Swartwout, *The Monastic Craftsman* (Cambridge, 1932).

7 F. Sacchetti, *Le trecentonovelle*, ed. E. Faccioli (Turin, 1970), no. clxi.

8 C. Klapisch, *Les Maîtres du marbre, Carrara 1300–1600* (Paris, 1969).

9 J. White, *Art and Architecture in Italy 1250–1400* (Harmondsworth, 1966), pp. 223ff. Cf. H. Tietze, 'Master and Workshop in the Venetian Renaissance', *Parnassus*, 11 (1939), pp. 34–45.

10 On the social origin of artists, Burke, *Italian Renaissance*, ch. 3; A. Condivi, *Vita di Michelagnolo Buonarroti*, ed. E. Spina Barelli (Milan, 1964), p. 24.

11 On apprenticeship, C. Cennini, *Il libro dell'arte*, ed. and trans. D. Thompson, 2 vols (New Haven, 1932). On associations, U. Procacci, 'Compagnie de' pittori', *Rivista d'Arte*, 10 (1960), pp. 3–37; on Fede and Lando, *Documenti sull'arte senese*, ed. G. Milanesi, 1 (Siena, 1854), no. 96.

12 For guild statutes from Florence (1339), Siena (1355) and Padua (1441), *Carteggio inedito d'artisti*, ed. G. Gaye, 3 vols (Florence, 1839–40); for Rome (1478), E. Müntz, *Les Arts à la cour des papes* (Paris, 1882), pp. 3, 101ff; for Venice, E. Favaro, *L'arte dei pittori in Venezia* (Venice, 1975).

13 Quoted in D. A. Covi, 'A Documented Altarpiece by Cosimo Rosselli', *Art Bulletin*, 53 (1971), p. 238.

14 G. Campori, 'I pittori degli Estensi nel secolo xv', *Atti e Memorie Modenesi e Parmensi*, 3 (1886), pp. 592–7.

15 Soprani, *Vite*, I, pp. 124–5.

16 M. A. Muraro, 'The Guardi Problem and the Statutes of the Venetian Guilds', *Burlington Magazine*, 102 (1960), pp. 421–8.

17 F. Haskell, 'Patrons', *Encyclopaedia of World Art*, 17 vols (New York, 1959–87) XI, cols 118–32.

18 M. d'Azeglio, *I miei ricordi* (Florence, 1867), p. 279.

19 Favaro, *L'arte dei pittori in Venezia*, pp. 119ff; cf. E. Bassi, *L'accademia di Venezia* (Venice, 1950), p. 12.

20 R. Salvini, *Willigelmo e le origini della scultura romanica* (Milan, 1956), p. 98.

21 M. Ayrton, *Giovanni Pisano Sculptor* (London, 1969), p. 160.

22 C. Gilbert, 'The Archbishop and the Painters of Florence', *Art Bulletin*, 41 (1959), pp. 75–87.

23 Quoted in E. Steinmann, *Die Sixtinische Kapelle*, 2 vols (Munich, 1905), II, p. 754.

24 Michelangelo, letter of 2 May 1548, in his *Lettere*, ed. G. Milanesi (Florence, 1875), p. 225.

25 *Esequie del divino Michelagnolo Buonarotti*, ed. R. Wittkower (London, 1964).

26 Pascoli, *Vite*, I, p. 122.

27 Cellini, *Vita*, I, paras 53, 62, 64 and 69.

28 D. Mahon, *Studies in Seicento Art and Theory* (London, 1947), pp. 59ff.

29 W. Friedländer, *Caravaggio Studies* (1955; second edn, New York, 1972), pp. 76ff.

30 On Zuccaro, G. Mancini, *Considerazioni sulla pittura*, ed. A. Marucchi (Rome, 1956), p. 205; on Scipione, Baglione, *Vite*, p. 54; on Algardi, Bellori, *Vite*, p. 417; on Pietro da Cortona, Pascoli, *Vite*, I, p. 14; on Guido Reni, Passeri, *Vite*, p. 11, and Mancini, *Considerazioni*, p. 241; on Mola, Pascoli, *Vite*, I, p. 128; on Bernini, F. Baldinucci, *Vita di Gianlorenzo Bernini* (1682), ed. S. Samek-Ludovici (Milan, 1948), p. 138, and R. Wittkower, *G. L. Bernini* (London, 1955), pp. 270ff.

31 On the humanist adviser, Burke, *Italian Renaissance*, pp. 109ff.

32 V. Cartari, *Le imagini* (Venice, 1556).

33 L. B. Alberti, *Della pittura*, ed. L. Mallé (Florence, 1950), p. 103; F. Algarotti, *Saggi*, ed. G. da Pozzo (Bari, 1963), pp. 116–17.

34 B. Bandinelli, 'Memoriale', *Repertorium für Kunstwissenschaft*, 28 (1905), p. 428.

35 Malvasia, *Felsina pittrice*, I, p. 361.

36 S. Rosa, *Satire* (Amsterdam, n.d.), p. 59.

37 Baldinucci, *Bernini*, p. 149.

38 N. Pevsner, *Academies of Art Past and Present* (Cambridge, 1940), pp. 39ff.

39 G. Coor, *Neroccio de' Landi* (Princeton, 1961), p. 157.

40 Pevsner, *Academies*, pp. 45ff, 59ff, 75ff. On Bologna, cf. Malvasia, *Felsina pittrice*, I, pp. 377ff, and M. J. Lewine, 'The Carracci Academy', in *The Academy*, ed. T. B. Hess and J. Ashbery (New York, 1967).

41 A. Marabottini, 'I collaboratori', in *Raffaello*, ed. M. Salmi, 2 vols (Novara, 1968), pp. 199–203.

42 Wittkower, *Bernini*, pp. 39ff, 187ff, 219ff, 230.

43 R. Brun, 'Notes sur le commerce des objets d'art en France', *Bibliothèque de l'Ecole des Chartes*, 94 (1934), pp. 341–3.

44 Wackernagel, *World of the Florentine Renaissance*, p. 283.

45 On Jacopo Strada, U. Thieme and F. Becker, *Allgemeines Lexikon der bildenden Künstler*, XXXII, pp. 145–7; on Ottaviano, R. J. W. Evans, *Rudolph II and his World* (Oxford, 1973), pp. 129, 181.

46 On Boschini, *Dizionario biografico degli Italiani*, XIII, pp. 199–202; on Pietro da Cortona, Pascoli, *Vite*, I, p. 6.

47 Quoted in Friedländer, *Caravaggio Studies*, p. 73.

48 Passeri, *Vite*, p. 388; Pascoli, *Vite*, I, p. 65.

49 B. de Monconys, *Journal des voyages*, 3 vols (Lyon, 1665–6), II, p. 463; Malvasia, *Felsina pittrice*, II, pp. 32ff.

50 J. G. Links, *Canaletto and his Patrons* (London, 1977), pp. 45–6; M. Levey, *Painting in Eighteenth-Century Venice* (London, 1959), p. 83.

51 Haskell, *Patrons and Painters*, pp. 125ff; *idem*, 'Art Exhibitions in 17th-century Rome', *Studi secenteschi*, 1 (1960), pp. 107–21; F. Haskell and M. Levey, 'Art Exhibitions in 18th-century Venice', *Arte Veneta* (1958); G. F. Koch, *Die Kunstausstellung* (Berlin, 1967), ch. 4; on Rosa, Pascoli, *Vite*, I, 71.

52 A. Caimi, *L'Accademia di Belle Arti in Milano* (Milan, 1873); C. F. Biscarra, *Relazione storica intorno alla Reale Accademia di Belle Arti in Torino* (Turin, 1873).

53 L. Alloway, *The Venice Biennale* (London, 1969).

54 Cellini, *Vita*, II, para. 70.

55 P. Aretino, *Lettere sull'arte*, ed. E. Camesasca, 3 vols (Milan, 1957–60).

56 A study of nineteenth-century Italian art criticism is much to be desired.

57 P. Selvatico, *Sull'educazione del pittore storico odierno italiano* (Padua, 1842), p. 462; U. Boccioni, *Scritti*, ed. Z. Birolli (Milan, 1971), p. 314.

58 Mahon, *Studies*, pp. 177ff; Friedländer, *Caravaggio Studies*, pp. 70ff.

59 Wittkower, *Bernini*, pp. 39ff.

60 K. Lankeit, *Florentinische Barockplastik* (Munich, 1962), pp. 25ff.

61 On Canova, M. Missirini, *Memorie* (Rome, 1823), pp. 337ff; on Camuccini, *Dizionario biografico degli Italiani* XVII, pp. 627ff.

62 Caimi, *L'Accademia* and Biscarra, *Relazione storica*.
63 Studies of typical artistic careers in Italy seem to be lacking. On other parts of Europe see Q. Bell, 'Conformity and Nonconformity in the Fine Arts', in *Culture and Social Character*, ed. S. M. Lipset (Glencoe, 1961), pp. 389–403, and *idem*, *Victorian Artists* (London, 1967).
64 Wittkower, *Born under Saturn*, pp. 67ff, 113ff, 187ff; Mahon, *Studies*, pp. 177ff, and Friedländer, *Caravaggio Studies*, pp. 70ff. McSwiney quoted in Links, *Canaletto*, p. 26.
65 L. Salerno, *Salvator Rosa* (Milan, 1963), pp. 24ff; Rosa, *Lettere*, no. 25.
66 A. Cecioni, an insider, described the Macchiaioli as a 'revolutionary' movement in *Scritti e ricordi* (Florence, 1905), p. 295.
67 On Bartolini, *Dizionario biografico degli Italiani*, VI, pp. 603–9; Selvatico, *Sull'educazione*, p. 48.
68 *Dizionario biografico degli Italiani*, XVII, pp. 266–8; de Nittis, *Notes et souvenirs*, pp. 26ff.
69 Hayez, *Memorie*, p. 70.
70 Cecioni, *Scritti e ricordi*, pp. 221 and 245ff; Boccioni, *Scritti*, p. 11.
71 Selvatico, *Sull'educazione*, pp. 444ff; O. Rossetti Agresti, *Giovanni Costa* (London, 1904), p. 272; de Micheli, *Giovanni Fattori*, pp. 83, 93.
72 Cecioni, *Scritti e ricordi*, pp. 199, 200, 292, 294.
73 Ibid., pp. 199, 210.
74 De Micheli, *Giovanni Fattori*, p. 93; Cecioni, *Scritti e ricordi*, p. 198.
75 C. Maltese, *Storia dell'arte in Italia 1785–1943* (Turin, 1960), p. 245.
76 Severini, *Tutta la vita*, pp. 13ff; Carrà, *La mia vita*, p. 68.
77 Carrà, *La mia vita*, p. 133.
78 T. Signorini, *Caricaturisti e caricaturati al Caffè Michelangelo* (Florence, 1890); Severini, *Tutta la vita*, p. 26; Carrà, *La mia vita*, p. 129; de Chirico, *Memorie*, pp. 167ff.
79 Agresti, *Giovanni Costa*, pp. 220ff.
80 Mahon, *Studies*, pp. 53, 102ff; Links, *Canaletto*, pp. 45ff.
81 Bell, 'Conformity'.
82 Severini, *Tutta la vita*, p. 20.

———————— ∞∞∞ ————————

Centre and Periphery*

ENRICO CASTELNUOVO AND CARLO GINZBURG

The periphery and the provinces

PERIPHERY or provinces? Perhaps it is more appropriate to talk about the periphery, as a more neutral term with fewer implicit value judgements. But even the apparent neutrality of the word 'periphery' is deceptive. It was a geographer who stated that in the paradigm 'centre/periphery' the term 'periphery' should be understood as a 'political and spatial allegory'.[1] But what importance should we ascribe to each of these elements? And in what kind of system will we find this complementary, rather than antithetic, couple?

These are obviously critical questions for geographers, and they could be just as important for art historians.[2] But we run a risk in adopting the rather disarming answer expressed by Sir Kenneth Clark:

The history of European art has been largely the history of a number of centres, from each of which a style has spread out. For a time, whether short or long, this style dominates the art of the period, turning in effect into an international style, while remaining metropolitan at the centre and becoming more and more provincial as it reaches the periphery. A style does not develop spontaneously over a large area. It is the creation of a centre, a single unit that provides the impulse. The centre may be small, like fifteenth-century Florence, or

* Translated by Ellen Bianchini.

large, like Paris before the war, but it has the self-confidence and coherence of a metropolis.[3]

If the centre is by definition the place of artistic creativity, and periphery merely means distance from the centre, then we need only conclude that 'periphery' is synonymous with later artistic development, and the question is settled. This would appear to be a process of subtle tautology, where the problems are eliminated rather than resolved. We should instead try to consider the terms 'centre' and 'periphery' in their entirety: geographical, political, economic, religious – and artistic. We shall then immediately realize the importance of identifying the link between artistic and extra-artistic phenomena, and escape the false antithesis of creativity in the idealistic sense (the spirit which blows whither it will) and superficial sociology. But the importance of this kind of study does not lie only in methodology. If we look at the relationship between centre and periphery from a member of different perspectives, it will take on a very different appearance from the peaceful one outlined by Sir Kenneth Clark. Its essence is not diffusion but conflict; and that conflict is apparent even in cases where the periphery seems to follow slavishly the lead of the centre. In an age of imperialism and subimperialism, when even Coca-Cola bottles become a tangible sign of (not only) cultural bondage, we are inescapably affected by the problem of the domination of symbols, of the forms that domination can take, and of the ways and means of confronting it.[4]

The Italian case

Italy is a privileged workplace for a study of the centre/periphery connection in art. There are many reasons for this, the most important one being geography. We should remind ourselves of the country's most obvious characteristics: the length of the peninsula; the relationship between the perimeter of the coastline and the surface area; the abundance of its inlets; the presence of two chains of mountains, the Alps and the Apennines, one transverse, the second longitudinal; the many valleys and passes. These elements have mapped out a country as contradictory and diversified as any can be. The relative ease of exchange with distant countries has been paralleled by limited and problematic communication between internal areas, even though they may be very close. (Even today, it is easier to go by train from Turin to Dijon than from Grosseto to Urbino.)

This contradiction was accentuated, rather than diminished, by the history of the peninsula from late antiquity onwards. The presence of a close web of Roman roads and an exceptional quantity of urban centres, as well as the political division of the peninsula from the Graeco-Gothic war, all contributed to an increase of diversification on the one hand, and of communication on the other. From then on, artistic production in Italy had to deal with a strongly polycentric tendency, but this was not all: it was a polycentrism that was well informed, and generally speaking characterized by a multiplicity rather than a lack of contacts. Moreover, these contacts were more often imposed than actively sought; we need only think of the Eastern emperors, or those of the Holy Roman Empire, or the Arab caliphs and the French kings, the Hungarian invaders and Norman pirates. So that if we are to rethink the physiognomy of artistic production in Italy in terms of the relationship between centre and periphery (though we will linger over painting in particular, rather less over sculpture and hardly at all over architecture), then we must rethink the entire history of Italy.

Lanzi's *History*

'And really the history of painting is similar to literary, civic and religious history', wrote Lanzi. The great system that Lanzi proposed must be the point of departure for our discussion: not least because he was the first to turn away from the old method based on the artists' biographies, and to follow another, historical-geographical path, that reflected his preoccupations as curator of the grand-ducal gallery.

The specific aim of his *Storia pittorica* was to provide an equivalent to Tiraboschi's *Storia*: 'This lovely country [Italy] already has the history of its literature, thanks to Cavaliere Tiraboschi; but it still needs the history of its art.' This, in his view, implied identifying a coherent principle of order that was appropriate to the subject: 'a distinguishing factor in the places, times, events, which divided up the ages and circumscribed the successes: if this order is taken away, it [the history of painting] degenerates, like the others, into a confusion of names that serves better to burden the memory than to illustrate understanding.' But where was he to find this thread?

> We cannot . . . imitate the naturalists, who, having categorized the plants into greater or smaller classes according to the various systems

of Tournefort or Linnaeus, can easily reduce every plant that grows in any place to one class, adding to each name detailed, notes of its immutable characteristics. To do a full history of painting we must accommodate every style through all its variants with other painters; to this end I did not know a better way than to trace separately the history of each school. I have followed the example of Winckelmann, the excellent author of the ancient history of drawing, who describes individually as many schools as there have been nations which produced them. And I see M. Rollin has done likewise in his history of nations.[5]

Only the schools, then, could provide a criterion for classification that would not be rigid or schematic, so as to enable him to 'weave a complete history such as Italy desires'. The wealth of the history of Italian painting was not to be reduced to identifying styles or narrating the biographies of the founders of the schools. But exactly which schools did he mean?

The geography of painting in Italy slowly began to take shape in Lanzi's mind. The original project was to be in two volumes, which would have followed Pliny's division of Italy into northern and southern: 'In the first volume I had thought to include the schools . . . in southern Italy; for there the art revival reached its maturity sooner; and in the second, the schools of northern Italy, whose greatness appeared at a later stage.' But only the first volume went to press, in 1792: it included two 'principal' schools, Roman and Florentine, and two more 'adjacent to the primary schools', Naples and Siena.[6] In his dedication to the Grand-Duchess of Tuscany, Marie Louise of Bourbon, Lanzi warned that work on the second volume, then at an advanced stage, had been interrupted, 'nor may it soon be resumed.' But the subsequent reworkings ultimately resulted in the third, definitive edition of 1809, and replaced the first two-volume concept with a more complete and complex work in five volumes (with the index in a sixth volume).[7] Each volume covered one of the principal schools (with one important exception, as we shall soon see). This subdivision was specifically based on the system formulated at the beginning of the seventeenth century by Monsignor Agucchi, although he mentioned only four schools (Lombardy, Venice, Tuscany and Rome), which in turn imitated the four 'styles of the ancients' (Attic, Sicyonian, Asiatic and Roman).[8] Giulio Mancini, identifying the stylistic tendencies in Rome around 1620, had written of 'orders, classes, or shall we say schools', though he left out issues of a geographical order.[9] Even earlier, in 1591, the painter G. B. Paggi had witnessed the activities of 'three famous

schools of painting in Rome, in Florence and in Venice'; and in the middle of the sixteenth century Cellini had talked about the 'virtuous school'.[10]

So Lanzi's definition of the Italian schools of painting was fitted into an argument that had been alive for more than two centuries. Within that time, the number of acknowledged schools had gradually grown, both because existing centres had achieved a higher profile (Bologna, Genoa) and because, in the field of art, the municipalistic attitudes of the Seicento had tried to replace Vasari's largely monocentric outline with a polycentric one. Lanzi's innovation consisted in surrounding the major schools with a rich constellation of smaller schools: fourteen in all, including Piedmont 'which, though it did not follow an ancient school like other states, has other considerable merits such as to be included in the history of painting'.[11] The result was a picture that was far better constructed than those of his predecessors: perhaps the greatest innovation was the five schools of Modena, Parma, Mantua, Cremona and Milan, which served to undermine the generic label 'Lombard school'. Even so, from a geographical point of view, the picture was still very distorted.

Our first consideration will be crudely quantitative: in the 1809 edition of the *Storia pittorica*, the lion's share predictably fell to the major schools (with the exception of the Lombard school, for the reasons given above): Florence (300 pages), Venice (293), Rome (280), Bologna (214). After a notable gap, came the schools of Milan (98 pages), Naples (85), Genoa (73), Siena (70), Ferrara (64). Even further behind came the schools of Parma (46), Cremona (45), Piedmont and its surrounding areas (38), Modena (35) and Mantua (25). In other words, the part of the book dedicated to southern Italy – the 'Neapolitan school' that Lanzi conceived as an appendix to the Roman school from the very beginning of his project – comprised no more than a twentieth of the total: 85 pages out of a total of more than 1,600.

It should be remembered, when we try to explain such a blatant imbalance, that first of all Lanzi never visited the kingdom of Naples or the islands. His conscientiousness as connoisseur, which spurred him on to comb even the less obvious areas such as Friuli (let alone Genoa or Lombardy) in order to formulate his opinions as far as possible at first hand, was evidently defeated in the face of the strains and difficulties of travelling south of Rome. Lanzi was the first to realize this situation of inferiority. In the interval between the second edition in three volumes (Bassano, 1795–6) and the third,

definitive edition (Bassano, 1809), he tried to gather more substantial and reliable information on the Neapolitan school. On 13 June 1801 he wrote to his friend Bartolomeo Gamba, from Bassano: 'I would like him [Cavaliere Lazara] or you to find me a good book on the most recent Neapolitan and Sicilian painting; for I haven't seen anything later than Dominici.'[12]

But his research did not meet with much success, and Lanzi found himself disregarding the late development of painting in southern Italy. His only source for the Neapolitan school was still de Dominici (*Vite dei pittori . . . napoletani* (Naples 1742–3)). For Sicily, or rather Messina, he used the *Memorie de' pittori messinesi* published in Naples in 1792 under the name of Hackert, though actually edited by a local scholar, Grano. Lanzi distanced himself from de Dominici with an outright condemnation, in which an isolated and generic expression of approval is apparently ironic, for it is accompanied by a series of sharp criticisms:

> The recent Guide or *Breve descrizione di Napoli* wishes to find in this copious work [by de Dominici] 'more facts, more method, fewer words'. We might add to this a better critique of antique objects and less arrogance towards the more modern ones. For the rest, the history of painting in Naples is most vaulable, for the assessments of artists are mainly dictated by other artists whose names inspire confidence. If architecture and scuplture are equally well treated there is no place here to question them.[13]

However, the *Memorie de' pittori messinesi* must have inspired Lanzi with ever greater mistrust, for the information he extracted from it was carefully confined to his notes.

To sum up, Lanzi's chapter on the Neapolitan school looked at only two centres, Naples and Messina. Other painters working in the kingdom outside Naples (Cola dell'Amatrice, Pompeo dell'Aquila, G. P. Russo da Capua, Pietro Negroni) received infrequent, generic commentary. The author hoped for a work on painters in Syracuse and Sicily in general. Sardinia and Corsica are not even mentioned.

Artistic history and geographical distribution

Nineteen-twentieths of the *Storia pittorica*, then, is concerned with central and northern Italy. Here Lanzi had both a direct knowledge of primary sources and a full, reliable network of secondary sources.

Still, in the course of his work he came up against a problem of a taxonomic sort, if we can call it that, which he discussed particularly in relation to the Roman and Lombard schools.

Of the first he wrote: 'I have often heard art lovers asking whether the Roman "school" is a misuse of the term, or whether it can be applied with the same propriety as when it indicates the Florentine, Bolognese or Venetian schools.'[14] For the artists who 'taught or raised the level of painting' in Rome were 'foreign painters', with the exception of Giulio Romano and Sacchi. But in Lanzi's eyes this did not present a problem

> for in Venice, Titian of Cadore, Paolo Veronese and Jacopo da Bassano were also foreign; but the subjects of this dominion are numbered among the Venetians, the latter being a word that in common usage means those born in the capital or the republic. The same is true of the pontiffs. Beside the native Romans, masters came from various subject cities, to teach in Rome and continue the heritage and in some ways to create its greatest inheritance.[15]

It seems, then, that being or not being a member of a particular school relates to political considerations, such as provenance from the capital's 'subject cities'. But Lanzi's attitude is actually more complex. On one hand, exclusion from a school, which may be justified in geographical-political terms, appears to rest on stylistic grounds: 'even less would I include [in the Roman school] those artists who lived there and practised quite a different style; as, for example, Michelangiolo da Caravaggio.'[16] On the other hand, some of the cities that were subject to Rome in Lanzi's time gave birth to independent schools:

> I do not set out the boundaries of this school with those of the ecclesiastical state; for this would be to include Bologna and Ferrara and Romagna, whose painters I have reserved for another volume. Here I will consider the capital and only the nearest provinces, Lazio, Sabina, Patrimonio, Umbria, Piceno and the state of Urbino, whose painters were mostly trained in Rome, or by masters who came from Rome.[17]

The two criteria, stylistic and political, often coincided, for every school presupposes a centre, which is also a political centre. But sometimes they diverge, for there are artistic centres which in the past were political centres, but are not any longer. In other words, the geographies of painting and politics in Italy in Lanzi's time did

not overlap. If this was the case, the determining factor for Lanzi was style. Let us look at his comments on Piedmont, where this is especially clear:

> The inhabitants of Novara, Vercelli and some of those on Lago Maggiore ... who were alive before this period, lived and died as subjects of another state: and with the new conquests, they became more *Torinese* than Parrasius and Apelles had become Roman when Greece was subject to Rome. For this reason ... I have considered them as belonging to the Milanese school; for they must have belonged there by education, habitat and vicinity, although, they did not belong by law. I have used this method so far, for my purpose is the history of the schools of painting, not of the states.[18]

But in one case Lanzi was forced to admit that such a method was inadequate. When he came to expounding 'the principles and development of painting in Lombardy', which 'is the least well known in Italy', Lanzi explained that 'the history of its painting will be unravelled by a method completely different from that adopted with the others.' This was due to the absence of a unifying centre, a capital:

> The Florentine school, and those of Rome, Venice and Bologna, may be likened to so many plays with changing scenes and acts, which are the different eras of each school; the actors change too, and these are the masters of every new period; but the unity of place, that is the same capital city, is always the same; and the principal actors and protagonists always remain as examples, though not in action ... The history of Lombardy emerges differently, for in the most flourishing times for painting it was divided into many more dominions than at present, and every state had a different school and yielded different periods. And if one school did influence the style of another, this happened neither so universally nor within the same time span that one period may be applied to many schools. Therefore from the very title of this book I have renounced the traditional narrative which identifies the Lombard school as though there were only one of them.

True, some had thought fit to give the name Lombard school to the followers of Correggio, by identifying their characteristics: 'but if the school is so restricted, where shall we place the Mantuans, the Milanese, the Cremonese and many others who were born in Lombardy, flourished there and influenced posterity, and earned their place among the Lombards?'[19]

The conventional concept of a large, unchallenged centre is here replaced by a polycentric image. But the diversification of the various

Lombard schools, which Lanzi insists upon in opposition to the 'traditional narrative', derived from political divisions in the past. The supremacy that he gives to stylistic factors reveals a connection that Lanzi does not unravel, between 'history of the schools of painting' and 'history of the States', a connection which is overshadowed by the fact that the artistic centres that he examines were also centres of political power at least once in their history.

To sum up: the galaxy of Italian painting that Lanzi describes seems to be dominated by four principal planets, the 'capital cities': Florence, Rome, Venice, Bologna. Only very rarely does one 'capital' become a sun that unifies the whole peninsula artistically: 'Giotto was an example to those studying art for the whole of the fourteenth century, as Raphael was in the sixteenth and the Carracci in the next; and I cannot find a fourth style which had so much of a following in Italy as these three.'[20]

But these were exceptional periods. As a rule, the 'capital cities' were those which managed to impose a lasting artistic hegemony on the 'subject cities' of their respective states. Where this did not happen, as with Lombardy, we find a constellation of secondary planets. It is clear that the term 'capital' has an artistic rather than political meaning; in 1809, when Lanzi sent the revised version of the *Storia* to the publishers, Milan was the capital of the kingdom of Italy, and all the other centres of the Lombard school that he had described (apart from Cremona) had been court centres until the more or less recent past. Lastly, we find a myriad of satellites (the 'subject cities') of a quite subordinate status, gravitating around the planets of primary and secondary importance:

> To be sure, every capital has its state, and there the various cities and events must be recorded; but generally these are so closely connected to those of the metropolis that they are easily reduced to the same category, either because those subjects learned their art in the capital city, or because they taught it there, as we can see in the history of the Venetian school, and the few who did break away did not much alter the unity of the school and the legacy of its subject.[21]

To illustrate this point, we need only look at the two cases of Jacopo Bassano and Veronese, which in some ways are conflicting. The former 'had limited ideas, which he repeated with ease; this was due to his place of residence, for it is certainly most true that the ideas of artists and writers grow in the great metropolis and diminish in small towns.'[22] But the latter, from Verona 'first went to Vicenza

and then to Venice. His talent was by nature noble, elevated, magnificent, delightful, vast; no provincial city could provide him with the ideas appropriate to his genius, as Venice did.'[23]

Capital cities and subject cities

It could be argued that in Lanzi's *Storia* the periphery is present only as an area of shadow that serves to bring out the radiance of the metropolis. Painters from the subject cities are characterized by a roughness and a lack of ideas, and Lanzi generally hurries through them to get on to the generic minor painters. In one of his rare generalizations, he writes, on the subject of a peripheric painter who was a follower of Maratta, Ubaldo Ricci of Fermo: 'Usually he does not rise above mediocrity; this being a very common condition for painters who live outside the capitals, without the stimulus to emulate and the wealth of good practice.'[24]

A good climate; patronage; emulation; good practice; these, in Lanzi's opinion, are the characteristics of the metropolis which will stimulate the arts. In more recent times, the list has been enlarged by a more widespread artistic culture and the presence of the academies. It is a traditional list (with the exception of the last two elements), linked to a specific, intrinsically seventeenth-century scenario. But the theme of emulation, which recurred frequently in previous literature (Vasari, for example), takes on new implications in Lanzi's work. To understand them we should have another look at the reasons that induced Lanzi to write his *Storia pittorica*:

> Everything seems to advise it: the enthusiasm of princes for the fine arts; the understanding of the arts that has spread to every kind of person; the custom of travel, taken from the example of the great sovereigns that is now more common among private individuals; the trade of pictures that has now become an important branch of business in Italy; the philosophical genius of our times, which abhors superfluity in all scholarship and demands systems.[25]

Paintings, then, have become trading activity: the principles of competition can be applied to them too. Let us look at the page which concludes the section on the Roman school:

> Thus, with increased subsidies, and the diffusion of culture to all levels of society, which previously was limited to only a few, art takes on a new tone, is animated by honour and interest. The custom of

public exhibitions of painting for the eyes of the people, which results in vindication for the good ones and sometimes in withdrawal of the badly composed ones by dint of people's criticism; public prizes awarded to the best of each nation, and accompanied by literary compositions and public fêtes on the Campidoglio; the splendour of the sacred temples, befitting a metropolis of Christianity, which is preserved through the arts, and preserves the arts in turn; the lucrative commissions which come into the city in abundance, through the generosity of Pius VI . . . ; the constant example of the sovereigns . . . ; these things keep artists and their schools in perpetual motion and admirable competition.[26]

'Honour' and 'interest'; 'admirable competition' and 'subsidy'; 'public prizes' and 'lucrative commissions'. Winckelmann had stressed the importance of 'public competitions' for the development of Athenian art in his *Storia delle arti del disegno presso gli antichi* which Lanzi specifically refers to, or rather uses as model for the structure of the *Storia pittorica*.[27] But the emphasis on 'interest' as the driving force of artistic development does not belong to Winckelmann. There have been attempts to connect it to the hypothetical reading of a work that is generally placed in a cultural orbit light years away from that of the Abbot Lanzi: the *Essay on the History of Civil Society* by Adam Ferguson (1767). An Italian translation of this appeared in 1791–2 in Vicenza – *Saggio sopra la storia della società civile* – based on a previous French translation and duly armed with a print licence of the Venetian Holy Office.[28]

As we shall see, the traces of a possible reading of the Ferguson translation by Lanzi are barely visible. It is certainly true that in the *Storia pittorica* the importance of competition is strongly underlined: both in terms of emulation among artists and among patrons. Why, for example, have there been high concentrations of artists – painters or writers – ·of exceptional quality in particular periods, as in the 'century of Leo X'? Lanzi begins with a traditional academic answer: 'I am of the opinion that the centuries are made up of certain maxims that are recognized universally by both professionals and amateurs and when these [maxims] meet at one time to become the truest and the most just, they make exceptional professionals and many excellent amateurs.' But the next sentence is of quite a different quality, and while it is presented as an afterthought sounds more like an alternative explanation: 'I should also add that these lucky centuries never dawn unless there is a great number of princes and individuals who vie with each other in welcoming and commissioning beautiful works; in this way a great many artists have work;

and among their great number some great talents always emerge to embellish art.'[29] Further proof of this, says Lanzi, is evident in the 'history of sculpture in Athens, a city where magnificence and good taste kept pace with each other': the direct reference is again Winckelmann, but we cannot omit Ferguson's pages on luxury and its relationship with the development of the arts.[30]

Clearly the emphasis on the plurality of patronage implicitly carries a political problem: is an absolute monarch in favour of the development of the arts keeping pace with a republic? Lanzi seems to have considered a similar problem in the first edition of the *Storia* (1792), in connection with Siena:

> After Cosimo I deprived the Sienese of a liberty that they would more willingly have surrendered to any other nation in Italy than the Florentines, the arts in Siena declined not just because they are wont to follow the civic welfare of their cities; but because on that occasion two-thirds of the citizens left their land, refusing to live as subjects in a place where they had been born free.[31]

In the third edition (1809) the passage is phrased more moderately, as follows: 'At last came the year 1555, when Cosimo I deprived the Sienese of their ancient liberty. They would have surrendered it more willingly to any other nation than to the Florentines; wherefore it is not surprising that two-thirds of the citizens then left their land, refusing to live as subjects of such a hated enemy.'[32] Thus the connections put forward in the first edition (liberty, civic welfare, flourishing of the arts) have been abandoned. Napoleon had come between the two formulations, the 'new Alexander' to whom Lanzi laconically rendered homage at the end of the 1809 edition.

The discreet but eloquent nod to liberty was highly reminiscent of Winckelmann. In his greatest work, the *Geschichte der Kunst des Altertums*, he had written, for example, that 'liberty was the principal reason for the development of [Greek] art.' 'Signor Winckelmann favours the principle', noted the editor of the Italian translation, C. Fea (Rome 1783), at this point, 'that liberty has always had a great influence on the perfection of the arts; but reason and history often prove the opposite to be true.'[33] It seems that Lanzi shared Winckelmann's ideas on this issue, rather than those of Fea, at least in 1792. But in his reference to 'civic welfare' we cannot exclude an echo of Ferguson's *Essay*. In chapter 7 of part III, entitled 'On the History of the Arts', he wrote: 'Imagination and feeling, the use of intellect and hands, are not the invention of particular men. The flourishing of the arts is a sign of the inner political well-being of a people, not

the result of enlightenment from outside or of any natural superiority of talent or endeavour.'[34]

'The flourishing . . . of a people', wrote Ferguson; 'the arts . . . are wont to follow the civic welfare of their cities', said Lanzi (except, as we saw, when he corrected the whole passage). We might conjecture that there is a sign of Ferguson's influence in the expression 'civil society' which recurs in the introduction to the *Storia pittorica* in the section devoted to the methods of the connoisseurs ('for the safety of civil society, nature has given each of us in writing a flourish of the pen which is difficult to reproduce and to mistake with the writing of another'): particularly because here 'civil society' is not the organized human community of Aristotelian tradition but, more precisely, bourgeois society – society founded on mutual trust, deriving largely from the difficulty of forging signatures in business contracts.[35]

Competition and civil society

The reason behind our emphasis on the possibility, however unproven, that Lanzi may have read Ferguson is that this would account for a frequent theme in the *Storia pittorica* which is generally not given the consideration it deserves. The existence of multiple patronage, and therefore of a market, is a positive influence on artistic production, as we have seen. But for Lanzi this is only one side of the coin. Indeed he sees the deplorable risk that the artist will be tempted to save time and materials in order to meet commissions and ward off competition. Here Lanzi's attention to the artisan, manual aspects of painting has an extraordinarily modern resonance. In distancing Correggio from the traditional accusation of avarice Lanzi does not draw back from a marked break in the stylistic tone that dominates the *Storia*, and inserts a detailed list of payments, culminating in the statement:

> All his paintings were either made on copper or wood or choice canvas, with a real profusion of ultramarine, enamel and marvellous greens, with a thick *impasto* and continuous *ritocchi*, and generally without lifting his hand from the work until he had finished it all; in short without any of the savings of expense and time which more or less all the rest used to do.[36]

Velocità, economizing with time, was in Lanzi's eyes a widespread and abominable practice. Too many painters followed in the footsteps

of Vasari who 'often put speed before completeness', recalling the hasty paintings of the ancients: Lanzi commented that Pliny's writings on Philosenus Eretrius speak of paintings where speed of execution was accompanied by perfection. But the modern method, based on 'mechanical technique', 'doing away with skill' 'is as beneficial for the artist, enabling him to increase his earnings, as it is harmful to art, which along this road necessarily rushes into mannerism, or the changing of reality'.[37]

The point of discrimination is represented by the Venetians and especially by Giorgione, who 'despised that minuteness which had still to be mastered; and he replaced it with a kind of freedom, almost a *sprezzatura*, wherein lies the perfection of art.' So, by working 'not so much with *impasto* as with short strokes or touches', the Venetians led other painters to accuse them of surrendering to 'a ruinous speed, which despises adherence to principles, which never finishes one work in its anxiety to move on quickly to the next and thus on to the next payment'.[38]

Lanzi absolves Titian from this accusation, saying that 'we know that he took great pains to perfect his works and at the same time was anxious to disguise those pains', and Veronese too, whose speed went together with the 'highest intelligence'. But he criticizes Tintoretto's lack of diligence, and the paintings of Palma Giovane which are more like sketches because of too many commissions; he criticizes Piazzetta's speed, which became carelessness, and lastly, on the Cremonese Giuseppe Bottani he writes: 'The reader will have noted by now during the course of this history that the most fatal cliff for the painter's reputation is that of haste. There are few who can paint quickly and well.'[39]

The 'civil society' analysed by Rousseau and Ferguson is bourgeois society based on competition. Lanzi's isolated reference to 'civil society' should not be loaded with too many implications: but there is no doubt that he underlined both the propulsive effect of competition on the development of painting and the spread of 'mechanism' to the detriment of quality of production, owing to the increasing commercialization of artistic activity.

Territorial disparities

Our rereading of Lanzi's *Storia* in terms of the relationships between centre and periphery has revealed two sets of unresolved and, as we shall see, interdependent questions: geographically, the disparity

between the section on central northern Italy and that on southern Italy and the islands; from the historical-genetic point of view, the fundamental importance ascribed to competition between both artists and patrons – and therefore an unclear connection between centres of power (political or otherwise) and centres of artistic production. These are issues which are still being resolved today (though inevitably posed in slightly different terms).

Let us begin with the geographical question. There is firm evidence that between the sixteenth and eighteenth centuries, between Tasso and Metastasio, via Marino and Gravina, Italian literary culture established an equal balance between north and south.[40] Yet we need no reminder of the very different, uneven picture outlined by Lanzi. It is fair to ask whether this distortion which, as we saw, Lanzi himself was aware of, is entirely due to his scarce and unreliable sources of information on southern Italy, as much as the lack of direct investigation.

There can be no doubt that the painting of southern Italy and the islands is still largely to be discovered. It is equally clear that the enduring neglect of art history with regard to this region of Italy may be ascribed to what can be summed up in the phrase 'the southern question'.[41] And yet (if we may pre-empt an apparently obvious conclusion) much-needed research on southern Italian painting will not reveal a network of artistic centres comparable to those of central and northern Italy. In this sense, we may state with some justification that the distortion apparent in Lanzi's *Storia pittorica* reflects a distortion, or rather *the* distortion that characterizes the history (not only the art history) of Italy. I called this an obvious conclusion. But the geographical distribution of artistic centres in Italy is not at all obvious. It is well worth analysing.

Let us try considering the artistic centres of Italy as a kind of club. What were the conditions of enrolment into this club? And when did the enrolment period close? Or to abandon the metaphor, why, in historical terms, did some centres in Italy become artistic centres but not others? And when (and why) did new centres cease to emerge?

We will have to go back a very long way to answer these questions. For classical antiquity and the persistence of urban centres are among the most prominent characteristics of the history of the peninsula. According to Sereni, out of a sample of 8,000 centres, more than a quarter (2,684) were founded in the Roman or pre-Roman era, a little less than a third between the eighth and twelfth centuries, and less than an eighth in the period after the fourteenth century.[42] But such quantitative data, while impressive, conceal a further,

qualitative type that is even more full of consequence for the history and artistic history of Italy: that is, that an underlying inequality among urban centres had already been established in the course of the first century BC.[43]

Some enduring questions

During this period two parallel but diverse processes were taking place. After the end of the Social War (88 BC) a large number of impoverished peasants in central and southern Italy began to abandon their land and move to Rome. The Roman ruling class was therefore obliged to look favourably upon the extensive works of reconstruction and renovation that its once allied towns were initiating. Although there does not seem to have been a conscious policy of absorbing unemployed labour through building work, the result was that the pressure of immigration to Rome was alleviated. Ancient centres were extended and surrounded by walls, and many communities passed from tribal status to urban life. These municipal works all happened in the centre and south of the peninsula, with the important (as we shall see) exception of the central swathe where there had been Etruscan settlements (Etruria and part of present-day Umbria).

At about the same time Rome was establishing the colonization of Cisalpine Gaul. This too was accompanied by the founding of urban centres, but through very different procedures from those of the centre and south. This was not just because the number of new centres was far smaller, but because they were founded with a proper planning policy which resulted in the reorganization of the territory, construction of water supplies and so on.[44] So, on the one hand there was a kind of 'indigenous urbanization' controlled by individual municipalities; and on the other urbanization that was planned and regulated by Rome. In short, differing relationships between city and country, with different balances.

Many years ago Salvatorelli, expounding one of his old ideas in greater detail, maintained that it was possible to think of Italian history in the proper sense only from the beginning of the first century BC, and, to be more precise, from the Social War, followed by the extension of Roman citizenship to the Italian tribes.[45] The issues we have just outlined tend to substantiate this hypothesis. Italian history, then, which is so bare of revolutions, was born under the star of a half-victorious revolution.

Obviously, this does not imply that the southern question started at this time. But it is certain that the fundamental imbalance which characterizes the history of the peninsula (without which the peninsula would be different from its present and past form) has its distant origins in the diverging developments of the first century BC. The havoc and upheavals that followed were able to alter this imbalance, but did not cancel it out.

Thus, at the end of the classical era, the spread of urban centres in Italy took on a double aspect: a closely woven web in the centre and south (with the exception of Etruria and present-day Umbria); in the north a much looser network. The powers of resistance that these two already greatly weakened sectors displayed in the upheavals that followed were equally different. There is sufficient proof of this in the map of Italian dioceses at the beginning of the seventh century. As we know, there were as many episcopal sees as there were urban centres: when the latter were destroyed or depopulated, after an often very long period of time the diocese was either transferred to a neighbouring centre or suppressed. In this way, an examination of the suppressed dioceses provides an important series of indicators.

The completeness of this phenomenon is very conspicuous: out of 232 dioceses in existence at the beginning of the seventh century, 106 (including three of uncertain fate) were suppressed. That is, almost half. It should be noted that the dioceses that were transferred from a destroyed centre to a neighbouring, more recent centre (for example, from Luni to Sarzana, or from Roselle to Grosseto) are not included among the list of those suppressed: so the picture of centres that vanished altogether or were reduced to villages is necessarily approximate. But just as striking as the totality of this phenomenon is its geographical distribution. Of the 106 dioceses that were lost, 15 were in the north, 42 in central Italy and 49 (almost half) in the south and the islands. The denser urban network was therefore the more fragile. Certainly, despite the devastation that occurred, the number of dioceses in the south was still very high: but these were, and still are today, usually small dioceses, in localities of minor importance.

In the north and part of the centre, the comparatively sparse urban network put up a very different resistance. Certainly, the coastal or semi-coastal centres, such as Aemonia, Aquileia, Altinum, Vicohabentia, disappeared or suffered severe declines, being more vulnerable to invasion. But as a whole, the picture was not greatly altered. On this basis, we could trace a line that joins Roselle (or,

if we prefer, Grosseto), Chiusi, Perugia and Ancona. South of this imaginary line is virtually a graveyard of ancient urban centres;[46] to the north a series of cities that sometimes suffered severely but hardly ever fatally. Corfinium and Marruvium never revived, in contrast to Bologna or Piacenza. Behind this dichotomy (apart from some divergencies in the area including northern Latium and southern Umbria) lies the opposition that had been developing in the first century BC, between the urban sieges in the various parts of the peninsula.

The differing fates of Bologna and Piacenza, as compared with Corfinium and Marruvium, can of course be explained in the light of Italian history, and here we come to the heart of our argument. Let us try and skip a few centuries. After the eleventh century there was an urban renaissance all over Italy. But in the course of one century there was a further diverging in the development of the centre and north from that of the south. City-state Italy is counterbalanced by feudal Italy. The independent development of the southern cities comes to a halt: Amalfi, to give a typical example, goes into a decline. Palermo flourishes and becomes strong, but only because it has a court. The general view that has been emerging, analogous with the rich polycentric picture of central northern Italy, is undermined by another, quite different one, which features the obstruction of the smaller cities in favour of the metropolis. This development is usually attributed to exogenous factors: the Norman conquest followed by Nordic domination. But explanations of the 'invasion of the Hyksos' kind are always simplistic. The geography of city-state Italy invites us to consider what importance its more ancient, deeply rooted features might have had. For the areas where the *comuni* were widespread coincide with that part of Italy where the Roman or pre-Roman urban network had shown greater resistance. Of course, the two do not perfectly overlap: if we superimpose the two areas, there is a part of central Italy that remains outside, south of the Roselle (Grosseto)–Chiusi–Perugia–Ancona zone, where city-states like Orvieto and Viterbo were also established. But this area of non-coincidence is also important, for once again it goes back to an even older dichotomy: the contrast between the two parts of the peninsula that emerged in the first century BC. More than a thousand years later, that contrast was still in force.

The displacement of artistic centres

We must take these long-standing contradictions into account if we want to understand the geographical displacement of artistic centres

in Italy. Many of these are of Roman or pre-Roman origin: but this does not constitute a precondition (still less a sufficient reason) for entry into the club that we spoke of earlier. We need only think of Venice and Ferrara to realize that we must look in a different direction. Was the important thing to have been a diocese, then? It is probable that this must be considered an almost necessary condition, in the sense that it is difficult to find an artistic centre in Italy that has not also been a bishopric. There are a very few exceptions, such as Fabriano or Saluzzo, which became episcopal sees only very late. As far as monasteries are concerned, these were a particular species of centre, characterized by a lack of related periphery. But certainly this was not a sufficient condition: there are innumerable diocesan centres which played no outstanding role in the artistic history of the peninsula – from Sarsina to Numana, to the myriad of minor bishoprics in southern Italy.

So, is it then the case that we must look for Italy's artistic centres among its diocesan centres? But what are the elements (historical, not formal) that can define this foundation?

Firstly let us go through all those that can be eliminated. We begin by examining the centres that disappeared or declined (and never revived) after the beginning of the seventh century. None of these (with the possible exception of Aquileia) can be defined as artistic centre – in the true sense. Our field of inquiry is immediately restricted. Now let us look at the episcopal sees that were founded after the seventh century. We can identify an intense phase of reorganization of ecclesiastical geography in Italy, which begins in the south from the eleventh and twelfth centuries, and in the centre and north in the second half of the fourteenth century.[47] Even so, none of the episcopal sees founded after these dates can aspire to the title of artistic centre. We find that the parade of possible candidates continues to diminish. If we pursue this pincer strategy we arrive at the following conclusion: enrolment in the club of Italian artistic centres, in principle was open to all episcopal sees, but closed at the end of the eleventh century. After this time, the new sees – those of Alessandria, Livorno, Carpi, Prato, Foggia or Civitavecchia – found the doors were closed.

By now we have restricted the chronological conditions that were necessary for entry, but we still have not identified the conditions that were adequate. In other words, the artistic centres of Italy all corresponded to episcopal sees that existed at the end of the eleventh century; but the opposite is untrue. Why did Andria, Matelica, Venosa, Taranto (to choose a few names at random) not manage to become artistic centres in the full sense of the term?

The marked contrast between the two Italies – feudal and commu-
nal – which emerged in the course of the eleventh century is the
factor which ultimately enables us to decipher the geographical and
chronological co-ordinates of Italy's artistic centres. In central and
northern Italy (apart from the peculiar cases of Venice and, of course,
Rome) artistic centres are identified with the cities which developed
intense communal life – all being, without exception, diocesan sees.[48]
In southern Italy (apart from Messina) they are identified with cities
which were later overwhelmed by Norman-Swedish centralism
(Amalfi, Bari) and with cities that were the seat of a court (Palermo,
Naples). The frontier between these two artistic Italies – polycentric
and oligarchic – retraced one that was drawn up in the first century
BC, which subsequent events had not erased.

The city communes

Obviously, our emphasis on the crucial importance of the city com-
munes to the development of Italian art does not imply that we will
rehearse those popular, nineteenth-century rhetorical themes upon
the free commune, rustic or otherwise. In our opinion what really
counts is above all the presence of a series of urban centres, with
both communal and episcopal systems of power, that were some-
times allied, more often hostile, and which gave rise to a two-sided,
uninterrupted source of patronage, lay and ecclesiastical, and, sec-
ondly, the high municipal tensions which exploded with particular
violence in the age of the city-states, though destined to last far
beyond this, and which strongly encouraged artistic diversification.
On one hand, then, there was a situation of potential competition
within individual centres; on the other, analogous situations be-
tween different centres. This means that even today we exist within
the scope of the competitive model described by Lanzi. For us, too,
the varying presence of competition between artists and patrons
corresponds with a varying degree of artistic innovation. Of course
we must beware of identifying innovation with quality, if we do not
wish to fall back into the tautology in Kenneth Clark's words that
we quoted earlier. But there is no doubt that the conditions that
favour artistic innovation are generally to be found in these centres.
Indeed, artistic centres may be defined as places which are charac-
terized by the presence of an outstanding number of artists and of
important groups of patrons who for various motives – family or
individual pride, a desire for hegemony, a yearning for eternal

salvation – are prepared to invest part of their wealth in works of art. This last point obviously implies that the centre is a place which enjoys large amounts of profits that can be used for artistic production. Also, it may have institutions for the preservation, education and training of artists, as well as for the distribution of works. Lastly, it will include a far wider public than its patrons, by no means homogeneous, but divided into groups, each of which will have its own traditions of perception and criteria of evaluation, to be translated into specific expectations and needs.

Clearly, this definition is still generic – but it is also historically restrictive. For example, it is impossible to imagine that multiple patronage could be found in a monastery of the high Middle Ages, on a scale that would cause the conflicts to be compared with those that sometimes occurred between bishop and chapter, over artistic questions as well.[49] Obviously, if they refer to monastic Europe, the notions of 'centre' and 'periphery' have an entirely different meaning from that which can be attributed to them after the eleventh century. Moreover, there is an implicit contradiction in the definition we propose in the notion of an *exclusively* artistic centre. Only a centre of extra-artistic power (political and/or economic and/or religious) can be an artistic centre. The mere presence, or even the concentration, of works of art in a particular locality is not enough to make it an artistic centre in the sense we have discussed. Castles, villas and sanctuaries can perhaps be thought of as the physical projections of a political, economic or religious power that had its base elsewhere.

Centres of innovation and areas of late development

If the centre tends to emerge as a place of artistic innovation, the periphery tends to emerge (though not always) as a place of delayed development. We will try to outline a summary typology of this phenomenon, which is certainly the most frequent in the relationship between centre and periphery. We can identify retardation spanning several centuries, as in the case of so-called 'popular' artistic production, often produced by peasants for peasants; retardation spanning several generations, as in the case of products that are made by professional artists but for a peasant clientele; and retardation over a few years, which is nevertheless experienced as traumatic because it coincides with sudden changes in taste. So we find, respectively, objects such as cradles and decorated spoons, beds, chests and cloth of various kinds, functional objects that have been made

by their users;[50] fresco cycles painted by schools of itinerant painters, working on the decorations of country chapels or the churches of small villages; or works by famous painters who suddenly find themselves pushed to the edge of the artistic market.

Let us take any product of peasant culture, whether a utensil or a liturgical object. Its fundamental forms are rooted in a limited repertory (spirals, circles, stars, etc., in a variety of combinations) which has remained virtually unchanged throughout the centuries, to the extent that some seem to go back even to neolithic times. Within this range of objects, the persistence of type is particularly strong. However, if we turn to the objects produced in itinerant workshops, for example the teams of artists working around Vercelli from about 1450–70 who were responsible, among other things, for the decoration of the oratory of San Bernardo in Gattinara,[51] we find that they use models that go back perhaps to the last decades of the fourteenth century, with minimal variations. An example of the third type can be found in the writings of Vasari regarding some of Perugino's paintings for the church of the Santissima Annunziata in Florence:

> It is said that when the work was unveiled it received no little censure from all the new painters, particularly because Perugino had availed himself of those figures that he had been wont to use in other pictures, with which his friends twitted him saying that he had taken no pains, and that he had abandoned the good method of working, either through avarice or to save time. To this Perugino would answer: I have used the figures you have at other times praised, and which have given you infinite pleasure; if they now do not please you and you do not praise them, what can I do? But they kept assailing him bitterly with sonnets and open insults; whereupon, although now old, he departed from Florence and returned to Perugia. There he executed certain works in fresco in the Church of San Severo . . . Perugino likewise worked at Montone, at La Fratta, and in many other places in the district of Perugia.[52]

There are then different degrees of persistence (and a related greater or lesser possibility of dating), which correspond to the different levels that we have outlined. We may therefore conclude that in a situation of artistic autoconsumption such as that of the peasants, the motives for innovation are practically nil. In a situation of semimonopoly such as that which governed the work of the itinerant painters of Vercelli in the second half of the fifteenth century, models that were sometimes quite ancient could safely be used without the

risk of disappointing the expectations of a public that had no oppor-
tunity to make comparisons. In a situation of competition such as
in Florence around 1505, the criticisms of the 'new painters', his
rivals and colleagues, persuaded Perugino to leave the city (though
not for ever) for the Umbrian countryside. Here we cannot properly
use the term 'retardation in the periphery': but the periphery was
where the painter was forced to take refuge, to continue his work
and receive commissions for a product that the centre no longer
wanted.

The peripheralization and declassing of works

There are other occasions when the physical displacement of a work
from the centre to the social and/or geographical periphery demon-
strates that the latter was identified with artistic tastes that devel-
oped more slowly. Take the example of the pulpit of the cathedral
of Cagliari, sculpted by a master Guglielmo between 1159 and 1162
(plate 1) for the cathedral of Pisa and transported to Sardinia when
the pulpit of Giovanni Pisano (plate 2) was inaugurated in Pisa
in 1312. An inscription in verse was written to record this event:
'*Castello Castri concexit / Virgini Matri direxit / Me templum istud
invexit / Civitas Pisana*'[53] (The city of Pisa gave me to Castel di
Castro, dedicated me to the Virgin Mary and erected me in this
temple).

The pulpit was destined for a new public, the Pisan colony in
Cagliari that had established itself in the higher quarter dominated
by Castel di Castro. The new cathedral had been built near to
the castle, the symbol and focus of Pisan domination. Thus for the
Tuscan colony the old pulpit from the cathedral of Pisa took on the
image of a venerable relic of the fatherland, a reference to a common
cultural patronage, an instrument of identification and aggregation.
It should be noted that at the time when the pulpit was transferred,
there was a serious threat to the future of Pisan supremacy, for the
Pope had conceded the investiture of the kingdom of Sardinia to the
king of Aragon. But it is important that the symbolic strengthening
of cultural ties with the fatherland came about through the transfer
of a work that was 150 years old: the colony was credited with a
more backward taste than that of the metropolis.

There are other similar, though less conspicuous cases which show
that this interpretation is not based on a contrived principle. Be-
tween the sixteenth and eighteenth centuries, the fourteenth-century

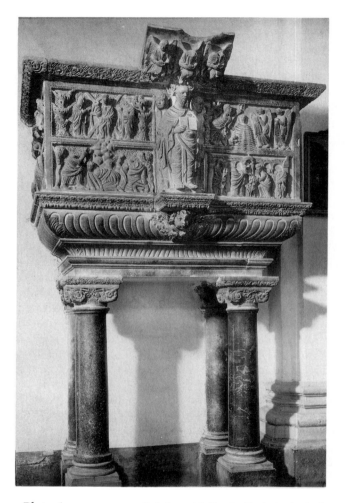

Plate 1 GUGLIELMO, Pulpit, *c.*1160, Cagliari Cathedral.
Photo: Archivi Alinari.

polyptychs were removed from the more famous churches of Siena
and relegated to remote oratories or country churches: one by Pietro
Lorenzetti, once in the Carmine, found its way to Sant'Ansano in
Dofana. Sometimes this declassing process was social rather than
geographical, as in the case of the *Annunciation* by Ambrogio
Lorenzetti, which travelled from the room of the Concistoro in the
Palazzo Pubblico to 'a room . . . next to the kitchen where the maids

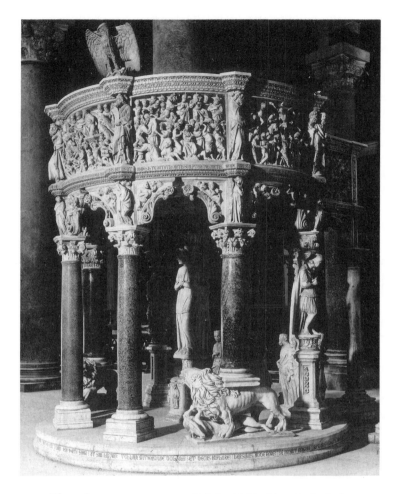

Plate 2 GIOVANNI PISANO, Pulpit, 1312, Pisa Cathedral.
Photo: Archivi Alinari.

eat their dinner'. Thus, a work that had been commissioned by Francesco, a monk of San Galgano and Camerlengo of Bicherna, originally destined for the rulers of Siena, was ultimately enjoyed by a body of spectators socially far inferior.[54] In other words, at certain times the monuments, furnishings and artistic works of the past were surrendered or thrown into a corner like clothes that are no longer worn. A systematic collection of this type of evidence would

be extremely enlightening as to the changeable relationships which tied individual centres and their respective peripheries throughout history.

All that we have said so far shows that the link between centre and periphery cannot be seen as an invariable relationship of innovation and backward development. On the contrary, we are looking at a flexible relationship that was subject to sharp accelerations and tensions prompted by social and political, as well as artistic influences. In this respect, it is worth analysing the overview that Vasari has given us, for with his *Lives* he provided a canon model of the periphery as backward, a model that was destined to have a lasting influence.

Vasari

Vasari believed that the only chance for an artist born and brought up in the provinces was to come into contact with the centre: only in this way would he be able to take part in the process of innovation and progress. The vocation to establish hegemony that had belonged to Florence from the end of the thirteenth century was taken up by Rome, from the second decade of the sixteenth century. To Rome, driven by a kind of unstoppable tropism, came artists from all over Italy who were perhaps vaguely aware of the changes in the air. Thus Parmigianino, who 'having conceived a desire to see Rome, like one who was on the path of progress and heard much praise given to good masters, and particularly to . . . Raphael and Michelangelo, he spoke out his mind to his old uncles';[55] and Niccolò Soggi, 'hearing that great things were being done in Rome, he departed from Florence, thinking to make proficience in art and also to save some money';[56] or Pietro da Vinci, who

> had often heard various persons speaking of the things connected with arts to be seen in Rome, and extolling them, as is always done by everyone; wherefore a great desire had been kindled in him to see them, hoping to be able to derive profit by beholding not only the work of the ancients but also those of Michelangelo and even the master himself, who was then alive and residing in Rome.[57]

The same was true of Giovanni da Udine, who, while in Venice 'learning the art of drawing' with Giorgione, 'heard the works of Michelangelo and Raphael so extolled that he resolved at all cost to go to Rome',[58] or of Battista Franco, who

having given his attention in his early childhood to design, went off at the age of twenty, as one who aimed at perfection in that art, to Rome, where, after he had devoted himself for some time with much study to design and had seen the manners of various masters, he resolved that he would not study or seek to imitate any other works but the drawings, paintings and sculptures of Michelangelo.[59]

In the face of the revelations of Rome, well-established artists turn their backs on their first training and start all over again. This was one of Vasari's recurring themes – the already famous artist who goes back to his apprenticeship when he discovers the *buona maniera*. A well-known example is that of Raphael who, on seeing Michelangelo's cartoon of the *Battle of Cascina*, did that which

> anyone else [who had] lost heart, believing he had been previously wasting time, would never have achieved, however lofty his genius ... But he, having purged himself of Pietro's manner, and having thoroughly freed himself of it, in order to learn the manner of Michelangelo, so full of difficulties in every part, was changed as it were, from a master once again into a disciple; and he forced himself with incredible study, when already a man, to do in a few months what might have called for the tender age at which all things are best acquired, and a space of many years.[60]

The same theme, with similar allusions to the 'purging' of previous training, or to changing from 'master to disciple', can be found in the life of Garofalo who, when he arrived in Rome

> was struck with amazement and almost with despair, by seeing the grace and vivacity that the pictures of Raphael revealed, and the depth in the design of Michelangelo. Wherefore he cursed the manner of Lombardy and that which he had learned with so much study and effort at Mantua, and right willingly, if he had been able, would have purged himself of all that knowledge; but he resolved, since there was no help for it, that he would unlearn it all, and after the loss of so many years, change from master into a disciple.[61]

The cursing of the Lombard style is reminiscent of the 'oaths of Lombardy' which ends Machiavelli's *Dialogo della lingua*, and bears witness to an equally monocentric view. This is all the more apparent when we remember that Vasari intended the life of Garofalo to be 'a brief account of the best and most eminent painters, sculptors and architects who have lived in Lombardy in our time'.[62] This was not an isolated case, since Girolamo da Carpi, talking to Vasari,

'lamented very often to me that he had consumed his youth and his best years in Ferrara and Bologna and not in Rome or some other place where, without a doubt, he would have gained much greater proficiency'.[63]

And so they came, from Parma, Florence, Venice, Mantua and Ferrara; anyone who had seen Rome and was then forced to leave suffered greatly, like Polidoro da Caravaggio. When he was in Messina 'he was always burning with desire to revisit Rome, which afflicts with unceasing yearning those who have lived there many years, when making trial of other countries.'[64] Garofalo in Ferrara 'in executing those works, remembering at times how he had turned his back on Rome, felt the bitterest regret; and he had resolved at all costs to return.'[65]

The image of the provinces is as different from the prestigious, stimulating image of the centre as can be imagined. One extreme example of this is Calabria, the home of Marco Cardisco, of whom Vasari writes: 'If we marvel when we see growing in some province a fruit that has not been wont to grow there, much more can we rejoice in a man of fine intellect when we find him where men of the same bent are not usually born.'[66]

The provinces were not always such a desolate heath where artistic roots would not grow; but when there were such men, it was better if they did not stay too long, for there were no models to follow or emulate, no competition, i.e. none of the fundamental elements to encourage innovation. Arezzo, where Vasari was born, was such a place. For Giovan Antonio Lappoli, this was a town where 'he was not able to learn by himself, although he had a strong natural inclination.'[67] Montorsoli held the same opinions about Perugia, where he found there was no point in staying on ('it did not suit him and he did not learn'). Daniele Ricciarelli felt the same about Volterra, where he noticed that there was 'no competition that might spur him to seek to rise to greater heights and that there were no works in the city, either ancient or modern, from which he could learn'.[68]

This applied not only to Arezzo, Perugia and Volterra: Vasari considered Siena to be uninspiring, and he tells how Sodoma, 'not finding any competition, for a time in that city [worked] alone; which, although it was some advantage to him, was in the end injurious, for the reason that he went to sleep, as it were, and never studied.'[69] Beccafumi thought the same: according to Vasari, he 'desired nothing so much as to learn, and knew that he was losing time in Siena'.[70] And the same was true for Vignola in Bologna and Ferrara, and for Girolamo da Carpi, in the case we have already quoted.

These are all cases where the artist – according to Vasari – was almost always aware of his predicament. In other instances he restricts himself to observing that if the artist he is writing about had had the opportunity to leave his provincial town, he would have achieved astonishing results (impossible for anyone who stayed on the periphery). Thus Luca de' Longhi: 'if Maestro Luca had gone forth from Ravenna . . . he would have become a very rare painter.'[71] Or a group of Lombard sculptors whose only limitation was that they worked in Milan: 'If there had been in that place the study of those arts that there is in Rome and Florence, those able masters would have done, and would still be doing, wonderful things.'[72]

It was particularly hard for Vasari to admit to examples of artists who deliberately stayed put, like the voluntary provincial artist Cola dell'Amatrice who 'without caring to see Rome or to change his country, remained always as Ascoli', although 'this master would have acquitted himself not otherwise than passing well if he had practised his art in places where rivalry and emulation might have made him attend with more study to painting and exercise the beatiful intellect with which it is evident he was endowed.'[73]

However, the challenge that the great works offered did not automatically lead to emulation. In some cases the 'challenged' artist felt incapable and withdrew. Thus Franciabigio, who 'would never leave Florence, because, having seen some works by Raphael of Urbino and feeling that he was not equal to that great man and to many others of supreme renown, did not wish to compete with painters of such excellence',[74] or Morto da Feltre, who intended to abandon the grotesques that were his speciality and work on figure painting:

> after he had conceived this desire, hearing the renown that Leonardo and Michelangelo had in that art on account of the cartoons executed by them in Florence, he set out straightaway to go to that city. But after he had seen those works, he did not think himself able to make the same improvements that he had made in his first profession, and he went back, therefore, to work at his grotesques.[75]

Other artists did not renounce the contest but simply postponed it, like Pierino da Vinci who

> went [to Rome] in company with some friends; but after seeing Rome and all that he wished, returned to Florence, having reflected judiciously that the things of Rome were (as yet) too profound for him, and should be studied and imitated not so early in his career but after a greater acquaintance with art.[76]

For Vasari, emulation between artists and the stimulus of their public's expectations are fundamental springboards for artistic progress. The lack of means for comparison and the easy tastes of the public result in less stimulus for artists working in the provinces. This was what happened to Donatello in Padua.

> He was held by the Paduans to be a marvel and was praised by every man of understanding; but he determined to return to Florence, saying that if he remained any longer in Padua he would forget everything that he knew, being so greatly praised there by all, and that he was glad to return to his own country, where he would gain by censure, since such censure would urge him to study and would enable him to attain greater glory.[77]

According to Vasari, Donatello knew that he lacked critical stimulus in Padua; others were not unaware of this, like Sodoma, who was stultified with the lack of competition in Siena, or the Emilian artists Bartolomeo da Bagnacavallo, Amico Aspertini, Girolamo da Cotignola and Innocenzo da Imola, who, 'since there were no painters in Bologna at that time who knew more than they did, were held by those who then governed the city, as well as by all the people, to be the best masters in Italy'.[78] The same was true of Marco Cardisco in Naples: 'having no rivalry to contend with in painting from other painters, he was always adored by the Neapolitan nobles, and contrived to have himself rewarded for his works by ample payments.'[79]

The role of patrons is therefore strategically crucial. And in the life of Caravaggio, Vasari paints a far more negative picture of Neapolitan patronage than that quoted above. When Caravaggio arrived in Naples, 'the noblemen of that city taking but little interest in fine works of painting, he was like to die of hunger',[80] and so 'seeing his talents held in little esteem, determined to take his leave of men who thought more of a horse that could jump than of a master whose hands could give painted figures the appearance of life'.[81]

Naples is presented as an extreme example, but even fifteenth-century Rome, with its conspicuous investment in works of art, seemed an expression of backward and peripheral taste to Vasari:

> If Pope Eugenius IV, when he resolved to make the bronze door for St Peter's in Rome, had used diligence in seeking men of excellence to execute that work (and he would easily have been able to find them at that time, when Filippo di ser Brunellesco, Donatello and other rare craftsmen were alive), it would not have been carried out in the deplorable manner which it reveals to us in our own day. But perchance

the same thing happened to him that is very often the worst to happen to the greater number of Princes who either have no understanding of such works or take very little delight in them. Now if they were to consider how important it is to show preference for men of excellence in public works by reason of the fame that comes from these, it is certain that neither they nor their ministers would be so negligent for the reason that he who encumbers himself with poor and inept crafts-men ensures but a short life to his works or his fame, not to mention that injury is done to the public interest and to the age in which he was born, for it is firmly believed by all who come after that if there had been better masters to be found in that age, the Prince would have availed himself of them rather than of the inept and vulgar.[82]

The stigma of provincialism is particularly evident in a pope like Sixtus IV, the traditional target of Florentine political and cultural debate. In Vasari's eyes, the Pope's preference for Cosimo Rosselli over Botticelli, Ghirlandaio, Signorelli and Perugino demonstrated his incompetence by showing that he preferred Cosimo's flamboyant and expensive colours to the ingenious conceits of the others:

those colours at the first glance so dazzled the eys of the Pope, who had little knowledge of such things, although he took no little delight in them, that he judged the work of Cosimo to be much better than that of the others. And so causing the prize to be given to him he bade all the others cover their pictures with the best blues that could be found, and to pick them out with gold, to the end that they might be similar to those of Cosimo in colouring and richness. Whereupon the poor painters, in despair at having to satisfy the small intelligence of the Holy Father, set themselves to spoil all the good work they had done.[83]

To understand the true sentiment of this passage it will be useful to recall another ancedote that Vasari inserts in the life of Michel-angelo, about Menighella,

a commonplace and clownish painter of Valdarno, who was a most diverting person. He would come at times to Michelangelo, that he might make him a design of St Roch or St Anthony, to be painted for peasants; and Michelangelo, who was with difficulty persuaded to work for kings, would deign to set aside all his other work and make him simple designs united to his manner and his wishes, as Menighella himself used to say. Among other things, Menighella persuaded him to make a model of a Crucifix, which was very beautiful; of this he made a mould, from which he formed copies in pasteboard and other

materials and these he went about selling throughout the country-side. Michelangelo would burst out laughing at him, particularly because he used to meet with fine adventures, as with a countryman who commissioned him to paint a St Francis, and was displeased because Menighella had made the vestment grey; whereupon Menighella painted over the saint's shoulders a pluvial of brocade and so contented him.[84]

The passage has obvious value for Vasari's theme, though the historical existence of Menighella has not been verified. But this is not relevant here. We should rather point out that in Vasari's eyes the tastes of Menighella's peasant clientele, ordering paintings of saints typical of rural worship (St Roch, St Anthony, St Francis) in bright, eye-catching colours, coincide with the preferences of a pope like Sixtus IV – a pope whose culture and training were those of a friar, rooted in the underdeveloped (according to Vasari) surroundings of fifteenth-century Rome. Once again social and geographical periphery overlap.

The end of polycentrism and the birth of the *terza maniera*

Vasari's intervention was a radical one. The pattern that was then emerging in Tuscany – an absolutist state organized on a regional base, where various centres were subordinated and despoiled to give advantage to the capital – was now a thing of the past. Siena and Pisa played a diminished role, while Pistoia, Volterra and Lucca lost all importance. Arezzo was saved by a fondness for his homeland. But this projection of the present on to the past, or, to put it another way, this adjusting (actually suffocation) of the past to the present, was not just limited to Tuscany. At a distance of only a few decades Vasari was summarizing the process which at the beginning of the Cinquecento caused a twofold fracture, artistic and political, in the history of the peninsula by drastically reducing its past polycentrism in favour of the few centres that were able to preserve a degree of autonomy. It was during the first years of the Cinquecento that Perugino was suddenly marginalized, forced to leave Florence by the hostility of the 'new painters'. These were decisive years, as a new paradigm was emerging and taking an early hold, 'the *terza maniera* which we will call modern', wrote Vasari: the style of Leonardo, Giorgione, 'the most gracious Raphael of Urbino', of 'the divine Michelangelo Buonarroti' who 'carries the palm among the living

and the dead and excels them all'. The 'awesome' variety and wealth of the *terza maniera* suddenly makes that 'new, more life-like beauty' that Perugino and the Bolognese artist Francia had begun to adopt seem antiquated, and reveals the 'error' of those who 'ran about like mad men when they saw it . . . for they thought it could never be bettered'.[85]

It was precisely the imposition of the *terza maniera* which accompanied the process of restructuring the artistic geography of Italy – a process which Vasari acknowledged and helped to accentuate by placing it back in the past.

A typical example: Umbria

Let us follow this phenomenon with a typical example – Umbria. Centres such as Perugia, Gubbio, Todi, Assisi, Montefalco, Spoleto and Orvieto, which produced complex and diversified art between the thirteenth and fifteenth centuries, have long been victims of Vasari's centralizing vision, to an extent that Umbrian painting before Perugino has been the subject of specific research only for a few decades.[86] But during the course of the sixteenth century the picture tended more and more towards uniformity and repetition. Innovation seemed to feature only in a privileged handful of the larger centres.

One important factor here was loyalty to a formula. Let us look at the fortunes of a painting such as the *Coronation of the Virgin* by Domenico Ghirlandaio. Painted in 1486 for the Observants of San Girolamo near Narni, it was imitated many times on the express wishes of patrons: in the *Coronation of the Virgin* in the Church of the Riformati di Montesanto in Todi, which Spagna committed himself to painting *'pictam de auro cum coloribus et aliis rebus ad speciem et similitudinem tabluale factae in Ecc. Sancti Jeronymi de Narnia'* (painted with gold, with the colours and other features to resemble the type and image of the painting in the Church of San Girolamo in Narni), which was finished in 1511; the *Coronation* also painted by Spagna, for the Franciscans of Trevi (plate 3), and the one made by Jacopo Siculo in 1541 for the Church of the Annunziata near Norcia.[87]

Another typical phenomenon was the founding of local dynasties, particularly noticeable from the second half of the Quattrocento. The way this happened was more or less as follows. The first step was the founding of a family workshop, where father and son would

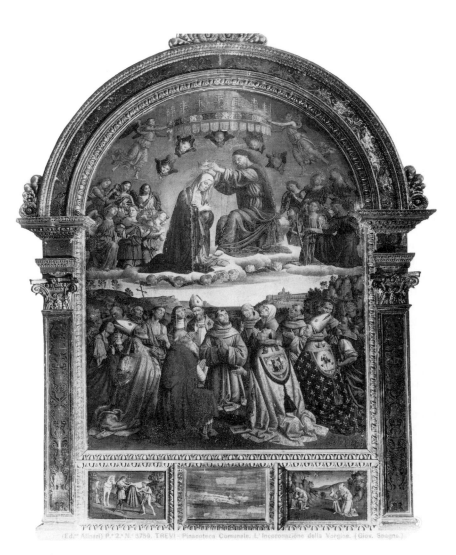

Plate 3 GIOVANNI DI PIETRO (known as Spagna), *Coronation of the Virgin*, Trevi, Pinacoteca Comunale.
Photo: Archivi Alinari.

work. At first the products of the workshop were fairly up to date, based on recent formulae and schemata which enjoyed great popularity. The head of the workshop might have acquired broad experience through travelling or training received outside the village, or through apprenticeship with a painter outside the region who was working locally. This was how Niccolò da Siena's stay in Norcia was able to influence the rise of the Sparapane family, or of Domenico da Leonessa.[88] The Sparapane dynasty began with painting the *Madonna with Child, saints and stories from the life of Christ* on the iconostasis of the Church of San Salvatore in Campi (near Norcia), inscribed with date and origin: 'Giovanni Sparapane of Norcia and his son Antonio painted this glorification in 1464.' Afterwards, the use of cartoons and the master's formal repertory became the usual *modus operandi* of the workshop, in a process which ensured the survival of some schemata even for generations. This was precisely what happened in the case of the Sparapane of Norcia and of the Angelucci of Mevale.[89] As time went on, there was a growing gap between these repetitive styles and formulae, which by now were archaic, and the production of larger centres. These dynasties were employed by individual patrons for votive paintings, by confraternities and also by rural communities. It might happen that an artistic dynasty would grow up in the shadow of a sanctuary of a place of pilgrimage, such as the dynasty of the Lederwasch, at Tamsweg, near Salzburg, where father and son were in charge of artistic production for the splendid Sanctuary of St Leonard, and whose house, next to the church, can still be visited.

Linked to a socially homogeneous source of patronage, this wealth of painting in the periphery did not at first manifest the clear characteristics of late development that it later assumed, when the divide between centre and periphery deepened. On the contrary, there was a stronger tendency and a greater willingness to invest in art on the part of social groups which hitherto had rarely been interested in the subject. It would be a worthwhile exercise to draw a map of the decorations carried out in the course of the Quattrocento with obviously educative intent, in country churches and oratories. Limiting ourselves to Piedmont alone, we can cite Domenico della Marca d'Ancona, who painted the frescoes in the apse of the Church of Santa Maria di Spinariano near Ciriè (plate 4),[90] Giacomino da Ivrea, active in the Canava region and the Val d'Aosta around the second half of the century,[91] and Giovanni Massucco, who worked in the Monregale region.[92] In the course of the Cinquecento, there was an increase in artists like Domenico della Marca d'Ancona who came

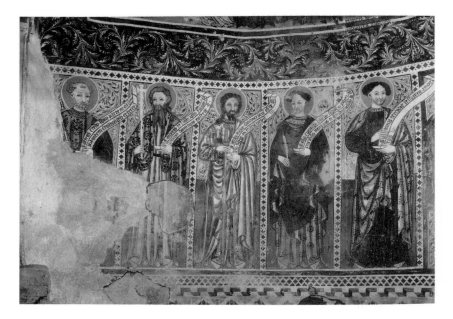

Plate 4 DOMENICO DELLA MARCA D'ANCONA, *Five Apostles* (detail of
the frescoes on the apse wall), Ciriè, Santa Maria di Spinariano.
© Parrocchia San Carlo Borromeo.

from distant regions, perhaps equally peripheral, and settled in the
provinces; Jacopo Santori from Giuliana, near Palermo, better known
as Jacopo Siculo,[93] worked between Umbria and Sabina; Lorenzo
and Bartolomeo Torresani from Verona also worked in Sabina in
the first half of the century; during the same period, we find Simone
da Firenze in the Basilicata.[94] At the same time, successful painters
in the centre were being forced to move, or move back to the peri-
phery, unable to follow the initiatives of the 'new painters' and the
subsequent changes in the tastes and expectations of the public.
Apart from the example of Perugino, who, as we have already seen,
had to repair from Florence to Montone and Fratta, a similar jour-
ney was made by Signorelli and, to go further back, by Antonio da
Viterbo. After working in Rome on important projects such as the
frescoes in Santa Francesca Romana, he was pushed out into the
Viterbo countryside by the activities of the Umbrian and Florentine
painters called to Rome by Sixtus IV, and reduced to practising his
art in Corchiano.[95]

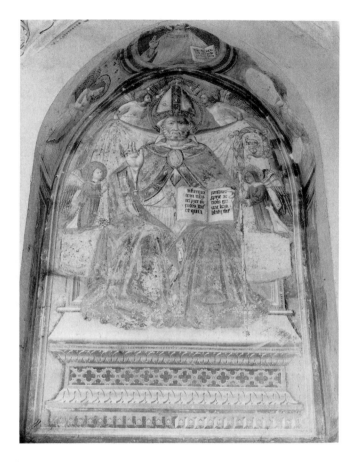

Plate 5 ANTONIO DA VITERBO, *San Biagio Enthroned*, Corchiano (Viterbo), Chiesa Parrocchiale.

Late development and counter-currents in the periphery

We have identified three phenomena which together give shape to a process of peripheralization, relegating many of the Italian regions to a condition of cultural subordination that was destined to last into the next centuries: (a) the constitution of local dynasties and the subsequent perpetuation of various schemata, with the use of

cartoons and drawings; (b) artists from far-off places who had not achieved any success in their home villages or in the more important artistic centres settling in the periphery; (c) the return to the periphery of artists who had already achieved some fame and were undermined by stylistic change. The strengthening of the absolute state at regional level, suffocation of local autonomies and increasing hierarchical stratification of society all had important consequences for art.

Given the absence of quantitative analyses on a regional scale and the scarcity, by comparison with the previous era, of research on 'provincial' artists, we shall refer to the excellent *Ricerche in Umbria*,[96] which analyses the results of a broad survey of seventeenth- and eighteenth-century painting in an area of southern Umbria. We shall try to sum up the important features that emerge here and seem to have a significance beyond the local level.

1 By the seventeenth and eighteenth centuries the region was an integral part of the Church States: as a result, the provinces tended to adapt to the metropolis on which they depended, guided by the patronage of a certain number of people variously linked to the capital. But we must beware of thinking of the provinces as purely an extension of the dominant centre of influence. For alongside average art we find evidence of rare and exciting works.

2 The process of refeudalization had important consequences inside the region, in terms of both change in patronage and types of commissions. The demand for works of art was concentrated in the city and more thinly spread in the countryside (with some exceptions and special cases). But it persisted where there were areas of smallholdings or forms of collective ownership, and ceased to exist in the areas of large landed estate.

3 Works of art sent to the periphery by artists in the centre had a more sharply liturgical flavour than those which the same artists made for the metropolis.

4 The seventeenth century bore witness to a relative ability to react to the meeting with metropolitan culture by blending with it or providing variations to it; but in the eighteenth century 'altarpieces come to the provinces from Rome as a specialized product that now has no competitor, sometimes furnishing the whole range of altars in a church with perfectly matching pieces', or transforming the naves into galleries of contemporary Roman painting.'[97]

Given this picture of unconditional and irreversible dependence that the division of labour and the internal powers of the state had created, we may dwell further on the consideration of the 'periphery

as late development'. At this stage the issue is not so much retarda-
tion but the domination of symbols, which we shall return to in due
course.

Late development in the periphery or in the method?

However, not all cases of late development are due to the periphery,
as the case of Perugino demonstrates, driven from the centre to the
periphery. It is also true that not all situations in the periphery
suffered from late development. To suppose that they did would be
tantamout to creating a unilinear vision of the history of artistic
production, maintaining that it is possible to identify a line of progress
(whatever its ideological motivation) and automatically accusing
any product that differed from the innovatory centre with back-
wardness. In this way, we would end up by looking at the art of the
periphery in the light of the features, principles and values that were
established on the basis of the characteristics or works produced in
the centre. If we then acknowledge the existence of different prin-
ciples, they will be examined solely on the basis of the dominant
paradigm, in a procedure that easily leads to judgements of decadence,
corruption, decline in quality, lack of refinement etc. This was what
happened, for example, in the case of Bolognese and Umbrian painting
of the fourteenth century, which for a long time were reduced to the
level of coarse, mediocre imitations of Florentine or Sienese art.

In 1855 Jacob Burckhardt wrote:

> It seems that only the incapable remained independent [of Giotto].
> Among northern artists, those of Bologna should have been the most
> completely and universally shut off from the influence of the Florentine
> school; but in the fourteenth century they were appallingly clumsy
> and inconsequent in their ability and activity alike. The oldest of
> them, Vitale, a contemporary of Giotto, manages at least a gentleness
> and grace in the Sienese manner, recalling Duccio, in his *Madonna
> Enthroned with Two Angels*, 1320 (Pinacoteca, Bologna). The rest,
> though half-following Giotto, produced such poor panel paintings
> that they were hardly mentioned in Florence. The same approach and
> the same lack of talent continued to mark the school till beyond the
> mid-fifteenth century.[98]

In 1908 E. Bernhard Berenson wrote, on the subject of Umbrian
painting before Perugino: 'Nelli was and remains an idiot'.[99] In 1918
the same author entitled his essay on the Orvieto painter Cola

Petruccioli 'A Sienese Little Master in New York and Elsewhere', which, as R. Longhi commented:

> says a great deal both about the low status assigned to the artist, and his supposed unconditional submission to the Sienese school. For at that time there was a fashion for the obsessive exaltation of Sienese products of the whole of the fourteenth century and the instant sub-ordination of anything that was in some way similar . . . That there was a particular artistic culture in Orvieto seemed inadmissible; I should rather say unthinkable. And yet it had existed.[100]

In short, identifying the periphery with late development means resigning oneself to writing history from the point of view of the present victor.

The periphery as a 'side-step'

Even that exponent of a monocentric model of historiography, Giorgio Vasari, admitted the possibility of an autonomous line of production in the periphery. In some circumstances the challenge posed by emulation could lead to great results. Mantegna's formation was shaped by this: 'the competition of Marco Zoppo of Bologna, Dario da Treviso and Niccolò Pizzolo of Padua, disciple of his master and adoptive father, was of no small assistance to him, and a stimulus to his studies.'[101] Similarly, Galasso's artistic achievements are seen as a kind of municipal response to the success of a 'foreign' painter in Ferrara, Piero della Francesca:

> When strangers come to do work in a city in which there are no craftsmen of excellence, there is always some man whose intelligence is afterwards stirred to strive to learn that same art, and to bring it about that from that time onwards there should be no need for strangers to come and embellish his city and carry away her wealth, which he now labours to deserve by his own ability, seeking to acquire for himself those riches that seemed to him too splendid to be given to foreigners. This was made clearly manifest by Galasso Ferrarese, who, seeing Piero dal Borgo a San Sepolcro rewarded by the Duke of Ferrara for the works that he executed, and also honour-ably received in Ferrara, was incited so strongly by such an example, after Piero's departure, to devote himself to painting, that he acquired the name of a good and excellent master in Ferrara.[102]

The presence of a powerful model can actually change the subordinate position of a provincial area. For it may happen that

> after one man has started on his own, others set up in competition with him; and so hard do they strive to outdo him that, even though they may never see Rome, Florence or other places rich in fine paintings, they produce works of wonderful quality. This has happened in our time especially in Friuli, where, from beginnings such as I have described, there have appeared numerous excellent painters – something unknown for centuries in those parts.[103]

On some rare occasions, then, 'through such a beginning' 'marvellous works' may come to light 'without seeing Rome or Florence'. But in the rest of his discourse Vasari ends by undercutting the very positive opinions expressed at the beginning, and by repeatedly belittling the work of Pordenone (by comparison with Titian, Beccafumi etc.). The kind of miracle that gave birth to 'marvellous works' outside the centres does not extend as far as making the periphery into an alternative to the centre; Vasari's system has no space for solutions of this kind.

But this is an issue which regularly emerges; as well as being a place of late development, the periphery is also the place of alternative production.

Such a statement requires a brief clarification of terms: 'different' and 'alternative' are not synonymous; not all variations can be defined as alternative, as a side-step from the norm. We will use the latter term in its specific definition as a 'sudden lateral movement from a given trajectory', which is used for example in describing certain movements of the horse. The side-step is, then, a kind of 'movement of the horse', and the use of this term enables us to avoid expressions of negative connotation, such as 'deviation' or the like. If we apply this meaning to artistic discussion, we can use 'given trajectory' to mean current artistic language.

Formulae such as 'language' or 'artistic language' are now so commonly used that their metaphoric nature is virtually forgotten. The analogy between language in the proper sense and artistic language is uneasy and generally flawed.[104] If, in spite of everything, we use terms such as language and code, we do it in the knowledge that we are introducing metaphors that pose more problems than they resolve. Despite all that has been written with any authority on the 'grammar' of artistic language, we are not now able to find a rigorous distinction between 'variation' and 'side-step', between lexical

borrowing and structures of syntax. But the important fact is that such a distinction was apparent, albeit in a different formula, to a public of connoisseurs at a given time in history. Indeed, this was apparent to Vasari, when he wrote of Pontormo:

> Now let no one believe that Jacopo is to blame because he imitated Albrecht Dürer in his inventions, for the reason that this is no error, and many painters have done it and are continually doing it; but only because he adopted the unmixed German manner in everything, in the draperies, in the expression of the heads, and in the attitudes, which he should have avoided, since he had the modern manner in all the fullness of its beauty and grace.[105]

For Vasari, 'manner' and 'invention' are in clear-cut opposition: the 'modern manner' is perfectly able to assimilate the conceits of the German artists. Pontormo's mistake, in Vasari's prescriptive vision, was to abandon the characteristic forms of the 'modern manner' to take on the 'unmixed German manner'. To us, 'inventions', i.e. compositions, may appear to be more profound, characteristic features of a style than clothes, posture, the pose of a head. But this is irrelevant here. The important point is that Vasari distinguished between some elements that could be safely altered and others which could not be altered without the work losing its terms of reference.

In Pontormo, then, we are looking at a true 'side-step'. This was not an isolated phenomenon, as is well known. Roberto Longhi, in a withering conclusion, compares the 'mannerism' of Genga, Beccafumi, Rosso and Pontormo with the work of Aspertini,

> the true axis of spiritual communication between the impulses of the centre and their kindred in the north of Italy; in other words [he is] of equal importance to understanding the sudden abandonment of the 'chromatic classicism' of Giorgione and young Titian by a group of artists from the Veneto and especially from Friuli, Brescia, Vicenza, Trento and Cremona in the course of the second decade.[106]

The leading figures of this anti-classical army worked in eccentric conditions or used methods that were imported from a peripheral culture such as that of Germany. This, at least, was how Vasari saw it, as he wrote with sarcasm that

> the features of all those soldiers are depicted in the German manner with bizarre expressions, so that it moves him who beholds it to pity for the simplicity of the man, who sought with such patience to learn

that which others avoid and seek to lose, and to lose the manner that surpassed all others in excellence and gave infinite pleasure to everyone. Did not Pontormo know, then, that the German and Flemish come to these parts to learn the Italian manner, which he with such effort sought to abandon as if it were bad?[107]

Pontormo's *Diario*, as well as Vasari's stories, makes it clear that his decision to move towards the periphery was accompanied by a real, physical self-exclusion from the group of his artist friends and colleagues. In other cases we find peripheralization that is imposed and suffered, or else deliberately accepted. But the problem does not end with examples of individual resistance which finds expression, or at least the chance to survive, in the periphery, when the centre leaves no room for diversity. We must look at the issue in broader terms, to understand the cases where the 'side-step', the alternative and the opposition to certain models formed attitudes that dominated a whole area.

Resistance to the model

In the rebuilding of the cathedral of Chartres, destroyed by fire in June 1194, an unknown master adopted highly innovative strategies, unifying and standardizing the support and reducing the three-dimensionality of the walls by eliminating the galleries and attenuating all emphasis on depth. In short, he created a model of a two-dimensional screen that opened up the way for that diaphanous casing that was to enjoy such wonderful application in the Ile de France in the course of the thirteenth century. However, a certain number of architects, working between Burgundy, the area of Geneva and the Rhône valley, did not accept such a strategy and came up with alternatives, or rather (if we ignore their individual differences) one alternative. Architectural historians have for generations talked of late development to explain such a situation. Only in relatively recent times has it become clear that this was not a case of late development but of coherent resistance.[108]

It is obvious that resistance and late development are quite different phenomena, one active, the other passive and subordinate. Besides, the solution of the opponents of Chartres was not simply linked to older models: it was rather the highly original elaboration of a kind of second wall that was lighter and perforated, placed in front of another, with a resultant perspective that salvaged the effects

of the three-dimensional wall. By comparison with the Chartres in-
novations, this alternative proposal tried to preserve the elements
that the new strategy eliminated, by transforming them. The central
position that the Ile de France eventually occupied at a political,
economic and cultural level ensured the prevalence of the Chartres
model.

Model and new paradigm

If we now return to Italy, or more precisely to Florence at the begin-
ning of the fourteenth century, we find solutions expressing resistance,
alternatives and lastly the peripheralization of alternatives, which
may be held to share some of the features of the Chartres resistance.

The solutions that Giotto had imposed on the world of painting
had had an even more divisive effect than those put forward by the
master of Chartres. For with Giotto there emerged in Florence a new
paradigm which had quickly altered the situation and relegated anyone
who did not adhere to it to the margins of the artistic universe.

We will use the expression 'new paradigm', extending its meaning
from the field of the history of science,[109] to indicate the rise of a lan-
guage that was not simply new, but which was powerful enough to
establish itself as the norm and to exert an inhibitive influence on
those who, for one reason or another, were excluded from using it.
Vasari gives an accurate description of the influence of a new para-
digm when he writes of the disconcerting effect wrought by the
Roman works of the *terza maniera* upon those who saw them for
the first time:

> He who changes his country or place of habitation seems to change
> his nature, talents, character and personal habits, insomuch that
> sometimes he seems to be not the same man but another, and all
> dazed and stupefied. This may have happened to Rosso in the air of
> Rome, and on account of the stupendous work of architecture and
> sculpture that he saw there, and the paintings and statues of Michel-
> angelo which may have thrown him off his balance; which works also
> drove Fra Bartolomeo di san Marco and Andrea del Sarto to flight.[110]

The first result that the imposition of the Giotto paradigm had in
Florence and Tuscany was that a large number of artists, and even
ancient centres, were pushed to the periphery.[111] At first there was
a group of heterodox painters that coexisted with Giotto and his

closest followers. These accepted some of the fundamental elements of Giotto's school (which saved them from the risk of immediate peripheralization), but differed on some points of the new paradigm and tried, for example, to develop the expressive experiments that Cimabue had worked on. To begin with, this dissent was tolerated; but things soon changed, as we can clearly see from the situation in Florence around 1340–50, if we compare it with that around 1310–20.

In about 1340–50, after the death of Giotto, his vision continued to influence Florentine painters then working in the city to the extent that the Giotto orthodoxy not only dominated but rejected every alternative to itself. From the beginning of the century to the 1320s, Florentine painting presents anything but a united appearance: next to the orthodox followers of Giotto ('Maestro della Santa Cecilia', Pacino di Bonaguida, Jacopo da Casentino) there were examples of open dissent by masters ('Maestro da Figline', Lippo di Benivieni, Buffalmacco, 'Maestro del Codice di San Giorgio') who attempted to establish a more openly Gothic style, or a revival of the older tendencies towards expressionism and pathos.[112]

This was an episode of 'resistance to Giotto' by a group of painters who, while acknowledging certain basic principles of Giotto's teaching, not only would not renounce the expressionist work of the end of the thirteenth century, but maintained its contemporary importance. It is then obvious that this is not so much a case of late development or clinging to an obsolete model as an alternative proposition, intended to demonstrate what kind of developments can grow from certain premises, which provide fertile ground. In some ways this situation can be compared to that of the architects working on the 'resistance to Chartres', who proclaimed the contemporary importance of a system derived from the Anglo-Norman 'thick wall'.[113]

When a system of forms and schemata is supported in the centre by a powerful group of patrons, and moves on to determine public requirements and expectations, anyone who is 'different' must bow out and move away to a less constraining cultural scenario. At the exact time when the irregular tendencies in Florence were diminishing, the records of Buffalmacco's activities in the city come to an end and the painter begins to be mentioned in other centres.[114] Buffalmacco, representing a 'side-stepping' line in relation to Giotto, was forced in the third decade of the Trecento to leave the most prestigious centre to find work in Arezzo, Pisa, Bologna; at the same time, an expressionistic trend found some favour and room for development

in Pistoia.[115] We should remind ourselves of the geographical map at this point, a 'municipal, not regional, Italy, which had existed for centuries, untamed and too rough and robust to be raffishly self-satisfied, to withdraw into its shell; yet too much so to accept political or literary subordination to region or nation'.[116] Political, literary or artistic; for art is an important component of that municipal identity that was so jealously guarded. The periphery that provided a territorial base to a 'side-stepper' was never amorphous or undifferentiated. Quite the contrary.

The alternative in Avignon

One of these fringe painters, the Maestro del Codice di San Giorgio, had to try and find a base in the town of Avignon.[117] Clearly, it would be absurd and nonsensical to consider Avignon, the fourteenth-century seat of the papal court, as being on the periphery. Yet we must clarify the meaning of our terms: while there is no doubt that the Provençal city immediately assumed a political, economic and religious importance, from an artistic point of view the city remained open to outside influences. In painting, these came from Italians – Sienese or Florentine painters like Simone Martini or the Maestro del Codice di San Giorgio. But the absence of an accepted tradition encouraged the development of painting that was very different from the usual canons and schemata of the larger Italian centres. This explains the astonishing fortune and the highly personal language of a Viterbo artist such as Matteo Giovanetti, to some extent an eccentric both in terms of origin and culture, who painted for the popes for more than twenty years. Several of the solutions that he put forward would not have been accepted where a strong tradition was in force. This much is confirmed by the fact that the 'side-steps' of Matteo Giovanetti, which were favourably received in the new papal capital and which had a significant impact in Europe, were later obscured by a tradition of art history that was born and developed in Florence: a tradition which accepted and celebrated other, more orthodox, canons and norms. At the end of the nineteenth century the painter's name was thought lost, and even when it was rediscovered in the Vatican archives, the works of Giovanetti still managed to arouse deep suspicion.[118]

Certainly, by comparison with the artistic traditions of Florence and Siena, the Avignon paintings show substantial variations; the symmetry, balance and coherence of figures, the composition of scenes,

the faces and expressions of the characters, all have undergone fundamental alterations, even distortions, that were destined to become a springboard for Gothic painting internationally, as is now generally admitted.[119]

These 'side-steps', which provided European painting with an opening to the future, were made possible in Avignon for different reasons, principally because of the change in patrons and public. In around 1340–50 the appearance of the papal court underwent a radical transformation by comparison with the first years of the century. The pope and the majority of cardinals came from southern France, the public which had access to the palace was as heterogeneous as ever; the same artists worked under different conditions from those of Italy. The teams who worked under the direction of Matteo Giovanetti included Tuscan artists of various origin (from Siena, Lucca, Arezzo, Florence), and artists from Viterbo, Parma, Piedmont, Provence, Lyon, England and Germany.[120] Lastly, the network of available references included Gothic examples by the masters of northern France or England, and a figurative culture of Provence, in chronic decline after the war, though still extant. All these elements combined to make Avignon in those years a 'double periphery' in artistic terms: with the fading of Provençal culture, the new terms of reference were the painting of central Italy and the Gothic design of the north.

Frontier regions

This was not an isolated phenomenon. Italy's frontier regions went through analogous situations at different times: the condition of 'double periphery' at these boundary areas could actually stimulate creation of fertile regions, places where different cultures met and which were the catalyst for original developments. This was the case with Piedmont in the Alps at the beginning of the fifteenth century, during the rule of the Duke Amedeo VIII: with the interaction of artists of diverse origin (Italy, Burgundy, upper Rhineland), this area became a high point of international Gothic art.

For many centres and regions in Italy, from Roccaforte Mondovi to Ripacandida in Basilicata, the language of late Gothic art was the final period of integration, homogeneity, participation in artistic production on equal terms. Nothing that came afterwards was of comparable importance for a long time: only what Vasari called 'the modern style' gave rise to a new paradigm that definitively ruled out

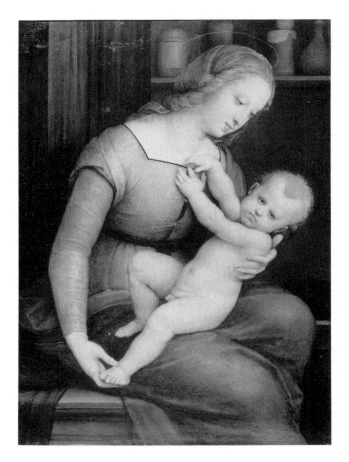

Plate 6 RAPHAEL, *Orléans Madonna*, Chantilly, Musée Condé.
Photo: Photographie Giraudon.

classical art, while the level of adherence indicated the first moves
towards discrimination between centre and periphery. Yet the first
formulations of the Renaissance had coexisted with those of late
Gothic art, without any paralysing effects.[121] But it was precisely the
widening of the gap between centre and periphery inside the penin-
sula that made it possible for Italy to be established as an artistic
centre in relation to the periphery of Europe.

 Once again, west Piedmont shows itself to be another example
of 'side-stepping', which took advantage of the region's status of
'double periphery'. This was in the work of Defendente Ferrari, who

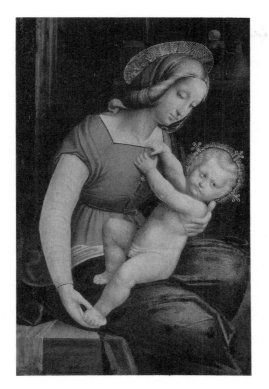

Plate 7 Attributed to Defendente Ferrari, Copy of the *Orléans Madonna* by Raphael, 1526, Amsterdam, Rijksmuseum.

reworked elements of various origin – Provençal, Flemish, Rhineland, Lombard – in forms that were to find a remarkable resonance in the Alpine region, and who came up with models that were significantly different from those which were then widespread throughout Italy. That distance was not due to ignorance or to lack of information on artistic developments in Florence or Rome. Raphael's works were in circulation in Piedmont, the *Orléans Madonna* for example; Duke Carlo II, who owned this work, had even had a copy (now lost) made by Martino Spanzotti in 1507; the surviving copies, by Defendente or Giovenone, are sufficient evidence of the diffusion of the prototype.[122] Later on, though before 1564, a copy of Michelangelo's *Judgement* was painted on the walls of the Madonna dei Boschi di Boves.[123] The road to reviving Gothic forms that Defendente apparently followed was not then the result of late development in

the periphery but rather a deliberate side-step, the choice of which was largely determined by the devotional character of a great part of his production. But it is precisely at this level that we witness the intertwining of archaism and novelty that so often characterized the painstaking elaboration of alternatives on the periphery. The inscription which accompanies *Christ's Farewell to His Mother* runs:

> You who contemplate the all-seeing, penetrating power of the face of the holy image, take in the living light of holy wisdom, and impress upon your mind how truly the beloved mother appears with utmost humility and ineffable wisdom, by great mercy, and with what grace maternal compassion is shown, through the memory of the pain in store that she holds deep in her heart.[124]

So what is being encouraged here is a far more complex self-projection than the immediate, almost physiological reaction of the onlooker before a sacred image. The prophetic memory of Mary, who sees the suffering of her son in the future, is held up as a model of the onlooker's own memory. Formulated in a language that is rich in Latinism, these 'instructions for use' invite a public that was probably clerical to read fully the psychological implications of the image.

In time, Defendente Ferrari's neo-Gothic devoutness led him to work parallel to the experiments of some mannerist painters.[125] Indeed *réculer pour mieux sauter* seems to be a recurrent element in the elaboration of peripheric side-stepping. In this sense, there is a convergence between, on the one hand, the expectations of public and patrons, and on the other the desire to avoid a dead end by trying paths that are far removed in time and space.

Lotto's exile

There are also cases where the search for an alternative is physically translated into exile. Let us look at the archetypal example of Lorenzo Lotto. He spent almost all his life outside Venice, and most of his paintings are to be found outside Venice too: in Treviso, Bergamo and the valleys around Bergamo, in the towns, villages and hamlets along the coast and in the hills of the Marches, from Ancona to Recanati, Fermo, Jesi, Cingoli, Monte San Giusto and Loreto, where the painter died in the convent to which he had retired.

Of course, Bergamo in 1515 could not be considered as a periphery. If anything, Lotto's activities in the area should be considered

as part of the process of penetration by Venetian figurative culture into a city which until a few years earlier had seen works by Bramante, Filarete and Amedeo. Moreoever, at this time Venice, like Florence in 1310–20, had not yet taken on one sole paradigm. It is against this background that we must view the decoration of the Cappella Suardi (1524) in Trescore, in the Bergamo valleys.[126] Here archaic iconographic models (the life of Christ or the narrative sequence where, as in Sacro Monte, the events are narrated in several stations, palazzi, logge and stages) have undergone a bold, naturalistic re-structuring. Vines spread from Christ's fingers, weaving a frame for martyrs, confessors, prophets and church Fathers. The two levels of representation, historical (scenes of the lives and martyrdoms of the female saints) and semi-historical (the vine of Christ assaulted in vain by heretics) are superimposed, both with a perspective frame-work, but radically different in their dimensions (plate 8). Once again the alternative experiment makes unbiased use of decidedly archaic elements and brings out their potential for innovation.

Clearly, all this would not have been possible in Venice; but even a work like the altarpiece of the Carmini, which did not have such disquieting effects, seemed to Ludovico Dolce 'a very clear example ... of these nasty colours'. This derogatory comment follows, al-most illustrates, the arguments given to Aretino which stress the conventions to be respected in the use of colours:

> Of course these colours must be varied, in consideration of the sex, age, and condition [of the subject]. With the sexes, one colour is generally used for the complexion of a young woman, and another for a young man; with age, one is required for an old man, and another for a young one; and with condition, do not apply to a peasant the colours that belong to a nobleman.[127]

The negative reaction engendered by an environment of patrons and critics who favoured Titian can be seen in the scarcity of works by Lotto in Venice, at intervals of several years. The most astonish-ing of these is the little altarpiece of San Zanipolo, painted for a friendly convent where Lotto had spent much time. At the other end of the scale, in the words of Lanzi, who appreciated the 'new depar-tures in *tavola*' of which Lotto was 'among the earliest and most brilliant exponents', 'his decline can be pinpointed from 1546, the period that is illustrated in the painting of San Jacopo dell'Orio.'[128] Lotto painted this work during his last visit to Venice. He had left Treviso where, he said, 'he was not earning enough to keep himself',

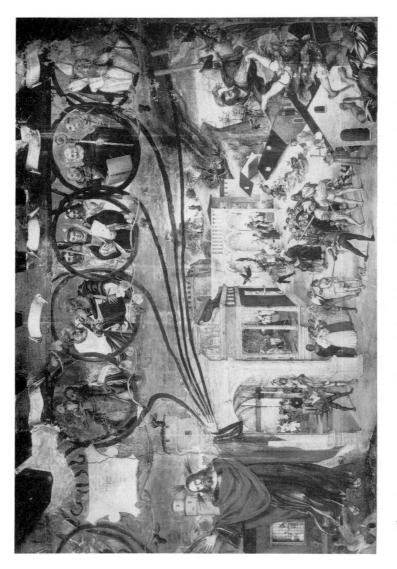

Plate 8 LORENZO LOTTO, *Christ – Life and Stories of St Barbara's Martyrdom*, detail, 1524, Bergamo, Trescore Balneario, Cappella Suardi. Photo: Archivi Alinari.

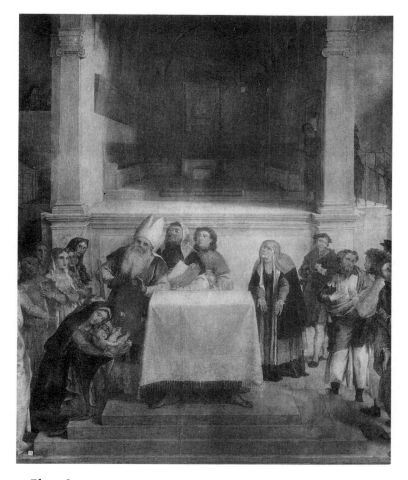

Plate 9 LORENZO LOTTO, *Presentation of Jesus in the Temple,*
Loreto, Palazzo Arcivescovile.
Photo: Archivi Alinari.

and he was trying to survive by adapting to the taste and the models
of Titian, making them more spare and devout.

After this period, when he had left Venice for the last time to go
to the Marches, Lotto went to Loreto. There, far from the confines
of convention, he rediscovered the freedom of expression that makes
his uncompleted *Presentation of Jesus in the Temple* (plate 9) look
so modern.[129]

After Bergamo, then, it was in the Marches that Lotto found space for his painting. Being a region that was traditionally linked to Venice, along the Adriatic coast at least, Venetian painters had worked there since the fourteenth century. But in the course of the sixteenth century it had gradually lost its economic and political importance. This meant that Lotto's more modern works found freedom but no future, and the avenues he opened up were not followed or developed, with a few local, limited exceptions.[130]

Urbino and Barocci

A few years after the death of Lotto, Federico Barocci left Rome at the height of his fame, and, without warning and well before time, retired to his home town of Urbino, now in decline. According to his biographers, his flight was due to illness, followed by an attempt to poison him. But more complex motives should not be excluded;[131] his departure was certainly definitive. Barocci, the creator of sacred images admired by San Filippo Neri, was a dyspeptic old man much sought after by dukes and cardinals, a tireless artist who paid great attention to realism, and an intellectual painter who sought for chromatic harmony in a model of musical harmony. For decades he had obsessively inserted the image of Urbino into his paintings to represent the 'view of the city of Jerusalem', complete with the 'magnificent palace' of the Duke, as an emblem of the most diverse evangelical scenes.

The choice of a city that was destined to early marginalization seemed to Bellori to be an act of desertion:

> I will go further and spell out something which seems unbelievable: there were no painters to be found either in Italy or outside it, since Peter Paul Rubens had not long since taken his colours out of Italy, and Federico Barocci, who could have restored and assisted our art, was languishing in Urbino and did not offer any help at all.[132]

The peripheric exile here takes on the guise of a fallen saviour. Perhaps in a similar spirit it has been supposed that the success of Lotto in his native land might have directed 'Venetian art (and perhaps not only art) ... towards Rembrandt instead of towards Tintoretto'.[133]

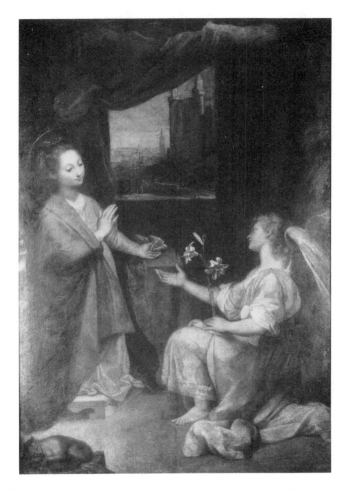

Plate 10 FEDERICO BAROCCI, *Annunciation*, Rome, Vatican Art
Gallery.

The seventeenth and eighteenth centuries

In the seventeenth century the side-steps of the periphery are less
dramatic and conspicuous. As political and economic restructuring
progressed, the situation tended towards stability, and the separa-
tion of centre and periphery that had begun in the previous century
became more marked. As the number and the autonomy of old

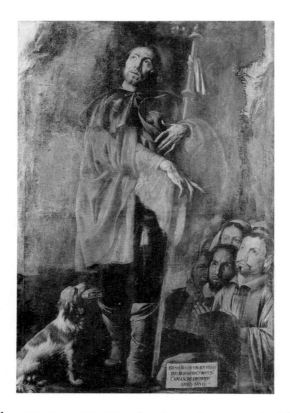

Plate 11 TANZIO DA VARALLO, *San Rocco Intercessor in Adversity*,
Varallo, Pinacoteca (in the deposit of Camasco, Parrocchiale).

municipalities were greatly reduced, different sets of rules were
applied, one for the metropolis, another for the provinces. Thus,
with the periphery subdued and resigned, the opportunities for side-
stepping were greatly diminished.[134] At least this is the context in
which to interpret the works of Tanzio in Abruzzi, Gentileschi in the
Marches, the return of Bassetti to Verona and of Niccolò Musso to
Casale Monferrato; most memorable of all, Tanzio's return to
Valsesia, when he visibly side-stepped in relation to Morazzone and
the Lombard models. A painting such as Tanzio's 'vow of the pro-
letariat', with the peasants of Camasco crowded round 'San Rocco
Intercessor in Adversity', revives the traditions of processional ban-
ners, from those of Foppa at Orzinuovi, clearly demonstrating how
the old devotional foundations of the provinces could become a

haven for the realist painters of the Roman diaspora. This was a strain of resistance that was destined to endure.

The best group portrait of eighteenth-century Italian painting, *I canonici di Lu* by Pier Francesco Guala, is plunged in the shadow of a church of Monferrato, the army of the *gueux* gathers on the walls of the houses of Bresciano. There was in the provinces, or at least in the provinces which were well disposed towards investing in symbols, a form of patronage that was relatively independent of the dictates of the metropolis.

The revival of municipal tradition constitutes one of the central phenomena of eighteenth-century culture. Bottari's collection of *Lettere Pittoriche*, later expanded and republished by Ticozzi, provides more than one example of this renewed zest for research. 'I tell you truly that in Cento you would have found something to rest your eyes upon', wrote Algarotti to one of his Venetian correspondents,[135] Luigi Crespi, who encouraged the publication of guides and descriptions of localities, criticizes the most widespread descriptions of Italy at that time for not mentioning Volterra, Cortona or Pescia, and complains at the absence of writing on the cities of Romagna:

> If this had happened to the paintings of the many cities of Romagna where many worthy masters flourished, they would not now be mostly unknown, and their many beautiful works would not be either dispersed or neglected, to the shame of the respective cities, to the masters and their families; but they would have been and still would be preserved with due respect, admired and visited by travellers! Do you, for example, have any knowledge of a certain Cristoforo Laconcello? Of Gio. Batista Bertuccio? Of Palmeggiani?[136]

In Crespi's view,

> Everything that in some way adorns a city should always be made public, to keep alive the memory of the person who encouraged or produced it . . . For if this is also true of any excellent object in general . . . how much stronger will the case be for the three most noble arts, painting, sculpture and architecture, by whose sole virtue cities are distinguished and visited by learned travellers . . . While they are practised, for the most part, by artists of obscure and sometimes lowly birth, yet through them they will earn esteem and receive great honour from the rest of the world.[137]

Ratti and many other writers express similar ideas. The recurring theme in these writings is the exaltation of the arts, which 'while

practised, for the most part, by artists of obscure and sometimes lowly birth', attract the attention of 'learned travellers', 'wise princes', 'scholars and erudite men', 'learned writers'.

The historical reconstruction of the glories of small centres – whether Cento, Faenza, Forlì, or Pescia, Cortona, Volterra – coincided with the period which saw research into traditions of antiquity, pre-Roman[138] and medieval. A new space, then, seemed to be opening up for the periphery: but this happened only in some of the more prosperous areas. In the greater part of Italy, the situation was beyond repair.[139]

Centre and periphery, persuasion and domination

There is certainly nothing new in the statement that images can be the instruments of persuasion and domination in the ever stormy relationship between centre and periphery. Sometimes this was a direct task, as when the image of the sovereign and his insignia were being put into force: we need only remember how, from Orvieto to Bologna to Anagni, Boniface VIII used and propagated the use of his own effigy to ratify the dominion of the Church and his personal power; how the equestrian statue of Azzone Visconti towered over subjects and faithful from the heights of the great altar in San Giovanni in Conca; how the coats of arms on the gates of Italian cities would be painted in and painted out according to the change of *signoria*, or how the displays at triumphal entries confirmed the power and magnanimity of the ruling lord. Very often, the use of images could be more indirect, as part of a more general political campaign: here too there are many examples, from the achievements of the Lombards painted in the Palazzo di Teodolinda in Monza, to the Church Fathers whom Martin I had painted on to the walls of Santa Maria Antiqua after the Lateran Council in 649 to ward off the Monotheletic heresy supported by Constantinople; the scenes from the Risorgimento painted by Cesare Maccari, Amos Cassioli and others in the Vittorio Emmanuele rooms of the Palazzo Pubblico in Siena, or even more recent episodes, many examples of which can be found in the artistic production of the Fascist era.

In other cases we have to decipher the political confrontations through the scars of these images, and understand how particular styles and particular formulae could have been imposed. The Ruthwell Cross and the capitals of Santo Domingo de Silos have revealed the

existence of a genuine battle of symbols, during which, in the course of the Middle Ages, a new style supported by a political and religious authority was imposed upon the resisting ethnic culture.[140]

The enforced adoption of stylistic and iconographic models originating in the centre, the elaboration in the centre of differentiated stylistic rules for metropolis and periphery, the pillaging of the symbolic heritage from the subject territory, the drift of talent from the periphery and that, in the opposite sense, from the centre towards the periphery of products of high symbolic potential – all these are forms and instances which illustrate means of domination. Since it is impossible to treat them broadly in any organic way, we shall proceed with a kind of typological enumeration that will allow us to illustrate cases and problems in question.

The domination of symbols

In order to identify some of the more important aspects of the relationship of symbolic domination we can look at each of the positions of some of the elements that make up the artistic arena: the works themselves, artists, patrons and public. Of these, the public is seemingly a fixed component between the continual shifting of the other three, but at the same time it is the least studied element, and for this reason the most elusive. Our inquiry then will be conducted around the others, and firstly, on the works themselves.

We can distinguish here between various situations, which range from the totally negative time of destruction of a work, the true zero mark on our scale, to the arrival in the periphery of works of the highest quality from the centre, passing through different phases.

We will not linger over our so-called zero mark; by and large the destructions of works that occurred through a centre–periphery conflict were of two kinds: those that were born of a direct will to eliminate the cultural heritage of the subject area, and those more indirectly caused by the low standing of products of the subject city's ancient culture. An example of the first type is the destruction of the antique 'delizie' of the dukes placed outside the walls of Ferrara after the devolution of the Este estates to the Holy See: this was a radical devastation of architectural heritage of an ancient power, justified by a Ferrara historian on the grounds that 'the useless expenditure which the Camera would have had to sustain to preserve them, and the fortification of the walls that were by nature

contrary to such delicate objects, did not allow them to last any longer.'[141] Examples of the second type can be seen in the laments over the fate of the artistic patrimony of provincial cities, regularly recorded in the *Lettere Pittoriche*.

The pillage of the symbolic patrimony requires a longer treatment. The history of these legendary, daring sequestrations is widely known, from Charlemagne, who took the equestrian statues of the so-called Theodoric from Ravenna to Aachen, to the requisitions that took place throughout Europe for the Musée Napoléon,[142] to those ordered by Hitler for the creation of the supermuseum of Linz.[143] Libraries (such as the Palatine in Heidelberg, seized from the Palatine Elector by the Duke of Bavaria after the battle of the White Mountain, and given to the pope as a symbol of victory over the Protestants and reverent submission), art collections, equestrian statues, altarpieces, portraits, sculptures – all abandoned their place of origin to be moved to capital cities needing to increase their symbolic supremacy.[144] This phenomenon is a regular feature in the process of peripheralization of many regions of Italy after the restructuring of the sixteenth century. A typical example is again Ferrara, when the Este dynasty became extinct and the state devolved to the Holy See. Evoking the artistic consequences of these events, Lanzi wrote:

> The change of government took place in the time of the great Pope Clement VIII. Scarsellino and Mona worked on the public festivities surrounding his investiture, chosen as painters most able to produce much work in little time. Later on various painters were employed to make copies of selected altarpieces around the city, which the Roman court wished to transfer to the capital; they left the copies to Ferrara, and the historians of Ferrara to their lamentations.[145]

Among the 'lamentations' of the historians of Ferrara, it is enlightening to recall those of Antonio Frizzi:

> Shameful it was to our citizens to see in the year 1617 churches despoiled of many of their best paintings, by the hands of Dossi, Ortolano, Garofalo, Carpi, Titian, Giovanni Bellini, Mantegna and other more illustrious national and foreign painters, to be replaced by copies, though they were admirablly done, by Bononi, Scarsellino, Bambini, Naselli and others. Who took them and where they were taken we were not told, but we know that at various times many of our precious monuments of similar kind, manuscripts and antiques, went to enrich the capital.[146]

Girolamo Baruffaldi gives evidence of this pilfering, when he wrote the life of Giacomo Bambini, one of the artists engaged to copy the sequestrated paintings:

> When this city devolved to ecclesiastical rule, in 1598, he was one of the masters who worked in Ferrara, and was therefore employed to copy many precious paintings by illustrious masters, so that the originals desired by the papal court could be sent to Rome. I can account for two of them, the panel of the Ascension of Christ in Santa Maria in Vado, and the other of St Margaret in the Church of the Consolation. The first was by Ortolano, the second by Benvenuto da Garofalo.[147]

Ferrara can serve as model of a situation that could be illustrated by many other examples. For instance, the consequences of the devolution to the Church of the della Rovere patrimony were not dissimilar.[148] An analysis of these negative points in the history of Italian art would unearth a wealth of information on the vicissitudes of the centre–periphery relationship; in the same context, we should not forget the vast dispersion of works of art which Italy has suffered during the last 150 years.

Dynamics of the works of art

The dispatch of works from the centre can be analysed by different types and degrees. Here too we may identify various cases.

Let us take the example of Massa Marittima during the fourteenth century. Here works of art imported from Siena were a means of infiltration by Sienese culture before the final surrender of the city in 1336. The first decades of the Trecento are entirely dominated by large artistic commissions given to Sienese artists: in 1316 the gentlemen of Massa's Council of Nine put pressure on the *Operaio* of the Vestry Board of San Cerbone to complete the great altarpiece for the cathedral's high altar, inspired by the model of Duccio's *Maestà* and undoubtedly made in the workshop of the great Sienese artist. In 1324, an inscription tells us that the Arch of San Cerbone, a masterpiece of Italian Gothic art and commissioned by Percius, the *Operaio* of the cathedral, was completed by Maestro Goro di Gregorio 'de Senis'; a few years later, but perhaps still before the Sienese conquest, came the *Maestà* by Ambrogio Lorenzetti, then in the church of Sant'Agostino, now in the Palazzo Comunale.

Some of the most important Sienese works of art, then, were made for the rich mining town of Massa Marittima, which appeared to be totally dominated by Siena even before the latter took political control, and Agnolo di Ventura completed his conquest with a new set of fortifications. Unlike centres such as Volterra or San Gimignano, the opulent Massa Marittima had no independent artistic tradition, though its range of patronage was very broad, and it submitted to a cultural hegemony that was externally imposed via a series of works of exceptional quality which anticipated political rule. Going back to the conditions of entry into our hypothetical club of Italian artistic centres, it is significant that the bishops of Populonia eventually found a stable see at Massa only at the beginning of the twelfth century, in the same way that the bishops of Roselle moved to Grosseto (also destined to be completely dominated by Sienese art) as late as 1138.

Let us look at another example of a consignment of works of art, again in the Trecento and in the region of Siena. Here we will not go to a rich, important city like Massa, but a humble village on the foothills of the Amiata mountain, Roccalbegna. The parish church houses three excellent panels by Ambrogio Lorenzetti, inviting speculation on the circumstances that led one of the best artists of his time to do such an important work for such a remote village.[149] The answer probably lies in the strategic role assigned by Siena to this small mining centre, lying on the southern borders of the state, which had been acquired and refounded at the end of the thirteenth century.[150] These pictures, then, can be seen in the context of a newly created centre, and the attempts – visible in the many facilities – to attract Sienese citizens. The prestigious paintings by one of the greatest Sienese artists were to be an instrument of identification, a focus of aggregation. This example must be related to the increase of works and art commissions during the fourteenth century in the towns and villages of southern Maremma, from Grosseto to Paganico, i.e. in an area of recent Sienese expansion.

In other examples, consignments of works of art reveal and confirm a state of cultural dependence that can coincide with economic or political dependence. In the parish church of Calvi in Corsica a large polyptych stands on the high altar, signed by Giovanni Barbagelata 'de Janua' (it would be instructive to collect the cases where the place of origin follows the name in the artist's signature and compare this with the actual destination of the work). Records tell us that the polyptych was commissioned by two citizens of Calvi, who wished for a replica of the one painted in 1465 by

Giovanni Mazone for Santa Maria di Castello in Genoa.[151] The prestige of the older work is significant (analogous to that of the copies made from the Ghirlandaio painting in Narni, which we discussed earlier), as is the fact that the original was Genoese and the commission was given to a Genoese painter. At this time the island was politically and economically controlled by Genoa, but cultural subordination may endure even beyond the limit of political subordination. The consignments of Pisan works of art to Sardinia are evidence of this (sculptures, polyptychs and bells);[152] these continued even when the island was firmly in the hands of the Aragonese, but as yet untouched by that Mediterranean 'Gothic–Hispanic–Neapolitan' wave which is recorded in important documents today.[153] The many works sent from Pisa and Genoa to Sicily during the fourteenth century are evidence of this phenomenon too, as are those sent from Venice to Apulia in the fourteenth and fifteenth.

Dynamic of the artists

Artists tended to move parallel to their works, though sometimes, as we shall see, in the opposite direction. Even so, we must distinguish between the various situations. For example, the expansion of Venetian power did not seem to lead to a generalized cultural submission. We might apply to painting in the *terraferma* Venetian states the same words that described the persistence of a local literary tradition in Verona in the eighteenth century:

> This was a municipal literary tradition that four centuries of Venetian domination had not been able to make conform to and even less to depend on that of the capital . . . I have said that four centuries of Venetian domination could not make Verona submit, but it should be emphasized that Venice never made any suggestion of submission.[154]

This did not mean that artists did not flock to Venice from Cadore, from the shores of the Brenta or the Adige, but rather that the conditions for local activity were not destroyed.

In other cases, though, painters of modest horizons remained where they were, finding work through the patronage of an unassuming public. A Corsican painter such as Maestro Antonio di Simone of Calvi signed a polyptych for the church of Cassano (near Calvi) in 1505,[155] while, as we saw, the polyptych for the high altar of the

parish church in Calvi was commissioned from Genoa. Sometimes, while local masters were occupied with various typical local products – such as the painting of ceilings – works on wood came from outside. This was the case in Palermo in the fourteenth century when *Mastru Simuni pinturi di Curigluni, Mastru Chicu pinturi di Naro*, or the Palermitan *Mastru Darenu* painted the ceiling of the Steri, while Bartolomeo da Camogli and Niccolò da Voltri from Genoa, and Jacopo di Nicola, Turino Vanni and many other Pisan artists sent polyptychs and panels for churches and oratories.[156]

It was typical for artists on the periphery to be drawn to a politically hegemonic centre. This was true of Niccolò di Lombarduccio di Vico, one of the greatest artists in Liguria in the fifteenth century, born in Corsica and thus known as Niccolò Corso – 'the Corsican'; or again of the brilliant painter Tuccio d'Andria 'de Apulia', who in 1487 painted a triptych for the cathedral of Savona with the marriage of St Catherine (relations with the western Mediterranean were probably facilitated by the Provençal origins of the lords of Andria, the del Balzo family). It was also true of other Apulian artists such as Reginaldo Piramo di Monopoli, who illustrated manuscripts in Naples and Venice;[157] and of many Calabrian artists such as the miniaturist Cola Rapicano, the architect Francesco Mormando, the painter Marco Cardisco, and later, in the seventeenth and eighteenth centuries, Mattia Preti and Francesco Cozza.[158] The same applied to Sicilians such as Agostino of Messina, called Sarrino in Genoa in 1400, or Pavanino of Palermo in the second half of the century in Salerno,[159] to say nothing of the two most celebrated Sicilian emigrants, Antonello da Messina and Francesco Juvara. In these last two cases Venice at the end of the fifteenth century and Turin at the beginning of the eighteenth provided bases from which their models would enjoy a diffusion all over Italy and indeed Europe.

In other circumstances artists would be forced to flee from the political centre: this was what happened, for example, after the Florentine conquest of Pisa. By contrast to the events that took place after the Venetian occupation of centres in the *terraferma*, a large number of Pisan painters left the city and went to Genoa. The number was so significant that in 1415 an artistic assembly of Genoese painters – where out of twenty in attendance three were from Genoa and no less than nine from Pisa – voted to amend the rules of the corporation to encourage foreign painters to work in the city.[160]

Another example to consider in this brief typology, is that of artists who moved from the centre to places that may be considered subordinate rather than peripheral. We shall leave aside the example

of the Sienese who during the fourteenth century not only sent their works but also went in person to work in Massa, San Gimignano, Paganico and so on; examples on a grand scale are to be found in the activities of Venetian painters in the fifteenth and sixteenth centuries in the cities of the *terraferma*, and in the great rush of Lombard painters to Liguria after Genoa had placed itself under the protection of the Visconti in 1421. In the latter case, it was an attempt to secure the best contracts – and positions – in a centre that had great economic power but was culturally (and at that time politically) very weak. Besides, the case of Genoa in the fourteenth and fifteenth centuries was anomalous by comparison with the physiognomy of artistic centres such as Florence, Siena or Venice: with the massive, frequent invasions of artists from Pisa, Piedmont and Lombardy, Genoa became a centre of distribution where different experiences were collected and then amplified and transmitted.

Dynamic of patrons

We are left with the patrons. As in the case of works of art, here too we find a zero rating in our proposed survey, i.e. the total dispossession of a group of patrons. This happened in Casale Monferrato, when Guglielmo Gonzaga succeeded to the ancient dynasty of the Paleologi and used policies which brought about the end of certain social groupings of citizens and the artistic tradition which was dependent upon them. This tradition later revived but took on a very different direction.[161] Similar examples may be found in Urbino and other Italian centres.[162]

A different type is that of patrons who came from an important centre and leave behind traces of their travels through the periphery. These were bishops, lieutenants, governors, commendatory abbots, who delighted in commissioning works for their temporary office which would show their origin, their travels and their elevated social or cultural positions. The fruits of this zeal for patronage fell rather like a thunderbolt, outside any context and unrelated to local events or expectations. This was the case with Philos Roverella of Ferrara, who returned from the Council of Trent in 1545 to his diocese in Ascoli Piceno with one of the most admired painters of the court in Trento, the Friulan Marcello Fogolino, whom he asked to decorate his bishop's palace with biblical scenes.[163] Similar in its extracontextual nature is the type of case where a patron, born in a peripheral area, wins great honour in a capital, as happened very frequently to prelates,

doctors, bureaucrats and lawyers in the course of the seventeenth and eighteenth centuries. It might then happen that this man thought to send his native village one or more works of art that would testify to his patriotic fervour, his taste and his social success. It was in this way that a man from Spoleto, as governor in Cento in 1636–7 and a high-ranking officer for the pope, made several visits to Guercino's workshop, bought his works and sent them as a gift to a confraternity in his native village.[164]

There are still other kinds of situation: for example, those where patrons in the periphery bear witness to cultural subordination to the centre through their choice of commissions. A typical example of this, and highly symptomatic of the feudal type of structures such as those in Calabria, is the patronage of the Sangineto family, the lords of Altomonte.[165] When Filippo di Sangineto was crossing Tuscany in 1326 in the train of Carlo di Calabria, he ordered the *San Ladislao* from Simone Martini, and a polyptych from Bernardo Daddi. Later on, a member of the same family, having to make choices for Ladislao di Durazzo, commissioned a polyptych in Naples showing scenes from the Passion from an anonymous master chosen by Antonio and Onofrio Penna. In both cases the choices of the Sangineto followed those of the Angevins of Naples, and in both cases the commissioned works were collected in the church of Altomonte, the seat of feudal power where there was a great concentration of cultural symbols by comparison with the desert of the surrounding territory. The disparity between the distribution of works and their heterogeneity points to a situation of not periphery but actual colony. This pattern is repeated in Teggiano, the fief of the Sanseverino family, who controlled the Valle di Diano at the borders of Campania; and again in Galatina in the Salento, where Raimondo Orsini del Balzo and his wife Maria d'Enghien founded the sanctuary of Santa Caterina and had it decorated by numerous different teams of painters.[166]

This cultural subordination to the centre is also manifest in patrons who belong to other social groups. The events of a restricted area of the mountains of Norcia are of some significance. There we find a remarkable concentration of late Gothic and Renaissance Florentine paintings, by artists such as Giovanni del Biondo to Neri di Bicci, Piero di Cosimo and Filippino Lippi. The unusual, repeated presence of these paintings, which ultimately make up a very homogeneous context, is explained by the prolonged relationship between a group of villages in the Apennine area and Florence, where the mountain dwellers of Umbria were traditionally employed as porters at the

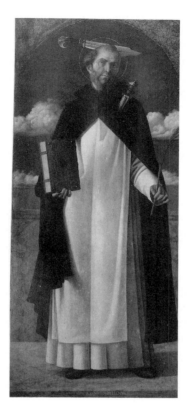

Plate 12 GIOVANNI BELLINI, *St Peter Martyr*, Bari, Pinacoteca Provinciale.

custom post.[167] The economic ties between the peripheral villages of emigration and the central place of work here gave rise to a form of cultural subjection.

Our last example comes from Apulia, where the centres on the Adriatic coast are marked by the concentration of Venetian works of art which lasted from the fourteenth to the sixteenth century (thereafter replaced by the penetration of Neapolitan works), and which accompanied the military, political and commercial presence of Venice.[168] Often it was religious orders that commissioned works from Venetian artists: the polyptych by Jacobello di Bonomo in the Museo at Lecce comes from the church of the Benedictine monks at St John the Evangelist of Lecce; the *St Peter Martyr* by Bellini in the

Pinacoteca in Bari comes from the Dominican church in Monopoli; Savoldo and Pordenone made paintings for the Franciscan church in Terlizzi. But Venice's prestige stood high in all social groups: while Muzio Sforza, a scholar of Monopoli, dedicated a poem to Tintoretto, Lorenzo Lotto on 16 June 1542 received a merchant of Barletta, Alouise Catalano, sent by 'the gentlemen of Juvenazzo' to order a triptych for their church of San Felice.[169]

The Church after Trent

The centralization and bureaucratic restructuring of the states and the reorganization of the Church after the Council of Trent meant new forms of central domination over the periphery in the course of the sixteenth century. These were evident in an expanded process of classification and codification of images[170] and architecture, processes that were stimulated and also more clearly defined by the increase in the treatise as a form of literature. In a time that is closer to our own, in Wilhelmine Germany, detailed controls decreed that in centres of less than 50,000 inhabitants the post offices should be in 'German Renaissance' style, while in the large cities of more than 100,000 they should be Romanesque.[171] Now, though the detailed surveys of the treatises of the Counter-Reformation did not foreshadow an appeal to differentiated historical styles, they still tended to construct a hierarchy of type by distinguishing and prescribing particular modes and forms according to whether the church was a cathedral, college, parish, branch or a monastery, and whether or not the oratory was for the purposes of celebrating the mass. Moreover the establishment of appointed places of learning, such as the academies which were instituted in the eighteenth century, was of specific importance in gaining a precise cultural control. However, the codification of type, and the centralizing of teaching also had effects quite different from a mechanical expansion of a kind of conformism of the periphery, for they aided the circulation of international experience and a broader knowledge of repertories. One example of this is offered by Bernardo Vittone, one of the greatest, most ingenious figures of eighteenth-century Europe, who, though he worked almost exclusively in the provinces of Piedmont on the construction of village churches and country oratories, used innovative forms which were on a par with the most advanced European systems.

Through the changes that came about in the training of artists and

the circulation of information, the eighteenth century saw profound changes in cultural structures, their functions and even in their geographical framework. One sign of this is the influence of the Piedmontese provinces in architectural questions in the European Alps; but this situation cannot be generalized.

On 14 September 1755 Lorenzo Daretti, an architect from the periphery of Ancona, wrote to Vanvitelli to ask his permission to continue the construction of the Augustine church, introducing himself in the following humble terms: 'After my return to this my native city of Ancona, with my feeble studies of architecture completed, I have had the chance to do a few poor buildings, which have met with a kind of approval.' The architect of the centre sends a lofty reply from Naples:

> I know not your name, as you yourself point out, and even less do I know your ability as architect, and when I went to Ancona I found no one there, nor in the province [who had any ability]. But in this city I found a great number of people who wished to learn this skill at my studio; but when they discovered the difficulties they thought it better to pursue comfort, ease and amusements, rather than give me the discomfort of suffering them come to my house to study; and from then until now I have never discovered anyone to reap any gain from this most difficult science, which holds all the other sciences in its embrace.[172]

The final account with Europe

In the eighteenth century Italian art and culture enjoyed wide circulation in Europe, but after the deaths of Piranesi and Canova no Italian work rose to the level of the European model for a very long time. The period that followed saw a lengthy eclipse, which had been forecast some time before. An age that spanned many centuries came to an end half way through the seventeenth century. By a symbolic coincidence the year of Poussin's death in Rome (1665) saw also the failure of Bernini's project for the Louvre. The deep-rooted crisis of Italian society, and even more of the weakness of the Roman court within the whole picture of European power inhibited the establishment of an Italian artistic paradigm: this had already happened in the not too distant past, when the artistic and extra-artistic prestige of Rome as the capital of Christianity (albeit a Catholic Christianity in name if not in fact) was enough to ensure

the world-wide success of the two conflicting paradigms that had developed there. This was the case firstly with Raphael and Michelangelo, and later with the Carracci brothers and Caravaggio: the apparently victorious paradigm and its alternative. But this was not to be repeated: at best there would be an emergence of sectorial codes, such as that of the *vedutisti*, which was linked to Italy's privileged position in the Grand Tour. Evidence of the persistence of this situation can be found in the history of the neoclassical paradigm. If the roots of this were Italian, the same cannot be said of all its leading figures. On the contrary, we find the paradoxical situation of non-Italian artists working in Rome in isolation from local artistic life, but seeking the key for a new future in the monuments of the past. It was here that the Anglo-Swiss artist Füssli developed the premise for his visionary style, that the English artists Barry and Runciman worked and studied, along with Swedes such as Sergel, Danes like Abildgaard and later Thorvaldsen, Americans such as Benjamin West, Swiss artists like Abraham-Louis Ducors and French artists such as Jacques-Louis David. It was in Rome that the manifesto of modern painting was painted and first exhibited (1784), David's *Oath of the Horatii*: but in spite of the interest it aroused, the work found few echoes. Rome was no longer the driving force that it had been in the past, nor could it be described as a relay centre: it was more like a kind of ghost centre which gathered the desires, aspirations and projects of so many foreign artists. Barely a month before the taking of the Bastille, David struggled to acclimatize to a Paris which seemed peripheral, and writing to his pupil Wicar, encouraging him to stay in Rome, he wrote: 'I am like a dog thrown into the water in this poor country, struggling not to drown but to reach the shore.'[173]

While for foreign artists Italy had a past where they hoped to find a future, the relationship of Italian artists with antiquity at this time was far from turbulent and dramatic. Piranesi's studies of the Roman ruins and his *Carceri* had created prototypes of sublime, visionary interpretation of the colossal grandeur of antiquity, but after his death no Italian artists were able to follow that path. In some senses, the neoclassical paradigm won Italy over only on the rebound, via political and military hegemony even before the artistic hegemony of Napoleonic France. In the Restoration period, the various regional centres persisted, strengthened by the presence of the academies, which had given institutional structure to the different schools, but their powers now varied considerably. Parma, Modena, Lucca and Mantua were by now completely in the hands of the larger centres, Venice

was in the midst of a deep crisis that would endure for many decades, while Milan strengthened its cultural role alongside its political role as capital of the Lombard Veneto. It was in Milan that the Venetian artist Francesco Hayez established himself, the imperturbable Nestor, who dominated the artistic field in Lombardy until after 1880, earning commissions from Lombard patriots and certificates of good conduct from the Austrian emperor and decorations of the kingdom of Italy. Turin maintained its privileged relationship with France, but it was in an atmosphere of bigotry and humiliation that David's pupil Gioacchino Serangeli, commissioned to make an engraving of that great revolutionary icon, the assassinated Marat, finally painted a *Virgin appearing to St Bernard* for the abbey of Hautecombe, rebuilt by Carlo Felice as a monument to the Savoy dynasty. With the presence of important colonies of foreign artists, Rome, Florence and Naples were able to maintain intense relationships with the cultures of northern Europe, but (analogous to the history of literary language at this time, as the case of Carducci demonstrates) where the persistence of antique structures was particularly marked there was a series of difficulties in bending artistic language to new concepts and new content. Italian centres appeared to have exhausted all their canons and were unable to renew them.

In this situation of backwardness, of ubiquitous mortgaging of the past, political unification brought with it the problem of the unification of the language of Italian art. This process is signalled above all at a thematic level, with the increase and spread of a common, patriotic iconography that celebrated Italy's recent history from the exploits of Garibaldi's men in the wars of independence to colonial ventures which saw the involvement of artists of different cultural and geographical origin: Lombardy, the Veneto, Tuscany and southern Italy. Another unifying theme, this time critical rather than celebratory, was that of social inquiry: here too artists of diverse origins dedicated themselves to the task of illustrating the obscure or hidden realities of the country, attempting to achieve a kind of anthropological survey which would show the peculiar aspects of individual cultures and regions, even the most obscure. But in each trend the common thematic commitment is accompanied by the search for unification of language as well, only partially satisfied by the widespread need for realism. Local peculiarities were reinforced: on the one hand the traditional centres, like Venice re-emerging from its long crisis, Milan, Turin, Florence, Rome, Naples; on the other, the forgotten regions, like Michetti's Abruzzo, which were appearing on the scene for the first time.

Ties with Europe became more clearly defined: these developed, almost exclusively, into relationships with the artists, critics and dealers who gravitated around the official Salons and not with the most committed or forward-looking groups. Such a choice was particularly serious in a period of class conflict, ideological tension and rival paradigms which characterized the nineteenth century. When the emergence of the avant-garde brought on the crisis in Salon art, many Italian artists and even many artistic centres in Italy found themselves in a position of complete isolation. A typical example of this was the Neapolitan school, which, although it received encouragement and supporting work from Goupil, Fortuny and Meissonier, was fated to vanish from the European artistic scene. The various stages of this history are well known: from the limpid landscapes of the school of Posilippo to Palizzi's turning towards France, from the ambiguous symbolic realism of Domenico Morelli to the brief interlude of the 'school of Resina', and the final loaded strokes and sequins of Mancini, an artist who enjoyed huge success in Europe, 'sharp-eyed but unteachable'. It is not difficult to notice the causes of the accidents along this road and of the final consequences of this progressive deterioration: modernization based on poorly selected and misunderstood French experiences, a perennial tendency towards compromise between reality and idealization, truth and symbol, compliance to the expectations both of a European public with large available funds and easily satisfied tastes, and of the international dealers in search of technical virtuosity and ways of displaying their trade, all of which took place within the framework of the city's increasing economic decline.

The question marks which hang over this story are summed up in the biography of Vincenzo Gemito, potentially one of the greatest sculptors of his time. On the one hand this artist created an astonishingly accurate and immediate gallery of fishermen, urchins and pickpockets, by carrying out the effects of the Hellenistic masterpieces in bronze with marvellous technique. On the other hand, he painted Fortuny's portrait, admired Meissonier unquestioningly and was a great success in the Salons. The long psychological crisis which cut him off from the world for more than twenty years can be interpreted as an outlet for the discrepancy between expectation and fulfilment, exceptional technical talent and a lack of appropriate stylistic direction. Gemito tried to use the Greek tradition as a corrective to the trap of sketchiness, but his desperate attempts to rival the Hellenistic bronzes of the Museo di Napoli bear the unmistakable stamp of provincial self-exclusion. To an unusual degree, Gemito

exemplified the way in which the artistic culture of Naples distanced itself from modern Europe.

In short, Rome and Milan became two hegemonic centres. Rome was the seat of the principal cultural institutions of the kingdom, and Milan gave birth to the first Italian art market which ran alongside and even promoted the Divisionist movement. Towards the end of the nineteenth century came Segantini and Pelizza da Volpedo, whose initiatives, quality and fundamental philosophies were certainly not provincial. Equally, the events which took place between Rome and Milan in these years are of significance for Europe: the socialist and libertarian aspirations, and great hopes such as those which press forward in the slow, impressive advance of the *Quarto Stato*, that 'great painting' which closes nineteenth-century Italian painting. This perhaps is less true of the events that followed in Milan in the wake of Marinetti's work, the Futurist movement that set out to take Italian art back into the most modern European experiences, or rather to place it at the head of these developments. In a sense, Futurism, as the progeny of Fascism and a belated industrialization,[174] can be considered an exemplary case of the 'peripheral side-step', which could explain its success in Europe, particularly where certain ideas and attitudes were no longer permissible. Indeed, its optimistic and provocative idolatry of modernity was possible only in a country where the industrial revolution had only just begun;[175] the dynamic, discordant synthesis of recent, even contradictory, European movements (from *pointillisme* to expressionism and cubism) was unthinkable where such movements had had an organic development. We should add that while the Futurists put forward group policies and activities, they encouraged the heroic, demiurgic aspect of artistic activity and neglected the modern issue of 'applied arts' which had already been correctly perceived by some artists in Italy.

The geography of artistic centres in Italy was further changed by the ebbing of the first Futurist wave and the movement's removal of its centre to Rome, as well as the brief season of metaphysical painting. The Futurist attempt to create an axis between Rome and Milan failed. The following decades, until the end of Fascism, saw a revival of local tendencies, linked to a greater or lesser degree to European experiences: from the Turin Six to the Milan Gruppo di Corrente, from the Roman school of Via Cavour to the isolated experiences of Rosai in Florence and Morandi in Bologna. Once again Italian polycentrism showed itself to be far stronger than all attempts at centralization.

Polycentrism or polyperiphery? We could apply this dilemma to a famous passage by Lewis Carroll:

> 'When you say "hill"', the Queen interrupted, '*I* could show you hills, in comparison with which you'd call that a valley.'
> 'No, I shouldn't', said Alice . . . 'a hill *can't* be a valley, you know. That would be nonsense.'[176]

Indeed, the problem of Italian culture in this period (not only figurative culture) continues to be its relationship with Europe. Europe has one capital, Paris: but it is largely a spiritual capital, isolated by a history that is no less sectarian than that of Vasari.

But for Italy, coming to terms with Europe means coming to terms with its own past. With the weight of such a prestigious tradition to shoulder, it is impossible not to feel peripheral. Thus finding the road out of the periphery presupposes coming to terms with tradition, with the museum. And here we come up against the two most radical ideas, proposed by the Futurists and by de Chirico: burn the museum down, or let it recede in a sublime, ironical light.

NOTES

1 Cf. Y. Lacoste, *Géographie du sous-développement*, and especially the 'Avertissement critique et autocritique de la troisième édition' (Paris, 1976).

2 The recent flourishing of studies on the territory will give wider scope for more accurate examination of the relationship between centre and periphery in the future. This growth is visible in the campaign for the re-evaluation of artistic and cultural heritage in the Emilian Apennines promoted by the Soprintendenza di Bologna, by the re-evaluation of the Pistoian Apennines by the Soprintendenza of Florence, by the studies of seventeenth- and eighteenth-century art in Umbria undertaken by a team from the Magistero of Rome University, and by numerous exhibitions such as *Arte in Calabria* (Cosenza, 1976), *Arte a Gaeta* (Gaeta, 1976), *Opere d'arte a Vercelli e nella sua provincia* (Vercelli, 1976), *Valle di Susa. Arte e storia dall'XI al XVIII secolo* (Turin, 1977). However, for a long time there was no reflection or debate on the methods, limitations or opportunities of the country's artistic geography, unlike in Germany where these issues have been discussed for over fifty years. On this debate see K. Gerstenberg, *Ideen zu einer Kunstgeographie Europas* (Leipzig, 1992); D. Frey, 'Die Entwicklung nationaler Stile in der mittelalterlichen Kunst des Abendlands', *Deutsche Vierteljahrsschrift für Literaturwissenschaft*

und Geistesgeschichte, 16 (1938), pp. 1–74; P. Frankl, 'Das system der Kunstlandschaften dargestellt am Beispiel der Po Ebenen', *Erdkunde*, 15 (1961), pp. 249–64; R. Hausherr, 'Ueberlegungen zum Stand der Kunstgeographie', *Rheinische Vierteljahrsblätter*, 30 (1965), pp. 351–72; D. Frey, 'Geschichte und Probleme der Kultur und Kunstgeographie', *Archaeologia Geographica*, 4 (1965), pp. 90–105; contributions by R. Hausherr, G. von der Osten, P. Pieper and others in 'Der Mittelrhein als Kunstlandschaft', *Kunst in Hessen und am Mittelrhein* (1969), Beiheft 9, pp. 38ff; R. Hausherr, 'Kunstgeographie – Aufgaben, Grenzen, Möglichkeiten', *Rheinische Vierteljahrsblätter*, 34 (1970), pp. 158–71, and the exhibition catalogue *Kunst um 1400 am Mittelrhein* (Frankfurt, 1975), where the problems of artistic geography are considered in relation to social and political circumstances, rather than being watered down by a mythical, unifying *Kunstlandschaft*.

3 K. Clark, *Provincialism*, The English Association Presidential Address (London, 1962), p. 3 (quotation retranslated from the Italian).

4 The centre/periphery coupling has known varying fortunes, analysed by those who prefer to see it as a kind of topography of consensus, such as E. Shils, *Center and Periphery. Essays in Macrosociology* (Chicago, 1975), and by those who emphasize its conflictual nature; see a study by N. Mackenzie, 'Centre and Periphery: The Marriage of Two Minds, *Acta Sociologica*, vol. 20, 1 (1977), pp. 55ff. D. Chirot, in a study of a peripheral society, Wallachia, *Social Change in a Peripherical Society. The Creation of a New Balkan Economy* (New York, 1976), has called into question the application of the model based on the series of economic phases normally accepted for peripheral societies. In this sense the problem might also be raised in art history.

5 L. Lanzi, *Storia pittorica della Italia dal risorgimento delle belle arti fin presso al fine del XVIII secolo*, ed. M. Capucci, 3 vols (Florence, 1968–74), I, pp. 5–7. Unless otherwise indicated, the quotations from Lanzi will be taken from this edition, and referred to as 'Lanzi', followed by the volume and page number.

6 *Idem, La storia pittorica della Italia inferiore o sia delle scuole fiorentina senese romana napoletana compendiata e ridotta a metodo* (Florence, 1792), pp. 9 and 37.

7 The edition by M. Capucci is based on this edition, which first appeared in Bassano.

8 Cf. G. P. Bellori, *Le vite de' pittori, scultori e architetti moderni*, ed. E. Borea (Turin, 1976), p. 330.

9 Cf. G. Mancini, *Considerazioni sulla pittura*, ed. A. Marucchi (Rome, 1956), I, pp. 108ff.

10 Cf. G. G. Bottari and S. Ticozzi, *Raccolta di lettere sulla scultura, pittura ed architettura* VI. (Milan, 1822), p. 625; B. Cellini, *Vita*, ed. G. Davico Bonino (Turin, 1973), pp. 469–70.

11 Lanzi, I, 20.

12 Cf. V. Segrè, *Luigi Lanzi e le sue opere* (Assisi, 1904), p. 179; Lanzi, III, 469.
13 Lanzi, I, 455.
14 Ibid., 259.
15 Ibid., 260.
16 Ibid.
17 Ibid., 261.
18 Ibid., III, 235.
19 Ibid., II, 185–6.
20 Ibid., I, 43.
21 Ibid., II, 185.
22 Ibid., 94.
23 Ibid., 105–6.
24 Ibid., I, 403. See also his observations on Piacenza, where he comments that the absence of local schools is an advantage for a city of secondary importance (II, 254).
25 Ibid., 4.
26 Ibid., 431–2.
27 Ibid., 7.
28 This edition is missing from the thoughtful bibliography edited by M. Massi that appears as an appendix to A. Ferguson, *Saggio della società civile*, ed. P. Slavucci (Florence, 1973), which lists (p. 337) French, German and Swedish translations of the *Essay*, but not Italian. References to Ferguson in the rest of this chapter are to the Italian edition.
29 Lanzi, I, 283–4.
30 Cf. Ferguson, *Saggio*, II, pp. 222ff.
31 Cf. Lanzi, *La storia pittorica della Italia inferiore*, p. 179.
32 Lanzi, I, 245.
33 J. Winckelmann, *Storia delle arti del disegno presso gli antichi* (Rome, 1783), II, p. 164n.
34 Ferguson, *Saggio*, II, pp. 74–5 (retranslated from the Italian).
35 Lanzi, I, 15. On the concept of a 'civil society', see M. Riedel, *Gesellschaft, bürgerliche* in *Geschichtliche Grundbegriffe*, ed. O. Brunner, W. Conze and R. Koselleck, II (Stuttgart, 1975), pp. 719–800.
36 Lanzi, II, 224.
37 Lanzi, I, 140 and n. 2. See also S. Settis, *Qui multas facies pingit cito* (Juvenal IX.146), *Athens and Rome*, 15 (1970), pp. 117–21.
38 Lanzi, II, 47–8.
39 Ibid., 70, 89–90, 107, 121–2, 168 and 200.
40 Cf. D. Dionisotti, 'Culture regionali e letteratura nazionale in Italia', *Lettere Italiane*, 22 (1970), p. 142.
41 Cf. G. Previtali, 'Teodoro d'Erico e la "questione meridionale"', *Prospettiva*, 3 (October 1976), pp. 17–34; G. Previtali, review of L. G. Kalby, *Classicismo e maniera nell'officina meridionale*, ibid., 4

(January 1976), pp. 51–4; G. Previtali, 'Il Vasari e l'Italia meridionale', in *Vasari storiografo e artista. Atti del Congresso nel IV centenario della morte (Arezzo–Firenze, 2–8 settembre 1974)* (Florence, 1976), pp. 691–9; G. Previtali, *La pittura del Cinquecento a Napoli e nel vicereame* (Turin, 1978).

42 Cf. E. Sereni, 'Agricoltura e mondo rurale', in *Storia d'Italia Einaudi,* I: *I caratteri originali* (Turin, 1972), pp. 176–7.

43 On the following section, cf. E. Gabba, 'Urbanizzazione e rinnovamento urbanistico nell'Italia centro-meridionale del I secolo a C.', *Studi Classici Orientali*, 21 (1972), pp. 73–112; 'Considerazioni politiche ed economiche sullo sviluppo in Italia nei secoli II e I a C.', in *Hellenismus im Mittelitalien*, ed. P. Zanker, *Abh.d.Ak.d.Wiss. in Göttingen* (1976), pp. 317–26; C. Violante, 'Primo contributo a una storia delle istituzioni ecclesiastiche nell'Italia centrosettentrionale durante il Medioevo: province, diocesi, sedi vescovili', in *Miscellanea Historiae Ecclesiasticae*, V (Colloque de Varsovie, sur la cartographie etc.) (Louvain, 1974), pp. 169–204.

44 Cf. G. Tibiletti, 'La romanizzazione della valle padana', in *Arte e civiltà romana nell'Italia settentrionale dalla Republica alla Tetrarchia* (Bologna, 1964), I, pp. 27–36.

45 Cf. L. Salvatorelli, *Spiriti e figure del Risorgimento* (Florence, 1961), pp. 3–35; see also *idem*, 'L'unità della storia d'Italia', *Pan*, 1 (1933–4), pp. 357–72.

46 The expression is due to E. Sestan (see below, n. 48).

47 See publication of the *Rationes decimarum*.

48 Cf. E. Sestan, 'La città comunale italiana dei secoli XI–XIII nelle sue note caratteristiche rispetto al movimento comunale europeo', in *XI Congrès International des Sciences Historiques, Rapports*, III (Stockholm, 1960), pp. 75–95, especially p. 85.

49 See for example the events in Lausanne at the end of the twelfth century, when Henri 'Albus', acting as overseer of the workshop in the name of the chapter, discharged all the masters who had been employed by the bishop, Ruggero di Vicopisano; cf. M. Grandjean, *La Cathédrale de Lausanne* (Lausanne, 1977), pp. 46ff.

50 But more frequently by craftsmen who had close contact with their own clients. Cf. S. Ottonelli, 'L'artigianato ligneo nelle Valli Occitane piemontesi', *Quaderni Storici*, 31 (1976), pp. 280ff.

51 *Opere d'arte a Vercelli*, p. 5.

52 *Le Opere di G. Vasari con nuove annotazioni e commenti di G. Milanesi* (Florence, 1906), III, 586ff. Further quotations from the *Vite* will be taken from this edition, indicated by 'Vasari' followed by volume and page number.

53 See D. Scano, *Storia dell'arte in Sardegna dall'XI al XIV secolo* (Cagliari and Sassari, 1907), pp. 292ff.

54 C. Brandi, *La Regia Pinacoteca di Siena* (Rome, 1933), pp. 135ff. For the altarpiece of the Carmine, see *idem*, 'Ricomposizione e restauro

della Pala del Carmine di Pietro Lorenzetti', *Bollettino d'Arte*, 33 (1948), pp. 68ff. An interesting example of how works quickly became obsolete and therefore relegated to the periphery is that of the *armille* (bracelets) from the coronation of Frederick Barbarossa, now in the Louvre and Nuremberg, which the emperor sent to the Crown Prince Andrei Bogoliubskii in Vladimir: cf. A. Buehler, 'Zur Geschichte der deutschen Reichskleinodien', *Das Münster*, 27 (1974), pp. 408–9.

55 Vasari, V, 221.
56 Ibid., VI, 18.
57 Ibid., 123.
58 Ibid., 550.
59 Ibid., 571.
60 Ibid., IV, 374.
61 Ibid., VI, 461.
62 Ibid., 457.
63 Ibid., 472ff.
64 Ibid., V, 151.
65 Ibid., VI, 463.
66 Ibid., V, 211.
67 Ibid., VI, 5ff.
68 Ibid., VII, 50.
69 Ibid., VI, 380.
70 Ibid., V, 634.
71 Ibid., VII, 420.
72 Ibid., VI, 517.
73 Ibid., V, 214–15, but see F. Zeri, *La sortita anticlassica di Cola dell'Amatrice*, in *Diari di Lavoro* (Bergamo, 1971), pp. 74ff.
74 Vasari, V, 198.
75 Ibid., 203.
76 Ibid., VI, 123.
77 Ibid., II, 413.
78 Ibid., V, 177.
79 Ibid., 212.
80 Ibid., 150.
81 Ibid., 151.
82 Ibid., II, 453ff.
83 Ibid., III, 189.
84 Ibid., VII, 282.
85 Ibid., IV, 111–13.
86 Cf. B. Toscano, 'La fortuna della pittura umbra e il silenzio sui Primitivi', *Paragone*, vol. 17, 193 (March 1966), pp. 3ff. Though I do not intend to give an exhaustive bibliography of recent studies of Trecento Umbrian painting (which would be extremely long), it is useful to note that R. Longhi's insights into the issue of Umbrian figurative culture during his course in Florence, 1953–4 (cf. 'La pittura

umbra della prima metà del Trecento attraverso le dispense redatte da Mina Gregori del corso di Roberto Longhi nell'anno 1953–54', *Paragone*, vol. 24, 281–3, July–September 1973, pp. 3ff.) have been followed by an increasing number of studies, particularly from M. Boskovits, P. P. Donati, G. Previtali, P. Scarpellini, B. Toscano, C. Volpe and F. Zeri. The situation can now be assessed in all its broad complexity.

87 G. B. Cavalcaselle and J. A. Crowe, *Storia della pittura in Italia*, X (Florence, 1908), pp. 8ff., n. 3 and p. 117, n. 1.

88 B. Toscano, 'Bartolomeo di Tommaso e Nicola da Siena', *Commentari*, 15 (1964), pp. 37–51; see also G. Chelazzi Dini, 'Lorenzo Vecchietta, Priamo della Quercia, Nicola da Siena', in *Jacopo della Quercia tra Gotico e Rinascimento* (Florence, 1976), pp. 203ff. On the development of a system of stylistic formulae by some provincial masters, their crystallization and subsequent rejection of updating, see the comments by F. Zeri on an unknown Umbrian painter of the Quattrocento, the 'Maestro di Eggi', in 'Tre argomenti Umbri', *Bollettino d'Arte*, 48 (1963), pp. 40–5.

89 A. Morini, 'Cascia. Chiesa delle Capanni in Collegiacone', *Rassegna d'Arte*, 9 (1909), pp. 173–4; G. Sordini, 'Gli Sparapane da Norcia. Nuovi dipinti e nuovi documenti', *Bollettino d'Arte*, 4 (1910), pp. 17–28; A. Morini and P. Pirri, 'Una sconosciuta dinastia di artisti umbri', *Arte e Storia* (1911 and 1912); P. Pirri, 'Di una tradizione pittorica in Norcia', ibid. (1914), pp. 321–9; C. Verani, 'Gli affreschi quattrocinquecenteschi nella chiesa di Santa Maria a Capanne di Colle Giacone presso Cascia', *L'Arte*, 62 (1963), pp. 41–58 and 289–92.

90 A. Moretto, *Indagine aperta sugli affreschi del Canavese* (Saluzzo, 1973), pp. 9ff.

91 A. Lange, 'Notizie sulla vita di Giacomo da Ivrea', *Bollettino della Società Piemontese di Archeologia e di Belle Arti*, 22 (1968), pp. 98–102.

92 Cf. A. Raineri, *Antichi affreschi nel Monregalese* (Cuneo, 1965); G. Romano, 'Documenti figurativi per la storia delle campagne nei secoli XI–XVI', *Quaderni Storici*, 31 (1976), pp. 134ff. On the many late Gothic cycles of a popular character, often commissioned by rural or mountain communities, confraternities, low- or middle-ranking clergy, situated in the western Alps, and painted mainly by itinerant masters who for a long time used the same schema, see M. Roques, *Les Peintures murales du Sud Est de la France* (Paris, 1961); E. Brezzi, 'Precisazioni sull'opera di Giovanni Canavesio. Revisioni critiche', *Bollettino della Società Piemontese di Archeologia e di Belle Arti*, 18 (1964), pp. 35ff.; A. Griseri, *Jaquerio e il realismo gotico in piemonte* (Turin, 1965), *passim*; C. Gardet, *De la peinture du Moyen Age en Savoie*, II (Annecy, 1966); Z. Birolli, 'Il formarsi di un dialetto pittorico nella regione ligure-piemontese', *Bollettino della Società Piemontese di Archeologia e di Belle Arti*, 20 (1966), pp. 115ff.; E. Rossetti Brezzi,

'Momenti della pittura piemontese', ibid., 25–6 (1972), pp. 35ff.; G. Romano and A. F. Parisi, catalogue of the *Mostra del gotico nel Piemontese centro-occidentale* (Turin and Pinerolo, 1972); G. Romano, entry for Giovanni Canavesio, in *Dizionario biografico degli Italiani*, XVII (Rome, 1974), pp. 728ff; *Valle di Susa*.

93 Cavalcaselle and Crowe, *Storia della pittura in Italia*, X, pp. 112ff.; L. Mortari, *Opere d'arte in Sabina dall'XI al XVII secolo* (Rome, 1957).

94 A. Rizzi, 'Un pittore rinascimentale in Lucania, Simone da Firenze', *Napoli Nobilissima*, 9 (1970), pp. 11ff; *idem*, 'Altre opere lucane di Simone da Firenze', *Antichità Viva*, vol. 15, 1 (1976), pp. 11ff.

95 I. Faldi, *Pittori viterbesi in cinque secoli* (Rome, 1970), p. 19.

96 V. Casale, G. Falcidia, F. Pansecchi and B. Toscano, *Ricerche in Umbria*, I (Treviso, 1976).

97 Ibid., p. 44.

98 J. Burckhardt, *Der Cicerone* (Basle, 1855), p. 780, quoted in the 'Commento antologica alla fortuna critica del Trecento bolognese', *Paragone*, vol. 1, 5 (1950), p. 25.

99 B. Berenson, *The Central Italian Painters of the Renaissance* (New York and London, 1909), p. v; cf. Toscano, 'La fortuna della pittura umbra', p. 26, n. 7.

100 R. Longhi, 'Tracciato Orvietano', *Paragone*, vol. 13, 149 (1962), p. 4.

101 Vasari, III, 386.

102 Ibid., 89ff.

103 Ibid., V, 103ff.

104 Cf. P. Junod, *Transparence et Opacité* (Lausanne, 1976), especially pp. 50–7 and 306–7.

105 Vasari, VI, 270. On the Pontormo–Dürer question set out by Vasari, cf. W. Friedländer, 'The Anticlassical Style', in *Mannerism and Anti-Mannerism in Italian Painting*, 2nd edn (New York, 1957), pp. 3 and 25; K. Hermann-Fiore, 'Sui rapporti fra l'opera artistica del Vasari e del Dürer', in *Il Vasari storiografo e artista*, pp. 701–15.

106 R. Longhi, 'Officina ferrarese', in *Opere complete di Roberto Longhi*, V (Florence, 1956), p. 151.

107 Vasari, VI, 267.

108 J. Bony, 'The Resistance to Chartres in Early Thirteenth Century Architecture', *Journal of the British Archaeological Association*, vol. 5, 20–1, 1957–8, pp. 35–52.

109 Cf. T. S. Kuhn, *The Structure of Scientific Revolution* (Chicago, 1962).

110 Vasari, V, 151ff.

111 Cf. P. P. Donati, 'Per la pittura pistoiese del Trecento', I, *Paragone*, vol. 25, 295 (1974), p. 5.

112 L. Bellosi, *Buffalmacco e il Trionfo della Morte* (Turin, 1974), p. 73. For enlightenment on the circle of Giotto secessionists, cf. C. Volpe, 'Frammenti di Lippo di Benivieni', *Paragone*, vol. 33, 267 (1972), pp.

3–13, and 'Ristudiando il Maestro di Figline', ibid., vol. 24, 227 (1973), pp. 3–25.

113 L. Grodecki, *Architettura gotica* (Milan, 1976), pp. 151ff.

114 Bellosi, *Buffalmacco*.

115 Donati, *Per la pittura pistoiese del Trecento*, I; II, *Paragone*, vol. 27, 321 (1976), pp. 3–15.

116 Dionisotti, 'Culture regionali', p. 137.

117 Cf. L. Bellosi, 'Moda e cronologia. (B) Per la pittura del primo Trecento', *Prospettiva*, 11 (October 1977), pp. 14ff.

118 Cf. H. Kreuter-Eggemann, *Das Skizzenbuch des 'Jacques Daliwe'* (Munich, 1964), especially pp. 27, 44 and 65.

119 E. Müntz, who was responsible for rediscovering the name of Matteo di Giovanetti in the Vatican archives, wrote of the decoration in the chapel of San Marziale in the Palazzo dei Papi: 'From the point of view of harmony, rhythm and the canons of decorative art, it is impossible to imagine a more startling and graceless composition.' On the deep reservations shown towards Giovanetti's works in Avignon, cf. E. Castelnuovo, *Un pittore italiano alla corte di Avignone* (Turin, 1961), pp. 54ff and 139ff.

120 On the international teams who worked in Avignon, cf. Castelnuovo, *Un pittore italiano*, pp. 54ff, 139ff and *passim*; E. Kane, 'A document for the fresco technique of Matteo Giovanetti in Avignon', *Studies. An Irish Quarterly Review* (Winter 1975).

121 Cf. R. Longhi's observations on the frescoes of Andrea Delitio, 'Primizie di Lorenzo da Viterbo', *Vita Artistica* (1926) where he criticizes 'that old misunderstanding whereby an "internationalist" can be placed on the same level as a "Renaissance" artist; or even considered, with an evolutionistic bias and resulting further confusion, as tending towards or even positively willing to embrace Renaissance form. In fact, the "world perspective" of the "internationalists" was self-sufficient, a figurative and therefore spiritual vision that was complete in itself, incapable (or more accurately alien to the aspirations) of synthesis and profound naturalistic analogy that characterized the so-called Renaissance. Andrea Delitio could have lived another fifty years without his artistic world ever seeming fallible, in short, without ever knowing the desire to be transformed into Lorenzo da Viterbo'; now in *Opere complete di Roberto Longhi*, II: *Saggi e ricerche* (Florence, 1967), I, p. 61.

122 Works by Defendente or his workshop were also commissioned outside Italy: there are some in the cathedral at Embrun, in the abbey of Hautecombe and in the cathedral of Saint-Claude in the Jura; for these, see A. Chastel, and A. M. Lecoq, 'Le Retable de Pierre de la Baume à Saint-Claude', *Monuments et Mémoires*, Fondation Eugène Piot, 61 (1977), pp. 165–204.

123 M. Perotti, 'Il Giudizio michelangiolesco di Madonna dei Boschi', *Cuneo provincia granda*, 2 (August 1964).

124 Cf. A. Boschetto, *La collezione Roberto Longhi* (Florence, 1971), pl. 31.

125 As can be seen particularly in some of the predellas in the Church of San Giovanni in Avigliana. Cf. L. Mallé, 'Fucina piemontese: Sodoma giovane, Gaudenzio, Defendente Ferrari, Gerolamo Giovenone', *Bollettino della Società Piemontese di Archeologia e di Belle Arti*, 8–9 (1954–7), pp. 63–4.

126 F. Cortesi Bosco, in *I pittori bergamaschi*, I: *Il Cinquecento* (Bergamo, 1975), pp. 49 and 56; *idem*, 'La letteratura religiosa devozionale e l'iconografia di alcuni dipinti di L. Lotto', *Bergomum*, vol. 70, 1–2 (1976), pp. 3ff.

127 L. Dolce, 'Dialogo della Pittura', in *Trattati d'arte del Cinquecento*, ed. P. Barocchi I (Bari, 1960), p. 181.

128 L. Lanzi, II, 53–4.

129 B. Berenson was to write about this painting (*Lorenzo Lotto*, London, 1901, p. 235), evoking Manet and Degas, and certifying the work as 'perhaps the most "modern" picture ever painted by an old Italian master'.

130 Ibid., pp. 243ff; G. Fabriani, 'Un mancato allievo di L. Lotto, Simone di Magistris', *Arte Cristiana*, 43 (1955), pp. 159ff; P. Zampetti, 'I pittori di Caldirola', presentation to the CNR Congresso di Storia dell'Arte, Rome, 1978.

131 Cf. the introductory essay by A. Emiliani in the catalogue of the *Mostra di Federico Barocci* (Bologna, 1975), particularly pp. xxixff.

132 Bellori, *Vite*, p. 32.

133 R. Longhi, *Viatico per cinque secoli di pittura veneziana* (Florence, 1946), p. 18.

134 B. Toscano provides an intelligent picture of the provincial artist in the sixteenth and seventeenth centuries, in his essay 'Andrea Polinori o la provincia perplessa', *Arte Antica e Moderna*, 13–16 (1961), pp. 300ff. On the issue of cultural selection, which a provincial painter had to confront when he came into contact with an important artistic centre, see F. Zeri's analysis of the altarpiece, *Holy Family, Saints and Angels*, Conservatorio di Santa Maria degli Angliolini, Florence, in 'Eccentrici fiorentini', II, *Bollettino d'Arte*, vol. 47, 4 (1962), p. 318. For further comments on analogous problems of acculturation at the beginning of the Cinquecento, see *idem*, 'Una congiunzione tra Firenze e Francia. Il Maestro dei cassoni Campana', in *Diari di lavoro* (Turin, 1976), pp. 75ff.

135 G. G. Bottari and S. Ticozzi, *Raccolta di lettere sulla pittura, scultura ed architettura*, VII (Milan, 1822), p. 66.

136 Ibid., pp. 94ff.

137 Ibid., p. 77.

138 A. Momigliano, 'Ancient History and the Antiquarian', *Journal of the Warburg and Courtauld Institutes*, 13 (1950), pp. 285ff.

139 In Britain at the end of the eighteenth century there was a period of rapid economic and cultural growth in the provinces. Cf. F. D. Klingender, *Arte e rivoluzione industriale* (Turin, 1972); T. Fawcett, *The Rise of the English Provincial Art* (Oxford, 1974).

140 M. Schapiro, 'The Religious Meaning of the Ruthwell Cross', *Art Bulletin*, 26 (1944), pp. 232–45; *idem*, 'From Mozarabic to Romanesque in Silos', ibid., 21, pp. 312–74, reprinted in M. Schapiro, *Selected Papers. Romanesque Art* (New York, 1977), pp. 28ff.

141 A. Frizzi, *Memorie per la storia di Ferrara*, V (Ferrara, 1809), p. 64; cf. also E. Riccomini, *Il Seicento ferrarese* (Milan, 1962), p. 10.

142 C. Gould, *Trophy of Conquest. The Musée Napoléon and the Creation of the Louvre* (London, 1965).

143 D. Roxan and K. Wanstall, *The Jackdaw of Linz. The Story of Hitler's Art Thefts* (London, 1964).

144 E. Müntz, 'Les Annexions de collections d'art ou de bibliothèques et leur rôle dans les relations internationales', *Revue d'Histoire Diplomatique*, 8 (1894), pp. 481–97; 9 (1895), pp. 375–93; 10 (1896), pp. 481–508; W. Treue, *Kunstraub. Ueber die Schicksale von Kunstwerken in Krieg, Revolution und Frieden* (Düsseldorf, 1957); H. Trevor-Roper, *The Plunder of the Arts in the Seventeenth Century* (London, 1970).

145 Lanzi, III, 169.

146 Frizzi, *Memorie per la storia di Ferrara*, V, p. 64.

147 G. Baruffaldi, *Vite de' pittori e scultori ferraresi*, II (Ferrara, 1846), p. 27.

148 A. Emiliani, *Gian Francesco Guerrieri da Fossombrone* (Urbino, 1958), p. 42.

149 E. Carli, *Dipinti senesi del Contado e della Maremma* (Milan, 1955), pp. 84ff.

150 W. M. Bowsky, *The Finance of the Commune of Siena 1287–1355* (Oxford, 1970), pp. 25ff.

151 G. V. Castelnuovi, 'Giovanni Barbagelata', *Bollettino d'Arte*, 36 (1951), pp. 211–24; F. Alizeri, *Notizie dei professori del disegno in Liguria dalle origini al secolo XVI*, II (Genoa, 1870), pp. 189ff.

152 C. Maltese, *Arte in Sardegna dal V al XVIII secolo* (Rome, 1962).

153 Cf. F. Zeri, 'Perchè Giovanni da Gaeta e non Giovanni Sagitano', *Paragone*, vol. 9, 129 (1960), p. 53.

154 Dionisotti, 'Culture regionali', p. 139.

155 G. Moracchini, *Trésors oubliés des églises de Corse* (Paris, 1959), pp. 22 and 114ff.

156 R. Longhi, 'Frammento siciliano', *Paragone*, vol. 4, 47 (1953), pp. 3ff; F. Bologna, *Il soffitto della Sala Magna allo Steri di Palermo e la cultura feudale siciliana nell'autunno del Medioevo* (Palermo, 1975).

157 M. d'Elia, catalogue of the *Mostra d'arte in Puglia del tardo Antico al Rococò* (Bari, 1964).

158 F. Bologna, preface to the exhibition catalogue *Arte in Calabria, ritrovamenti, restauri, recuperi* (Cosenza, 1976), pp. 6ff.

159 F. Abbate, La pittura in Campania prima di Colantonio', in *Storia di Napoli*, IV, 1 (Naples, 1976).

160 F. Alizeri, *Notizie*, p. 210.

161 G. Romano, *Casalesi del Cinquecento. L'avvento del manierismo in una città padana* (Turin, 1970).

162 Cf. Emiliani's comments in *Gian Francesco Guerrieri da Fossombrone*, and in the introduction to the catalogue of the *Mostra di Federico Barocci*.

163 G. Marchini, 'Un incontro imprevedibile: il Fogolino ad Ascoli Piceno', *Antichità Viva*, vol. 5, 1 (1966), pp. 3ff.

164 Casale, Falcidia, Pansecchi and Toscano, *Ricerche in Umbria*, I, p. 34.

165 F. Bologna, *I pittori alla corte angioina di Napoli* (Rome, 1969), pp. 173, 349; *idem*, preface to *Arte in Calabria*.

166 A. Antonaci, *Gli affreschi di Galatina* (Milan, 1966).

167 A. Fabbi, 'Artisti fiorentini sul territorio di Norcia', *Rivista d'Arte*, 34 (1959), pp. 109–22; *idem*, *Preci e la Valle Castoriana* (Spoleto, 1963).

168 R. Cessi, 'Venezia, le Puglie e l'Adriatico', *Archivio Storico delle Puglie*, vol. 8, 1–4 (1966), pp. 53–9; M. S. Calò, *La pittura del Cinquecento e del primo Seicento in terra di Bari* (Bari, 1969).

169 P. Gianizzi, 'Una pala dipinta da Lorenzo Lotto per la cattedrale di Giovinazzo', *Arte e Storia*, 12 (1894), p. 91.

170 Cf. S. Marinelli, in *La pittura a Verona tra Sei e Settecento*, exhibition catalogue (Verona, 1978), p. 35.

171 N. Pevsner et al., *Historismus und bildende Kunst* (Munich, 1967), p. 89.

172 E. Rufini, 'Ricerche sull'attività del Vanvitelli nelle Marche', in *Atti dell'XI Congresso di Storia dell'Architettura. Marche, 6–13 settembre 1959* (Rome, 1965), pp. 466ff.

173 Letter from David to Wicar dated 14 June 1789. Reproduced in D. and G. Wildenstein, *Documents complémentaires au catalogue de l'oeuvre de Louis David* (Paris, 1973), pp. 27ff.

174 B. Moore jr, *Le origini sociali della dittatura e della democrazia. Proprietari e contadini nella formazione del mondo moderno* (Turin, 1966).

175 M. Schapiro, 'Nature of Abstract Art', *Marxist Quarterly* (New York), vol. 1, 1 (January–March 1937).

176 L. Carroll, *Through the Looking-Glass* (London, 1901), p. 34.

THREE

Italian Art and
the Art of Antiquity*

NICOLE DACOS

Fundamental areas of affinity between Italian culture
and the culture of antiquity

THE birth of Italian art – from the time that Giotto changed
'the art of painting from Greek into Latin', in Cennini's words
– did not bear witness to the special relationship that in the
course of its history was to unite it to the art of classical antiquity.
In Giotto's great revolution, the links with classical art were quite
secondary, if not altogether absent, with the exception of a few
decorative motifs which undoubtedly indicate familiarity with classical
art, but whose stylistic importance remains negligible. The artist's
decisive rejection of the culture of the Eastern Empire, and therefore
of Byzantine art, was evidence of his efforts to create a new 'language'
that would be rooted in local tradition and based on completely
different foundations: the religious, irrational vision was replaced by
a naturalistic, rational one, centred on the predominant role of man.
Within this vision, the main problem to be tackled was that of
unifying space: Giotto tried to represent this three-dimensionally, for
the law of perspective had already been discovered.

This was a crucial step for Western art, and Vasari had already
alluded to it in his statement that Giotto 'discovered something of
tapering and shortening his figures'. But it was not made quickly.

* Translated by Ellen Bianchini.

Plate 13 GIOTTO, Perspective niche, 1306, Padua, Cappella degli
Scrovegni.

Giotto laid the foundations and, particularly in some marginal areas
of the Cappella degli Scrovegni, achieved some highly advanced
results. This is especially true in the case of the famous niches that
are drawn in perfect perspective, with a complexity that is high-
lighted by the depiction of the iron springs suspended from the
keystone, which Longhi compared to a *scatola mimetica* in his *Giotto
spazioso*.[1]

In freeing his art of the theocratic, liturgical premises characteris-
tic of Byzantine art, Giotto created a national idiom which can be
compared to the creation of the Italian language. These two phe-
nomena, art and language, emerged almost simultaneously, and
both within a culture that was based on the usage and development
of aboriginal traditions, and which remained essentially distinct from
classical antiquity.

It is still true that during this period, in the first third of the
fourteenth century, many classical works were being used, though
not in painting. It was the sculptors in the first instance, followed by
the architects, who began to study ancient fragments and to include

them in their works, perhaps moved by a sense of affinity to the objects left by their remote ancestors, which were to be found in such great quantities, particularly in Rome but also in other regions of Italy. This close relationship was of a technical, almost materialistic nature and did not necessarily imply a genuine cultural trend. It was more a case of artists finding a spontaneous affinity to the familiar archaeological remains that surrounded them, whose qualities they vaguely recognized.

The specific nature of this relationship is made clear with Nicola Pisano, who brought to Tuscany the classical culture that Frederick II had elaborated for a very different, essentially political purpose. This was an early example of the specific intention to realize the potential of classical art in order to strengthen the analogy between the new state and the Roman Empire.

The pulpit in the baptistery of Pisa, completed around 1260, reveals a new method of using the Roman sarcophagi and an attempt to render the true volume of the human body, for almost every figure reveals the artist's close study of his sources. The stately, strong-limbed figure of the seated Venus is inspired by a Phaedra, while the allegory of Courage is taken from a figure of Hercules. But despite the way the artist has transformed his models, he never quite manages to break free of his own Gothic vision, and the expressive power of physical volume is therefore never completely mastered. Of the next generation of artists, Giovanni Pisano abandoned the path taken by his father and was soon drawn back towards Gothic culture, while Arnolfo di Cambio continued to move in a classical direction. By contrast with Nicola Pisano, it is often difficult to identify the ancient original of his models, though some figures are directly inspired by the recumbent figures on Etruscan tombs, such as the *Vergine della Natività* in the Museo dell'Opera del Duomo in Florence. The artist clearly made a study of sarcophagi and reliefs, assimilated their strength and plasticity, following the way already signposted by his master.

The work of the humanists and their relationship with artists. Iconology and knowledge

It is well known that the concept of a return to antiquity was developed not by artists but by the humanists. In essence it originated with Petrarch, who elaborated a new vision of history after his first visit to Rome in 1337: he conceived classical antiquity as an era

of brilliance, followed by a long decline, which began with the con-
version of Constantine. But Petrarch's vision was not directed towards
the aesthetic contemplation of ancient remains, 'L'antiche mura,
ch'ancor teme ed ama / E trema 'l mondo quando si rimembra / Del
tempo andato.'[2] (The ancient walls, still feared and loved by the
world which trembles at the memory of time past.) For he belonged
to a culture that was not trained to look at monuments or sculptures
on their own merits, but merely to see them as an important point
of departure for a literary knowledge of the past and its archaeologi-
cal, political and moral implications, all invoked with a nostalgic
longing.

It was Boccaccio who focused on the idea of an intentional return
to ancient sources, and this was developed in humanist circles but
did not spread far enough to influence artists. Scholars and artists
belonged to two different social classes which had little contact and
whose origins had little in common. It was only at the beginning
of the fifteenth century that a real passion for classical art began to
spread, when scholars passed on their love of antiquity to artists,
and artists could at last perceive classical art in the light of their
personal taste, studying figures, floral decoration and architecture
for their own sake, not just as historic documents.

The contrast between these two approaches to the classical past
cannot be underestimated, yet they have often been confused. Both
have persisted up to the present day, where they have been trans-
lated into two schools of fundamental methodology in art-historical
criticism, still distinguishable today in spite of all the interdisciplinary
studies that have justly been established between them: the icono-
grapher and connoisseur. The former is still firmly rooted in a lit-
erary vision of the world and literary culture, where classical works
are seen as documentary evidence and expressions of a culture. The
latter follows a specific field of art, examines and evaluates a work
in terms of its lines, form and colour, i.e. in terms of the hand of
the artist who conceived and created it.

In the twentieth century, one important trend in studies of the
relationship between Italian art and classical art initially developed
in Germany, in particular in the Warburg Library in Hamburg.
Later the library was transferred to London, to become one of the
most brilliant university institutions in England and the United States.
This trend gave particular emphasis to the literary, scholarly content
of Italian art in the Renaissance period, derived as it was from
classical texts; it also examined the relationships between artists
and the humanists. This work was done by scholars trained in the

German school, with a detailed knowledge of classical philology that was essential to their research and which often led them to give only a secondary importance to the problem of form, and the stylistic affinities between Italian and classical art. Thus an eminent scholar like Panofsky did not clearly distinguish between the two schools of criticism and so construed an erroneous interpretation. A particularly significant example of this is the case of a well-known letter by Giovanni Dondi, Paduan doctor and friend of Petrarch, about his visit to Rome in 1375.

> Few of the works of art produced by the ancient geniuses have been preserved; but those which have survived somewhere are eagerly looked for and inspected by sensitive persons [*qui in ea re sentiunt*] and command high prices. And if you compare to them what is produced nowadays [*si illis hodierna contuleris*], it will be evident that their authors were superior in natural genius and more knowing in the application of their art. When carefully observing ancient buildings, statues, reliefs, and the like, the artists of our time are amazed. I knew a sculptor in marble famous in his craft among those then living in Italy, particularly as far as figures are concerned; him I have often heard hold forth upon the statues and reliefs which he had seen in Rome with such admiration and reverence that, in merely relating it, he seemed to get beside himself with enthusiasm. Once (so I was told), when in the company of five friends he passed by a place where images of this kind could be seen, he stayed behind and looked at them, enraptured by their artistry; and he kept standing there, forgetful of his companions, until they proceeded five hundred paces or more. After having talked a good deal about the excellence of those figures and having praised their authors and their authors' genius beyond all measure, he used to conclude, to quote his own words, with the statement that, if those images did not lack the breath of life, they would be superior to living beings – as though he meant to say that nature had not so much been imitated as vanquished by the genius of those great artists.[3]

In his commentary on the letter Panofsky rightly emphasized the importance of this text as one of the first in the Renaissance to reflect such enthusiasm for the culture of ancient Rome. Yet, by contrast with Krautheimer, who wrote a very subtle commentary on the letter, he did not perhaps clearly grasp that the interpretation of the sculpture no longer rested with the humanist scholar but with the artist himself. When Dondi states that this interest was shared 'ab iis qui in ea re sentiunt' he was not referring to 'sensitive' people, as Panofsky thought, but, as Krautheimer understood, simply to

those who could judge such things: the experts, or, to use the term that art historians have brought into general usage, the connoisseurs. This use of the term 'connoisseur' or 'cognoscente' had already been in existence for a long time. It is found at the end of the thirteenth century in the writings of Ristoro d'Arezzo: on the subject of the sealed terracotta vases which were being discovered in vast numbers in the region at that time, he wrote:

> When the connoisseurs saw them, they argued and quarrelled over them in great excitement and became so beside themselves that they almost lost their wits. Those who were not connoisseurs wanted to break [the vases] up and throw them away. When some of these pieces came into the hands of the sculptors or artists, or other connoisseurs, they held them as though they were holy relics and marvelled that human nature could reach such heights.[4]

In Dondi's text, too, there is a clear contrast between those who are educated but not expert (the five friends who do not stop on the way) and the connoisseur in the figure of the sculptor who at the end of the passage explains very clearly how the superior quality of classical sculpture consists in its naturalism.

It was precisely in the direction of naturalism that Italian art found its true expression, right until the end of the nineteenth century. Dondi's intuitive comment is in tune with the revolution that Giotto had brought about: contemporary artists realized that their objective of naturalism had already been achieved in a different era, and their way was to a certain extent made easier by the opportunities for referring back to ancient models. Yet this process did not flourish all at once. In painting Giotto's achievements tended to be diminished by his followers, who did not understand their importance. The three generations of his followers who succeeded each other in the fourteenth century gradually forgot the perspective system that their master had set up, and were overtaken by Gothic culture. Moreover, one consequence of the Black Death in 1348 was a wave of asceticism and penitence in Florence and Siena that certainly did nothing to encourage interest in the ruins of the pagan world.

At the end of the fourteenth century a wealthy Florentine merchant and great collector of manuscripts was one of the humanists to have a crucial role in the process of circulating classical culture. This was Niccolò Niccoli who, according to Vespasiano da Bisticci, was the greatest specialist in Greek and Latin literature, surpassing even Dante, Petrarch and Boccaccio. Being highly critical of those

around him, as indeed he was of himself, he made many enemies who reproached him with the short-sightedness of his grammatical interpretation of humanism. Thus Guarino, writing on a treatise on orthography that Niccoli had written for young people (though its attribution is sometimes still contested), criticizes him in the following terms:

> This demonstrates that the author is still a child, and, contrary to all the rules, has no qualms about pronouncing syllables that are by nature contracted by a diphthong . . . This old grey-beard is not afraid to use bronze and silver coins, marbles and Greek manuscripts as evidence of cases where the words are unequivocal . . . Can this Solon tell us which of the writers of his time he finds innocent of errors?[5]

This text has an astonishing modernity in our present day, when the necessity of learning classical languages is in dispute, purism banned from official language and the values of ethnic minorities and dialects under review, and it underlines the extent to which succeeding generations have, to the present day, been tributaries of ideas that were established by a handful of educated men at the beginning of the Renaissance.

However, Niccoli's relationship with artists did not only exhibit the reactionary, slightly arrogant side of his nature. His attitude was certainly more open-minded than that of some of his contemporaries, for instance Leonardo Bruni, who still looked down on artists as mere artisans. Interest in ancient works of art was beginning to take hold in Florence, just as it had in the Veneto. Already in Padua in about 1398 the house of the Carrara was decorated with medallions imitating the coins of imperial Rome that were being enthusiastically collected, and in Florence it was the more advanced humanists, to an even greater extent than the princes, who created important collections of precious documents that would add to their wealth of knowledge. As well as manuscripts Niccolò Niccoli collected objects that he had transported from Greece and the Near East, as we know from Traversari.[6]

A few years later Poggio Bracciolini took this interest a stage further: his vision of the Roman ruins, which found its richest expression after his visit of 1429, belongs to the same intellectual framework as the vision of Petrarch – a literary, lyrical evocation of past splendour. But there are several passages in his letters which reveal a more personal interest, a more spontaneous enthusiasm that is independent of its cultural context. In one passage, written from Rome, he describes three marble heads that a friend is sending him

from Chios and adds: 'I too have something to send home. Donatello has seen it and praised it greatly.'[7] We have come a long way from the time when Giovanni Dondi was amazed at the sculptor's interest in a work of ancient Rome. Poggio dares to lean on the authority of a contemporary sculptor to demonstrate his appreciation of an artist of ancient Rome. The greatest humanists and artists have begun to exchange their ideas and are gradually drawing closer together.

The cult of antiquity around 1400. Ghiberti

During the last decade of the fifteenth century a taste for classical models developed among the most modern sculptors. The architraves of the Porta della Mandorla (Florence, Duomo), to use just one among many examples, are evidence of this, with their almost archaeological decoration.[8] The fashion flourished in 1401, appearing in the two panels preserved for the competitions for the north door of the baptistery. In Brunelleschi's panel Isaac is derived from the figure of a prisoner similar to those on the Arch of Constantine; one of the two slaves is taken from a Cavaspino, the other probably from a figure in a relief of a sacrifice. In Ghiberti's panel the sources are no less numerous, though less easily identifiable. His Isaac testifies to the artist's study of classical models, both in his pose, which is similar to that of Niobe's children, and in his expressive force, reminiscent of fourth-century BC Greek sculpture. Moreover, Abraham's head is like that of a Jove, while his servants are taken directly from the group of Pelops and his companion on a sarcophagus depicting the myth of that hero. The two artists' interpretations of these sources are so different as to be almost in opposition. Brunelleschi expresses himself in violent, naturalistic terms, Ghiberti has developed a fluid style that rejects the rough craftsmanship of the Roman sarcophagi in favour of rediscovering the harmonious rhythm of Hellenistic art, rhythms which blend with the Gothic foundations of his own training. Both artists display such a rich archaeological repertoire that one is tempted to wonder whether one of the specific conditions imposed by their patrons was the use of 'classical' motifs.

Moreover, taken within the whole body of Ghiberti's work, the panel of the sacrifice of Isaac contains a far more noticeable degree of classical culture than later works, and particularly the first reliefs of the north door. This line expanded only at a later stage, reaching its zenith in the east doors, where the artist crossed a significant

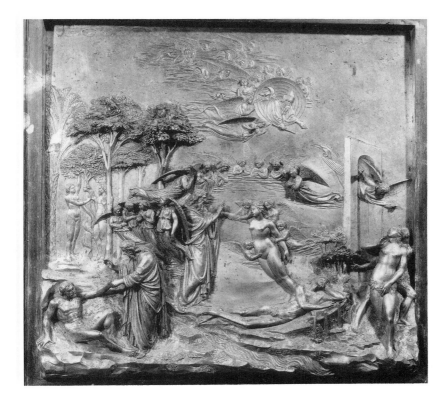

Plate 14 LORENZO GHIBERTI, *The Creation of Eve*, detail from the
east doors, *c*.1430–9, Florence Baptistery.
Photo: Archivi Alinari.

threshold in Renaissance culture. In broadening his range of re-
search into the areas of Pisa and Rome he acquired an intimate
knowledge of the great historic reliefs, and especially of Roman
sarcophagi. But he always surpassed the artisan qualities of his pro-
totypes, recreating entirely new ideals that were to have enormous
influence on Italian art: Ghiberti's classical tones evoked the Hellen-
istic art that he could not have known, but which was to remain the
most sought-after among all classical art in Italy until the nineteenth
century. While basing his work on a vast archaeological repertoire
(which can be substantially reconstructed thanks to some details on
the east doors of the baptistery), he was never limited to a dogmatic
rehearsal of his sources. In the scene depicting the Creation of Eve,

Plate 15 *Thiasos with Bacchus and Ariadne*, from a Roman Sarcophagus, second century AD, reproduced by courtesy of the Trustees of the British Museum, London.

the female figure, of unparalleled grace, is reminiscent of both a chaste Venus and a frenzied Maenad taken from a Dionysian sarcophagus. With an astonishing flexibility, Ghiberti has combined two separate sources, which are reproduced with a greater or lesser degree of accuracy, and blended them to create his own variants which elude the precise line of demarcation between imitation and 'classical' invention.

There are other works of this period which bear witness to the same tastes and the same enthusiasm: Vasari tells how one morning, as Brunelleschi was talking with Donatello in the piazza of Santa Maria del Fiore, the latter told him how on his return from Rome 'he passed through Orvieto in order to see the famous marble façade of the Duomo . . . and when he was travelling through Cortona, he added he went into the parish church, where he saw a very beautiful antique sarcophagus on which there was a scene carved in marble.' Brunelleschi's reaction to the description of the sarcophagus was such that 'just as he was in his cloak and hood and wooden shoes, without saying where he was going he trudged off to Cortona, drawn there by his love and enthusiasm for the art of sculpture. He saw and admired the sarcophagus, made a sketch of it, and with that went back to Florence before Donatello or anyone else realised that he had been away.'[9]

From the fourteenth century onwards, all works created in Florence were influenced, to a greater or lesser extent, by the new passion for classicism. The most important example is that of the anonymous master who made the architraves of Porta della Mandorla between 1391 and 1396. Some of his figures, such as Prudence and Hercules, both of which are nudes, must be interpreted within a context of Christian allegory, yet indicate an obvious familiarity with classical models, placed among floral decorations that are also taken from Roman prototypes.[10] Even the artists who were still rooted in Gothic culture, such as Nanni di Banco or Jacopo della Quercia in Siena, were caught by the same enthusiasm. The Four Crowned Saints in Orsanmichele were probably based on sepulchral monuments and reveal above all a familiarity with Roman portraits. A remarkable head (plate 17), preserved in the Camposanto in Pisa, seems to indicate the way in which artists would intervene with Roman prototypes, perhaps in this case in the workshop of Nanni di Banco. The features of Antinous are recognizable but, perhaps in order to repair the damage of a few cracks, the nose has been altered, the beard reworked in the style of St Castor of Orsanmichele and the hair adjusted to a modern shape.[11]

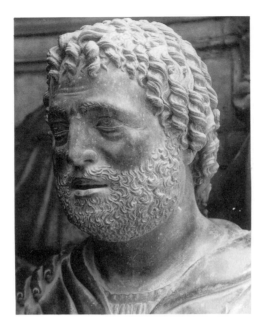

Plate 16 NANNI DI BANCO, *Nicostratos*, detail from *Four Crowned Saints*, after 1413, Florence, Orsanmichele. Photo: Archivi Alinari.

The progressive importance of Brunelleschi and Donatello's return to antiquity

During the same period these issues were approached in a more decisive manner by the three true leaders of the Florentine Renaissance, Brunelleschi, Donatello and Masaccio. With these three artists the culture of antiquity acquired an indisputably progressive importance, the importance of a genuine conquest which it would never attain again and which was already diminishing some years later, in the Porta del Paradiso or in Alberti's architectural works.

Shortly after the competition of 1401, perhaps in 1402 or 1404, Brunelleschi and Donatello went to Rome together to further their knowledge of antiquity. They were the first to make that journey to Rome that was to become essential for Italian and foreign artists right up to the nineteenth century. Other artists had gone to the Eternal City in the past – we need only remember Giotto and Arnolfo,

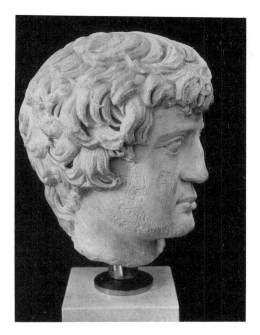

Plate 17 Roman head in marble (reworked in the early
Quattrocentro), Pisa, Museo dell'Opera del Duomo.

or going further back, Buschetto, architect of the cathedral of Pisa.
But these masters went there to work, not simply to study the vast
field of ruins that the city must have been at that time, when even
the popes had abandoned it.

Donatello, the greatest sculptor of the fifteenth century, acquired
the widest knowledge of the figurative world of antiquity, and with
these foundations was able to execute his revolutionary works.[12] But
the consequences of his visit to Rome were not immediately appar-
ent: there was a long period of assimilation for, like all great mas-
ters, Donatello never copied, but used the classical past not only for
its iconographic and stylistic aspects but above all for the very basis
of the types that he created. For the same reason, it is always dif-
ficult to find his models, and often these are not enough to explain
the fundamental importance of his cultural knowledge in all the
kinds of art that he practised.

Firstly let us look at how he developed the relief. In 1417, the *St
George and the Dragon* at the foot of the statue in Orsanmichele is

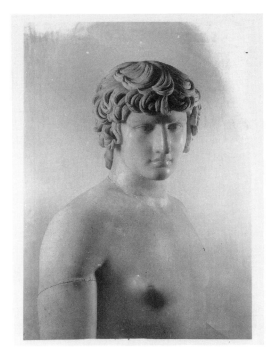

Plate 18 *Antinous*, Roman head, first half of the second
century AD, Naples, Museo Archeologico Nazionale.
Photo: Soprintendenza Archeologica della Provincia Napoli e Caserta.

completely revolutionary because of the discovery of *stiacciato* – the
kind of relief that is given its effect of depth through tiny variations
in the cutting (*lavoro in cavo*) which allow the maximum rendering
of space. In the portico behind the princess, which is only a few
centimetres high, this revolutionary technique enabled the artist to
rediscover the effects of linear perspective for the first time since
classical antiquity, and to portray the drapery of the moving female
figure, just as in classical art.

Both these elements are indicative of Donatello's unprejudiced
way of looking at classical art, without limiting himself to the great
commemorative or architectural reliefs, the sarcophagi or the statues
of his predecessors. His wide vision took in all the types of work
that he knew, and particularly those on a small scale such as coins,
terracotta vases, sealed ceramics and especially the gems – cameos
and engraved hard stones – which artists and amateurs had always

collected, though until then without gaining any insight into technique or style.

This astonishing capacity for finding formal solutions that were continuously and completely renewed can be identified in Donatello's various statues in full relief, beginning with the first attempts that were still redolent of Gothic culture, such as the marble *David*, commissioned in 1408 and the *Prophets* and *San Lodovico*. In completing Ghiberti's works at Orsanmichele Donatello gave new life to large-scale bronze statuary, but again with important innovations in their interpretation, inventing a figure with abundant and fluid drapery, whose force of emphasis would long be echoed throughout the Renaissance.

Here then, the references to classical art are essentially of a technical character: the artist took a type which must have been familiar through many examples, and which may have also been highly praised in Roman texts. But the weight of this reference is typically humanist: it consists in a conscious return to the past, but a return that is free, without slavishly following models.

The theory has recently been put forward that, in the same humanist spirit, Donatello salvaged the technique of terracotta (which was also linked to that of bronzes), in particular in the famous chest illustrated with scenes from the life of Adam and Eve, now in the Victoria and Albert Museum.[13]

Finally the artist reached his zenith in his full relief statues with his bronze *David*, the first modern statue that was made to be viewed from all sides, again an imitation of his classical predecessor, and then with his *Judith* group, where references to the pagan models by now seemed obsolete.

Donatello displayed the same confidence in another type of Roman work, the equestrian statue, with his *Gattamelata* completed in 1450. He revived this type in a humanist dimension, giving importance both to the man and to the best-loved animal of the Renaissance, as a symbol of man's victory over animal strength. As before, there are several precedents from the end of the Middle Ages, but none has the importance of the *Gattamelata*, which Donatello created in direct relationship to the *Marcus Aurelius*, and perhaps even with the *Regisole* that stood before the cathedral in Pavia. As usual, Donatello finished by abandoning his model: the *condottiere* has none of the Roman Emperor's calm dignity. The artist portrays him as he advances in a manner that is almost threatening, with an audacity that goes beyond all forms of realism.

The return to half-length busts in the Roman manner must also

be attributed to Donatello.[14] Here, too, there had never been a complete break in this type of art since half-length busts and reliquary busts were in existence at the end of the Middle Ages. In the fifteenth century, however, the model did not come from Donatello – the *Piero de' Medici* in the Bargello, dated 1453, is the work of Mino da Fiesole. But it differs profoundly from the classical models, which were conceived as cult figures rather than living people, and from the reliquaries, which had an equally religious significance. These differences had already been stated by Donatello, primarily in the reliquary of San Rossore (*c.*1424), where the saint has become quite human; also in the *Bust of a Young Neoplatonist* (*c.*1440), which retains an echo of a medieval reliquary in the emphasis given to the medal on his breast, though the latter does not open on a relic but illustrates the myth of the soul according to Plato's *Phaedrus*.

Even if Donatello did not create true half-length busts (or if he did tackle this genre in works that are now lost) he must still be held responsible for the return to antiquity in this case too, with the modifications in form and content that sprang from the mingling of medieval precedents and from humanist interpretation. With artists of a lesser creativity we can witness the return to a practice that Pliny described in detail and whose disappearance he lamented in his own time: the old Roman tradition of preserving wax masks of one's ancestors, with the religious significance inherent in such a custom.

This tradition was revived in Florence and we know that in some churches there were large statues in wax, though unfortunately not one example has survived. These also functioned as votive effigies, a practice which Francesco Sacchetti criticized in the following terms:

> Many vows of this kind are being made every day, which are more idolatry than Christian faith. And this writer has seen a man who, after he had lost his cat, vowed that if he found it he would give a wax image of it to Our Lady of the Orto San Michele, which he did.[15]

Aby Warburg has studied the spread of this fundamentally pagan practice in Florence in the fifteenth century.

However, to return to the subject of half-length busts, there are some cases where artists were unable to override and disguise the funeral mask used as a model – one example of this is the *Giovanni Chellini* by Antonio Rossellino (who died in 1462) which is preserved at the Victoria and Albert Museum.

Further on we shall discover that Donatello was also responsible

for the survival of one type of antique that became enormously popular – bronze statuettes. But at this stage the phenomenon was no longer limited to Florence and became widespread in many towns in northern Italy.

We may justly claim, then, that all of Donatello's innovations were based on his knowledge of antiquity, that he extracted its essential qualities but then profoundly altered their meaning and form. For he always surpassed his models: once he had adopted their inspiring principles, he fundamentally transformed them as though unconsciously wishing to reject the premises he had started from.

Donatello's manner of reviving classical themes is essentially different from that of Ghiberti and the Hellenistic fashion that he had established: Donatello's *putti*, for example, are never smiling or serene, but animated by some power or some torment that is completely extraneous to orthodox classical tradition. It is a phenomenon which runs directly counter to that tradition, and which now and again surfaces alongside it in Italian culture.

After Donatello all Quattrocento Florentine sculpture remained to some extent bound to the study of antiquity: Michelozzo and his slavish imitations of historical reliefs, Luca della Robbia and the smiling, Hellenistic *putti* of his cantoria, the Rossellino brothers, Mino da Fiesole, Benedetto da Maiano, Verrocchio, Pollaiuolo, Bertoldo and Torrigiani.

While Donatello was concentrating on sculptural remains during his years in Rome, Brunelleschi changed direction: he too had been a sculptor at one time and now developed his vocation as an architect. He began to study the measurements and relationships of various elements of architecture among the ruins, as well as their method of construction. When, after several years spent between Rome and Florence, he returned to his home ground, he was in a position to make a definitive break with Gothic constructions and build revolutionary buildings that were based on his knowledge of the models and the systems used by the ancient architects, to which he added his discoveries on central perspective. By these principles he was able to build the true symbol of the Florentine Renaissance, the dome of Santa Maria del Fiore, as well as the Ospedale degli Innocenti, San Lorenzo and Santo Spirito. His sources for these works are never apparent, and it would be a mistake to see them as a kind of archaeological return to the past. Brunelleschi's objective was the evocation of an ideal antiquity, and the ruins of Rome provided him only with a starting point in his search for perfection. Moreover, it

has already been observed – and Gombrich has emphasized this with great insight – that in breaking with Gothic tradition Brunelleschi did not only apply the laws of perspective he had deduced from his studies in Rome, but he also made practical use of his knowledge of Romanesque architecture. The interior of San Lorenzo, for example, was rebuilt more along the lines of the Florentine church of Santi Apostoli, than of an ancient temple.[16]

Leon Battista Alberti

One generation later, however, a more archaeological cultural knowledge was evident in the work of the architect and scholar Leon Battista Alberti. With his extensive humanistic education, he produced architecture that was much closer to the Roman models. Comparisons between these two masters have often been unfavourable for the later man. Schlosser in particular has criticized Alberti for being over-erudite and veering towards aristocratic (i.e. reactionary) values, which led him to despise the practical phase of a building's construction, and it is certainly true that he was concerned with these issues only much later in his life.

Such a judgement is certainly too harsh. Alberti did not turn exclusively to the Roman past, nor was he totally unmoved by medieval art. In his *De re aedificatoria* he often cites early Christian basilicas. As for Gothic art, he was especially mindful of this when he was working on modernizing the façade of Santa Maria Novella, which is why it excited such criticism on the part of the more rigid classicists such as Bottari and latter Milizia and Quatremère de Quincy, who refused to attribute it to Alberti.

Alberti was fortunate in that his humanist education was coupled with a great creative talent that should not be underestimated. This is not to deny that he was principally a man of letters: his work as an architect, on the other hand, began only a few years after the completion of the *De re aedificatoria*, the first Renaissance treatise on architecture. (It was not published until 1485, and its influence was particularly powerful in the sixteenth century, but we know that in 1452 the author had already shown the finished manuscript to Pope Nicholas V, being a member of his court.) After 1436 he had published a *De pictura* and later went on to publish *De statua*, both of which texts are key witnesses to the breadth of their author's interests, and his commitment to all types of figurative art.

In the *De re aedificatoria*, which is most closely related to Alberti's

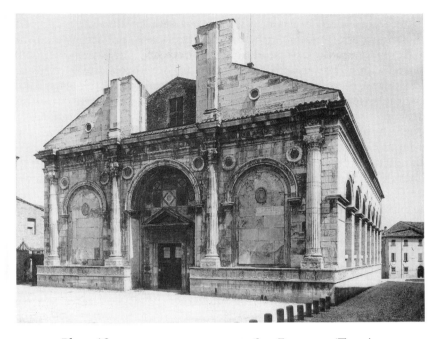

Plate 19 LEON BATTISTA ALBERTI, San Francesco (Tempio
Malatestiano), Rimini, 1450.
Photo: Archivi Alinari.

practical work, we can see the first great return to Vitruvius.[17] In this
treatise the author develops at length his concept of classicism, which
may be summed up in the famous definition of beauty, conceived as
'the harmony of all the parts within a body so that nothing may be
added, taken away, or altered but for the worse. It is a great and
holy matter.' The primary conceit is then the concord of all ele-
ments, based on proportion and on the relationship of background
and architecture; in this respect, the relationship with the architec-
ture of imperial Rome is fundamental, and it is possible to trace its
influence in the principal buildings where Alberti tried to put his
theories into practice. In the church of San Francesco in Rimini
(1450) he tried to endow the pre-existing church with a monumental
classical façade, inspired by triumphal arches, thus creating a whole
that apparently contradicts the principles of unity he had always
upheld, and in doing so he reveals his attitude towards antiquity
to be more emotional than orthodox, as Wittkower has rightly

emphasized. The same problem arises with the church of Santa Maria Novella in Florence, where it is resolved with an absolute respect for the pre-existing Gothic structure superimposed by various elements that derive from classical antiquity. This same purist attitude, combined with a highly sophisticated taste for simple ornament, is visible in the first plan of San Sebastiano in Mantua, where the artist takes on the essential problem of the Renaissance – the church with a central plan that Brunelleschi had already built with Santa Maria degli Angeli in Florence (1434) and which Michelozzo had also adapted with the Annunziata (1451) where he faithfully followed the plan of the Temple of Minerva the Healer in Rome. Lastly in the church of Sant'Andrea in Mantua (planned in 1470 and begun in 1472), Alberti strove to combine the contemporary need for a rational stone structure with classical inspiration by applying a façade that derived from a Roman temple to the plan of the church, a method that was to be repeated throughout the Renaissance. He thus arrived at a unique relation to his classical models, which contained the seeds of anti-classicism and in a sense opened up the way for mannerist architecture.

From the very beginning of his career Alberti advocated a free interpretation of the canons of classical antiquity, and it is certainly true that even as early as his San Francesco di Rimini, the reference to a Roman arch is not enough to explain the complexity of the façade, with its characteristic spatial tension. In the same way, the reworking of the Corinthian capitals reveals a profound originality. Moreover, Alberti in his *De re aedificatoria* wrote of classical examples: 'We should not go back to them and fit their designs to our work as if we were bound by rigid laws; we should rather gain strength by our knowledge of them to enrich our work with new things that we have discovered for ourselves, and strive to earn praise which will equal or surpass that accorded to our exemplars.' The work of the scholar bows to creative imagination, and a chronological study of Alberti's works will confirm the increasing role of his own inventiveness over the models which inspired him.

Masaccio and Piero della Francesca: Hellenism without archaeology

By comparison with Donatello and Brunelleschi, Masaccio, the third leader of Renaissance art, was influenced by classical antiquity to a much lesser degree. But because of their friendship and because the

revolution led by his painting ran parallel to that led by their sculpture and architecture, scholars have often tried to prove that he too had a grounding in detailed studies of classical works, claiming that there is a series of indicators of this in his art. It is indeed possible to recognize some elements, though they are few and far between. Yet the most convincing idea of the relationship between Masaccio and antiquity is that established recently by Polzer: the composition of the *Tribute Money* follows that of an early Christian fresco, *St· Paul Preaching to the Jews*, repainted by Cavallini, that was part of a cycle in the old Basilica of San Paolo fuori le Mura (fire destroyed the whole building in the nineteenth century, but there is a seventeenth-century copy).[18] Polzer's observations confirm both the break that Longhi had already noted between the first frescoes of the Cappella Brancacci and the *Tribute Money*, which he saw as a 'Colosseum of figures', and his own intuition in explaining this change through Masaccio's visit to Rome in 1425.[19]

It is particularly surprising that it should be a painting which establishes the most important return to classical antiquity. Familiarity with ancient frescoes must have been limited to a small circle of people at the beginning of the fifteenth century, and probably Masaccio had studied the great biblical cycles of the Roman basilicas, grasping the residual classical elements, perhaps of the early Christian era or those by Cavallini. Even so, the case remains exceptional. Wherever, in the traditional way, art historians try to establish a link between certain elements in Masaccio's works and the repertoire that was then most widely known to artists (statues, reliefs and architectural remains), their conclusions are never convincing.[20] *Eve Expelled from Paradise* is certainly reminiscent of a chaste Venus but probably because of its interpretation by Nicola Pisano on the pulpit of the baptistery in Pisa. In the fresco of the *Tribute Money*, the famous curly head of St John derives not from an archaeological model, as has sometimes been stated, but from one of the four crowned saints by Nanni di Banco in Orsanmichele. In other examples, classical motifs are passed on to the artist by Donatello and also by Brunelleschi. In particular the *trompe-l'oeil* architecture of Santa Maria Novella does not indicate the direct study of classical models but the type of vault favoured by Brunelleschi, as Mesnil has already noted.

The elements of Masaccio's work which might be interpreted as deriving from a study of antiquity were in fact almost always passed on to him by his friends Donatello and Brunelleschi. It was they who influenced him, more than archaeological research. It could be claimed

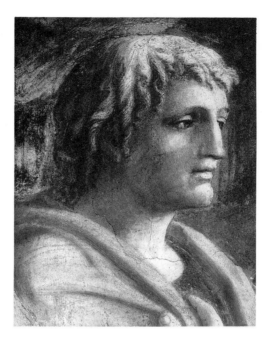

Plate 20 MASACCIO, *St John*, detail from *The Tribute Money*, 1425, Florence, Santa Maria del Carmine.
Photo: Archivi Alinari.

that Masaccio brought about his revolution without the aid of antiquity, just as Giotto had done. Yet, despite the enormous importance of that revolution, it remains less significant than that of his predecessor; moreover, Masaccio's greatest debt was to Donatello and Brunelleschi.

In painting, Masaccio's followers did not demonstrate an interest in the past. Just as after the death of Giotto, there was a gradual diminishing in the perspective construction of his works, and the plastic solidity of his figures (which are the essential features of his classical, not pseudo-classical, art).

We have to wait for the appearance of Piero della Francesca before these elements return to a dominant position. His works constitute a new pillar of classicism in Italian painting: once again, classical and not classicizing, for there is no visible trace of an archaeological culture. Yet despite this total independence from the Roman world, the figures in the *Legend of the True Cross* in the

basilica of San Francesco in Arezzo (1451–9) are endowed with a supreme serenity that can be compared only to that of fifth-century BC Greek art. They stand once more in the midst of a nature whose forms are of a rigorous conception in their use of geometry and perspective (the artist dedicated two treatises to these subjects). This 'perspective synthesis of form–colour', to use Longhi's description, is the very essence of classicism, of rationalism, and of the human world.

Notebooks of models and Panofsky's theory of disjunction

At the same time, painters who were still tied to the traditions of the Gothic period began to study archaeological remains and, following Ghiberti's example, to fill entire notebooks with their drawings. We still have some of the workshop material put together by Gentile da Fabriano when he was working on the frescoes in San Giovanni in Laterano, at the same time as his pupil Pisanello.[21] It was at this time that Masaccio suddenly died, leaving the frescoes of nearby San Clemente unfinished, with nothing in them to betray his interest in the pagan world.

By contrast, the numerous drawings by Gentile that have been preserved show figures that are generally taken from the large scenes on sarcophagi. These probably provided the artist with a natural substitute for all the elements he could not obtain directly from his models, i.e. the nude in particular, which appears over and over again in his drawings, especially stiffened into violent gestures, which were a novelty for him. While Gentile's and above all Pisanello's drawings and paintings of animals and plants bear witness to the artists' acute powers of observation, and at the same time of a detached, abstract vision that results in a form of perfection, the drawings that were done according to antique notions are almost always wooden and impaired by a kind of clumsiness that is probably due to an inability to master a still unfamiliar method.

The use of archaeological models in painting remained fairly limited. A youthful work by Andrea del Castagno, a leather shield made around 1452 and now preserved in Washington, shows the figure of David based on a similar one of a 'pedagogue' from the *Niobe* group, as is clear in the statue in the Uffizi. But this is a rare example, and the rendering of the classical model was certainly

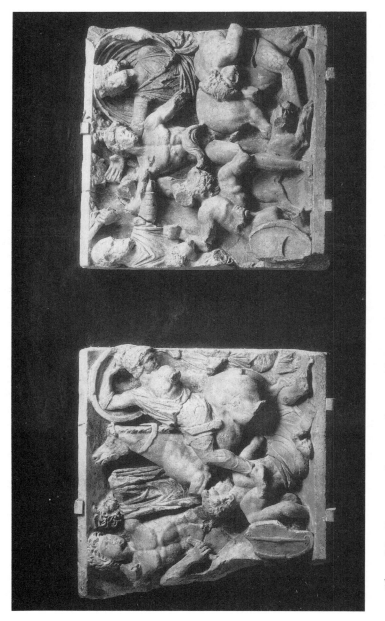

Plate 21 Fragment of a sarcophagus with Dionysiac scene, second century AD from Grottaferrata Abbey.

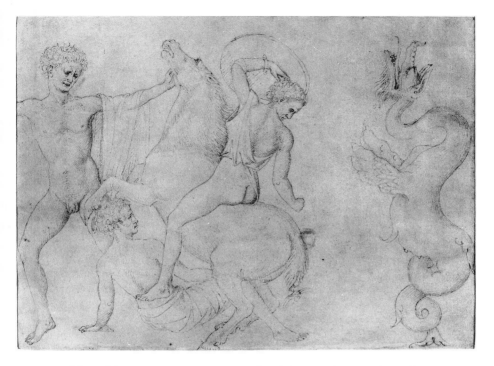

Plate 22 GENTILE DA FABRIANO, detail from a drawing from the antique, 1426–7, Milan, Biblioteca Ambrosiana, f. 214, inv. 14v.

achieved with the mediation of a sculptor, perhaps Donatello, who had a strong influence over painters and especially over Paolo Uccello and Andrea del Castagno.

The example of Castagno's shield had already led Warburg to observe that in the fifteenth century pagan models were used to establish the iconography of Christian themes.[22] He cites another example of this, the *Funeral Lament* in the relief by Giuliano da Sangallo in the Cappella Sassetti of the church of the Santa Trinita, which he traces back to the sarcophagus illustrating the *Lament for the Death of Meleager* that used to be in the Palazzo Montalvo in Florence, whose iconography had indeed been reproduced by the artist with an almost archaeological fidelity.[23]

The phenomenon of the 'energetische Inversion', as Warburg called it, has been studied in depth by Panofsky and Saxl in a brilliant

essay, where they also consider the opposite problem, that is, the illustration of classical themes. [24] They observe that, curiously enough, these are treated as contemporary subjects. If, for example, we take the scenes from the *Aeneid* illustrated by Apollonio da Giovanni on the panel of the *cassone* now in New Haven (*c.*1460), we will see that Aeneas wears the *mazzocchio*, Dido a pointed hat, and generally all the characters are dressed in the best tradition of the fifteenth century. Similarly, the *Cronaca della pittura fiorentina* (*c.*1460) shows Paris and the newly won Helen solemnly advancing, adorned with the richest ornaments of Medicean Florence.

We thus arrive at the paradox whereby on the one hand classical models are adopted for Christian iconography while on the other hand classical subjects are treated as contemporary stories where the gods are transformed into fifteenth-century gentlemen. This is what Panofsky calls the law of 'disjunction', which he identifies throughout the Gothic period. He thinks that it would have extended to the end of the fifteenth century, but the first attempt at reintegration between pagan theme and content had already been made by Mantegna. In the three stories of St James in the church of the Eremitani in Mantua (1448–55), the Roman soldiers once more appeared in Roman dress against an appropriately classical background.

With its wealth of documentation, the essay by Panofsky and Saxl is one of their best. Panofsky developed it further, in the same spirit and with the same scholarship.[25] However, if we analyse the works that he considered a little more closely, we can discover that in stylistic quality there is a yawning gap between the two categories. In the fifteenth century works on Christian themes were commissioned from the most important artists, while works illustrating classical themes appear only in manuscripts, drawings or engravings, or particularly on chests which, with rare exceptions, were entrusted to craftsmen of a more modest ability. These chests comprised a line of production that was intended for the bourgeoisie, the products of specialized workshops, of which that of Apollonio da Giovanni was a typical example.[26] These artisans did not have the same level of training as a Masaccio or a Donatello, and they continued the tradition of Gothic tales in their pictures, illustrated with little or no attention to historical detail. Even when artists of a higher calibre, such as Pesellino or Gozzoli, take on the genre of chests, they too fall in line with a totally codified tradition. The paradox that Panofsky so brilliantly brought into focus does not then take sufficient account of the social background of the artists; it refers to works that have

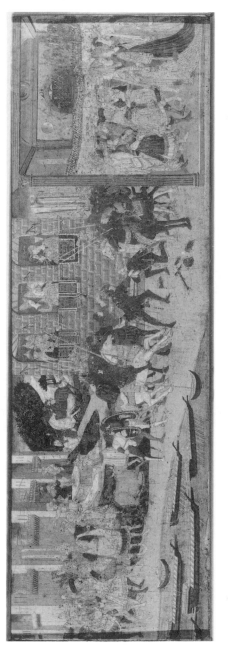

Plate 23 *Cassone* with scenes from the *Aeneid*, by Apollonio di Giovanni, Ecouen, Musée National de la Renaissance, Château Ecouen.
Photo: Réunion des Musées Nationaux.

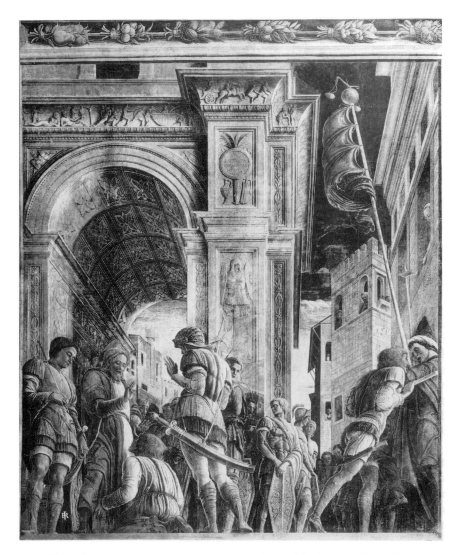

Plate 24 ANDREA MANTEGNA, *Martyrdom of St James*, after 1453, Padua, Eremitani, Ovetari Chapel.
Photo: Archivi Alinari.

very little in common, and which actually correspond to two complementary poles of the same culture.

As for Panofsky's observation that Mantegna ended this state of 'disjunction', this can be explained only by the historical consciousness of the artist, by the fact that in Padua he was part of a humanistic environment and thus had the means to take on the great pagan themes which his predecessors had not had the chance to interpret. But these themes constitute only a small part of his work. Moreover, his *St Sebastian* in Vienna, which Panofsky considered to be his most archaeological work because of the marble fragments that lie behind the saint and the signature in Greek, τὸ ἔργον τοῦ Ἀνδρέου, is still a Christian theme interpreted in pagan form, and certainly does not enshrine a solution to the principle of 'disjunction'. Lastly, the soldiers in historical dress in the story of St James do not mean that the theme is any less Christian, but merely that St James lived in Roman times.

In Mantegna's work the reintegration of classical form and content occurs above all in his great cycle of nine canvases representing the *Triumph of Caesar* (1485–92), now in Hampton Court, which were probably painted for the Marchese Luigi Gonzaga.[27] If form and content are integrated here it is because the classical subject is not now limited to a simple illustration on a chest or in a book but has assumed monumental proportions. The novelty is therefore not so much in the artist but in the man who commissioned the work, who had close relationships with the humanists. The latter were probably responsible for providing the artist with the texts to inspire him, i.e. the descriptions by Appian and Suetonius and the *De re militari* by Valturius, published in Verona in 1472.

The fashion for classical themes actually began only at the end of the fifteenth century and was to last for more than 100 years. Typical of the changing tastes and mentality that lay behind this evolution is the following letter written in 1501 by one of the most cultivated and by far the most avant-garde princesses in Italy at the time, Isabella d'Este. On the subject of her study, she asks: 'If Giovanni Bellini is so reluctant to do that story, as you have told me, then I shall be content to submit to his judgement, as long as he does some ancient story or fable, or makes one of his own invention that depicts something antique, of great import.'[28] The case of Mantegna which Panofsky, with his characteristic nostalgia for antiquity, viewed as bringing an end to 'disjunction' and the triumph of humanism, leads us on to consider the history of the return to antiquity after the heroic period of the Tuscan Renaissance.

Other cultural centres

Padua was undoubtedly the city which followed the lead given by
Florence, because here also the humanists played a critical role. The
Florentine Renaissance was brought here by Donatello, who, in the
ten or so years that he stayed, stimulated the whole artistic scene
to direct itself towards research on classical models. Mantegna'a
archaeological vision can be explained only in the light of Donatello's
presence, and the same is true of Donatello's pupil and collaborator
Bellano and of Andrea Riccio.

With the latter artist came the increasing diffusion of bronze sta-
tuettes. Donatello had already had some notion of these in some of
the details of his large sculptures, but he had not produced them
separately. The dimensions of his *Atys-Amorino* are half-way be-
tween a statue and a bronze, and it is, after all, not impossible that
Donatello made some small objects that have not been preserved.

However, the bronze statues that were inspired by and often di-
rectly copied from the ancients were very much in demand to embel-
lish the studies of humanists and connoisseurs, and were to become
enormously popular.[29] In Florence the specialist was Bertoldo,
Donatello's pupil. In Padua, the most beautiful were those of Riccio,
and these must be linked with the Greek and Roman Hellenistic
objects that came straight from Greece and the Near East via the
port of Venice. Finally, from Mantua came a more precious and
noble variant by Pier Jacopo Alari Bonacolsi, whose works (made
for the Gonzaga family) were enough to earn him the nickname
'Antico'. This artist was a great expert on Roman art and had spent
some time in Rome. To him we owe the precious miniatures of the
most famous antique bronzes of the time: the *Apollo del Belvedere*,
the *Spinario* and especially the *Venus Felix* whose value the artist
enhanced even further by placing her on a base decorated with
imperial coins.[30]

This brief digression into bronze statues leads us to follow the
diffusion of the taste for antiquity to Padua and Venice, where the
large sculptures of Antonio Rizzo and the Lombardo family demon-
strate a wish to return to a classical serenity – and here certainly
more Greek than Roman. We can also follow this trend to Mantua
where Alberti's presence was already beginning to make its mark.
We have seen that the latter was also in Rimini where, after his
renovation of the church of San Francesco, and together with the
sculptor Agostino di Duccio and the engraver Matteo de' Pasti, he

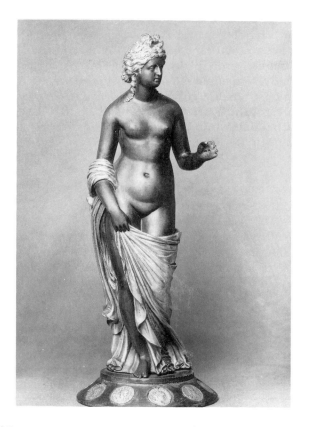

Plate 25 PIER JACOPO ALARI BONACOLSI (known as L'Antico), *Venus Felix*, Vienna, Kunsthistorisches Museum.

breathed new life into a highly original circle of classical humanist art that had formed around Sigismondo Pandolfo Malatesta.

But this was a time of transience. In other artistic centres, as in almost the whole of Lombardy, the interest in archaeological remains was more superficial, and diminished into a mere ornamental vocabulary. In Naples, there are elements of an antique culture that occasionally appear in the sculptures of Francesco Laurana. The strongest proof that the abundant presence of archaeological remains was insufficient to give birth to a true classical style lies in the fact that in all of southern Italy – where such remains are most plentiful – quotations from antique works are very rare in figurative art. The same was true of Rome, where at that time there was no

native artistic circle. It is exceptional to find an echo of antiquity in the reliefs of Isaia de Pisa (*c*.1440), at one time in the Cappella San Biagio in St Peter's, and especially in the bronze door of St Peter's by Fiorentino Filarete (probably towards 1443).[31] Apart from the floral decoration and the small mythological/historical scenes that have been inserted, which probably correspond to a well-defined humanistic programme, the great figures of the apostles seem to have been taken from early Christian ivories, and perhaps indicate a political will to return to the Middle Ages.

The discovery of the *Domus Aurea* and the evolution of the *grottesche*

The last twenty years of the fifteenth century saw a change in the concept of antiquity, as the custom of the journey to Rome became widespread and new classical sources were used. It was at this time that the ruins of Nero's palace, the famous *Domus Aurea*, began to be explored with the discovery of all the frescoed and stucco vaults. As these were reached via the top of the Oppian hill, excavating galleries that were parallel to the ceilings, the impression of descending into a grotto was formed, giving rise to the name *grottesco*, used to describe the paintings that could be seen there.

This discovery was soon immensely popular. A short poem written around 1500, the *Antiquarie prospettiche romane*, evokes:

> spelonche ruinate grotte
> di stucco di rilievo altri colore . . .
> D'ogni stagion son piene di pintore
> più lastate par che'l verno infresche . . .
> Andiam per terra con nostre ventresche . . .
> con pane con presutto, poma e vino
> per essere più bizzarri alle grottesche.[32]

(Caves, ruined grottoes with stucco, reliefs and different colours . . . in every season are full of painters, the summer seems to cool them more than the winter . . . Let us go down with our salami, bread, ham, fruit and wine, to be gay among the *grottesche*.)

These explorations and archaeological picnics brought about fundamental changes in the image of classical antiquity: it was no longer an image in black and white, but for the first time was beheld with all the potency of its gold and its range of colours.

But this was not all. The discovery of the decoration of Nero's vaults managed to undermine the very foundations of artists' aesthethic convictions. It was a vocabulary composed of monstrous elements, part human, animal or vegetable, that were put together according to all the traditional combinations of decorative floral background of Hellenistic origin, and it stirred the imaginations of artists to conceive new hybrid creatures and new metamorphoses. In this way the discovery of Roman painting tended to encourage the anti-classical tendencies of Italian painting at the end of the Quattrocento.

The grotesque genre initially developed around the margins of frescoes and paintings with the first generation of Florentine and Umbrian painters summoned by Sixtus IV to decorate the Sistine Chapel, and particularly with Ghirlandaio, Botticelli, Filippino Lippi, Perugino, Pinturicchio and Signorelli. These painters established the drawings of reliefs, sarcophagi, buildings, ornaments and pictures in the sketch books that later circulated around the workshops, and they encouraged the diffusion of Roman motifs outside Rome. One of the oldest and most influential of these sketch books was the *Codex Escurialensis*, named after the library where it is preserved, and probably derived in part from Ghirlandaio's codex of around 1480.[33]

The most original of these painters were those who made a decisive break with the classical tradition of the Tuscan Renaissance, especially Filippino Lippi who collected the most unusual archaeological details in his paintings and who in Vasari's words 'never executed a single work in which he did not avail himself with great diligence of Roman antiquities, such as vases, buskins, trophies, banners, helmet-crests, adornments of temples, ornamental headdresses, strange kind of draperies, armour, scimitars, swords, togas, mantles'. This tendency was reinforced with the next generation, not only in Umbria and Tuscany with Peruzzi, Raffaellino del Garbo, Giannicola di Paolo, Sodoma and Andrea di Cosimo Feltrini, but also in Emilia where Araldi, Ripanda and particularly Aspertini created some highly original interpretations. In the Veneto, it was reaffirmed by the mysterious Morto da Feltre and also in Lombardy where one of the most remarkable variants appears in the Cappella di Santa Margherita delle Grazie at the foot of the Sacred Mount of Varallo, painted by Gaudenzio Ferrari, perhaps around 1507. By now the vocabulary of classicism had been distilled through Pinturicchio and Signorelli into a highly lyrical interpretation that is almost reminiscent of Aubrey Beardsley. The morphology of the

grotesque spread even further with engravings, ceramics, mosaics and every kind of decoration, and in this form continued to flourish for nearly a century. It was no longer restricted to secondary panels but extended over large surfaces. At the same time, artists no longer felt the need to return to classical sources: the great wealth of the ornamental vocabulary which they had acquired had grown up independently, stimulated only by their imaginations.

The political function of the classicism of Julius II. Bramante and Raphael. Hellenistic classicism

With Julius II Rome became the first city of Italy, in both political and cultural terms. This growth had already begun under the pontificate of Sixtus IV, but his nephew Julius considered himself more of a temporal than a spiritual leader: his wish was to be compared to a Roman emperor and to give Rome the kind of monuments that would illustrate his power. He therefore encouraged the growth of a classicism that was directly linked to the political system – centralized power and a courtly elite. At the same time Rome's growing importance was such as to bring about the decline of Florence, and in artistic terms the Papal See remained for a long time the principal city not only of Italy but of all Europe.

Julius was responsible for founding the nucleus of the collection of classical sculpture at the Belvedere, destined to be the most celebrated and prestigious collection in Rome. It was further enriched by successive popes until the neoclassical period, and helped to establish the classical ideal not so much with fifth-century BC Greek art as with later works – Roman copies of fourth-century BC work or Hellenistic originals that were essentially in the classical style, such as the *Venus Felix*, *Antinous*, *Meleager*, *Cleopatra*, *The Nile* and others that were dear to Michelangelo such as the *Torso* and particularly the *Laocoon*, whose discovery in 1506 was to change the vision of classical art and to have a profound influence during the mannerist period and beyond.[34]

Julius turned to Bramante for architecture. During his training in Urbino and Milan he had already introduced a return to antiquity, both in architecture and painting, that followed in the footsteps of Alberti. He came to Rome in 1502, the year before Julius's accession to the papacy, where he created the first building of the high Renaissance, the Tempietto of San Pietro in Montorio commemorating

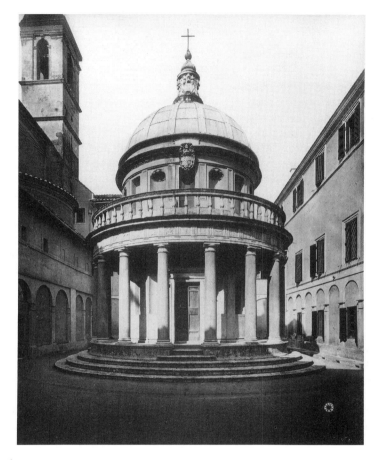

Plate 26 DONATO BRAMANTE, Tempietto, 1503, Rome, San Pietro in
Montorio.
Photo: Archivi Alinari.

the place of St Peter's crucifixion. A kind of monumental reliquary,
this small building is characterized by great discipline and austerity,
both in the Tuscan order of its colonnade and in the total absence
of decoration, which make it into the equivalent of a Greek temple.
When in 1506 Bramante was commissioned to design a new church
to replace the old Constantinian basilica of St Peter, which the pope
considered too modest for the modern papacy, he turned to the same
humanistic culture which then dominated the heart of Christianity.

He chose a central plan, a Greek cross with four apses, and for the walls and pillars that supported the dome he took his inspiration from imperial models, in order to give the basilica all the greatness that it was to symbolize.[35]

His work was continued by Raphael, his successor as architect of St Peter's, who was committed to the same classical traditions.[36] He built *palazzi* and churches, and later on the Villa Madama for Leo X and his nephew, Cardinal Giulio de' Medici, who was to become Clement VII. Taking his inspiration from Bramante's works of 1505, Raphael linked the little *palazzo* of the Belvedere to the older buildings of the Vatican, in a series of terraces, steps and *logge*, and created the model for the Renaissance villa and monumental gardens. We still have Raphael's detailed description of the villa as he conceived it, laid out at different levels on the terraces of the hill; this is a unique document which shows the artist's efforts to render the equivalent of the classical monumental villa, based not only on the study of ancient monuments (particularly evident are his borrowings from Hadrian's villa at Tivoli) but more especially on classical literature, in particular Pliny the Younger's description of the Villa Laurenziana which Raphael probably wished to attempt to reconstruct.[37] Raphael's influence remained very powerful throughout the fifteenth century but, just as in painting, though his pupils and successors continued to refer to ancient models, the licence they took eventually undermined the classicism of their master.[38]

In 1515, at the request of Leo X, the artist accepted a task that may be compared to that of a 'curator' of antiquities. The famous letter that he wrote to the pope, explaining how he planned to rebuild ancient Rome, one area after another, indicates his awareness of the urgency of preserving the monuments of the past which were already under serious threat:

> Therefore, Holy Father, your Holiness should not be slow to ensure that the little that remains of this ancient mother of glory and the name of Italy . . . should not be destroyed altogether and laid waste by evil and ignorant men . . . but you should try, by helping the comparison of the ancients to survive, to equal and surpass them with great buildings.[39]

The artist demonstrated his great historical understanding which led him, through a strict analysis of style, to establish for the first time distinctions between the different periods of Roman art, clearly separating the 'good ancients' from their successors, whom he criticizes:

For there are only three styles of buildings to be found in Rome, of which one is that of the 'good ancients', which lasted from the first emperors until the time that Rome was destroyed and pillaged by the Goths and other barbarians; the next lasted for the time that Rome was dominated by the Goths and for another hundred years after that; the third style lasted from those times until our day . . . So it is not difficult to recognize the buildings of the imperial times, for they are the most excellent and constructed in the finest style and with greater cost and skill than all the others . . . And though literature, sculpture, painting and almost all the other arts had long been in decline and degenerated until the time of the last emperors, architecture maintained sound principles, and was built in the same style as before. And this was the last art to be lost, as can be recognized from many things, for example the Arch of Constantine, which is beautifully composed and well constructed in all its architectural aspects, but its sculptures are very coarse, with no good art or design. The objects that have survived from Trajan and Antoninus Pius are excellent, in a perfect style. The same can be seen in the bath of Diocletian, where the sculptures are in an ugly style and poorly made, and the visible remains of paintings have nothing in common with those of the time of Trajan or Titus.

Raphael seems to be the spokesman for a classicist ideal that would reign right up to the time of Winckelmann, and whose last echoes can still be heard in the writings of Berenson.[40] It is remarkable that he makes no allusion to Greece: his only comment is that this was 'the land of inventors and perfect masters of all the arts' with whom he was not acquainted. His cultural world is strictly Roman, although his ideal is that of Hellenistic art in its most classical manifestation.

Raphael expressed this ideal more clearly in painting than in architecture. It was as a painter that Julius II called him to Rome in 1508 to decorate his *Stanze*. The subject of the first of these, the Stanza della Segnatura, demonstrates in particular the crucial synthesis of the pagan and Christian worlds. In the meantime the artist drew the ancient works that he saw in Rome and gradually built up a repertoire, as yet unique, of all the works that were known at that time.

Raphael altered the models that inspired him. When he drew the *Venus Genitrix* for the Sassi Palazzo he immediately turned her into a Judith brandishing the head of Holofernes. When, in the same collection, he designed a male bust, he varied its position to turn it into a captive barbarian, as though he had a living model that he could study from every angle. Similar prototypes can be recognized in Raphael's works, which he used over and over again. But as his

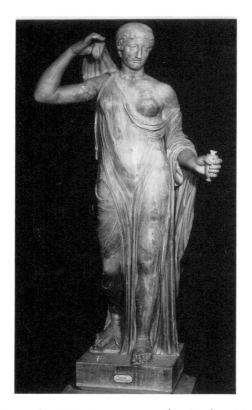

Plate 27 *Venus Genitrix*, Roman copy of a Greek original, Naples,
Museo Archeologico Nazionale.
Photo: Soprintendenza Archeologica della Provincia Napoli e Caserta.

workshop expanded he gave his pupils the task of making copies of
these as records.[41]

One of Raphael's fundamental problems was to compete with
the classical artists in decorative art: this is already visible, after he
had completed the Stanze, in the cartoon of the tapestries, but it is
particularly evident at the Farnesina, in the bathroom and loggetta
of Cardinal Bibbiena, and then in the Logge of the Vatican. In
architecture Raphael judged that Bramante had already achieved this
objective.[42] In his letter to Leo X he states that

> it has happened that in our times architecture has bestirred itself and
> come close to the style of the ancients, as we see in the many lovely

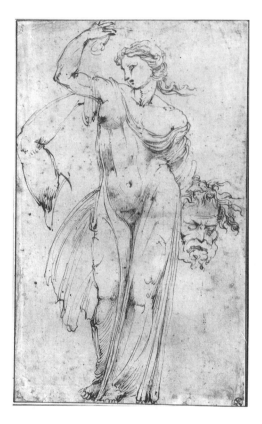

Plate 28 RAPHAEL, *Judith*, drawing, *c*.1510, Graphische Sammlung, Albertina, Vienna.

works by Bramante; nonetheless [his] decoration does not use precious materials, as the ancients did, who seemed to achieve the things they desired at great expense and to overcome every difficulty.

For the Logge he set himself the task of outdoing the splendour of the great palaces of imperial Rome by adding three elements to the grotesque style, which by now were enriched by elements of fantasy and conceived according to classical canons: firstly, scenes in white stucco, for which his pupil Giovanni da Udine had rediscovered the formula; secondly, floral elements of the garlands which give the loggia its character of something between a garden and a palace; lastly, the biblical heaven, which covers the vaults and the floor in imitation of a mythological story.

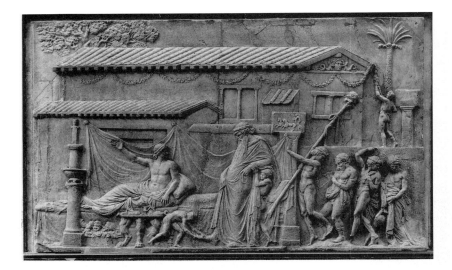

Plate 29 *Dionysus Visiting the Dramatic Poet*, Roman copy of a
Hellenistic relief, reproduced by courtesy of the Trustees of the British
Museum, London.

Almost all the figures which make up the stories exhibit the art-
ist's studies of classical models – God the Father and Noah, for
example, have the appearance of a drunken Dionysus. Here the
blending of Christian and classical is perfected, though the latter is
by now decidedly dominant.

Generally speaking, at the beginning of the sixteenth century, Ital-
ian artists had built up such an affinity with classical art that in the
rest of Europe, where the culture of archaeology was far less well
established, it was common that objects or decorative motifs in the
classical style were genuinely mistaken for Roman works of art. One
typical example occurs in the accounts of the castle of Gaillon, built
by Cardinal d'Amboise: French workers mistook the medallions of
Roman emperors, made by contemporary Italians, for antiques.[43]

Michelangelo and the break with classicism

The classicism which characterized Raphael's last great decorative
compositions contained the seeds of the crisis among his pupils which
became apparent shortly after the death of the master and has be-
come known as 'mannerism'. For each of these artists the classical

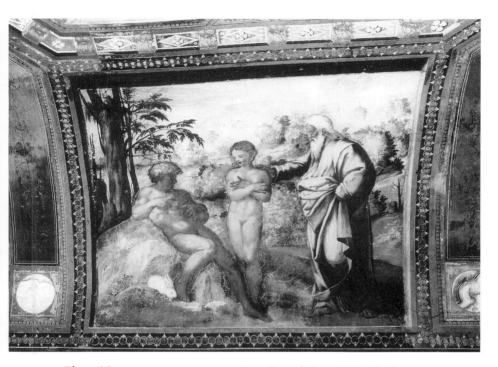

Plate 30 TOMMASO VINCIDOR, *Creation of Eve*, 1517–19, Rome,
Raphael's Logge, Vatican.
Photo: Vatican Museums.

foundation was of critical importance. In Mantua Giulio Romano
developed a style based on the reliefs of Roman sarcophagi that
tended towards gigantism. In Genoa Perino del Vaga interpreted
Raphaelism in a more graphic style, taking his main inspiration
from Roman painting and smaller objects. In Rome Polidoro da
Caravaggio exhibited his knowledge of classical figures in the
chiaroscuri on the façades of houses and graffiti as well as in paint-
ing.[44] All of them had a vast knowledge of Roman art and made
quantities of drawings. As Smyth has quite rightly pointed out,
mannerist painting in central Italy depended on the repertoire of
figures on Roman sarcophagi and its great variety of violent poses
that break with the classicism of the models.[45]

The artists certainly had plentiful material to draw on, which
allowed them to find many variations on the poses delineated, which

Plate 31 GIOVANNI DA UDINE, *Dionysus*, detail of stucco under an
arch, 1516–19, Rome, Raphael's Logge, Vatican.
Photo: Vatican Museums.

they sought to make 'serpentine'. Classicism was therefore a crucial
point of departure, but did not overlap with the desire to conquer
that characterized the beginning of the century. By this stage the art-
ists had mastered a vast cultural knowledge and studied the reliefs
that led them to an almost romantic form of archaeology. More-
over, Raphael's tendency to select models became more and more
rigorous. If we examine the drawings of ancient works in the numer-
ous sixteenth-century codices that have been preserved it is surpris-
ing to see that, though the repertoire is enormous, it is of a highly

stereotyped form, and that often the artists did not feel it necessary to see the original works, but were content to copy the drawings that already existed. In this way, assured in their knowledge of the ancients and by now also of the great modern painters, Raphael and Michelangelo (to whom they considered themselves to be equal), artists merely ended up with repetitions of tired academic formulae.

It was the works of Michelangelo, rather than those of antiquity or of Raphael, which provided the point of departure for mannerist painting. Michelangelo had studied classical art from his childhood, as he worked alongside Bertoldo in the Medici garden. One of his first works, the *Battle of the Centaurs* preserved in the Casa Buonarroti, clearly shows that he studied the original Roman models, though his imitation is by no means slavish and his use of alabaster suggests he may have been inspired by Etruscan urns.

The most typical example of classical inspiration is that of his *Cupid*, which Michelangelo, at the age of twenty, passed off as a fake. The story is well known:

> [Michelangelo] then immediately started work on another marble figure, a sleeping Cupid, life-size. When this was finished, Baldassare del Milanese showed it as a beautiful piece of work to Lorenzo di Pierfrancesco, who agreed with his judgement and said to Michelangelo: 'If you were to bury it and treat it to make it seem old and then send it to Rome, I'm sure that it would pass as an antique and you would get far more for it than you would here.' Michelangelo is supposed to have then treated the statue so that it looked like an antique; and this is not to be marvelled at, seeing that he was ingenious enough to do anything. Others insist that Milanese took it to Rome and buried it in a vineyard he owned and then sold it as an antique for two hundred ducats to Cardinal San Giorgio . . . All the same this work did so much for Michelangelo's reputation that he was immediately summoned to Rome to enter the service of Cardinal San Giorgio, with whom he stayed nearly a year, although the cardinal, not understanding the fine arts very much, gave him nothing to do.[46]

The reaction is quite typical: the deception helped to launch Michelangelo, creating his reputation of equalling and surpassing the ancients.

In the works that followed, particularly those he did in Rome, his knowledge of Roman art expanded. But soon his approach diverged from that of Raphael: in the wide range of types offered by Hellenistic art Michelangelo tended more towards the works of those schools which expressed a kind of classical 'baroque', or, to put it

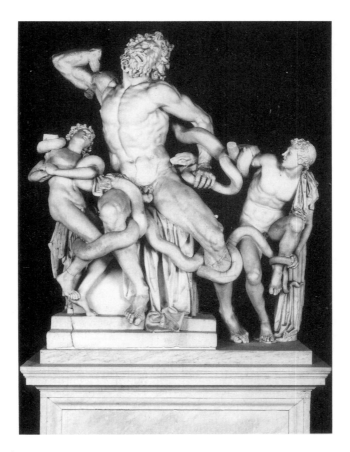

Plate 32 *Laocoon*, Hellenistic original from Rhodes, *c.*second
century BC, Rome, Cortile del Belvedere, Vatican.
Photo: Vatican Museums.

more simply, which were characterized by their anti-classicism. He
gave little importance to the gracefulness, so dear to Raphael and his
school, of an *Apollo del Belvedere* or a *Venus Felix*. His preference
was for works such as the *Laocoon*, the masterpiece of the school
of Rhodes, whose discovery had a decisive effect upon him (Raphael
had never been inspired by it) or the massy bulk of the *Torso del
Belvedere*, an important work of the neo-Attic school. Even when
Michelangelo drew inspiration from small objects, he chose them
for the violent physical movements which he would then reinterpret

with greater vigour. This was the case with the *Diomedes*, from a marble relief now lost, which showed the seizing of the Palladium. Its use is evident in many of the nude figures in the Sistine Chapel.[47]

The richness of classical culture in Michelangelo's work is particularly visible up to the completion of the ceiling of the Sistine Chapel (1512), both in painting and in sculpture. It was always interpreted in controversial terms in relation to classical principles, and from the outset opened up the way for the 'mannerist' tendencies which would dominate the third decade of the century.

The same polemical attitude towards classical art is evident in the artist's architectural work. This may be characterized by the famous debate between the supporters of the cornice that Michelangelo added to the Palazzo Farnese built by Antonio da Sangallo. On the pretext that cracks had appeared, probably as a result of inadequate foundations, Sangallo's supporters accused Michelangelo of using classical elements contrary to tradition, and achieving effects of tension that went completely against the classical mode of his predecessor.[48]

In the field of sculpture, the first years of the Cinquecento saw a classical tendency, strongly influenced by Raphael, that existed parallel with Michelangelo, represented in particular by the work of Andrea and later Jacopo Sansovino and Baccio Bandinelli. But Michelangelo's influence was ultimately to triumph, sweeping sculptors along in the same wave of anti-classicism. This did not diminish the importance of the relationship with classical art that all these sculptors had, which was even closer than that of the painters, probably because the knowledge of technique encouraged such an affinity. Many sculptors were called to Rome as young men to restore antiques, just as Stefano Maderno, François Duquesnoy, Algardi and Bernini were to do at a later date. Lorenzetto, a mediocre sculptor of Raphael's circle, had organized the Valle collection, and restored the pieces. Montorsoli, though clearly mannerist, was employed by Michelangelo to restore antiques for Clement VII; he was responsible for the intervention on the *Laocoon*, which is now separate from the original group and displayed at one side, on the pretext that it distorted the balance, accentuating the anti-classical open posture of the arms. In 1520 Baccio Bandinelli was commissioned to make a life-size copy of the *Laocoon* (finished in 1525), now in the Uffizi. A little later Guglielmo della Porta was paid for a head of Antoninus Pius and the restoration of a *Cupid*.[49] Other artists grounded themselves in classical art, and began to practise as goldsmiths like Cellini, medallists like Leone Leoni, or stone-cutters like Annibale Fontana. The sculptors, however, did not have much

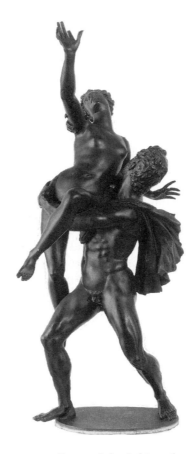

Plate 33 GIAMBOLOGNA, *Rape of the Sabines*, bronze, 1579, Naples,
Museo di Capodimonte.

respect for antique restorers. Though Cellini enjoyed cleaning and
restoring, together with Cosimo, the statues that were discovered at
the same time as the Arezzo *Chimaera*, it was a great concession on
his part to put his hand to the bust that was to become *Ganymede*,
and he was careful to note: 'it's not for me to patch up statues – the
sort of work done by botchers, who still make a bad job of it.'[50]

In the second half of the century it was the turn of Giambologna,
an artist of Flemish origin, to go to Rome to study the art of anti-
quity. On his way home he stopped at Florence, and remained there
for more than half a century, working a profound change in the

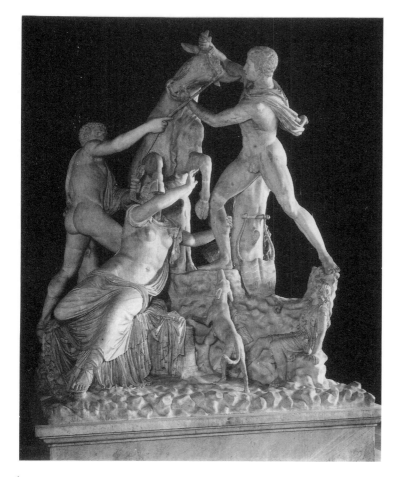

Plate 34 *Farnese Bull*, copy from the Antonine period of an original
from the middle of the first century BC, Naples, Museo Archeologico
Nazionale.
Photo: Soprintendenza Archeologica della Provincia Napoli e Caserta.

development of Italian sculpture. This time the objective was to
surpass the ancients. No sculptor of the Hellenistic groups had
arranged a figure with the arms raised over the head of another fig-
ure, but Giambologna at this time conceived the *Rape of the Sabines*
(1579–83). The bronze model has been preserved, originally restricted
to two figures: these are explicit echoes of the figures of Amphion
and Dirce in the renowned *Farnese Bull*, discovered during the

pontificate of Paul III, and of a copy of a famous work of the school of Rhodes. But the artist took them out of their original context and regrouped them in a way that gave maximum stress to the precariousness. This group could not be reproduced in marble. In the final work – now in the Loggia dei Lanzi, where it took the honoured place of Donatello's *Judith* – the artist consolidated the different poses and conceived of three figures, whose echoes of classical art are all the more marked, particularly the head of the old man, which is reminiscent of that of Laocoon. Thus, with explicit references to Roman art, the sculptor brought about the last revolution before the baroque era.

Peculiarities of art in Venice

We have followed the development of art in the Renaissance almost exclusively in central Italy, between Rome and Florence. During this period a classical style in art was developing in Venice as well, but based on very different principles. Here artists were not overwhelmed by the magnificence of ancient Rome, nor were they used for the purposes of propaganda as a means to enable the reconstruction of the past, as the popes desired to do. Their view is never archaeological and was linked less directly to a return to the past. Their vision, which ran parallel with another kind of humanism, was one of an idealized antiquity which had nothing overwhelming, and which was often evoked as mythical and benign.

One of the clearest expressions of this tendency is the work of the young Titian in the four paintings he made for the study of Alfonso d'Este in Ferrara. Delacroix and Théophile Gautier observed long ago that Titian was the artist who came closest to the ancients. He achieved this without following any kind of intellectual procedure comparable to those being followed in Florence and Rome. It is significant that his *Offering to Venus* and *Bacchanal* (now in the Prado) were painted between 1516 and 1519: it was at this time that Raphael was executing his great compositions of decorative art in the classical style. In Titian's work the links with Roman statues are still visible. But his evocations are classical rather than being in a classical style, perhaps because of the different cultural climate in Venice where there were many original Greek works, and especially in the intensity of his colours and the harmony of the chromatic relationship between man and nature. This has been underlined by Longhi: 'There is something of Phidias in all young Titian's work:

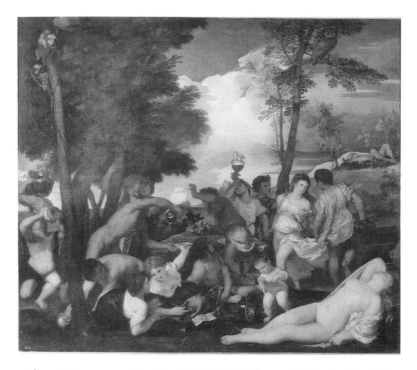

Plate 35 TITIAN, *Bacchanal*, 1518–19, Museo del Prado, Madrid.

his very mix of colour has the living warmth of a Grecian statue; and the same sublimated, guileless sensuality, as compared with that overstated, flagrant sensuality of late Giorgione.'[51] Titian's love for all things classical never left him, and he continued to study classical models. His letter of 1545 from Rome to Charles V mentions the great pleasure that copying gives him. But although this element was always to be an integral part of his culture, he never again equalled that marvellous period in the study of Alfonso d'Este. Not even Tintoretto would reach that level again, despite the importance of the paintings inspired by antique sculptures.[52]

In the humanistic air of Venice the evocation of an ideal antiquity found expression in the other arts. This was especially marked in architecture, particularly in the work of the Florentine Jacopo Sansovino, who established himself permanently in the city in 1527,[53] and later, in the second half of the century, in Palladio's master-pieces.[54] The development of this artist is typical of Venetian culture:

his point of departure is not found in archaeology but in his vision
of a perfect antiquity, in which the artist endeavoured from the
outset to realize the teachings of Vitruvius. His villas were built on
principles that were judged to be universal, with a courtyard on the
central axis, rooms of absolute symmetry on either side, as in Roman
houses, and a façade inspired by ancient temples. In the same way,
the Teatro Olimpico in Vicenza (1580–5) follows the reconstruction
of the Roman theatre published by D. Barbaro in his *Vitruvio*.

It has been remarked that when Palladio's works are subjected
to stylistic analysis they do not denote total submission to the rules
that he set himself, and the licence he took enabled him to avoid
academic rigidity. But it must be said that all good artists, even the
most assiduously classical, have always reinterpreted the precepts
that they claimed to follow, and this limitation was the very source
of their strength. The same phenomenon was true of all the great
masters of the eighteenth century.

Pirro Ligorio. Archaeology and scholarship

By the end of the sixteenth century artists in all fields, painting,
sculpture and architecture, produced nothing more than tired repe-
titions of the models which had now been used for more than 100
years, and the classical element was no more than one of several
components.

Scholarship, on the other hand, had made great strides forward.
Historical and archaeological research began to be organized accord-
ing to more modern criteria, particularly with Pirro Ligorio, who
inherited the traditions of the ancient historian from the amateurs of
the fourteenth century, the artists and humanists of the fifteenth, and
lastly from Raphael and Fulvio and their successors. The fifty-two
manuscript volumes which he left are only one section of his planned
treatise on all the works of ancient Rome.[55]

Only a fraction of his research has been published: even today the
greater part is still unedited, among other things the eighteen vol-
umes of the alphabetic dictionary of antiquity dedicated to Alfonso
II d'Este. This was the astonishing *Libro d'antichità*, often consulted
in the seventeenth century and particularly in the circle of Cassiano dal
Pozzo. It bears witness to his immense knowledge not only of archaeo-
logy but of philology as well. The union of these two disciplines,
with particular emphasis on the latter, led the author to examine the

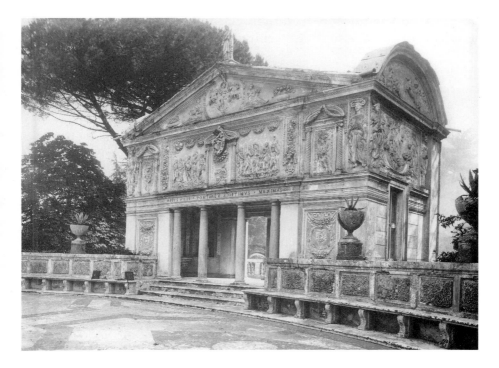

Plate 36 PIRRO LIGORIO, Casino of Pius IV, 1555–9, Rome, Vatican.
Photo: Vatican Museums.

symbolism of monuments in order to understand their 'hieroglyphics'. This problem, which for him was crucial, led to the triumph of hermetism and thus of pure learning over artistic creation.

The same approach was adopted in his architectural works and particularly in their decoration. This was visible in the Villa d'Este which was built for his first patron, Cardinal Ippolito d'Este, and was destined to house the many finds from the archaeological sites that he had organized at the nearby Villa Adriana. But it is even more apparent in his masterpiece – the loggia built for Pius IV in the Vatican. This is covered with decoration in stucco that leaves nothing to chance, where all the elements are part of a strange and complex iconography in a strict programme, for which an explanation has only recently been found.[56]

Caravaggio and Annibale Carracci. Naturalism and classical art reinterpreted from life

It was Caravaggio who provided the strongest and most modern reaction against the culture of late mannerism, by veering towards a complete break with the past and a return to naturalism. This approach dismissed the study of antiquity as unimportant, and it is hard to discover any derivation from sculptural models in his work. But despite his desire to create a completely new art, Caravaggio's work achieves such a quiet greatness, in the superb equilibrium of his compositions, that it is difficult to understand without evoking its remote predecessors, which were almost always present at that time.[57] It is certainly typical of the fundamental classicism of Italian art that the artist who rebelled most violently against tradition and the tired repetitions it encouraged should achieve such a quiet strength which occasionally cannot avoid evoking elements of Hellenism. Perhaps the most striking example of this is the *Beheading of St John the Baptist* in Malta, where the figures are endowed with an absolute strength and serenity that is emphasized by the architectural framework where the drama is enacted.

Parallel with Caravaggio, Annibale and Agostino Carracci in Bologna also broke with the abstract vision of the late mannerists. They breathed new life into their art with the study of nature that was a component of studies of classical art. Raphael's studies were most often used for reference, since he was considered to have been the most successful at reviving classical art, filtering it through his own vision.

Within the broad range of his targets for reform Annibale (a more pugnacious personality than Agostino) was especially critical of those scholarly men who spent their time discoursing on ancient works instead of painting. His attitude is clearly demonstrated in an anecdote that must have become notorious, for it is referred to by Agucchi, a theorist of classicism in Bologna, and by Malvasia and Bellori. When Agostino arrived in Rome to help Annibale in the Galleria Farnese, he began to discourse on the qualities of the *Laocoon* and was astonished by Annibale's silence, which he took to be disapproval.

> While he went on talking to his attentive audience, Annibale turned to the wall and drew the statue with charcoal as accurately as if he had it before him. The others were astonished and Agostino was

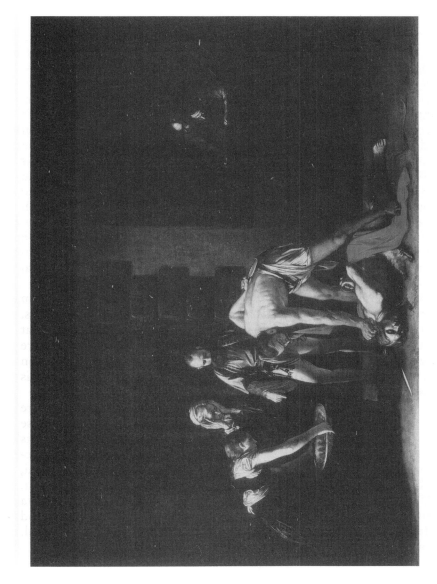

Plate 37 CARAVAGGIO, *Beheading of St John the Baptist*, 1608, Valetta Cathedral, Malta.

silent, and then confessed that his brother had described it better than
he. Then, as he was leaving, Annibale turned to his brother laughing
and said: 'Poets paint with words, painters speak with their works.'
This retort wounded Agostino, who wrote verse and set great store on
being known as a poet.[58]

This criticism is levelled directly against the numerous scholarly art-
ists of the mannerist era, of whom the extreme example was Ligorio,
the man of letters rather than artist. The old polemic that Dondi
inspired was rekindled, with a fresh demonstration of the risks of
giving too much significance to content, to the detriment of form
and artistic technique. For art historians the perils of iconology where
knowledge is defective are made clear.

While they lived in Emilia the Carracci brothers' remarkably broad
cultural base absorbed Venetian and Lombard painting, as well as
that of Correggio. The return to Raphael (and sometimes Michel-
angelo) occurred, yet again, only after their removal to Rome at the
invitation of Cardinal Odoardo Farnese, where they began the dec-
orations of his *palazzo* (1597–1600). The classicism of this period
was enriched by the study of ancient models in a completely natural
way. In their grand evocation of the eternal triumph of love (drawing
on a wide mythological culture for its illustrations) the references to
Roman models are almost a complementary feature of the return to
early sixteenth-century culture. Classical art was to be limited to this
role throughout all the classical trends of the seventeenth century.
The Carracci brothers even went so far as to dispute the return to
the Roman marbles: commenting on the passage in which Vasari
explains that Giambellino and the Venetians took their models 'from
life', as they had no ancient models to study, Annibale (or Agostino)
noted that 'The ignorant Vasari doesn't realize that the great masters
of the past forged their works from life, and he judges a good artist
by the secondary objects, which are those ancient objects, rather
than the first and most important objects, which are living things,
and which should always be imitated.'[59] The influence of classical
art is still very powerful but direct imitation is being replaced by
examining the exact principles which brought about the miracle.

It is certainly significant that very few drawings by the Carracci
brothers imitating archaeological models have survived. Even so,
there are a few examples, made almost by way of a joke during the
commission for Cardinal Farnese, where Annibale achieved works
that were remarkably close to Hellenistic art. One of these is the
small panel for a clavichord depicting *Apollo and Marsyas* (now in

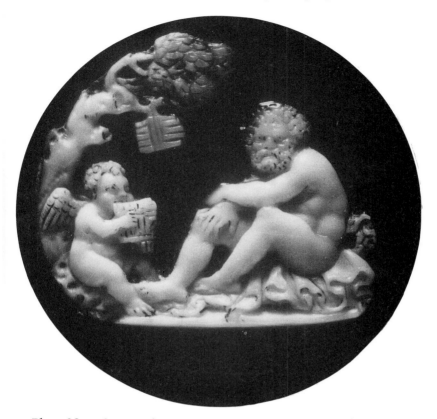

Plate 38 *Silenus and Putto*, Roman cameo in agate, Naples, Museo
Archeologico Nazionale.
Photo: Soprintendenza Archeologica della Provincia Napoli e Caserta.

the National Gallery).[60] The various drawings that relate to the
work give an insight as to how Annibale managed to create this little
masterpiece, which Lanzi remarked could compete with 'the best
paintings of Herculaneum', the rediscovery of rustic painting being
already well under way. For the formation of the group Annibale
used two cameos (plate 38), deriving from these the figure of the
seated Silenus (plate 39, drawn separately on a sheet of paper that is
now in the Louvre); then, in a marvellous water-colour sketch which
can today be seen in the Städtlisches Kunstinstitut in Frankfurt,
he sketched an initial composition with Silenus in front of Eros,
who plays the pan-pipes, just as in one of the cameos. It was probably
after this that he altered the landscape and, most importantly, replaced

Plate 39 ANNIBALE CARRACCI, *Silenus*, preliminary drawing, Musée du Louvre. © Cliché des Musées Nationaux, Paris.
Photo: Réunion des Musées Nationaux.

Eros with Bacchus (plate 40). The latter was in turn inspired by the famous group *Pan and Olympus* (plate 41). Annibale drew the figure (plate 42) directly from the ancient model (the drawing is now at Windsor), faithfully copying even the movement of his fawn-skin, and his copy of the head of Pan is also well known, preserved in the Louvre. Annibale took as his starting point two cameos and the Roman copy of a Hellenistic group of statues (all of which are in the Museo Archeologico in Naples, but which he would have seen in the collection of Cardinal Farnese): such was his intuition of the Hellenistic past that he managed to introduce these elements into an extraordinary landscape, reminiscent of the concise manner of Roman art; using sculpture and engraving he created a small miracle

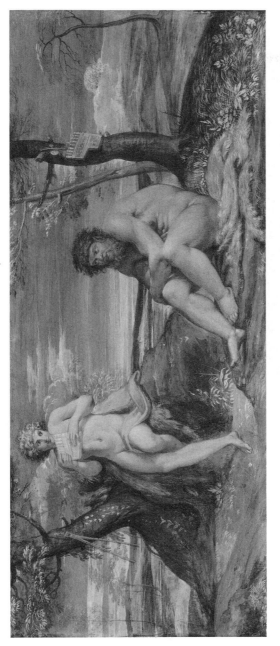

Plate 40 ANNIBALE CARRACCI, *Apollo and Marsyas* c.1599, reproduced by courtesy of the Trustees of the National Gallery, London.

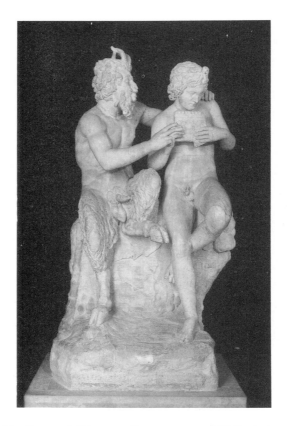

Plate 41 *Pan and Olympus*, Roman copy of Hellenistic original,
Naples, Museo Archeologico Nazionale.
Photo: Soprintendenza Archeologica della Provincia Napoli e Caserta.

of painting. Moreover, he had been an attentive visitor of the ruins
of Nero's Domus Aurea, where, more than anything else, he had
copied above all the fresco of *Hector and Andromache*.[61]

The legacy of Annibale was first handed down to Domenichino,
who developed a poetic interpretation of classicism, in the histories
of St Nilus at Grottaferrata (1608–10), and those of St Cecilia at
San Luigi dei Francesi (1611–14) and then in the apse of Sant'Andrea
della Valle (1622–8). At the same time he contributed to the theo-
retical formula for this movement in his discussions with Monsignor
Giovan Battista Agucchi. It could be said that the study of ancient
sculpture was handed on through Domenichino at a secondary level,

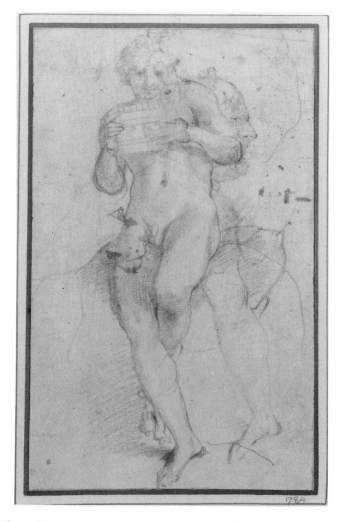

Plate 42 ANNIBALE CARRACCI, *Young Bacchus*, Royal Library, Windsor Castle, reproduced by gracious permission of Her Majesty the Queen.

after the study of Raphael and the teachings of the Carracci brothers, in such a way as to be passed through a series of filters.[62] This was true of the other Bolognese painters living in Rome at the beginning of the seventeenth century, Francesco Albani and Guido Reni, though Guercino, with his more sentimental temperament and more chromatic

quality, rarely assumes such a clear-cut position. Thus, the classical movement at its height, during the pontificate of the Bolognese Pope Gregory XV who encouraged the work of his fellow citizens in Rome, was founded on the ancient past in a quite indirect way.

Poussin and Cassiano del Pozzo.
Nostalgia for the past

This situation changed with the next generation and with Poussin who, though born a Frenchman, must still be considered within the scope of Italian art history: he arrived in Rome in 1624 and made his home there, to such an extent that when in 1640 Cardinal Richelieu invited him to Paris to work for Louis XIII, he accepted but in less than two years was back in Rome, where he remained until his death in 1665.[63] At first Poussin did not tend towards classical art. In the famous competition in San Gregorio al Celio which had set Domenichino against Reni, Poussin openly supported the former and copied his *Flagellation of St Andrew*, while the Romans preferred the *Martyrdom* of the saint.[64] Thus the Raphaelesque elements became less important, and although the artist sometimes made references to the great master, to his followers or to the engravings of his workshop, his relationship to Raphael was always filtered through the classical culture of the early seventeenth century. But soon Poussin turned his attention to a very different world, Titian's *Bacchanalia* series, which were then at the Villa Ludovisi and which were to prove crucial factors in the development of his art towards the classical.[65]

It was from these works of the young Titian that Poussin took his inspiration for the greatest masterpieces of his own youth, masterpieces which often depict the same Dionysian themes with unparalleled passion. And yet it was through these Venetian paintings that Poussin was brought to the study of antiquity, which he examined more closely than anyone else and which inspired him during the first years in Rome to create the *Giochi di Putti* of the Incisa Collection of Rocchetta, where the limpid colours achieve a result that is surprisingly close to antique paintings, although iconographically the direct model was a sarcophagus.[66]

In around 1630 Pietro da Cortona disputed the classical position defended principally by Poussin and seconded by Andrea Sacchi, in a famous debate on composition in painting that took place within the Accademia di San Luca. Sacchi and his friends, supported by the Brussels sculptor François Duquesnoy and to some degree Algardi,

praised clarity and therefore a smaller number of characters, while Pietro da Cortona opposed this, thus opening up the road to baroque art. In fact these artists had far more in common than they believed, despite the violent arguments that went on between them. Their cultural base was also favoured by antique dealers of the time who gathered rich collections of antiques in their houses.

The group is dominated by the personality of Cassiano dal Pozzo, an aristocrat of Turin who, having been the librarian of the Barberini family, went on to be antiquarian for the pope and Queen Christine of Sweden. In about 1620 he took on the editing of a vast encyclopaedia illustrating all aspects of life in antiquity: in public and private life, religious and secular customs, this was a kind of imaginary museum which aimed at embracing all knowledge of illustrated antiquity, and which certainly represented the most important work in this field in that century. The greater part of the *Museum Chartaceum* is now in Windsor and the British Museum in London, and according to Carlo Dati the whole work consisted of twenty-three volumes, if Cassiano's brother Carlo Antonio is to be believed. Its interest is primarily as a source.[67] In his brief description of the five albums drawn by Pietro Testa, Baldinucci writes:

> The first of these is full of drawings of bas-reliefs and ancient Roman statues, which embrace all those things that belong to false beliefs, from deities to sacrifices. In the second he included drawings also taken from ancient sculptures, wedding ceremonies, the customs of consuls and matrons, inscriptions, customs of artisans, funeral topics, theatre, country things, baths and meals. In the third you will find Roman stories and fables, drawn with great skill from the reliefs on triumphal arches. The fourth contains vases and statues, various ancient tools and other objects of interest for scholars. Finally in the fifth there are the figures of Virgil and Terence from the Vatican, the mosaic from Sulla's Temple of Fortune in Praeneste, now Palestrina, and other items in colour.[68]

Cassiano provided the continuation and renewal of Ligorio's work, whose *Dictionary* he knew. He was also acquainted with Bellori, the theoretician of classicism responsible for numerous publications of an archaeological kind, whose collection is illustrated in the *Museum*, and with his collaborator P. S. Bartoli, who succeeded him in 1696 as antiquarian to the pope.

Along with the marbles and antiquities, paintings and drawings in his house (for he was also a connoisseur) Cassiano dal Pozzo had accumulated the most heterogeneous objects: skeletons, anatomical

tables, live birds, medals, mechanical instruments, to which he often alluded in his scholarly correspondence and whose enumeration forms the impression of a kind of late Renaissance *Wunderkammer*. But the climate had changed: the magical, fantastic atmosphere which characterized the first cabinets of curiosities, as well as the books of Ligorio, had given way to a rigorously methodical spirit which revealed more clearly the science of archaeology. Cassiano, who was in correspondence with Father Kircher, Peiresc and Gassendi, but also with Campanella and Galileo, was the author of works on botany and a pharmacopoeia.

However, the taste for collecting antiques was not the monopoly of Cassiano dal Pozzo. This hobby, which went hand in hand with an interest in the natural sciences, was cultivated by many rich noblemen. A most vivid portrait of some of them has survived in the *Pinacotheca* by Giano Nicio Eritreo, which was used as a *trait d'union* among the great families and artists of the time.[69] Still it was the figure of Cassiano which emerged most sharply among them and around him gravitate Nicolas Poussin, François Duquesnoy, Pietro Testa and Pietro da Cortona who, according to contemporary biographers, were part of the group commissioned to draw the antiquities for the *Museum Chartaceum*. The inventory of the English volumes was made very quickly, but it is not clear to what extent these four artists were involved with the work. The publication of the codex, now in Florence, includes most of the drawings in the London and Windsor volumes, and perhaps can give the answer to the riddle: the hands of Poussin and Testa are visible here, and, just as in other examples where original archaeological drawings by Poussin have been preserved, the drawings of the 'Museum Chartaceum' include 'fair copies' of the great masters, next to the folios that go back to the sixteenth century.[70]

Bernini and the new classicism of the baroque movement

The formation of such an apparently disparate group of people shows that these men had a common culture, in spite of their diverging allegiances to classical or baroque tendencies in art. Pietro da Cortona, spokesman for the baroque in the controversy in the Accademia di San Luca, had long been a student of classical antiquity, as had Rubens before him. In a still unpublished codex, now in Toronto, are his drawings of Roman statues and the reliefs of Trajan's Column,

imperial reliefs from the reigns of Trajan, Marcus Aurelius and Hadrian; the epic tones of these drawings must surely be expressive of the artist's temperament, jumbled up with copies of the graffiti of Polidoro da Caravaggio for the façades of the Palazzo Milesi and Palazzo del Bufalo, which by now were part of the classical repertoire.[71]

Similarly, Bernini and Poussin had a great deal in common and shared the conviction that the artist must be well educated, that decoration should be appropriate to the subject-matter and that historical subjects were the worthiest of illustration, and lastly that ideal rather than natural beauty should be represented simultaneously in the study of antiquity and the study of Raphael, who by now was placed at the same level as classical antiquity.

There were several occasions, moreover, when Bernini expressed his admiration for Poussin: he declared to Fréart di Chantelou, 'Truly that man was a great painter of histories and fables', and during his visit to Paris he took leave of his host with the words 'You have filled me with disgust today, by showing me the virtue of a man who makes me know that I know nothing.'[72]

As far as the attitude of these artists towards classical antiquity is concerned, the most that can be said is that Poussin had a deeper knowledge of the past, particularly from a documentary and literary point of view. As such, his position as scholar undoubtedly placed him in an elite cultural circle which had no heirs, whereas the baroque movement, which enjoyed the consensus of a wider social group, lasted for more than a century.[73]

The choice of models generally reveals diverging tendencies. The classicists preferred the Roman or Greek compositions of bas-reliefs, while the baroque artists favoured the monumental group sculptures that came from the schools of Pergamum or Rhodes, like the *Laocoon*. But these are only rough distinctions, which do not allow a complete explanation of the distance that separated the final results of the two groups. The best method of evaluating that distance is to follow the various stages that made up the creative process of Bernini and Poussin, and this method has been brilliantly applied by Wittkower.[74] If we take as an example the *Massacre of the Innocents* in the Musée Condé in Chantilly, the preparatory drawing (now in Lille) shows how the artist took the idea from an engraving by Marcantonio Raimondi which illustrates the same subject taken from a drawing by Raphael; but he then transformed it into a composition which could almost be called baroque, constructed on a series of diagonals which cut across the space. However, on his canvas Poussin controlled

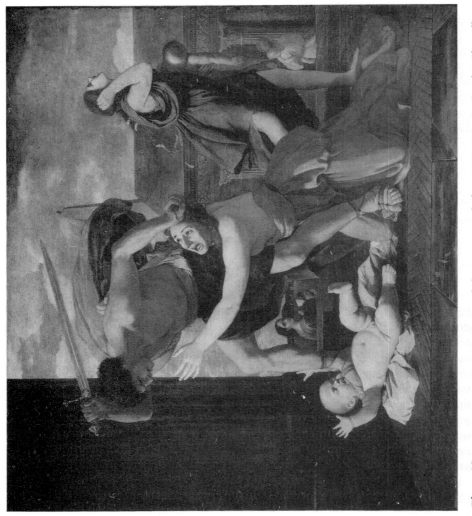

Plate 43 NICOLAS POUSSIN, *Massacre of the Innocents*, before 1630, Musée Condé, Chantilly.
Photo: Photographie Giraudon.

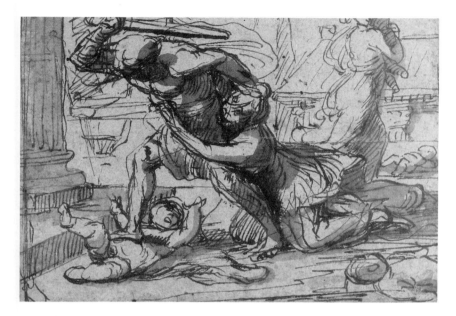

Plate 44 NICOLAS POUSSIN, *Massacre of the Innocents*, preparatory
drawing, Musée des Beaux-Arts, Lille.

his groups more closely, reducing the number of figures, and intro-
duced classical models – in particular a figure derived from a sar-
cophagus and a tragic mask – in such a way as to show his characters
more clearly as expressive individuals.

Bernini's procedure is completely different. In his youth the artist
was broadly inspired by the Greek repertoire. It is well known that
the *Capra Amaltea* in the Galleria Borghese was considered to be by
an unknown hand or even a classical work until Longhi recognized
one of the artist's first works (1615). The Apollo in the group *Apollo
and Daphne* was directly inspired by the statue on the Belvedere,
and *David* was conceived on the model of the Borghese *Guerriero*.

Among Bernini's later works *Daniel* in Santa Maria del Popolo
(1665) is particularly important. Five preparatory drawings survive,
the first of which (Lipsia) should not necessarily be considered directly
in relation to the statue but as an exercise based on the *Laocoon*.
The following stages show how the artist moved steadily away from
the model, gradually modifying the position of the limbs and lengthen-
ing the proportions until he achieved a baroque composition that

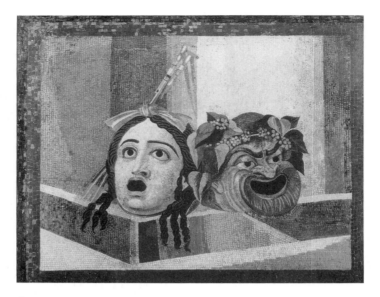

Plate 45 Tragic mask, Roman mosaic, Rome, Musei Capitolini.
Photographic Archive, Rome.

was entirely independent of the original. Classical art was a point of departure for Bernini, while for Poussin it was a goal to be reached via a strictly rational and intellectual approach.

In sculpture the classical movement was represented by Poussin's friend François Duquesnoy, nicknamed 'Il Fiammingo', and by Algardi, whose fame was at its height just as the glory of Bernini began to fade, during the pontificate of Innocent X. Algardi had come to Rome to broaden his knowledge of antiquity and was sent to Cardinal Ludovico Ludovisi, nephew of Gregory XV, by the Duke of Mantua. The young sculptor began to restore the statues collected by the cardinal in his Villa del Pincio (1626–31). After this he was commissioned by Innocent X's nephew Camillo Pamphili to refurbish the Villa del Belrespiro, now the Villa Doria Pamphili, and to furnish it with hundreds of antique fragments (1644–52). These fragments had a crucial role in this ambitious work, to the extent that the façade of the villa was conceived around them. Algardi designed the decorative classical stucco of the rooms, surely one of the most characteristic of its kind in the seventeenth century, and supervised the restoration that was necessary to the fragments he used. It is not yet known which parts of the work can safely be

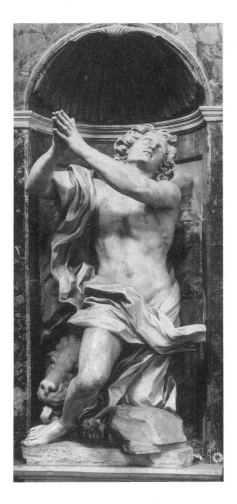

Plate 46 GIANLORENZO BERNINI, *Daniel*, 1657, Rome, Santa Maria
del Popolo.
Photo: Archivi Alinari.

attributed to him. But the essential problem is to decide to what
extent the restoration work that was completed in his workshop
may be considered as an example of real integration, based on a
precise idea of antique sculpture. Such an idea deserves a closer
examination, since it has been observed that these integrations aimed
at completing a work without ever harming its own unity.[75]

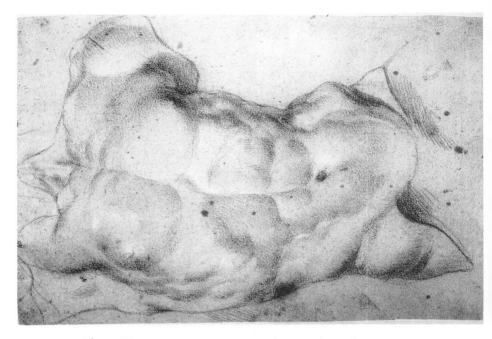

Plate 47 GIANLORENZO BERNINI, drawing from the *Laocoon*,
Museum of the Visual Arts, Leipzig, Stadtbibliothek.

Wittkower's observations on the culture of Poussin and Bernini
also prove highly relevant when applied to architecture. Indeed the
representatives of the classical movement, Bernini, Borromini and
Pietro da Cortona, were just as influenced by their knowledge of
classical antiquity, if not more so.[76] In the case of Bernini evidence
of this can be seen in the colonnade of St Peter's or the Baldacchino
(altar canopy), where at first the artist intended to use the original
antique column, before he altered its proportions. The question is
rather more controversial in the case of Borromini, whose anti-
classicism has often been underlined, as well as the fact that Bernini
charged him with heresy, although there were numerous classical
elements in his works. Either way, the interpretation of these ele-
ments is of critical importance. Among the last vestiges of the Ro-
man world, which are the bedrock of his cultural education, the
architect systematically sought out alien, mysterious elements, un-
familiar to the classical taste, that would stimulate the imagination:
the play of curves, perspective and light in the Villa Adriana, which

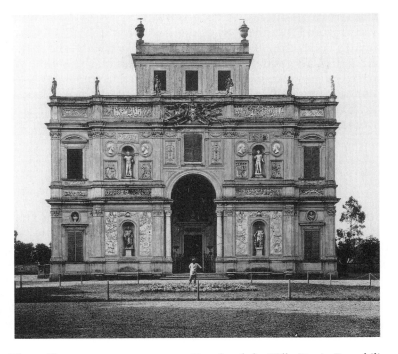

Plate 48 ALESSANDRO ALGARDI, Façade of the Villa Doria Pamphili,
1648, Rome.
Photo: Archivi Alinari.

he worked at over a long period of time; the hexagonal structures of a little temple drawn probably by Montano, which gave him inspiration for Sant'Ivo della Sapienza, or lastly the astonishing diminishing perspective (which had undoubtedly already been observed by Montano in his engraving) of a tomb in the Via Appia, which he used in the Palazzo Spada.

This contrast between the two approaches to understanding and imitating classical antiquity is highlighted by comparing Borromini's fantastic project, which he put forward to Cardinal Pamphili for his villa outside Porta San Pancrazio (the description survives, with notes and drawings), and the classical solution proposed by Algardi and Grimaldi, which their patrons selected as they could more easily identify their aspirations to erudition. But Borromini's project is based on a very detailed knowledge of Roman architecture mostly based on texts, and proposed a central vault like the one described by Suetonius in Nero's Domus Aurea and 'over all . . . the statue of

Pope Innocent, positioned in such a way that on 15 September the sun's rays would kiss the foot of the statue at the hour in which he was made Pope; this idea was used by the ancients and Baronius describes it'.[77] The audacity of this conceit, which the author strives to justify by producing references to antiquity, could not win the consent of a family that aspired to an established place in tradition, rather than experiences projected towards the future, as baroque ideas tended to do at that time.

Academicism and free inspiration in the eighteenth century

The death of Alexander VII in 1667 marked the end of a glorious era for Rome. From then on papal patronage fell into a rapid decline and the Eternal City lost its cultural prestige. It continued to attract foreign artists, but they now came not to find work but to study antiquity, although this aspect of their training was not fundamental to their art.

The popes were worried by the sight of Roman marbles working their way to northern Europe, where they enlarged the collections that were beginning to be established, particularly in England. Innocent XI was forced to forbid their export, a measure that was confirmed by Clement XI in the edicts of 1701 and 1704. It was Clement who conceived the idea of creating a new museum of antiquity in the Vatican, continued by Clement XII, Benedict XIII and Clement XIV (1769–74), who finally began to build the new museum named the Pio-Clementino.[78]

This archaeological fervour was particularly noticeable during the pontificate of Clement XII (1730–40), who had the distinction of opening the first museum of antiquities to the public on the Capitoline, and who displayed a special interest in architecture. He was responsible for the famous competition for the façade of San Giovanni in Laterano in 1732, won by the Tuscan Alessandro Galilei with his most classical proposal, which blended Roman culture with elements reminiscent of Michelangelo.[79]

But by now it would be incorrect to refer to a strictly Italian culture. Today it may seem excessive to interpret Galilei's style in terms of the influence of neo-Palladian English architecture, and we must acknowledge a certain originality within the culture of Rome. Nevertheless, there were by now frequent exchanges, particularly with English and French artists who met in the academies. Rome

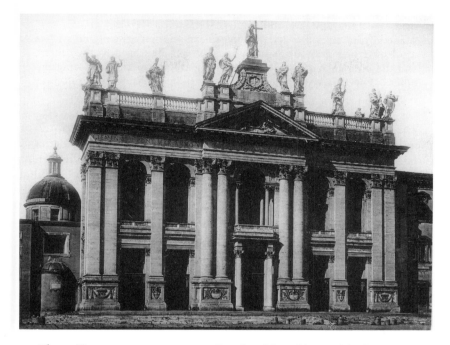

Plate 49 ALESSANDRO GALILEI, Façade of San Giovanni in Laterano, Rome.
Photo: Archivi Alinari.

still had an important role, but the artists who lived there were no longer necessarily Italian.[80]

Painting and sculpture at the beginning of the eighteenth century were dominated by an essentially baroque and rococo movement, where the study of antiquity was of secondary importance.[81] It held no interest for the majority of artists, who now extolled free inspiration and fancy and the 'sketch', and rejected a training based on the study of Roman statues. Antonio Balestra, a painter in the school of Maratti, faithful to the precepts of his master and in open conflict with the new rococo movement, wrote a letter in 1773 that is highly relevant to this issue:

> The evil derives from the pernicious practice now introduced in all the schools, of not studying anything except what is in their own imaginations, without having learnt to draw or to compose upon sound models and along sound principles. We no longer see young men go

to draw and study antiquities; on the contrary many ridicule such study as futile and harmful; and if sometimes a young man is persuaded by his reason or by some person of wise judgement and wishes to observe and draw from antiquities, he will be teased by the others, and the poor man will be shamed into giving it up and following the others. For this reason I predict that poor painting will fall into ruins.[82]

The first reaction is visible not in great art but in antique or pseudo-antique statues and reliefs, which were in growing demand outside Italy. The most important personality in this field was Bartolomeo Cavaceppi, who began his career as restorer to Cardinal Albani when the latter sold an important collection to Clement XII in 1733–4 for the newly created Capitoline Museum. Cavaceppi produced an enormous amount of work, ranging from restorations of varying interest to reproductions and copies.[83] He continued to work for Cardinal Albani, the leading collector in this field in Rome. Using the many contacts he had made in English society through his diplomatic role as ambassador of the Holy See in England, he managed to unite his cultural interests with extensive commercial activity: building up collections was not just an investment, but the basis for a highly lucrative activity.[84]

Within this cultural context some painters still followed the classical path, in the footsteps of Maratti. The most famous of these was Pompeo Batoni of Lucca, who after his arrival in Rome in 1727 dominated the scene for about sixty years. We know that he developed his art studying the frescoes of Raphael and the Carracci brothers, as well as the statues in the Belvedere, which he was not above copying. As a poor young artist he gained his first success when he sold these and similar drawings to the English. Later, as well as his great religious compositions, he did portraits of travellers on the Grand Tour. It is significant that the most famous models which he liked to arrange in the backgrounds of his pictures had not changed since the Renaissance: the *Apollo*, *Ariadne*, *Hermes*, *Laocoon* again conveyed the same Greek aspirations that they had in the early sixteenth century.[85]

Piranesi and his deviant antiquity

Alongside this academic tendency the only artists in Italy who exalted classical antiquity were the *vedutisti* and landscape painters,

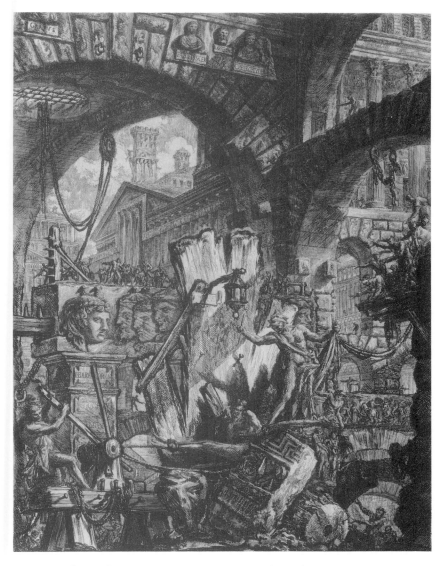

Plate 50 GIAMBATTISTA PIRANESI, Etching from *I Carceri*.

to whom ruins worn away by the elements were an especially impor-
tant part of the poetry of the past. However, about half-way through
the century, Piranesi broke away from this course, to become in time
one of the greatest artists grounded in the knowledge of antiquity: his
engravings disseminated an entirely new vision throughout Europe,
whereby the traditional architectural forms of antiquity gave rise to
a diverging interpretation. Piranesi occupies a place in the history of
Western culture as one of the most characteristic examples of a deter-
mined liberation from classical principles, for the sake of absolute
freedom.

The process was already complete in the collection of the *Carceri*,
where the total overturning of traditional concepts of architectural
structures is clearly in evidence. Wittkower made the astute observa-
tion that load-bearing elements are often transformed into the decor-
ative and the decorative into load-bearing, in constructions that are
strange to the point of arousing an uneasy, nightmarish sensation.[86]

The fundamental idea behind these creations, expounded by the
artist in theoretical form some years later, still consisted in an ad-
miration for Roman art and the conviction that it was superior to
Greek art. Scholars all over Europe were divided into two camps
over this issue. The two positions derived from interpretations of a
famous passage by Vitruvius, declaring that the Greeks had derived
their architecture from the Egyptians, which they perfected and then
handed down to the Romans. Those favouring the Greeks main-
tained that the Romans simply applied their principles but did not
retain the purity of their architecture. The other side claimed that
the Greeks merely repeated the canons of the Egyptians, and it was
the Romans who brought architecture to perfection.

In the collection *De Romanorum magnificentia et architectura*
Piranesi adds his voice against the apologists of the Greek style, who
were particularly numerous in England and France, and took a
stand in favour of Etruscan art, in an astonishingly early anticipation
of the claims of national supremacies that were to develop in the
romantic period. For him it was Etruscan, not Greek art that was
distinctive for the simplicity and purity of its lines, equalled only by
Egyptian art. However, Piranesi changed his mind some years later
and declared himself in favour of decoration, which alone could
allow the imagination to flourish – and to which, it must be said, he
had already had recourse in the *Carceri*. Towards the end of his life,
in his *Diverse maniere d'adornare i cammini ed ogni altra parte
degli edifizi* (1769), though he tended again towards the superiority
of Egyptian and Tuscan architecture, he revised his position on the

Greek artists to one that no longer condemned them, and thus from a theoretical point of view mapped out a partial return to classicist tendencies.

Piranesi's fluctuating theories (which received the response they deserved from the champions of Greek art) did not prevent him from having an enormous influence on his contemporaries. The gigantic, inhuman dimensions he gave to the Roman ruins in his engravings have inspired architects from Russia to the United States, far more than the models themselves, which visitors to Rome sometimes do not even recognize.

The historic vision of neoclassicism and the end of a dialogue

The theoretical field of neoclassicism is dominated by the ideas of two non-Italians who made their home in Rome, first A. R. Mengs, the painter from Dresden, and then particularly J. J. Winckelmann, who came to Rome in 1755 and soon struck up a friendship with his compatriot and later with Cardinal A. Albani.[87] This German archaeologist was therefore able to study the great collection of his protector, and those of the Vatican and the Capitoline as well as other works, to such an extent that he was able to master, as no one had been able to do before, a vast wealth of material through direct experience and his own cultural knowledge. His research eventually produced the *Geschichte der Kunst des Altertums*, published in Dresden in 1764, and then the *Monumenti antichi inediti* of 1767. In these works Winckelmann draws up an analysis of art history based for the first time on a historical method, subdividing it on grounds of style, into great cycles of greatness and decadence, which include above all the archaic style, before Phidias, and then the sublime style, with Phidias and his contemporaries, the fine style from Praxiteles to Lysippus and lastly, until the end of the Roman era, the imitative style, which corresponds to a long era of decadence. This process, analogous to organic development, was to be repeated during the Italian Renaissance, where art before Raphael corresponded to the archaic style, that of Raphael and Michelangelo to the sublime style, the art of Correggio to the fine style and that of the later artists to the imitative style of the Roman era.

These ideas were expounded in a systematic way for the first time, though many aspects had actually been touched upon at the beginning of the Italian Renaissance and Raphael had even expressed

them with amazing clarity. They dominated studies of antiquity for the whole of the nineteenth century. Even today the prejudices that they are based upon have not wholly disappeared, after they were put forward for the last time by Berenson in his book on the Arch of Constantine.[88]

However, it should be remembered that Winckelmann never travelled as far as Greece. With the exception of the excavations at Paestum, for which he was almost entirely responsible, he had almost no direct knowledge of original works. He completely ignored the fact that the works which he considered the great masterpieces of Greek art (such as the *Apollo del Belvedere*, which he described in a famous, highly lyrical passage) were in fact merely distant Roman copies. As for the discovery of the paintings of Herculaneum and Pompei, here his response was simply one of confused enthusiasm, for he certainly did not appreciate their originality of technique, the 'compendiary' style, which is assuredly one of the newest elements of Hellenic art. The taste for linearity which he extols so highly, corresponds more closely to the style of vase painting or to the neo-Attic reliefs and conjures up a very limited and inaccurate image of antiquity. He had no idea of the colours of the temples and statues and never suspected that Graeco-Roman civilization was above all a civilization of colour. The image that he imposed was one of antiquity in black and white, and the consequences of this have been felt right into the twentieth century, until Western culture opened the dialogue with the ancient world.[89]

In philosophical terms Winckelmann's ideal corresponded to the demand for simplification which grew stronger as the Enlightenment spread. Artistically, it corresponded to the search for 'purity'. For the first time this fashion was founded on a broad theoretical base throughout the whole of Europe but paradoxically remained far more distant from the art of antiquity than the classical works of the Renaissance and even, to a certain extent, those of the early seventeenth century.

The study of classical models was at first enlarged by the study of the masters who had shared this ideal. In painting, artists took their inspiration from Raphael (judged as equal to the ancients), and sometimes from Correggio, but also from Annibale Carracci, Guido Reni, Domenichino and Poussin, with the result that the 'filters' began to outnumber the classical sources.[90] In architecture the search for the Greek ideal went back to the creations of Palladio. The 'classical' essence of the style that emerged from these processes was often compromised by academicism and merely had intellectual ties with classical art.

Turning to the popular subjects, we find a continuous moving away from Renaissance and baroque themes. Although Mengs still painted mythological subjects (and exerted a fundamental influence on the Roman scene after his paintings in the Villa Albani, thereby ensuring for himself at least one mention in any Italian art history), these were gradually abandoned, as were religious subjects, in favour of scenes from Roman or Greek history. Society steeped itself in the classical world and painted the themes that illustrated its greatness and its virtues. The most typical example of this phenomenon is the *Oath of the Horatii and Curiatii* which David exhibited in Rome in 1785; it is well known that its exaltation of patriotism found a profound echo among the newly emerging middle class.[91]

In paintings of this kind, i.e. after Mengs, the return to antiquity is noticeable not just in the choice of subject but in the meticulousness that went into the representation of architectural elements, furniture and dress. Artists were no longer interested in reviving the stylistic structures of antique works, and were often convinced that the classical world was brought back to life by painting historic scenes against a background of archaeological precision, where the finds of the new excavations in Campania were often the point of departure.[92]

Rome was still the most important centre, primarily because of its opportunities for study, but by now the protagonists were no longer the Italians.

Cultural horizons had also begun to widen. Even before the Napoleonic campaigns the cult of Egypt had spread from Rome. In some quarters, particularly French and English, Greece assumed an enormous importance, and travellers began to venture there. In Italy Tuscany revealed the importance of Etruscan civilization and lastly, after the wealth of discoveries at the beginning of the century, Herculaneum and Campania excited universal interest. There has been much discussion of the influence that these excavations might have exerted on the formation of the neoclassical style, but there can be no doubt that their wide acclaim was increased by the secrecy that had surrounded them for a long time and by the lengthy delay in publishing the works that made them known. But, as is always the case, their sucess was tied to the fact that their public was prepared to receive them. The excavations were begun at the beginning of the eighteenth century, but the jealous king of Naples had them shrouded in mystery. The illustrations of Cochin (1751) and Caylus (1752–9) left much to be desired. It was necessary to await the publication of eight volumes in folio of the *Antichità di Ercolano esposte*, edited by the Accademia Ercolanese founded by Charles III

(1757–92), and of that on the vases in the cabinet of William Hamilton (1766), whose success immediately opened the way for more manageable publications.[93]

Europe eagerly learned all the rudiments of this vocabulary, and the air of Pompeii was breathed even as far as Russia. The frescoes of Liborio Cocetti, Angelika Kaufmann, Charles Cameron, for example, are only one of the many aspects of a fashion that invaded the palaces of princes, to conquer even their wallpapers.

Even Italian cabinet-making in Rome or Milan does not give an adequate idea of the diffusion of antique furniture, from chairs with arm-rests supported by sphinxes or by swan feet, to three-legged chairs – the history of these has been brilliantly reconstructed by Mario Praz, from their triumphal entrance into the palazzi to their miserable end as stools in provincial hotels. For a more vivid evocation of the Pompeian climate there is even the luxury of serving oneself from porcelain depicting dreamlike themes and animals. In 1782 Ferdinand IV sent to his father in Spain a 'Herculanean' service from Naples of eighty-eight pieces that had taken one year to make.

All decorative elements were derived from the tables in the *Antichità*, and their success was such that there were even improvisations of living copies. In the *Italienische Reise* Goethe describes the evolution of Miss Hart, the future Lady Hamilton, who appeared against a black tapestry background with the same dress and the same veils as one of the most famous ballerinas of the Herculaneum paintings.[94] The fashion set by the *Antichità* was so universal that while the painters used it to place their historic paintings with accuracy, the polite society of Naples applauded its *tableaux vivants*, despite their being performed by non-Italians.

These frivolities are a good illustration of the superficiality of the enthusiasm for the discoveries in Campania, and bring to mind the vogue for photographs in ancient costume which flourished at the beginning of the twentieth century. In their eagerness to learn the style of antiquity the society of the eighteenth century completely neglected its more original artistic aspects; it restricted itself to creating a repertoire of motifs that were stylized according to the canons of the age, with no awareness of the ancient meaning of the models. Moreover, it is highly significant that artists had no hesitation about working from engravings: the difficulties of recognizing the originals gave them no anxiety at all. If we compare the antique paintings restored by Raphael or his workshop, or the evocations of antiquity by the young Titian with those of the eighteenth century,

we shall readily see the abyss that separates the two interpretations – the progressive one of the Renaissance and the nostalgia of the late eighteenth century – obviously from a strictly art-historical point of view, and independently from the use of such examples taken from Greek and Roman history that were adopted to support the ideals of revolution.

This type of aestheticism is accurately reflected, with all its cold precision, in the work of Canova who dominated the Italian scene throughout the neoclassical era, and who indeed was to some degree its flagship. Though it is impossible not to have doubts about his polished groups, crystallized in their perfection (the same detachment towards his classical sources is also typical in his Pompeian paintings), it should also be remembered that in theory he was against imitation. In 1779, soon after his departure from Venice and his arrival in Rome, he wrote about his visit to the Abbot Bonaiuti, who had given him protection and was generous with his advice, saying that the abbot

> told me many things, for example that I should never think that anyone can become a good sculptor by studying the Farsetti statues [i.e. those in the collection of the Venetian, Farsetti], and that I should never desire to create statues of my own invention. That I should not speak to the other young men in the house . . . and again that he would place me under the direction of a good painter so that I could learn to know the beauty of antiquity, and inside I was raging.[95]

Artists rooted in antiquity like Canova and the sculptors of his generation sternly refused to subscribe to the traditional practice of copying. This attitude can be explained through a distinction fundamental for neoclassicists, between the straightforward copy, considered sterile, and imitation, which allowed the artist to grasp the life and spirit of the famous statues of the Roman world.

Canova's broadening mental horizons were evident especially towards the end of his life, when, almost the only man to do so in Italy, he remarked on the true greatness of the Greek art in the marbles of the Parthenon, which had just arrived in London:

> I have seen the Greek marbles. I already had some idea of the bas-reliefs from prints, from a few casts, and even from some fragments of marble. But I knew nothing of the larger figures, where the artist can really display his skill. It may be true that these are the works of Phidias or directed by him, or that he applied his skill to finish them;

these statues clearly show that the great masters were true imitators of nature's beauty: there was nothing about them that was affected, exaggerated or hard, nothing of those things that we would see as arising from convention or geometry. I conclude that the many, many statues that we have which show those exaggerations must be copies made by the many sculptors who copied the great Greek works to send to Rome.[96]

The whole history of Italian art had been bound up with the remains that artists found on their home ground, i.e. essentially with Rome and Roman art. However, in the fifteenth century, and to some extent still in the early sixteenth, they managed to surpass their models and achieve a style that was wholly comparable to that of classical Greek and particularly Hellenistic art, of which they were totally ignorant. This happened through a process of natural filtration and refinement, thus proving a fundamentally progressive and modern attitude in the relationship with the classical past. In the eighteenth century, and especially in the neoclassical period, the return to tradition consisted in an actual process of identification with the past. From the historical point of view, then, the works of Phidias became accessible when they arrived in London, and in Italian art, as all over Europe, artists' ties with the world of antiquity were gradually weakened.

When Canova's most direct and prestigious pupil, the Danish artist Thorvaldsen, took his inspiration from the friezes of the riders on the Parthenon or the traditional Roman repertoire, he had travelled a long way from the spirit of his models, in the search for the simplicity and linearity that lead to purism.[97]

The debate on Graeco-Roman models in the nineteenth century

The political climate under Austrian rule did not encourage a significant return to the fundamental structure of classical art. In painting, historical subjects derived from antiquity were often reproduced with a total lack of originality. Towards the end of the nineteenth century, at the height of the polemic against academicism, these subjects gave rise to the style that was reviled as *pompieristica* ('fire brigade art') because it tended to feature a large number of characters in helmets.

Soon even the study of historic works was forbidden, while the study of texts for historic subjects was encouraged. When the competition for the grand prize of the Milan Academy was launched in 1812, the chosen subject was *Laocoon* but the condition was that it should be treated independently of the Greek group. This formula was important, but though the winner, Franceso Hayez, strove to take his inspiration from Virgil alone he could of course not hide the influence of the original sculpture.[98] The Trojan priest became a kind of trouser-clad barbarian prisoner, and though his face lost all pathos (and, it must be said, all expression) and though the play of muscles is hidden beneath his tunic, the artist could not resist reproducing the raised arm of the statue, paradoxically enough following the arrangement of the sixteenth-century restorer, which has now been altered! Later on, however, Hayez showed no further interest at all in classical statues.

The debate about neoclassical culture and the city of Rome, with which it was associated, began to take precise shape especially in Emilia, where classical decoration had been introduced by Felice Giani, whose personality eludes any categorization and in many ways can be seen as already romantic: 'I have always been against your journey to Rome . . . where now only poets study the pictures and not painters . . . I have told you a hundred times over that you need to study nature and the truth.'[99] With these words, written in 1801 in a letter to the young Pelagio Palagi, Count Aldrovando Marescotti, president of the Accademia di Belle Arti in Bologna, comes down squarely in favour of the study of nature. During the Renaissance the two objectives of antiquity and nature were intimately linked, but the interpretation of Greek and Roman works offered by neoclassicism made their separation inevitable. Still, in Rome Palagi developed his archaeological interests and later was prolifically inspired by them, even though he allied himself with the anti-classicism of Piranesi. In the castle of Racconigi he achieved the reinstatement of a freely interpreted antiquity, dealing simultaneously with other civilizations of the past, from Egyptian to Gothic, Etruscan to Chinese. For this very reason the Graeco-Roman world lost its leading role, to be limited to one component of history among the others.

However, Rome would experience a return to her ancient traditions on two more occasions, in clearly defined political situations.

The penultimate wave of classicism took place at the end of the nineteenth century, when, after the unification of Italy, the country

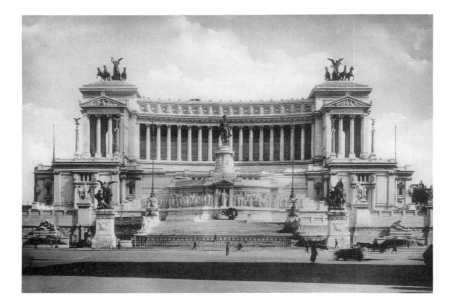

Plate 51 GIUSEPPE SACCONI, *Il Vittoriano*, begun 1886, Rome.
Photo: Archivi Alinari.

needed to fill its piazzas with effigies of the national heroes, often produced in that most unremarkable academic style which then pervaded the whole of Europe.

Rome concentrated on the commemoration of the *pater patriae*, and next to the Campidoglio Giuseppe Sacconi erected the Vittoriano, a rhetorical hymn to ancient and oriental architecture of overwhelming dimensions, which breaks with Roman tradition, not least in the unhappy choice of the *botticino*, whose glaring whiteness sets the monument in isolation.[100]

There was no lack of attempts at classicism in this period, particularly in more conservative Roman circles. The historical paintings of Cesare Maccari in the Senate bear witness to this tendency, with their realism that renders them almost photographic.

The classical heritage blossomed again sporadically in the liberty era. But within the movement In Arte Libertas, founded by Nino Costa in 1886, the artists who looked for innovation, headed by Sartorio and de Carolis, abandoned classical culture once again and established a neo-Michelangelism which was to enjoy a long career in Italian art.

Avant-garde and classical culture. The residues of neoclassicism and the final parting

It might be said that generally the art of classical antiquity gradually lost its *raison d'être* with the growth of Romanticism and the return to medieval art and national traditions. In this new climate only Italy remained tied to it, and indeed the break with the literature and figurative art of the ancient world happened more slowly and less completely there than elsewhere. It became more violent with the avant-garde movements, however, whose abandonment of the past was definitive and brutal, and who wished to fix art in the present. With the exception of a few cases (particularly Picasso who with the breadth of his artistic conception never stopped looking at ancient art with affection), at the beginning of the twentieth century antiquity, now linked with the past and with academicism, effectively disappeared from the cultural horizons of contemporary artists.

Only Italy could not quite untie itself completely, and it is possible to quote many examples of the surviving trend, diluted and unimportant though it had become. In the case of de Chirico, who represented an essentially Italian phenomenon despite his broadly international culture, ancient temples and statues appear repeatedly, intact or as fragments, right from his earliest works. Their shining whiteness and linear perfection still bear out the neoclassical ideal which de Chirico never fully abandoned. When he exalted classicism in *La Ronda* and made a hopeless appeal for a return to the past, the echoes of Winckelmann's effusions can still be faintly heard:

> The fact of classicism is more a problem of trimming and pruning than of adding on. Reducing the phenomenon, the first appearance, to its skeleton, its mark, the symbol of its inexplicable existence. If a Greek painter or an Italian painter of the Quattrocento were to get his hands on a painting of the decadent era where all sense of features or lines, all subtlety of artistic emotion had disappeared, with the task of correcting and classicizing it, his first act would be to clean and clarify and suppress superfluous mass and form, so that he could find the outline of the apparition.[101]

The same cultural tendency, less systematic but just as spirited, is evident in the work of de Chirico's brother, Alberto Savinio. But there are only a few examples; classical antiquity in the works of the two artists was by now situated in an undefined past and took on

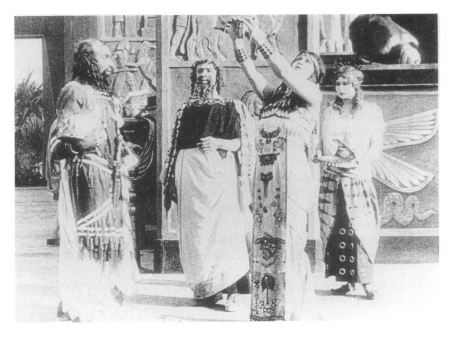

Plate 52 Film still from Giovanni Pastrone's *Cabiria*, 1915.

such a remote dimension that it completely lost that active value of a return to the sources of Western civilization that characterized it right through the eighteenth century and guaranteed its survival.

Alongside these manifestations, which were limited, and influential only in restricted circles, there was from the beginning of the century a movement of the future which was destined to become the culture of the masses: this was filmed costume drama. After *The Last Days of Pompei* by A. Ambrosio and L. Maggi (1908), the crucial production was *Cabiria* by d'Annuzio and Pastrone, a real triumph of spectacular film *all'antica*. The enormous success of *Cabiria* is well known; the genre met with increasing popularity with audiences, until the *colossals* of Cecil B. De Mille and the more recent productions of a trend that is by no means exhausted: Zeffirelli's *Jesus of Nazareth*, for example, fits perfectly into this category, which has often taken its inspiration from Christianity. Because of its past, Italy was and still is a fertile ground for costume cinema; quite independently of the encouragement which produced such films during the Fascist regime for obvious political and propaganda objectives,

there has been an important revival during the fifties which received an enthusiastic welcome in the *Cahiers du Cinéma*.

The costume film genre is, in effect, a further derivation of Hellenistic culture, as were the *tableaux vivants* staged by Miss Hart in eighteenth-century Naples, or, in the atmosphere of the late Risorgimento, the paintings of Roman subjects (such as those by Maccari) or the group photographs of people dressed in togas. Cinema and its techniques made an ancient figurative culture accessible to the masses.

A deliberate return to ancient Rome was attempted one more time in the history of Italy, with Fascism. Certainly the results were not remarkable, despite the great efforts that were made, and in any case they were not results of any cultural content but of pure propaganda. The apparent grandeur of the architectural achievements was due merely to their size.

The 1930s saw the growth of imperial ambitions, as the new regime aspired to the traditions of ancient Rome, and the conquest of Ethiopia was an attempt to realize the dream of empire. The specific model was the reign of Augustus, who became the object of a genuine cult which reached its height in 1937, the bimillennium of the emperor, solemnly inaugurated by Mussolini. One consequence was the greater emphasis on archaeology, especially in Rome; but excavations were hurried through in a frenetic and heedless way, with none of the necessary stratigraphic analyses (one need only think of the Via dell'Impero), and the final result was the demolition of the ancient city centre.[102]

The young architects who made up the 'Group of Seven' had organized two exhibitions, in 1928 and 1931. Here they attempted to impose the rationalist movement, criticizing the flourishes which characterized the years of the monarchy and even daring to attack the official culture, dominated by M. Piacentini and his like. It is well known that Piacentini, his hand strengthened by the support of the regime, managed to undermine the rationalist movement; however, with that transforming ability that characterized his whole career, he also effected a slight conversion which led him to a compromise between the rhetoric and academicism of his previous works and a kind of ultimate reduction of forms. Under his guiding authority arose the monumental groups of buildings in the 'lictorian' style, the Foro Mussolini by E. del Debbio (1933), the Piazza Augusto Imperatore by V. Ballio Morpurgo (1937) and the church of St Peter and St Paul by A. Foschini (1939) and all the other buildings of the universal exhibition of 1942 (the Palazzo della Civiltà by B. La Padula is certainly the most important): all were characterized by an

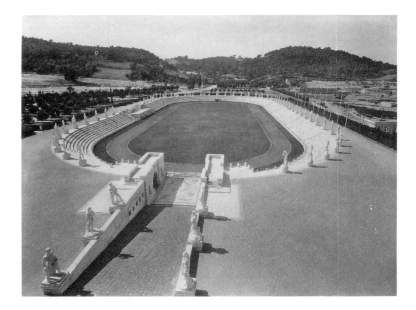

Plate 53 ENRICO DEL DEBBIO, Foro Mussolini, Stadium of Marble,
Rome.
Photo: Archivi Alinari.

accumulation of marble, columns, arches, porticoes, repeated in
symmetry on a monumental scale and modified by the elimination
of ornamental elements. There were the last throes of neoclassicism,
marked most of all by a lack of expressive connotation.[103]

In fact in the same years the great authoritarian states (the Soviet
Union and Hitler's Germany) encouraged a kind of classicism that
was not dissimilar to that we have just described, with a tendency
that perfectly fulfilled the need to erect buildings whose stylistic
elements were taken for granted and whose only new feature was
that they should be built on a colossal scale: in this way cultural
experiments were avoided and the propaganda of the state was re-
inforced by order and grandeur of size. However, while the Russian
architects or Speer and his kind were postulating a return to what
they considered to be the Greek, Attic or Aryan ideal, and even
France tended towards a kind of classicism despite the absence of a
totalitarian political system, this phenomenon in Italy was so closely
tied to the examples that existed in the territory that it gained a

specific dimension through its aspirations to a direct return to *Romanità*. This was the last faded version of the neoclassical vision that had dominated Europe from the eighteenth century: a reduced and limited vision by comparison with the antiquity that had come alive for Western culture wherever it was interpreted in a free and stimulating way.

NOTES

1 R. Longhi, 'Giotto spazioso', *Paragone*, 31 (1952), pp. 18–24.

2 Quoted in particular by d'Essling and E. Muentz, *Pétrarque, ses études d'art, son influence sur les artistes, ses portraits et ceux de Laure, l'illustration de ses écrits* (Paris, 1902), p. 45, nn. 2–3.

3 The much quoted passage from this letter is reproduced and interpreted in particular by E. Panofsky, *Renaissance and Renascences in Western Art* (Stockholm, 1960), p. 209, and also by R. Krautheimer and T. Krautheimer-Hess, *Lorenzo Ghiberti*, 2nd edn (Princeton, 1970), I, p. 295.

4 Ristoro d'Arezzo, 'Mappa Mundi, Destinazione ottava, IV: Delle vasa antiche', in V. Nannucci, *Manuale della letteratura del primo secolo della lingua italiana*, 3rd edn (Florence, 1874), pp. 201–3.

5 Guarino Veronese, *Epistolario, raccolto, ordinato e illustrato da R. Sabbadini* I (Venice, 1915), p. 38. Since then, E. H. Gombrich has brilliantly evoked the personality of Niccolò Niccoli in 'From the Revival of Letters to the Reform of the Arts: Niccolò Niccoli and Filippo Brunelleschi', in *The History of Art presented to Rudolf Wittkower* (London, 1967), pp. 71–82, reprinted in *The Heritage of Apelles. Studies in the Art of the Renaissance* (London, 1976), pp. 93–110, which accepts the attribution of the treatise to Niccoli. Sabbadini, in Guarino, *Epistolario*, III, p. 25, believes the work to be by another 'Nicolaus' whom Guarino mistook for the more famous man. Indeed, if comments of his contemporaries are to be believed Niccolò Niccoli did not write anything except for letters in the vernacular, and according to Sabbadini he could not have committed the crude errors with which Guarino charges him.

6 A. Traversari, *Latinae epistolae*, ed. F. Cannetus and L. Mehus (Florence, 1759), II, no. 35, coll. 393–4, and no. 48, coll. 416–17.

7 Poggio Bracciolini, *Epistolae*, IV, 12, ed. T. de Tonellis (Florence, 1831), I, p. 322.

8 The artistic trends of this period had been studied among others by Krautheimer and Krautheimer-Hess, *Lorenzo Ghiberti*, pp. 52–3.

9 G. Vasari, *Le vite de' più eccellenti scultori e architettori* (Milan, 1962), II, pp. 253–4; English translation by G. Bull (Harmondsworth, 1965), pp. 141–2.

10 See above, n. 8.
11 The head was published and masterfully studied by R. Bianchi Bandinelli, 'An "Antique" Reworking of an Antique Head', *Journal of the Warburg and Courtauld Institutes*, 9 (1946), pp. 1–9, and under the title 'Antico non antico' in *Archeologia e cultura* (Milan, 1961), pp. 276–88.
12 The fullest history of the artist is to be found in the monograph by H. W. Janson, *The Sculpture of Donatello* (Princeton, 1957). Aware of the complexity of Donatello's fruitful relationship with the art of antiquity, the author returned to the same subject in two further works: 'Donatello and the Antique', in *Donatello e il suo tempo. Atti dell'VIII convegno internazionale di studi sul Rinascimento (Firenze–Padova 1966)* (Florence, 1968), pp. 77–96, 11 and i–xv; 'The Revival of Antiquity in Early Renaissance Sculpture', *Medieval and Renaissance Studies*, 5 (1971), pp. 80–102. Also on the question of Donatello and antiquity, see W. Wolters, 'Eine Antikenergänzung aus dem Kreis des Donatello in Venedig', *Pantheon*, 32 (1974), pp. 130–3, where there is an analysis of a statue preserved in the apse of the Church of San Paolo in Venice, an Attic figure of the fourth century BC transformed into St Paul by a sculptor of Donatello's circle.
13 This attractive theory has recently been put forward by L. Bellosi, 'Ipotesi sulle origini delle terrecotte quattrocentesche', in *Jacopo della Quercia fra gotico e Rinascimento. Atti del convegno di studi*, ed. G. Chelazze Dini (Florence, 1975), pp. 163–79.
14 The problem has been taken up by L. Lavin, 'On the Sources and Meaning of the Renaissance Portrait Bust', *Art Quarterly*, 33 (1970), pp. 207–26.
15 A. Warburg, 'Arte del ritratto e borghesia fiorentina. Appendice. Statue votive in cera' (1902), in *idem, La Rinascita del paganesimo antico. Contributi alla storia della cultura*, ed. G. Bing (Florence, 1966), p. 137.
16 Gombrich, *The Heritage of Apelles*. On the classicism of Brunelleschi, in addition to the monographs on the artist which, it must be said, are still far from finding answers to all the problems he continues to pose, see M. Horster, 'Brunelleschi und Alberti in ihrer Stellung zur römischen Antike', *Mitteilungen des Kunsthistorischen Instituts in Florenz*, 17 (1973), pp. 29–64. Among the publications marking the artist's centenary see G. Miarelli Mariani, 'Brunelleschi a Roma. Un incontro tra mito e realtà', *Studi romani*, 25 (1977), pp. 187–210.
17 He also copies the division into ten books. The treatise has been republished in exemplary form: L. B. Alberti, *L'architettura (De re aedificatoria)*, Latin text and translation, ed. G. Orlandi, with introduction and notes by P. Portoghesi (Milan, 1966). For Alberti's writings *De pictura* see the new edition in vol. III of the *Opere volgari*, ed. C. Grayson (Bari, 1973). The same author also republished the

treatise by itself (Bari, 1975). For Alberti's third treatise, *De statua*, see the edition by O. Morisani (Catania, 1961). Lastly, for Alberti's writings relating to Roman antiquity see also L. Vagnetti, 'La "Descriptio urbis Romae". Uno scritto poco noto di Leon Battista Alberti. Contributo alla storia del rilevamento architettonico e topografico', *Quaderno dell'Università degli Studi di Genova*, 1 (1968), pp. 25–78, and G. Orlandi, *Nota sul testo della "Descriptio urbis Romae" di L. B. Alberti*, ibid., pp. 81–8. On antique art in Alberti's architectural work see the classic work by R. Wittkower, *Principi architettonici nell'età dell'umanesimo* (1949) (Turin, 1964); and, in addition to the lengthy monograph by F. Borsi, *Leon Battista Alberti* (Milan, 1975), the article by Horster, 'Brunelleschi'.

18 J. Polzer, 'Masaccio and the Late Antique', *Art Bulletin*, 53 (1971), pp. 36–40.

19 Cf. the essay, still essential reading, by R. Longhi, 'Fatti di Masolino e di Masaccio', *Critica d'Arte* (1940), pp. 145–91, reprinted in *Opere complete*, VIII (Florence, 1975), pp. 3–65.

20 On this issue, reference can be made to J. Mesnil's treatment of the problem in *Masaccio et les débuts de la Renaissance* (The Hague, 1927), *passim*, and also to the article by the same author, 'Masaccio and the Antique', *Burlington Magazine*, 48 (1926), pp. 91–8, with no need to linger over the works of writers such as Fremantle, for example. (The essential bibliography on this issue is given by Polzer, 'Masaccio'.)

21 The collection of these drawings is in B. Degenhart and A. Schmitt's excellent 'Gentile da Fabriano und die Anfänge des Antikenstudiums', *Münchner Jahrbuch der bildenden Kunst*, 2 (1960), pp. 59–151.

22 The classical link was observed by A. Warburg, 'Dürer e l'antichità italiana' (1905) in *idem, La Rinascita*, p. 199 and figures 60 and 107, although he did not stress the fact that the derivation is most likely indirect. Also it should not be forgotten that the statue was discovered only in the sixteenth century.

23 Warburg, 'Lo stile ideale classicheggiante', *La Rinascita*, p. 298 and figures 109–10.

24 E. Panofsky and F. Saxl, 'Classical Mythology in Medieval Art', *Metropolitan Museum Studies*, 4 (1932–3), pp. 270ff.

25 Panofsky, *Renaissance and Renascences*, which is a kind of synthetic essay by Panofsky on himself and the corpus of his studies.

26 On Apollonio di Giovanni, see the classic essay by E. H. Gombrich, 'Apollonio di Giovanni', *Journal of the Warburg and Courtauld Institutes*, 18 (1955), pp. 16–34, reprinted in *Norm and Form* (London and New York, 1971), pp. 11–34. On wedding chests in general see the essential work by P. Schubring, *Truhen und Truhenbilder der italienischen Renaissance. Ein Beitrag zur Profanmalerei*, 2nd edn (Leipzig, 1923).

27 Since the early works by I. Blum, *Andrea Mantegna und die Antike*

(Strasbourg, 1936) and by A. M. Tamassia, 'Visioni di antichità nell'opera del Mantegna', *Rendiconti della Pontificia Accademia Romana di Archeologia*, 28 (1956), pp. 213–49, the problem has more recently often been considered from an archaeological viewpoint: P. M. Lehmann, 'The Sources and Meanings of Mantegna's "Parnassus"', in P. M. Lehmann and K. Lehmann, *Samothracian Reflections: Aspects of the Revival of the Antique* (Princeton, 1973), pp. 59–178; M. Vickers, 'Mantegna and the Ara Pacis', *Journal of the J. Paul Getty Museum*, 2 (1975), pp. 109–20; *idem*, 'Mantegna and Constantinople', *Burlington Magazine*, 118 (1976), pp. 680–7; *idem*, 'The Palazzo Santacroce Sketchbook: A New Source for Andrea Mantegna's *Triumph of Caesar, Bacchanals and Battle of the Sea Gods*', ibid., pp. 824–34; *idem*, *The Roman World* (Oxford, 1977), pp. 33–42; *idem*, 'The Source of Mars in Mantegna's "Parnassus"', *Burlington Magazine*, 120 (1978), pp. 151–2; but there is something laboured in all these works.

28 Letter to M. Vianello, 28 June 1501, published by W. Braghirolli in *Archivio Veneto*, 13 (1877), p. 377. For the updated bibliography on Isabella d'Este's collecting, see the study by C. M. Brown, ' "Lo insaciabile desiderio nostro per cose antique": New Documents for Isabella d'Este's Collection of Antiquities', in *Cultural Aspects of the Italian Renaissance. Essays in honour of P. O. Kristeller* (New York, 1976), pp. 324–53.

29 See *Il tesoro di Lorenzo il Magnifico*, exhibition catalogue (Florence, 1972); N. Dacos, A. Giuliano and V. Pannuti, *Le gemme* (Florence, 1973); D. Heikamp and A. Grote, *I vasi* (Florence, 1974). On antique collections in the Renaissance see also R. Weiss, *The Renaissance Discovery of Classical Antiquity* (Oxford, 1969).

30 On Bertoldo, in addition to the traditional bibliographies by W. von Bode, *Bertoldo und Lorenzo dei Medici. Die Kunstpolitik des Lorenzo im Spiegel der Werke seines Lieblings-Künstlers Bertoldo di Giovanni* (Freiburg im Breisgau, 1925), see the perceptive observations of A. Chastel, *Art et humanisme à Florence au temps du Laurent le Magnifique* (Paris, 1959), pp. 76–82. On Riccio, the early monograph by L. Planiscig, *Andrea Riccio* (Vienna, 1927), and later the texts which provide the earlier bibliography, B. Jestaz, 'Un bronze inédit', *Revue du Louvre et des Musées de France*, 25 (1975), pp. 156–62; L. Montobbio, 'Testimonianze sulla giovinezza padovana di Andrea Briosco', *Atti e Memorie dell'Accademia Patavina di Scienze, Lettere ed Arti*, 87 (1974–5), pp. 297–300; P. Meller, 'Riccio's Satyress Triumphant; Its Source, its Meaning', *Bulletin of the Cleveland Museum of Art*, 63 (1976), pp. 324–34. On Antico, see H. J. Hermann, *Pier Jacopo Alari Bonacolsi genannt Antico* (Vienna and Leipzig, 1910).

31 These works are reproduced in the highly useful, classic manual by J. Pope-Hennessy, *Italian Renaissance Sculpture* (London, 1958). On

Filarete see C. Seymour, 'Some Reflections on Filarete's Use of Visual Sources', in *Il Filarete. Atti di corso di specializzazione promosso dall'Istituto per la storia dell'arte lombarda e diretto da M. Salmi, Arte Lombarda*, 38–9 (1973), pp. 36–47. Filarete's *Trattato d'architettura* has been edited by A. M. Finoli and L. Grasse (Milan, 1972).

32 N. Dacos, *La Découverte de la Domus Aurea et la formation des grotesques à la Renaissance* (London and Leiden, 1969).

33 The classic edition of the codex, introduced by an essay that is a marvellous period piece, though its conclusions are now dated, is the one by H. Egger, *Codex Escurialensis. Ein Skizzenbuch aus der Werkstatt Domenico Ghirlandaio*, ed. C. Hülsen and A. Michaelis (Vienna, 1906). On its constituent parts, which, as we saw, originate from different sketchbooks, see the penetrating analysis by J. Shearman in 'Raphael, Rome and the Codex Escurialensis', *Master Drawings*, 15 (1977), pp. 107–46. For a typical example of copy in the codex and of reproduction in Renaissance works of the same work (in this case a sarcophagus that was particularly favoured by artists), see a work based on a census of the works of antiquity that were known in the Renaissance before 1527, and written with a methodology more common in archaeological research than in art history; R. Olitsky Rubinstein, 'A Bacchic Sarcophagus in the Renaissance', *British Museum Yearbook*, I: *The Classical Tradition* (1975), pp. 103–56. This kind of research is also carried through in the highly disciplined works of G. Schweikhart, who gave particular thought to the same sarcophagus in 'Antikenkopie und Verwandlung im Fries des Marcello Fogolino aus der Villa Trissino-Muttoni (Cà Impenta) bei Vicenza. Ein Beitrag zur Geschichte der Villendekoration des frühen 16. Jarhunderts im Veneto', *Mitteilungen des Kunsthistorischen Instituts in Florenz*, 20 (1976), pp. 351–8.

34 On the statues in the courtyard of the Belvedere see J. S. Ackerman, *Cortile del Belvedere* (Vatican City, 1954), and for Renaissance drawings of them see especially H. H. Brummer, *The Statue Court in the Vatican Belvedere* (Stockholm, 1970). But there is still scope for more research into the problem posed by the choice of works in the collection in the context of the diverse trends in Graeco-Roman art that they illustrate. Especially on the *Laocoon* see M. Beiber, *'Laocoon'. The Influence of the Group since its Rediscovery*, 2nd edn (Princeton, 1967). The recent restoration by F. Magi, who replaced the arm raised upwards (this sixteenth-century restoration had an enormous influence) with the antique *Pollak* arm, is explained in detail by the author in *Il ripristino del 'Laocoonte'. Atti della Pontificia Accademia Romana di Archeologia*, 3rd series, *Memorie*, IX, x (Rome, 1960). On the discussions on this intervention see the conference held at the Zentralinstitut für Kunstgeschichte of Munich and Bavaria, *Antikenergänzung und Ent-Restaurierung* (Munich, 1971), with contributions by H. H. Brummer, G. Daltrop, F. Magi, J. Montagu, R. Wünsche,

L. O. Larsson, D. Ohly, and W. H. Gross. A detailed résumé is given
by J. Paul in *Kunstchronik*, 25 (1972), pp. 85–112. As a last analysis
see the interesting comments of W. Öchslin, 'Il "Laocoonte" o del
restauro delle statue antiche', *Paragone*, 287 (1974), pp. 3–29.

35 See the marvellous monograph by A. Bruschi, *Bramante architetto*
(Bari, 1969).

36 On Raphael as architect (which as a rule is a subject mistakenly
passed over without comment) see the stimulating book by S. Ray,
*Raffaello architetto. Linguaggio artistico e ideologia nel Rinascimento
italiano* (Bari, 1974), and the research by C. L. Frommel, which
should also produce a monograph on Raphael as architect.

37 The text of Raphael's letter is published by K. Foster, 'Raphael on
the Villa Madama: The Text of a Lost Letter', *Römisches Jahrbuch
für Kunstgeschichte*, 11 (1967–8), pp. 307–12. However, the author's
commentary is lacking, and we have to await H. Bierman's study
on the same subject. Generally, on sixteenth-century architecture see
P. Portoghesi, *Roma del Rinascimento* (Milan, 1971). An essay by the
same author (preliminary to a book) considers in particular Roman
classicism firstly in Bramante and Giuliano da Sangallo, then in
Michelangelo, Raphael, Antonio da Sangallo the Younger, B. Peruzzi,
J. Sansovino, and Sanmicheli, and is published under the title 'La
lingua universale. Cultura e architettura tra il 1503 e il 1527', *Contro-
spazio*, 11–12 (1970), pp. 3–19. On the question of the return to
antiquity in the architecture of Giuliano da Sangallo, see the excellent
essay by H. Biermann, 'Das Palastmodell Giuliano da Sangallo für
Ferdinand I. König von Neapel', *Wiener Jahrbuch für Kunstgeschichte*,
23 (1970), pp. 154–95.

38 See J. Shearman, 'Giulio Romano: tradizione, licenze, artifici', *Bollet-
tino del Centro Internazionale di Studi di Architettura Andrea Palladio*,
9 (1967), pp. 354–68.

39 So far the most complete edition of the letter is by V. Golzio, *Raffaello
nei documenti, nelle testimonianze di contemporanei e nella letteratura
del suo secolo* (Vatican City, 1936), pp. 78–92. However, the tra-
ditional dating needs to be anticipated, as J. Shearman ('Giulio
Romano') has suggested: the English scholar demonstrates that it
seems Raphael did not go to Rome for the first time in 1508, but that
he had made two brief visits at an earlier time, probably in 1502 and
then in 1506 or 1507. This persuasive hypothesis (which Shearman
backs up with numerous pieces of evidence) would then give us a
different chronology for Raphael's famous letter to Leo X. In the first
version Raphael declares that he has been in Rome 'for not yet eleven
years', while in the more accurate version which follows the first about
one year later, he says 'for not yet twelve years'.

40 Particularly in B. Berenson, *The Arch of Constantine and the Deca-
dence of Form* (Milan and Florence, 1952). The author puts forward
a visual analysis from a chronological and stylistic point of view of

the different parts which make up the Arch of Constantine, from the reliefs of Trajan to Hadrian's medals, and from the reliefs of Marcus Aurelius to those which were made at the time the arch was erected, in 312–15. As with Raphael, the latter are considered to be decadent as they do not follow the classical canons set up by the author.

41 His *Judith* is reproduced in the collection of Raphael's drawings of O. Fischel, *Raphaels Zeichnungen*, V (Berlin, 1924), no. 221. The drawing and antique model are reproduced in N. Dacos, 'Soprav-vivenze dell'antico', in *Enciclopedia dell'arte antica classica e orientale*, supplement (1970), p. 735, figures 755–6. The Sassi bust is reproduced in O. Fischel, *Raphaels Zeichnungen*, V, no. 219, while the collection of the antique works as Maarten van Heemskerk saw them in the Sassi courtyard is especially well illustrated in M. Winner's interesting exhibition catalogue, *Zeichner sehen die Antike. Europäische Hand-zeichnungen 1450–1800. Staatliche Museen der Stiftung Preussischen Kupferstichkabinetts* (Berlin, 1967), pp. 97–9, no. 60.

42 N. Dacos, *Le Logge di Raffaello. Maestro e bottega di fronte all'antico* (Rome, 1977).

43 This detail is to be found in the ever valuable book by L. Courjod, *L'Imitation et la contrefaçon des objets d'art antiques* (Paris, 1889), p. 44.

44 On the whole phenomenon of the diffusion of Raphaelesque lan-guage, see especially G. Briganti, *La maniera italiana* (Rome, 1961), pp. 29–38. On Giulio Romano, it is still important to go back to the first monograph (now outdated) to be dedicated to a pupil of Raphael, F. Hartt, *Giulio Romano* (New Haven, 1958). However, there is soon to be a study on the specific problem of the artist's relationship with antiquity in Mantua, by T. Yuen, in *Journal of the Warburg and Courtauld Institutes*. On Perino del Vaga, reference can be made specifically to the catalogue for the exhibition of the artist's drawings at the Uffizi in 1966, written by B. Davidson, who is currently writing a monograph on the artist. For Polidoro da Caravaggio, see the lengthy monograph by A. Marabottini, *Polidoro da Caravaggio* (Rome, 1969), which should be supplemented, especially as far as the graffiti on façades are concerned, by reference to the articles of R. Kultzen.

45 C. H. Smyth, *Mannerism and Maniera* (New York, n.d.).

46 Vasari, *Vite*, pp. 116–17 [translation: Harmondsworth, 1987, pp. 334–5].

47 Dacos, Giuliano and Pannuti, *Le gemme*, p. 150. On the role of antiquity on Michelangelo's work, in addition to the monographs on the artist, see E. Battisti, 'The Meaning of Classical Models in the Sculpture of Michelangelo', in *Stil und Überlieferung in der Kunst des Abendlandes, Akten*, II (Bonn, 1967), pp. 73–8, and, more re-cently, E. Pogany-Balás, 'Sur la date du carton de la Bataille de Cascina de Michel-Ange', in *Évolution générale et développements régionaux en histoire de l'art, Actes*, II (Budapest, 1972), pp. 747–51.

48 On the role of antiquity in Michelangelo's architecture see the mono-
 graphs by P. Portoghesi and B. Zevi, *Michelangelo architetto* (Turin,
 1964), and by J. S. Ackerman, *L'architettura di Michelangelo* (1961)
 (Turin, 1968). See also P. Portoghesi, 'La critica michelangiolesca alla
 tradizione classica', *Capitolium*, 50 (1975), pp. 8–36. More generally,
 see T. Buddensieg, 'Criticism of Ancient Architecture in the Sixteenth
 and Seventeenth Centuries, in *Classical Influences in European
 Culture*, A.D. *1500–1700*, ed. R. R. Bolgar (Cambridge, 1976), pp.
 335–48. For an especially interesting case of a mannerist architect
 attracted to antiquity see F. Borsi, C. Adini, F. Mannu Pisani and
 G. Morolli, *Giovanni Antonio Dosio. Roma antica e i disegni di
 architettura agli Uffizi* (Rome, 1976).
49 For all these artists, who have not yet been the subject of mono-
 graphs, see J. Pope-Hennessy, *La scultura italiana. Il Cinquecento e
 il Barocco* (Milan, 1966). A thesis has been written on the early years
 of Jacopo Sansovino: M. Garrard, *The Early Sculpture of Jacopo
 Sansovino: Florence and Rome* (Baltimore, 1970).
50 B. Cellini, *Vita*, ed. G. Davico Bonino (Turin, 1973), p. 413 [trans-
 lation: Harmondsworth, 1976, p. 335].
51 R. Longhi, *Viatico per cinque secoli di pittura veneziana* (Florence,
 1946), pp. 22–3.
52 Pope-Hennessy, *La scultura italiana*, II, pp. 11, 85–6 and 391–2.
53 On Sansovino see the excellent book by M. Tafuri, *Jacopo Sansovino
 e l'architettura del '500 a Venezia* (Padua, 1969), with a very accur-
 ate analysis of the cultural climate in Venice in contrast with that of
 Rome and Florence. For a later publication, D. Howard, *Jacopo
 Sansovino. Architecture and Patronage in Renaissance Venice* (New
 Haven and London, 1975).
54 On Palladio see Wittkower, *Principi architettonici*. On his links
 with antiquity cf. G. Zorzi, *I disegni di antichità di Andrea Palladio*
 (Venice, 1959); *idem*, 'La posizione di Andrea Palladio di fronte
 all'antichità', *Bollettino del Centro Internazionale di Studi di
 Architettura Andrea Palladio*, 7 (1965), pp. 59–76; H. Spielmann,
 *Andrea Palladio und die Antike. Untersuchung und Katalog der
 Zeichnungen aus seinem Nachlass* (Munich and Berlin, 1966);
 E. Forssmann, 'Palladio e l'antichità', in R. Cevese et al., *Mostra del
 Palladio* (Vincenza and Milan, 1974), pp. 15–26.
55 P. Ligorio, *Libro delle antichità di Roma* (Venice, 1553), fo. 26: '. . . it
 was my desire to write of the antiquities of Rome, and encompassing
 all the things that are worthy of memory, to strive not only to de-
 scribe them in words but even to draw them and conjure them up
 before men's eyes in a picture. I have already spent many years of
 perpetual study and continuous vigil pursuing this enterprise, which
 has turned out far more difficult than I imagined (as happens with all
 human affairs) both in the great toil and in the intolerable expense
 on my fortune . . .' For a bibliography on Ligorio, his methods as

archaeologist and historian, his predecessors and the contents of his manuscripts, see the book by E. Mandowski and C. Mitchell, *Pirro Ligorio's Roman Antiquities. The Drawings in ms XIII. B.7 in the National Library in Naples* (London, 1963). On Villa d'Este, see D. Coffin, *The Villa d'Este at Tivoli* (Princeton, 1960).

56 The iconographic analysis of Pius IV's loggia according to Ligorio's writings has been carried out simultaneously by M. Fagiolo and M. L. Madonna, 'La casina di Pio IV in Vaticano. Pirro Ligorio e l'architettura come geroglifico', *Storia dell'Arte*, 15–16 (1972), pp. 237–81, and by J. Graham Smith, initially in an article and afterwards in *The Casino of Pius IV* (Princeton, 1977), with roughly similar results. M. L. Madonna is currently preparing a selection from the *Libro dell'antichità*, based on the Turin manuscripts.

57 G. P. Bellori, *Le vite de' pittori, scultori, e architetti moderni* (1672), ed. E. Borea (Turin, 1977), p. 230, where he writes: 'The dignity of art was so overcome by Caravaggio that everyone took great licence, with the result that beautiful things began to be despised, and Raphael and antiquity had no authority . . .' In spite of this break, which nobody can doubt, even R. Guttuso (introduction to *L'opera completa del Caravaggio*, Milan, 1967, p. 9) recognizes Caravaggio's classical spirit, and even manages to see in it an echo of Greece and Pompeii. For a different viewpoint, M. Gregori, 'Addendum to Caravaggio: the Cecconi "Crowning with Thorns" reconsidered', *Burlington Magazine*, 118 (1976), pp. 671–80, which sets out the hypothesis (which admittedly leaves us unconvinced) whereby Caravaggio's painting, presumed to be the original and painted around 1601–2, indicates the study of *Laocoon*, just as does Rubens's painting of the same subject. Caravaggio may even have followed a part (the date of this is overlooked) of the Flemish painter's treatise *De imitatione statuarum*.

58 Bellori, *Vite* cit., pp. 43–4, with notes. On this issue see also D. Mahon, *Studies in Seicento Art and Theory* (London, 1947), *passim*.

59 Bellori, *Vite* cit., p. 23, n. 1.

60 D. Posner, *Annibale Carracci. A Study in the Reform of Italian Painting around 1590* (London and New York, 1971), II, p. 51, n. 116, with reference to sources and preparatory drawings.

61 Dacos, *La Découverte*, p. 14 and figure 8.

62 R. Spear, *Studies in the Early Art of Domenichino* (degree thesis, Princeton University, 1965), p. 59, has noticed an antique influence in the figure of Hyacinth in the Loggia del Giardino, which is derived from an Antinous. But the author also realizes that this is an exceptional case.

63 On this issue see the essay by J. Thuillier, 'Poussin peintre français ou peintre romain?' in *Nicolas Poussin*, exhibition catalogue (Rome, 1977–8), pp. 36–7.

64 On this dispute see E. Borea, *Domenichino* (Milan, 1965), pp. 33–8.

65 On Poussin, see the recent bibliography in the catalogue (edited by
 P. Rosenberg) of the first-rate exhibition on the artist at the Villa
 Medici in Rome, 1977–8.

66 On this problem see the evocative book by G. Briganti, *Pietro da
 Cortona* (Florence, 1962), pp. 88–92.

67 C. C. Vermeule, *The dal Pozzo–Albani Drawings of Classical Anti-
 quities in the British Museum* (Philadelphia, 1960), and *idem, The
 dal Pozzo–Albani drawings of Classical Antiquities in the Royal
 Library at Windsor Castle* (Philadelphia, 1966). The two volumes on
 Windsor, which Vermeule published rather hurriedly, are exclusively
 on classical antiquity. There are quotations from essays by Ver-
 meule, who is also the author of *European Art and the Classical
 Past* (Cambridge, Mass., 1964). An essential study of Cassiano dal
 Pozzo has yet to be written, so it is still necessary to go back to
 G. Lumbroso, 'Notizie sulla vita di Cassiano dal Pozzo', in *Miscel-
 lanea di storia italiana* (Turin, 1874), pp. 129–211.

68 F. Baldinucci, *Notizie de' professori del disegno da Cimabue in qua*
 (Florence, 1728), p. 479.

69 Briganti, *Pietro da Cortona*, pp. 54–60.

70 See G. Conti, 'Un taccuino di disegni dall'antico agli Uffizi', *Rivista
 dell'Istituto Nazionale d'Archeologia e Storia dell'Arte*, 21–2 (1974),
 pp. 141–68. In this study the author announces the publication of the
 complete codex of Poussin's drawings based on classical models; see
 W. Friedländer and A. Blunt, *The Drawings of Nicolas Poussin.
 Catalogue raisonné, V: Drawings after Antique Miscellaneous Draw-
 ings. Addenda* (London, 1974). The only drawing based on classical
 models that is known to originate from the dal Pozzo collection and
 which was part of the 'Museum Chartaceum' is one illustrating a
 Roman sarcophagus from Villa Pamphili (ibid., no. 302a, tab. 320a).
 There is also a drawing of the same relief in the dal Pozzo volumes
 in London (no. 30). Lastly, see A. Blunt, 'The Massimi Collection of
 Poussin Drawings in the Royal Library at Windsor Castle', *Master
 Drawings*, 14 (1976), pp. 3–31, where this collection is studied
 separately from that of Cassiano, which includes only one archae-
 ological drawing (no. 46) but is made up of many drawings in the
 classical style.

71 Briganti, *Pietro da Cortona*, pp. 287–332 and especially figures 2–7.
 See also the more recent catalogue of the exhibition *Disegni di Pietro
 da Cortona e Ciro Ferri dalle collezioni del Gabinetto Nazionale
 delle stampe*, ed. M. Giannatiempo (Rome, 1977). Also a short ar-
 ticle by M. Campbell, 'An Antique Source for an Early Drawing by
 Pietro da Cortona', *Art Bulletin*, 45 (1963), pp. 360–1.

72 A. Blunt, 'Poussin and Rome' in *Nicolas Poussin*, pp. 28–9.

73 This point has been well emphasized by M. Volpi Orlandi, 'Anno-
 tazioni in margine alle tendenze classicisti nella cultura artistica romana

tra il 1607 e il 1672', *Annali delle Facoltà di lettere, filosofia e magistero dell'Università di Cagliari*, 34 (1971), pp. 69–96.

74 On this issue see R. Wittkower's excellent essay, 'The Role of Classical Models in Bernini's and Poussin's Preparatory Work', in *Studies in Western Art, Acts* (Princeton, 1963), pp. 41–50.

75 This observation was made by Y. Bruand in an interesting article, 'La restauration des sculptures antiques du cardinal Ludovisi', *Mélanges d'Archéologie et d'Histoire*, 68 (1956), pp. 397–418. Studies are currently being prepared on Algardi, who certainly merits a detailed analysis, but for now refer to the monograph by M. Heimbürger Ravalli, *Alessandro Algardi scultore* (Rome, 1973). The problems of restoration are treated on pp. 25–30. There are other works on the artist, especially A. Nava Cellini, 'L'Algardi restauratore e Villa Pamphili', *Paragone*, 161 (1963), pp. 25–37, and S. Howard, 'Pulling Herakles' Leg. Della Porta, Algardi and Others', in *Festschrift V. Middledorf* (Berlin, 1968), pp. 402–7. The problem may now be brought up again, to be given full consideration, following the publication of the book by R. Calza, M. Bonanno, G. Messineo, B. Palma and P. Pensabene, *Antichità de Villa Doria-Pamphili* (Rome, 1977). This work is essentially archaeological in its approach and does not include 'modern' statues from the seventeenth to nineteenth centuries, and only a few pages on classical-style sculpture of the seventeenth century, and Algardi's name is occasionally mentioned. On the stuccoes of Villa Doria-Pamphili see O. Raggio, 'Alessandro Algardi e gli stucchi di Villa Pamphili', *Paragone*, 251 (1971), pp. 3–38, and for the iconographic programme D. Batosska, 'Additional Comments on the Iconography of the Sala di Ercole at Villa Pamphili in Rome', ibid., 303 (1975), pp. 22–54.

76 See A. Blunt, 'Baroque Architecture and Classical Antiquity', in *Classical Influences on European Culture, A.D. 1500–1700*, ed. R. R. Bolgar (Cambridge, 1976), pp. 349–54. On Borromini and antiquity, in addition to P. Portoghesi's monograph *Borromini. Architettura come linguaggio* (Milan, 1967), see the same author's 'Intorno a una irrealizzata immagine borrominiana', *Quaderni dell'Istituto di Storia dell'Architettura*, 6 (1954), pp. 12–28, and G. Egger, *Das Bild der Antike in Literatur und Druckgraphik der Renaissance und des Barocks* (Vienna, 1976), pp. 37–8.

77 The text is published in Portoghesi, 'Intorno a una irrealizzata immagine'. It was taken up again by A. Nava Cellini, 'Il Borromini, l'Algardi e il Grimaldi per Villa Pamphili', *Paragone*, 159 (1963), pp. 67–75. Algardi's activity as architect at Villa Pamphili seems quite plain but still raises some objections: cf. M. Heimbürger Ravalli, 'Algardi architetto?' *Analecta Romana*, 6 (1971), pp. 197–224.

78 C. Pietrangeli, 'Il Museo Clementino Vaticano', *Atti della Pontificia Accademia Romana di Archeologia. Rendiconti*, 27 (1951–4), pp. 87–

109, and the more recent S. Howard, 'An Antiquarian Handlist and Beginnings of the Pio-Clementino', *Eighteenth-Century Studies*, 7 (1973), pp. 40–61. On the fashion for amateur archaeology in the first half of the eighteenth century see L. Guerrini, *Marmi antichi nei disegni di Pier Leone Ghezzi* (Vatican City, 1971).

79 On the English architecture of A. Galilei, see I. Toesca, 'Alessandro Galilei in Inghilterra', *English Miscellany*, 3 (1952), pp. 189–220. The issue of the competition for the façade of San Giovanni is considered by V. Schendler, *Alessandro Galilei. The Façade of S. Giovanni in Laterano* (Ph.D. thesis, New York University, 1967). An important thesis will soon be published on all of the artist's works, in the light of the cultural climate of Clement XII's pontificate: E. Kieven, *Alessandro Galilei (1691–1737) Architekt in England, Florenz und Rome* (Univ. diss., Bonn, 1977).

80 The issue of the internationalization of architecture which was already taking place in the first half of the eighteenth century has been emphasized by W. Öchslin, 'Aspetti dell'internazionalismo nell'architettura italiana del primo Settecento, in *Barocco europeo, barocco italiano, barocco salentino. Congressi salentini*, I (Lecce, 1969–70), and considered again by *idem, Bildungsgut und Antikenrezeption des frühen Settecento in Rom. Studien zum römischen Aufenthalt Bernardo Antonio Vittones* (Zurich, 1972), pp. 109–17. But the same phenomenon is evident in the other arts.

81 In this respect, it is typical that there is no mention at all of links with classical antiquity in the recent book by R. Engass, *Early Eighteenth Century Sculpture in Rome. An Illustrated Catalogue Raisonné* (University Park and London, 1976), which considers the period from the pontificate of Innocent XI (1676–89) to that of Clement XII (1730–74).

82 This letter, dated 10 September 1733, is published by G. G. Bottari, *Raccolta di lettere sulla pittura, scultura ed architettura*, II (Milan, 1822), pp. 404–5.

83 A thesis will soon be published on B. Cavaceppi, by S. Howard, who is also the author of the article in the *Dizionario biografico degli Italiani*. See also the following articles by Howard: 'Boy on a Dolphin: Nollekens and Cavaceppi', *Art Bulletin*, 46 (1954), pp. 178–89; 'Bartolomeo Cavaceppi and the Origins of Neoclassical Sculpture', *Art Quarterly*, 33 (1970), pp. 120–33; 'Sculptures of Bartolomeo Cavaceppi and Origins of Neo-Classicism: Ceres Series and Sundries', in *Congrès international d'histoire de l'art. Actes (Budapest 1969)* (Budapest, 1972), pp. 227–32; 'The Antiquarian Market in Rome and the Rise of Neo-Classicism: A Basis for Canova New Classics', *Studies on Voltaire and the Eighteenth Century*, 41–5 (1976), pp. 1057–68.

84 On the role of Cardinal Albani from a political, artistic and antiquarian point of view, cf. the thrilling book by L. Lewis, *Connoisseurs and*

Secret Agents in Eighteenth Century Rome (London, 1961). The author also wrote the article on Alessandro Albani in the *Dizionario biografico degli Italiani*, I (1960), pp. 595–8.

85 I. Belli Barsali, *Mostra di Pompeo Batoni*, exhibition catalogue (Lucca, 1967), p. 32.

86 R. Wittkower, 'Piranesi's "Parere sull'architettura"', *Journal of the Warburg and Courtauld Institutes*, 2 (1938–9), pp. 147–58. From this time onwards there is vast bibliography on Piranesi. Most recently, for the issues which we are considering, see P. D. Late, 'Piranesi's Imperial Vision of Rome', *Art News*, 72 (1973), pp. 40–4; R. Kroll, 'Giovanni Battista Piranesi und die antike römische Baukunst', in *Archäologie zur Zeit Winckelmanns* (Stendal, 1975), pp. 55–60. The most recent bibliography is related to the two latest exhibitions on the artist, *Rassegna di stampe*, ed. T. Villa Salamon, Calcografia Nazionale (Rome, 1976), and *Piranesi et les Français, 1740–1790*, catalogue of the exhibition in Rome, Villa Medici; Dijon, Palais des Etats de Bourgogne; Paris, Hôtel de Sully (1976).

87 From a theoretical point of view, the most recent study is that by R. Assunto, *L'antichità come futuro. Studio sull'estetica del neo-classicismo europeo* (Milan, 1973). See also the introductions to the various parts of the catalogue of the exhibition *The Age of Neo-Classicism, The Royal Academy and the Victoria and Albert Museum* (London, 1972). On Mengs, cf. D. Honisch, *A. R. Mengs und die Bildform des Frühklassizismus* (Recklinghausen, 1965). But above all we must wait for the publication of the thesis by S. Röttgen. See this scholar's 'Mengs sulle orme di Poussin', *Antologia di Belle Arti*, 2 (1977), pp. 148–56, and 'Mengs, Winckelmann und Alessandro Albani, Idee und Gestalt des Parnass in der Villa Albani', which is about to be published in the review *Storia dell'Arte*. See also W. Leppmann, *Winckelmann* (London, 1971).

88 B. Berenson, *L'arco di Constantino o della decadenza della forma. Versione dal manoscritto inedito*, ed. L. Vertova (Milan and Florence, 1952).

89 See especially R. Bianchi Bandinelli, 'Situazione dell'arte greca nella cultura contemporanea', in *Archeologia e cultura* (Milan and Naples, 1961), pp. 127–52, and *idem, L'arte romana, due generazioni dopo Wickhoff*, ibid., pp. 234–58.

90 On this phenomenon see the study of an exemplary case in Röttgen, 'Mengs sulle orme di Poussin'.

91 This aspect of the question was first emphasized by F. Antal, 'Reflection on Classicism and Romanticism', I–V, *Burlington Magazine*, 66 (1935), pp. 159–68; 78 (1941), pp. 14–22, reprinted in *idem, Classicism and Romanticism* (London, 1966), pp. 1–45.

92 See especially A. Gonzales-Palacios, 'La grammatica neoclassica', *Antichità Viva*, 12 (1973), pp. 29–55, which uses the example of David's painting of *Paris and Helen*, now in the Louvre. See also

D. Irwin, 'Neo-Classical Design: Industry Plunders Antiquity', *Apollo*, 96 (1972), pp. 288–97.

93 On this subject, which deserves to be researched in greater depth, see the initial attempt by M. Praz, 'Le antichità di Ercolano', in *Gusto neoclassico*, 3rd edn (Milan, 1974), pp. 75–86, which is a marvellous book, indeed a classic.

94 Quoted ibid., p. 83. See also J. B. Hartmann, 'La musa del Thorvaldsen', in *Colloqui del Sodalizio*, 3 (1970–2), pp. 100–19.

95 A. Canova, *I quaderni di viaggio (1779–1780)*, ed. E. Bassi (Venice and Rome, 1959), p. 29.

96 Quatremere de Quincy, *Canova et ses ouvrages ou mémoires historiques sur la vie et les travaux de ce célèbre artiste* (Paris, 1834), pp. 288–9. The issue was brought up again in the light of unpublished documents by M. Pavan, 'Antonio Canova e la discussione sugli "Elgin Marbles"', *Rivista dell'Istituto Nazionale d'Archeologia e Storia dell'Arte*, 21–2 (1974–5), pp. 141–68, reprinted in *idem*, *Antichità classica e pensiero moderno* (Florence, 1977), pp. 159–210. See also the article by the same author, *Canova*, with unpublished documents, in *Dizionario biografico degli Italiani*, XVIII (1975), pp. 194–219.

97 On Thorvaldsen, see the exhibition catalogue *Bertel Thorvaldsen, ein dänischer Bildhauer in Rom. Skulpturen, Modellen, Bozzetti, Handzeichnungen, gemeldet aus Thorvaldsens Sammlungen* (Cologne, Kunsthalle, 1977), and the works which it prompted, *Bertel Thorvaldsen Untersuchungen* (Cologne, 1977); see also the numerous articles by J. B. Hartmann, who has studied the artist and taken particular interest in the classical sources of his works.

98 G. Nicodemi, *Francesco Hayez* (Milan, 1962), pp. 55–6 and pl. 6.

99 *Pelagio Palagi artista e collezionista*, catalogue of the exhibition organized by the Museo Civico (Bologna, 1976), p. 1051; M. Matteucci, 'Carlo Filippo Aldrovandi e Pelagio Palagi', *Atti e Memorie dell'Accademia Clementina di Bologna*, 11 (1974), pp. 87–93.

100 On the Vittoriano, besides the general works of C. L. Meeks, *Italian Architecture, 1750–1914* (New Haven and London, 1966), and F. Borsi, *L'architettura dell'unità d'Italia* (Florence, 1966), see F. Sapori, *Il Vittoriano* (Rome, 1946), especially for the many photographs of the decoration, and M. Venturoli, *La patria di marmo* (Pisa, 1957), for the cultural and historical climate of the period.

101 G. de Chirico, 'Classicismo pittorico', *La Ronda* (July 1920), now in *La Ronda*, anthology ed. G. Cassieri (Rome, 1969), pp. 345–9. On the sense and origins of de Chirico's classicism, see the superb essay by M. Volpi Orlandini, 'Alcune sopravvivenze del classicismo nelle poetiche e nelle opere dei pittori dell'immaginario', *Storia dell'Arte*, 26 (1976), pp. 73–91, which may open up a way to further studies.

102 The extensive bibliography on Fascist politics boils down to very little as far as our specific subject is concerned. See the collected

bibliography in the *Quaderni di storia*, 3 (1976), *Dodici interventi nella discussione sul classicismo nell'età dell'imperialismo* and particularly the essay by L. Canfora, *Classicismo e fascismo*, pp. 15–39.

103 See, for example, B. Zevi, *Storia dell'architettura moderna*, 3rd edn (Turin, 1955), and L. Benevolo, *Storia dell'architettura moderna* (Bari, 1971). More particularly, cf. E. Crispolti, B. Hinz and Z. Birolli, *Arte e fascismo in Italia e in Germania* (Milan, 1974), *passim*.

The Dispersal and Conservation of Art-historical Property

FRANCIS HASKELL

T HE museums and private collections of Europe and America are liberally supplied with masterpieces of Italian art; the main works of some of the very greatest Italian painters – Titian is the supreme example – can be seen in far larger numbers outside, not only their native cities, but Italy itself. Yet not all such instances should be considered under the general heading of 'dispersal': the case of Tiepolo responding to the magnificent opportunities offered to him in Würzburg and Madrid quite clearly belongs in a different category from that of the many masterpieces created in fifteenth-century Florence and acquired (more or less legitimately) four hundred years later by collectors in London, Paris or Berlin. In this chapter foreign patronage of contemporary Italian art will be referred to in passing, but the main emphasis will be placed on works which were made in Italy for Italians and which subsequently found their way abroad or were destroyed by man-made catastrophes.

Another limitation must be mentioned: it is obvious that the very notion of 'Italian' is something of an anachronism before comparatively recent times. When (as will be mentioned shortly) the popes tried to prevent ancient sculptures leaving Rome, their policies were directed just as much against the Medici of Florence or the Gonzaga of Mantua as they were against the king of France. Lorenzo de'

Medici himself and rulers of other states within the Italian peninsula do not seem to have distinguished much between 'foreigners' and 'Italians' when making diplomatic use of art and artists to export prestige and influence. To the inhabitants of Ferrara, who in 1598 saw the treasures of Alfonso d'Este's *camerino* – great masterpieces by Bellini, Titian and Dosso Dossi – being seized by Cardinal Aldobrandini, it is unlikely to have proved very consoling to learn that these pictures were destined for Rome rather than for Paris or Madrid. But in fact it is not only the exigencies of space – or an indifference to history – that allow us to pay little attention to the 'dispersal' of Italian art within Italy itself. A notion of the kinship of Italian art existed long before the achievement of political unity. In all the endless parochial controversies stirred up by Vasari's championship of the primacy of Florence, none of his opponents from Bologna, Siena, Venice, Naples or elsewhere, however embittered, ever suggested that 'the revival of painting' should be looked for in Flanders . . . This article will therefore be primarily concerned with the dispersal of Italian art outside the frontiers of present-day Italy.

The Italian states were the earliest in Europe to try to impose restrictions on the export of works of art, and the laws of Italy which have been enacted for the same purpose in our own times are among the most stringent in the world. Yet already before the end of the fifteenth century we hear of the most ingenious methods being successfully used to evade papal prohibitions,[1] and few people would seriously maintain that the dispersal of the Italian patrimony has come to an end today. But whereas the eagerness of foreign collectors to obtain art from Italy by whatever means can be looked upon as a tribute (however unwelcome in Italy) to the genius of Italian artists over many centuries, the terrible losses which have been incurred through wars – the sack of Rome in 1527, looting during the French invasions at the end of the eighteenth century, the fighting between 1943 and 1945 – offer no such comfort. Nor, alas, does the probably still greater destruction which has been wrought by misguided town planning and speculation (such as that which took place in Rome in the years after unification or during Fascism) or through absurd attempts to 'restore' monuments to a supposed 'original' condition (as with so many churches in the Abruzzi and elsewhere in our own day). If to this melancholy list we add the losses caused through accident or natural disasters (the fire in the Palazzo Ducale of Venice in 1577, the earthquake of Messina in 1908, the floods in Florence in 1966, and all too many more) it will

be appreciated that the story is a long and complicated one, which can here be dealt with in only the most summary way.

It is a story, moreover, which is difficult to understand today through the great changes in taste which have come about during the last 150 years, and this makes it particularly important to emphasize that for many centuries the most treasured works of art in Italy were not (as they are today) those built, painted or sculpted by artists since the fourteenth century but the Graeco-Roman marbles which had survived from a completely different civilization. It was these that the popes were particularly keen to keep in Rome, and these that foreigners were particularly keen to obtain for themselves. The most elaborate efforts were made to impose and to evade laws governing the export of sculptures which today attract hardly a glance from the average art-lover.

Yet though this needs to be borne constantly in mind, it is also true that it is very soon after the French invasions of Italy beginning in 1494 that the dispersal of the Italian patrimony as we would understand the term today begins to get under way. As early as 1495 we hear of the transport from Naples to Amboise of 'several tapestries, book collections, paintings, marble, porphyry and other furnishings'.[2] More ambitiously François I apparently thought of trying to remove Leonardo da Vinci's fresco of the *Last Supper* from Santa Maria delle Grazie in Milan to take it to France, and though he was unsuccessful in this, both he and his predecessor as king of France, Louis XII, were able to obtain some exceedingly important pictures by Leonardo – the *Gioconda* and the *Virgin of the Rocks* – which had certainly been painted for Italian clients, and which therefore belong in a somewhat different category from pictures like Andrea del Sarto's *Charity* (Louvre) which were actually commissioned by the French king (as, of course, was the decoration of Fontainebleau by Rosso and Primaticcio), or commissioned by Italian patrons to give to him – as the Medici did with Raphael's *St Michael* and *Holy Family* (both in the Louvre). This distinction was perfectly well understood in the sixteenth century. Writing of Giambattista della Palla, one of the dealers employed by Francis I, Vasari commented[3] that he 'had despoiled Florence of countless choice objects, without any respect'. This is perhaps the first indication that some people in Italy were becoming as alarmed by the dispersal of 'modern' art as they were by that of antiquities.

This alarm was registered in the remarkable decree drawn up by Grand Duke Ferdinand I of Tuscany in 1602, by which time the French were by no means the only foreigners trying to lay hands on

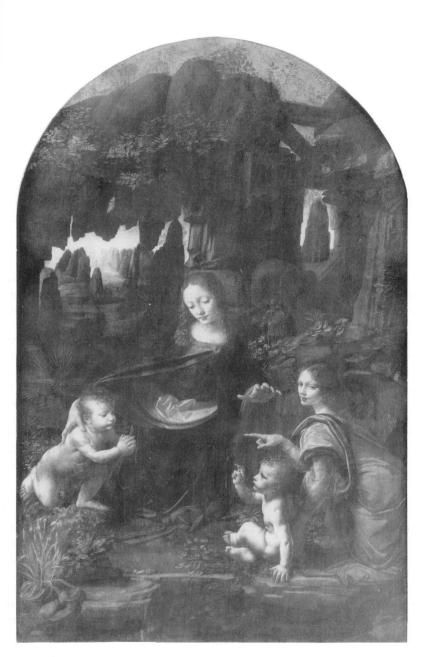

Plate 54 LEONARDO, *Virgin of the Rocks*, Musée du Louvre.
© Cliché des Musées Nationaux, Paris.
Photo: Réunion des Musées Nationaux.

modern art – the Holy Roman Emperor Rudolph II was a particu-
larly avid collector. By this decree,[4] which was motivated 'by the
high opinion held of fine paintings, that they may not be taken
elsewhere and the city lose the adornment they give, but that gentle-
folk and the whole populace may keep the fame they bring', the
Accademia del Disegno was authorized to control the export of all
works of art from Florence. A list was drawn up of eighteen artists
(headed by Michelangelo, Raphael and Andrea del Sarto – but in-
cluding Titian, Correggio and Parmigianino, whose relations with
Florence had not been close) whose work was not to leave the city
on any account, though exceptions were made for 'portraits . . . land-
scapes . . . bedhead pictures'; and the Academy was also given the right
to decide which artists should, after their deaths, be added to the list.
This distinction between the dead 'Old Master' and the living artist
working for a foreign patron has naturally been adhered to in nearly
all subsequent legislation enacted throughout the world (though some-
times the rulers of Italian states refused to allow a painter or sculp-
tor in their employment to accept commissions from other clients,
still less to travel abroad), and the fact that the prohibition did not
apply to the paintings of Giotto or Masaccio, Fra Angelico or Botticelli
would have surprised no one – and would have been of no practical
relevance – until the nineteenth century. But it is, perhaps, worth
commenting on the fact that the greatest paintings produced in Flor-
ence by the two most famous Florentine artists on the list – the
cartoons by Leonardo for the *Battle of Anghiari* and by Michelangelo
for the *Battle of Cascina* (both intended for frescoes in the Palazzo
Vecchio) had both apparently vanished – in somewhat mysterious
circumstances – in Florence itself.

No loss to the arts even comparable to this was sustained during
the terrible sack of Rome in 1527, a decade or so later. Certainly
tapestries were destroyed, stained glass broken, enormous quantities
of silver and gold vessels melted down, and medals and jewels
looted; but such objects have always been the first casualties in every
war, and it is impossible to think of a single recognized master-
piece, whether of ancient statuary or of modern painting, which is
recorded as having suffered seriously in this period. It was the con-
struction of the Palazzo Farnese some years later, and not the de-
predations of the *landsknechts*, which was responsible for the re-
moval of large sections of the Colosseum.

The treasures of Venice, the third great centre of the Italian Re-
naissance, also attracted attention from foreign collectors, above all
from the Habsburgs, in the sixteenth century, and it has already

been pointed out that the majority of Titian's most important clients lived outside the city. But it was the fire of 1577 in the Doge's Palace which caused far more terrible losses to the city's patrimony than any foreign ruler, however insatiable: in that fire perished masterpieces by Bellini, Carpaccio, Titian himself and most of the other leading painters of the Venetian school.

Illegal exports, foreign invasions, fires – these were the traditional perils to which the artistic holdings of Italy, and all other countries, had always been liable and were always to remain liable. But it was not until the seventeenth century that a dramatic new factor entered the scene: the wholesale purchase of a major art collection, perhaps the most important collection in the whole of Italy, the one which had been built up by the Gonzaga in Mantua. The source from which this new danger came, suddenly and unexpectedly, was England – almost the only significant country in Europe which had hitherto played virtually no part in the more leisurely despoiling of Italy indulged in by France, Spain and the Holy Roman Empire. But the combination of a passionate lover of the arts on the throne in London (Charles I) and a weak and bankrupt duke in control of Mantua (Vincenzo II) led in 1627 to the greatest transfer of masterpieces that had been seen since antiquity.[5] There is no point in discussing here the elaborate and secret negotiations that led to the sale, carried out – for the most part – through a Dutch merchant, Daniel Nys; nor would this be the place to give a list of any but a very few of the most famous pictures that were sold from Mantua. To contemporaries the most celebrated of all were probably the eleven *Caesars* that had been painted by Titian between 1537 and 1539 and that are now known only through copies of various kinds, because in 1734 they perished in a far worse disaster than the breakup of the Gonzaga collection:[6] the fire in the Alcazar in Madrid. But other astonishing Titians fortunately survive – among them, the *Entombment*, the *Supper at Emmaus* and the *Portrait of a Man with a Glove* (all now in the Louvre). Among the Raphaels was the *Holy Family with Saints Elizabeth and John* (Prado), which later came to be known as 'La Perla'. Correggio was represented by *The Education of Love* (National Gallery, London) and by the two *Allegories of the Vices and Virtues* (Louvre) from the studiolo of Isabella d'Este, Caravaggio by the *Death of the Virgin* (Louvre), which had been bought by the Gonzaga on the advice of Rubens; and the list could be enormously extended. In a second sale, after Duke Vincenzo's death at the end of 1627, his successor Duke Charles I of Nevers disposed of Mantegna's cartoons of the *Triumph of Caesar* (Hampton

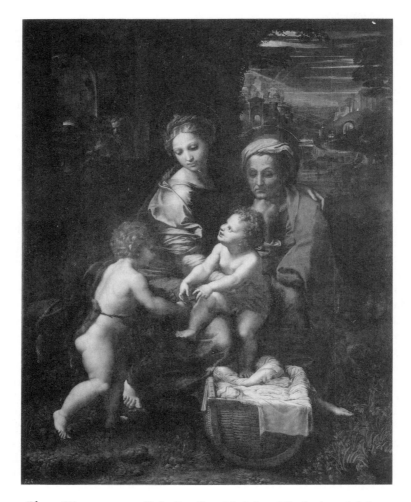

Plate 55 RAPHAEL, *Holy Family with Saints Elizabeth and John,*
Museo del Prado, Madrid.

Court) and of sculptures attributed to Praxiteles and Michelangelo.
At much the same time – though in circumstances which are not yet
known – the remaining paintings from the studiolo of Isabella d'Este
by Mantegna (*Parnassus* and *Minerva Expelling the Vices*), Perugino
and Costa – all now in the Louvre – were acquired by Cardinal
Richelieu.

The dispersal of the Gonzaga collection is important in the context

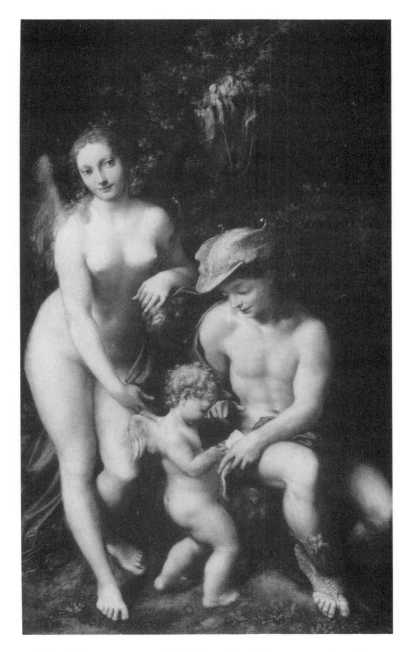

Plate 56 CORREGGIO, *The Education of Love*, reproduced by courtesy of the Trustees of the National Gallery, London.

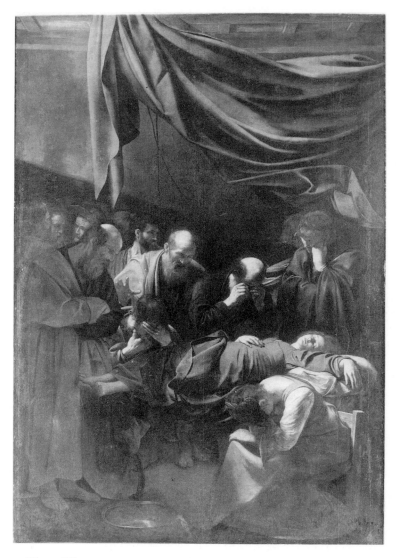

Plate 57 CARAVAGGIO, *Death of the Virgin*, Musée du Louvre.
© Cliché des Musées Nationaux, Paris.
Photo: Réunion des Musées Nationaux.

of this chapter not only because thereby Italy permanently lost many very important masterpieces, but also because it reveals something about the attitudes felt at the time towards the ownership of paintings. The Duke of Mantua was very keen to maintain the utmost secrecy about the sale, to conceal its full extent, and above all (to the great dismay of historians writing under the impact of the Risorgimento who deplored his 'unpatriotic sentiments) to make sure that the pictures went to England – 'so far that they will never again be seen' – rather than to some rival collector in Italy. This behaviour was no doubt prompted more by shame at his financial crisis than by any special feeling about pictures or nationalism. More interesting is the fact that 'the people of Mantua made such an uproar that if Duke Vincenzo had been able to recover them, he would readily have paid double the price, and the people would willingly have given him the money.' This shows clearly enough that already by now the lines between a 'private dynastic collection and a 'public' museum were becoming a little blurred, though it was to be a very long time before a precise distinction could be drawn. The sensitive 'popolo di Mantova' could in any case reflect three years later on the irony that it was the very recklessness of their ruler in disposing of his (or their) pictures that probably saved them for posterity, for they would almost certainly have been destroyed when the town was sacked in 1630.

Above all, Duke Vincenzo set an example. Over the following years many Italian collectors began to dispose of their treasures *en bloc*, as he had done. Within a short time, for instance, the Venetian merchant Bartolommeo della Nave sold his entire collection to England, whence it eventually passed to the Habsburg Archduke Leopold Wilhelm and to Vienna:[7] among the many wonderful pictures that left Venice in this way were Antonello da Messina's *San Cassiano Altarpiece*, Giorgione's *Three Philosophers*, and Titian's late *Nymph and Shepherd* (all in the Kunsthistorisches Museum, Vienna). But in fact the whole of seventeenth-century Venice was something like an unparalleled saleroom for collectors from all over Europe. Ridolfi's lives of the Venetian artists, *Le meraviglie dell'arte o vero le vite degli illustri pittori veneti*, were dedicated to two of these (the Reynst brothers who were based in Amsterdam and who themselves owned superb pictures from Venice – Lorenzo Lotto's *Portrait of Andrea Odoni*, now in Hampton Court, among them), and his book sometimes reads like an elaborate catalogue of what was available for anyone who was prepared to pay. In the mercantile society of Venice no one seems to have felt any of the qualms that had afflicted Duke

Plate 58 ANTONELLO DA MESSINA, *San Cassiano Altarpiece*, Vienna, Kunsthistorisches Museum.

Vincenzo Gonzaga in dispersing pictures inherited over the generations; and it would be impossible even to try and list the masterpieces that left the city in these years. Some indication of how the rest of Europe benefited can be seen from the names associated with just two of them. Titian's so-called *Portrait of Ariosto* (London, National Gallery) went to Amsterdam where its pose inspired a self-portrait by Rembrandt; Velazquez bought Veronese's *Venus and Adonis* (Prado) for the king of Spain.

Spectacular as were these and many other purchases, it was still Rome that provided the greatest lure and the greatest challenge – to Louis XIV more than to anyone else, for it was at least as much the symbolic nature of the city's possessions as their intrinsic aesthetic quality which really attracted him. Rumours of the king's omnivorous

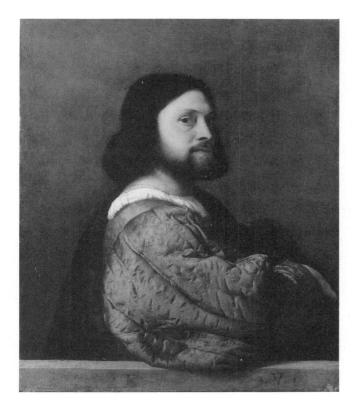

Plate 59 TITIAN, *Portrait of Ariosto*, reproduced by courtesy of the Trustees of the National Gallery, London.

collecting were repeated endlessly by the Romans and by foreigners alike: 'it is very likely', noted one English observer in 1686,

> that a great part of their movable wealth [of the Roman nobility] will be ere long carried into France; for as soon as any Picture or Statue of great value is offered to be sold, those that are imploied by the King of France, do presently buy it up so that as that King hath already the greatest collection of Pictures that is in Europe, he will very probably in a few years more, bring together the chief Treasures of Italy.[8]

Like similar stories that were to be told of the English in the eighteenth and nineteenth centuries and of the Americans in the twentieth, this

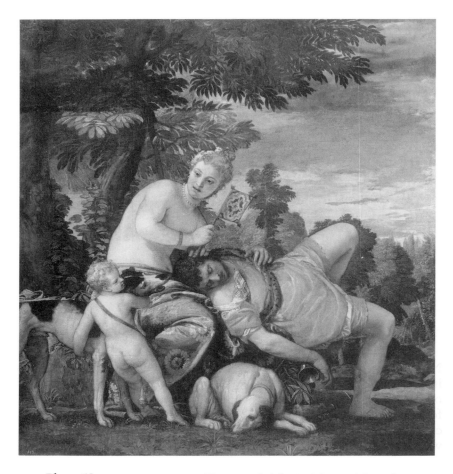

Plate 60 PAOLO VERONESE, *Venus and Adonis*, Museo del Prado, Madrid.

proved to be grotesquely exaggerated. Louis XIV failed in all his most ambitious plans to acquire important works in Rome: the *Farnese Bull* (Museo Nazionale, Naples) and the antiquities from the Ludovisi collection (Museo Nazionale Romano, Rome). And though the king did manage to buy or to obtain as gifts some very fine pictures by Caravaggio (*La buona ventura*), Annibale Carracci (*Landscape with Hunting Scene, Landscape with Fishing Scene*), Domenichino (*Hercules and Achelous, Hercules and Cacus*) – all now

in the Louvre – and some other masters, he obtained little in Rome that could compare in importance with Veronese's *Supper in the House of Simon* (Louvre) with which he was presented by the Venetian Senate in 1664. In fact, Louis XIV's most significant acquisitions – in the eyes of his contemporaries – proved rather counterproductive. In 1685 he was able to buy from Prince Savelli two famous antique sculptures – the so-called *Germanicus* (Louvre) and the so-called *Cincinnatus* (Louvre). Such was the fury aroused by this alienation of the Roman heritage that in the following year Pope Innocent XI issued the most stringent regulations that had ever yet been enforced anywhere to control the export of works of art. All previous efforts to this effect by the papacy were reasserted, and the new laws went into the greatest possible detail:

> By the present ordinance we forbid all persons severally, ecclesiastical and lay of every degree, to take or cause to be taken from our State by river, sea or land any kind of statue, figure, bas-relief, column, vase . . . neither ancient figures, designs and paintings nor other works of any sort, whether carved, painted, inlaid, modelled, shaped or made in any other manner, whether newly found in excavations or existing in Rome or outside, or in the possession of any person or in any place without our authority.[9]

Nothing so explicit or all-embracing had ever been conceived, and it might have seemed that from now on not a sculpture or painting of value would ever leave the Papal States. But even if we choose to forget that no law, however well framed, can of itself put an end to crime when the incentive is great enough, it is obvious that there was another flaw in this particular legislation: the words 'without our authority' implied that under certain circumstances authority to export could be granted. It was in the next generation that the pope's formidable series of vetoes was to be tested – and found wanting.

When Queen Christina of Sweden settled in Rome in the middle years of the seventeenth century she brought with her the great collection of Italian pictures she had owned in Stockholm. These had for the most part been looted from Prague, where they had belonged to Rudolph II, who had himself acquired them sometimes directly from the artists, but more often through dealers. In Rome Christina increased the collection and also added to it a number of classical sculptures, some of which were considered to be of the highest importance. After her death, pictures and statues passed

Plate 61 DOMENICHINO, *Hercules and Cacus*, Musée du Louvre. © Cliché des Musées Nationaux, Paris.
Photo: Réunion des Musées Nationaux.

Plate 62 PAOLO VERONESE, *Supper in the House of Simon*, Musée du Louvre. © Cliché des Musées Nationaux, Paris. Photo: Réunion des Musées Nationaux.

through a number of hands, but always remained in Rome. Early in the eighteenth century the Régent, the Duc d'Orléans, Louis XIV's successor as ruler of France, began negotiations with the Duke of Bracciano, who was then the owner, to buy both collections, with – so he claimed – the tacit agreement of the pope that they would be allowed to leave Rome. In 1720 negotiations were nearing completion, and the Duc d'Orléans wrote to Pope Clement XI: 'I very humbly beg Your Holiness to renew the authority' (for them to leave Italy).[10] These collections were of such infinitely greater importance than the *Germanicus* and the *Cincinnatus* which had stimulated Innocent XI's law of 1686 that all logic demanded that the pope answer with a polite but firm refusal. But the papacy was hardly in a position to risk angering the ruler of France, and Clement XI began to vacillate in rather an alarming manner: 'We are constantly offered reasons to hope, but it [the permission] does not come', wrote Cardinal Gualtiero who was acting for the French. The issue was almost as important as that of Mantua nearly a century earlier, but very different in character. The picture collection at least was both strictly 'private' and in no way linked to the history of Rome to which it had only come by accident and fairly recently. And this time there was no possibility of maintaining secrecy. It is perhaps the first occasion when we can trace in detail the clash, that has been repeated so often since both in Italy and elsewhere, between on the one hand wealth and power and on the other laws designed to safeguard an artistic heritage. For months enormous pressure was put on the pope: he was told threateningly that 'it was truly insulting to refuse such a thing to a prince of his rank and worth, and especially at a time when he was spending his resources in the service of the Holy See.' Despite this the pope remained absolutely firm on one issue, and though his decision hardly coincides with present-day taste it was logical enough in the context of the early eighteenth century. On no account would he allow the ancient statues to leave Rome, and this effectively put an end to negotiations for their purchase. As regards the paintings he was less rigid. At one stage he suggested that the Regent might be allowed to remove 'only the obscene pictures'. As the paintings included in this category no doubt comprised Titian's *Venus Anadyomene* (on loan to the National Gallery of Scotland) and Correggio's *Danae* (Rome, Villa Borghese) among many others of equal splendour, the offer was not unattractive, but the Régent's agent answered icily that 'it would make a fine impression to have only scandalous portrayals of nudity arrive, and for it to be known that it was [the pope] himself that was responsible.'

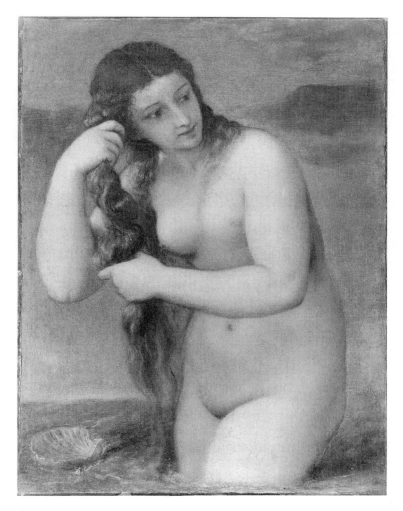

Plate 63 TITIAN, *Venus Anadyomene*, Duke of Sutherland Collection on loan to the National Gallery of Scotland, Edinburgh.

Meanwhile the painters of Rome protested to the pope that if he granted permission for the pictures to leave 'he would be plundering Rome of all the most precious things of that kind that it had.' Certainly the pope did what he could: bribes were suggested, but not apparently followed up, and at one stage the French threatened that if Clement refused to allow the pictures to leave Rome,

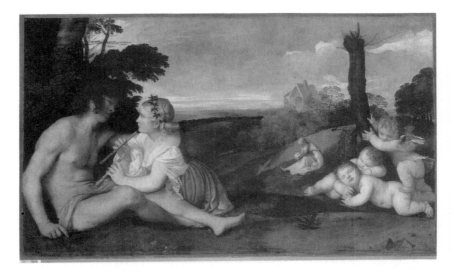

Plate 64 TITIAN, *The Three Ages of Man*, Duke of Sutherland
Collection on loan to the National Gallery of Scotland, Edinburgh.

these would indeed be kept in the city – but hidden there so that
nobody would be able to see them. And then the pope died. Plans
were immediately projected to take advantage of the absence of any
strong central authority and to smuggle out the pictures, but the
conclave proved to be a fairly short one, and soon after his election
the new pope, Innocent XIII, granted the necessary permission. And
so Titian's *Three Ages of Man* (on loan to the National Gallery of
Scotland), and Veronese's *Mars and Venus* (New York Metropolitan
Museum) and *Mercury and Herse* (Fitzwilliam Museum, Cam-
bridge) and Raphael's *Madonna del Passeggio* (on loan to the Na-
tional Gallery of Scotland) and large numbers of other pictures left
Italy for ever – despite the enactment of laws, unequalled in their
explicit severity, designed to prevent just such a contingency.

Three years later in 1724 the ancient statues, which included the
beautiful group of *Castor and Pollux* (Prado) which the painter Carlo
Maratta had many years earlier persuaded the queen of Sweden to
buy for the express purpose of keeping it in Rome, were acquired by
the king of Spain with, paradoxically, much less difficulty than had
been faced by the Duc d'Orléans over the pictures: the fact that the
pope was engaged in exceptionally difficult negotiations with Spain

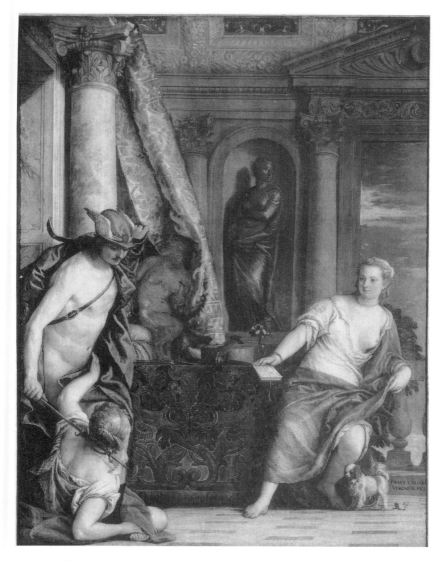

Plate 65 PAOLO VERONESE, *Mercury, Herse and Aglauros*,
reproduced by permission of the Trustees, the Fitzwilliam Museum,
Cambridge.

no doubt helped matters. One addition needs to be made to any account of this revealing episode. Drawings had not been mentioned among the works of art whose export had been prohibited by the pope. Thus Pierre Crozat, the fabulously rich banker who acted as the Régent's principal agent in negotiating the purchase of the Duke of Bracciano's pictures, was able to take full advantage of his visit to Rome by acquiring for himself great quantities of those Old Master drawings which constituted his particular passion. No legal obstacles prevented him buying entire collections – 'I have again applied for your drawings, Monsieur', Cardinal Gualtiero wrote to him. 'You will undoubtedly have them, but the price will be a lot of champagne' – and even if modern scholars would doubtless contest the attribution of many of the 155 drawings by Raphael, the 292 by Polidoro da Caravaggio and so on, which Crozat claimed to own (and which were judged authentic by the great connoisseur Mariette), nonetheless it is obvious that Italy provided an inexhaustible and easily accessible supply of the very finest drawings for those foreigners who were interested.

The acquisition by the Régent and the king of Spain of the queen of Sweden's pictures and statues seemed to prove that political power and diplomatic blackmail were likely in the end to override even the most strenuous attempts to keep in Rome some of the most famous works of art in the city. In the eighteenth century, however, the main pressure was to come from economic power, and the English aristocracy and the German princes who soon replaced the French in the proverbial literature that grew up about the despoiling of Rome were to prove the richest and most acquisitive collectors. On a growing scale antiquities from the most important Roman collections – the Giustiniani, the Chigi etc. – began to find their way to English country houses and German palaces. And Cardinal Albani, the greatest amateur in Rome, whose responsibility it was to preserve the city's heritage, was himself one of the leading exporters: 'The king of Poland has sent here a person who has bought all the ancient statues belonging to Prince Chigi, and a large part of Cardinal Alessandro Albano's collection. Some time ago the king of Spain took those of Dom Livio Odescalchi, which were a considerable number. So, bit by bit, the plunder of this poor country goes on', wrote the Director of the French Academy in Rome at the end of 1728,[11] and with the balance of economic power shifting so strongly against the papacy there seemed no reason why the process should ever end.

It was in these circumstances that a succession of popes took a series of measures to preserve the heritage of the past which proved

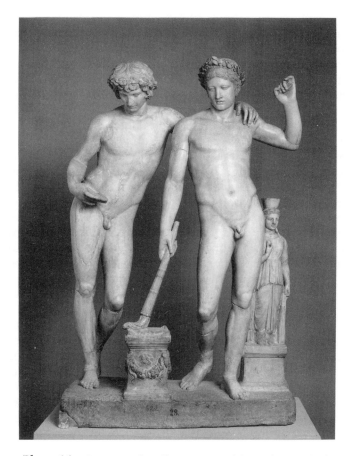

Plate 66 *Castor and Pollux*, Museo del Prado, Madrid.

infinitely more effective than the thunderous, but ultimately impotent, proclamations that had characterized previous moves. To Clement XII (1730–40) and to Clement XIV (1769–74) and Pius VI (1775–99) must go much of the credit for seeing that the principal way of solving the problem was through the formation of public museums, first the Capitoline and then the Pio-Clementino in the Vatican, for which they themselves would have to provide funds for purchasing the threatened works of art. There are many reasons why these magnificent institutions must count among the main landmarks in the cultural history of Europe – and indeed the world; but

only one is of special interest in the context of this chapter. The establishment of these public museums signified, at least by implication, that the works in them were inalienable and could not be disposed of. This had never been quite clear until now. The Renaissance and baroque popes had sometimes acquired sculpture and paintings for the Vatican palace (Julius II, above all), sometimes for themselves (Paul III, followed by nearly all later popes until Clement XII): in the latter case they made it clear that their possessions were entirely the private property of their families, but even in the former it was not absolutely certain what was the true position. During the Counter-Reformation, for instance, some popes had not hesitated unduly about selling or giving away 'pagan statues' from the Vatican, even though these had been collected by their predecessors. But by creating museums specially designed to prevent the dispersal of sculpture from Rome – as always it was sculpture rather than pictures that was the chief concern – the popes of the eighteenth century were warning foreigners that the most important pieces were always going to remain beyond their grasp. On the whole this new policy worked surprisingly well, though naturally it was often hindered by the inability of the popes to match the wealth of foreign collectors and by the ingenuity with which these collectors managed to smuggle out what they wanted or to bribe the officials responsible for the granting of licences. As far as new excavations were concerned the popes enacted laws entitling to themselves one-third of anything found within their dominions, and they also reserved the right to prevent the export of any other specific pieces which were considered to be of great importance.[12] And this right was frequently exerted, so that although vast quantities of sculpture did leave Rome, the city was certainly not denuded of her greatest masterpieces, as might have been feared at the beginning of the eighteenth century and as would surely have happened if market forces had been met only with unenforceable laws. Moreover, when in 1748 Pope Benedict XIV bought for the Capitoline Museum the superb collection of pictures that had been formed in the seventeenth century by the now-bankrupt Sacchetti family, he showed, in what must have been a surprising way, that paintings also could be kept in Rome despite the avidity of foreign collectors.

Five years before this an even more important step had been taken to preserve the cultural heritage of Italy. In her will of 1743 Anna Maria Ludovica, 'the last of the Medici', confirmed an agreement that she had made with the Duke of Lorraine, who had succeeded her brother as the ruler of Tuscany, whereby she ceded

to His Royal Highness and to his grand-ducal successors all the fur-
nishings, effects and curiosities of the line of her brother the grand-
duke, such as the galleries, pictures, statues, libraries, jewels and other
precious objects, as also the holy relics, the reliquaries and the orna-
ments of the chapel of the royal palace, which His Royal Highness
undertakes to preserve, accepting the express condition that it is for
the adornment of the state and the benefit of the public, and to attract
the interest of foreign visitors, and that nothing from it shall be
moved from the capital and territory of the grand-duchy.[13]

On the whole the terms of her will were faithfully adhered to, and
the close association of the works of art with the city even proved
to be of some use in resisting the forceful depredations of the French
during the revolutionary and Napoleonic occupations.

Elsewhere it was still considered quite normal for a dynastic
collection to be looked upon as private property. Thus in 1745
Duke Francesco III Este of Modena virtually repeated the behaviour
of Duke Vincenzo II Gonzaga of Mantua of more than a century
earlier by selling 100 of the greatest masterpieces of the family's
picture collection.[14] The purchaser was Augustus III of Saxony (aided
by a skilful team of Italian negotiators) who thus acquired for his
gallery at Dresden some of the most famous pictures in Italy, nota-
bly four by Correggio, including *La Notte*, Titian's *The Tribute
Money*, the *Sacrifice of Isaac* by Andrea del Sarto, four masterpieces
by Veronese and important works by Parmigianino, Carracci, Guido
Reni, Albani and Guercino, as well as fine pictures by Dosso Dossi
and other Ferrarese artists. Yet in the eyes of contemporaries (and
perhaps also some later historians), even a loss on this scale took
second place to Augustus's acquisition in 1754, again with the help
of Italian agents, of Raphael's *Sistine Madonna* from the church of
San Sisto at Piacenza. Piacenza belonged to the Duke of Parma, and
Parma, more than any other Italian city, was used as a pawn in the
cynical game of chess played by the European powers. At the time
of the sale, its duke was the younger son of the Spanish king, and
his attachment to Parma was tenuous in the extreme. That perhaps
helps to explain the absence of effective measures to keep the cel-
ebrated picture in his domain. Such measures were all the more
needed after the removal twenty years earlier of the Farnese collec-
tion from Parma to Naples. Evidence of the resentment caused by
the sale of the Raphael is pro-vided by a French visitor. An old
priest, seeing a traveller inspecting the copy left as a substitute for
the *Sistine Madonna*, came up to him and said,

Plate 67　TITIAN, *The Tribute Money*, Gemäldegalerie Alte Meister, Staatliche Kunstsammlungen, Dresden.

'Monsieur, you must not be kept in error. The celebrated picture you seek is no more.' As he finished speaking, his tears began to flow. The Italians, jealous guardians of the treasures of their land, have all too often cause to lament such losses. Taste and wealth are still growing in the north, and the process is not yet at an end.[15]

Augustus's insatiable appetite was not always gratified so easily. When he tried to obtain some of the most famous pictures in the Papal States – among them Raphael's *Madonna di Foligno* (Vatican) and *St Cecilia* (Bologna) and Domenichino's *Diana Hunting* (Rome, Villa Borghese), he met with no success partly through the intervention of the authorities to prevent their export.

Venice, on the other hand, retained throughout much of the eighteenth century the role she had kept in the seventeenth as the chief

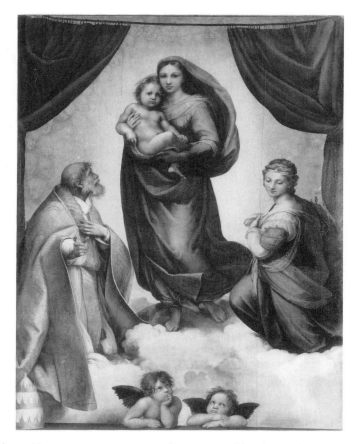

Plate 68 RAPHAEL, *Sistine Madonna*, Gemäldegalerie Alte Meister, Staatliche Kunstsammlungen, Dresden.

supplier of paintings to foreign collectors. Nor did Venetians feel it in any way wrong to act as agents for such collectors. Francesco Algarotti, for instance, was proud of his acquisition for the court of Dresden of Palma Vecchio's beautiful *Three Sisters* from the Cornaro family, and it is quite misleading to see such transactions through the eyes of later historians whose patriotism was of a very different kind. Algarotti thought of himself as an apostle of Venetian culture in a Europe dominated by France, and he was as keen to obtain commissions for contemporary painters as he was to sell Old Masters. This was a period when many artists – Tiepolo and Canaletto

Francis Haskell

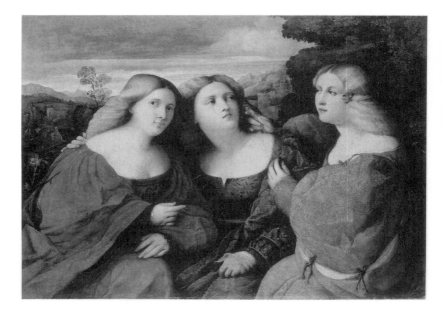

Plate 69 JACOPO PALMA VECCHIO, *Three Sisters*, Gemäldegalerie Alte
Meister, Staatliche Kunstsammlungen, Dresden.

spring to mind immediately – worked far more for the foreign than
the home market, and the time was long past when the rulers of
Tuscany or Rome could try and keep a monopoly for themselves of
the works of favourites such as Giambologna or Bernini. In holding
the view that both old and new should be exported Algarotti was by
no means exceptional, and the logic of his attitude needs to be borne
in mind in any consideration of the events described in these pages.

Pressure, however, mounted dangerously during the second half
of the eighteenth century and began to cause serious alarm. When
in about 1804 Don Giacomo della Lena wrote his 'Esposizione istorica
dello Spoglio, che di tempo in tempo si fece di Pitture in Venezia',[16]
he named as those primarily responsible for this state of affairs
the foreign diplomats in Venice, especially the English. Among the
more remarkable episodes he mentions is the purchase by the Eng-
lish Consul (and dealer) John Udney 'con la sua astuzia, e con la
corruzione dell'oro' of Titian's *Madonna in Glory with Six Saints*
(Vatican) from San Niccolo ai Frari. In this case, however, the picture
did not go to England as might have been expected, but was bought

by Pope Clement XIV and taken to Rome. This pope was the founder of the Museo Pio-Clementino, and his acquisition of Titian's altarpiece from Venice confirms once again how far ahead of most of the Italian states was the papacy in the preservation of the Italian heritage.

In fact, it was at this very moment – in 1773 – that the government of Venice woke up to the threat and realized that it was 'inescapably important to abolish the outrageous freedom with which some of the best and most notable pictures in the churches, schools and monasteries of the city and the neighbouring islands had been removed at will and sold, even to foreign buyers'.[17] Among many examples given were 'three altarpieces and the organ panels of the church of San Giacomo on Murano, outstanding works by Paolo Veronese, sold to the English Resident for a few *zecchini*'. To remedy this state of affairs the Inquisitors appointed an 'Ispettore' who was to draw up 'a catalogue of all the pictures that are the work of famous and highly regarded painters, and from it a list of the said pictures in each location . . . to commit this to the superiors, priests, directors and custodians of the churches, schools and monasteries, with the duty, applying both to the present holders of these offices and their successors, to protect and preserve them, and to take responsibility for any consequent removal or loss'. The man chosen as the first inspector was Anton Maria Zanetti the Younger 'known for his integrity, his experience and his knowledge of the arts, of which he has also given proof in his book on Venetian painting', and he was required to take active steps to see that the various priests in charge of pictures in their respective churches really did comply with the regulations forbidding their export. The Venetian move is interesting also because it was concerned not only with trying to retain the Venetian heritage in Venice but in addition to maintaining it in good condition, though the problem was approached philosophically: 'It is right to accept with resignation that time takes away its pristine beauty. Such is the law of all things human, but it is not to be endured that the paintings be allowed entirely to perish.' Largely as a result of these steps the Venetians gained a reputation, unrivalled throughout Italy, for the efficient restoration of pictures – though whether such 'restoration' did more harm than good would be a difficult point to decide. Moreover, there was one huge loophole in all this legislation. No provision was made for the preservation of private collections, and della Lena's notes make it clear that these continued to be dispersed on quite a large scale.

Naples was the one other city to grow in cultural importance

during the second half of the eighteenth century, though it was exceptional in that foreigners were likely to be interested almost exclusively in the purchase of those sculptures, paintings and other relics from the past that had come to light as a result of the excavations in Herculaneum and Pompeii. Nowhere in the world was a stricter control maintained over the national treasure. Visitors were not even allowed to copy, let alone to buy, the antiquities found in these buried cities. Moreover, when King Charles III left Naples to inherit the throne of Spain, he made a point of leaving behind all the treasures of his first kingdom, thus demonstrating that he too acknowledged the shadowy existence of a 'national patrimony' as distinct from the ruler's personal possessions, though the publicity that was given to his magnanimous gesture makes it clear that it was a case of 'noblesse oblige' rather than of any binding obligation.

Thus by the end of the *ancien régime* all the leading states of Italy whose art might be at risk from foreign despoilers (and this hardly as yet included Piedmont or the Austrian province of Lombardy) had taken steps of one kind or another, and of various degrees of efficiency and legal force, to ensure the permanent safeguard of the works of art under their control. By far the most efficient were the Papal States with their superbly constructed public museums and active, even if inadequate and often corrupt, measures for preventing the export of highly desirable antiquities and paintings.

Ironically enough, it was this very efficiency (as well, of course, as the city's artistic wealth) that was responsible for Rome suffering more than anywhere else during the French invasions of the revolutionary and Napoleonic periods. Many cities were dreadfully hit by the indiscriminate looting and sometimes deliberate sacking common to all wars, but when the French started demanding works of art as part of the peace treaties they forced on the states that they successively conquered, they did attempt to apply a specific policy based on what was seen as a rational system. Private collections were to be respected as sacred, but the 'prince's' treasures could legitimately be seized. It has been the purpose of this chapter so far to demonstrate that the more enlightened Italian states, and above all the popes, had been gradually feeling their way towards a *de facto* third category – that of the public collection. The French recognized that this presented them with an awkward problem, and that it was hardly very seemly to come to Italy as liberators and then take from the people of Rome what in fact, though not strictly in theory, belonged to that very people: instructions were given to try and avoid arousing too much indignation through the indiscriminate

looting of churches or public buildings.[18] Nonetheless, if the French were going to take to Paris – as they were determined to – the *Apollo Belvedere*, the *Laocoon*, Raphael's *Transfiguration*, Domenichino's *Last Communion of St Jerome* (all now in the Vatican) and the other most famous sculptures and paintings in the world, they had to claim that these were the personal property of the 'Prince of Rome' and thus liable to confiscation. And so it happened that the very steps that the popes had taken to rescue the main sculptures left in private hands by gradually acquiring them for the Capitoline and Pio-Clementino Museums now led to these being seized and taken to Paris, whereas the private collections – whose impoverished owners had always been on the verge of exporting their main treasures – were left intact. Let us take one example. Had the pope not bought the famous *Barberini Candelabra* (Vatican) in 1770, they would almost certainly have been sold by that family to the English. Because they had been acquired, however, they were now taken by the French, while the sculptures still remaining in the Barberini palace were not touched. It is quite impossible to discuss here what was taken to the Musée in Paris between 1796 and 1814 from all over Italy, because the list would embrace not just single masterpieces, such as the *Sistine Madonna* (Dresden), or entire collections, such as those of the Gonzaga or Este, as had been seized in the past, but virtually everything that was, by the standards of the time, considered to be of overriding quality. The four examples mentioned above (out of a hundred pictures and sculptures demanded from the pope alone) are sufficient to make the point – but we should perhaps add to them (merely as another indication of the lack of inhibitions with which the French treated the most famous masterpieces in the world) the *Horses of St Mark* and Titian's *Death of St Peter Martyr* (destroyed by fire in 1867) from Venice and the *Venus de' Medici* from Florence. Some people were disappointed that Raphael's frescoes in the Vatican and Trajan's column in Rome were not also taken,[19] and for a time attempts were actually made to detach Correggio's frescoes from the Camera di San Paolo in Parma.[20] In fact, only two important cities remained relatively unscathed (for political reasons which were always liable to change, and against the advice of Napoleon's chief counsellors): Naples and Florence (apart from the removal of the *Venus de' Medici*).

But though, for the most part, their principles did not allow the French to seize private collections – the Borghese sculptures were bought, quite legitimately and for a vast sum, by Napoleon, who was Prince Camillo Borghese's brother-in-law – this does not mean

that those collections emerged unscathed from twenty years of wars, invasions and occupations. English principles would have been outraged by proposals to seize the main treasures from the public museums of Rome, but could cope unruffled with the idea of buying for as little as possible (and then smuggling out of the country) the best pictures in the private palaces of those nobles whose incomes had been drastically reduced by huge new taxes imposed during the upheavals. Nor could the English claim, as the French justifiably could, that, once taken, these works of art would be publicly displayed for the benefit of all mankind. And so, vulture-like, agents, dealers, artists and adventurers of all kinds flocked to Rome, Genoa and elsewhere and sent back to remote country houses, inaccessible to all but the most privileged, amazing pictures from collections as famous as the Aldobrandini, the Borghese, the Colonna and many more – Titian's *Bacchus and Ariadne*, Raphael's [Garvagh] *Madonna and Child* and *St Catherine*, Correggio's *Ecce Homo* (all now in the National Gallery, London). And, as had so often happened with the great German acquisitions of the eighteenth century, Italian dealers collaborated eagerly in the spoliation of their native cities.

The equally ruthless, but quite different, approaches adopted by the French and the English towards potential booty from Italy led to opposing results. With the exception of one field, to which reference will be made on a later page, French operations had been remarkably efficient – and remarkably centralized. Apart from coins, jewellery and other small portable objects (in which category we must include drawings), almost every work of real quality taken from Italy had found its way to the Musée and not to the private houses of military commanders or art dealers (as so often happened during the conduct of similar operations in Spain). Thus when, after Waterloo, the Allies insisted on full restitution being made to the various Italian states, this – despite vigorous French protests and obstruction – was, theoretically, quite possible. In the event it was not fully enforced. Pictures which had been sent to provincial museums remained there; nobody bothered to ask for the return of the 'primitives'; Veronese's *Marriage at Cana* (Louvre) was considered inconveniently large to take back (though the French had managed to transport it to Paris); and to appease the restored Bourbons the pope decided not to press in full his claims for the return of some of his classical sculptures. Nevertheless, the overwhelming majority of paintings and statues which were thought of as belonging to the first rank did return to Italy, whereas everything that had been bought privately by the English remained in England.

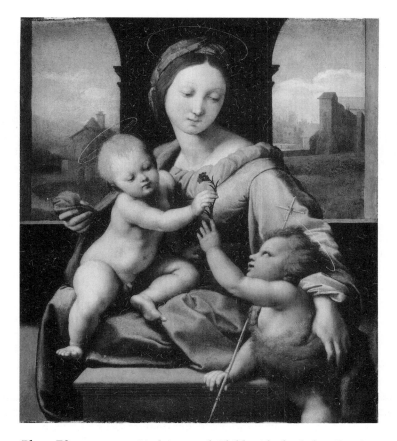

Plate 70 RAPHAEL, *Madonna and Child with the Infant Baptist,*
reproduced by courtesy of the Trustees of the National Gallery,
London.

But the French invasions did not, of course, result only in the
temporary removal of most of the important Italian art treasures to
Paris, and the permanent alienation of many of the others by the
English. Fundamental dislocation of the Italian heritage occurred on
Italian territory. In Venice alone, for instance, Leopoldo Cicognara
estimated[21] that 'There were 288 public buildings, the work of
centuries, erected for worship in Venice and its neighbourhood be-
fore the time in question; in a few years 176 of these were closed or
demolished', and he ends his understandable lament with the words:

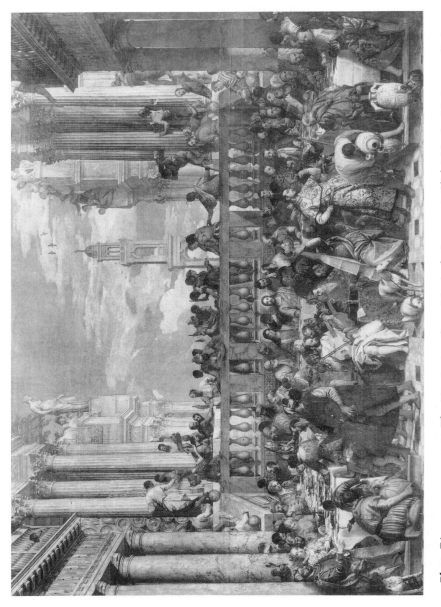

Plate 71 PAOLO VERONESE, *The Marriage at Cana*, Musée du Louvre. © Cliché Musées Nationaux, Paris. Photo: Réunion des Musées Nationaux.

'How bitter a recollection would be a similar list made for all the chief places in Italy.' Among the churches pulled down in Venice was, to give only one example, Sansovino's San Geminiano, which was destroyed so as to 'complete' the Piazza San Marco with the 'ala napoleonica'. Yet the problem of just how to appraise such 'vandalism' cannot be seen entirely in the context of twentieth-century notions of preservation. It is true that at least since the early years of the sixteenth century when Pope Julius II destroyed the old St Peter's to make way for Bramante's new church, there had been complaints about such reckless disregard for the past. Yet it is also true that every step in the creation of Rome, which at the end of the eighteenth century was everywhere admitted to be one of the most beautiful cities in the world, necessarily involved such moves; and as late as the 1770s the chapel of Innocent VIII, which had been frescoed by Mantegna (an artist who was beginning to attract admirers once again after centuries of neglect), was pulled down to make way for an extension of the Museo Pio-Clementino. And in 1818 an English visitor was disturbed by what were generally considered to be 'improvements' made to the fabric of ancient Rome:[22] 'I find that Rome has lost much of its picturesque quality through the treatment of buildings dating from antiquity. This may suit architects, but landscape painters must be made wretched by it. It brings to mind the old rhyme: 'Tutto indagare / E tutto guastare' (Investigating all spoils all). The complaint is one that was to be heard again and again during the nineteenth, and even more during the twentieth, century. It is in fact quite impossible to draw an exact chronological line between those desirable improvements which are universally acceptable even at the cost of destroying the past and that insensitive over-restoration, modernization and 'tidying up' which for many people was inaugurated with the French occupation of Italy, but which for others began only much later.

Other issues are raised by such complaints – the 'picturesque' whose passing was deplored by so many visitors to Italy early in the nineteenth century was, in actual fact, very often the visible decay of a great artistic heritage which as yet attracted little attention. When in 1827 Maria Callcott visited the Arena Chapel in Padua, it was clearly very 'picturesque', as can be seen from the drawing she made of it, but she wrote that she was printing a description and illustrations of Giotto's frescoes there because no one else had yet done so and 'I am anxious that a memorial of the state of this interesting relic should be preserved. The Chapel itself, from its situation, and the neglect into which it has fallen, being likely to

perish in a very few years . . .'[23] And even when Giotto and the late 'primitives' were winning the most enthusiastic admirers, travellers were horrified by the decay into which they had declined.

'What a scene of beauty, what a flower-garden of art – how bright and how varied – must Italy have presented at the commencement of the sixteenth century, at the death of Raphael!' wrote Lord Lindsay, the historian of early Italian art, in 1847.

> The sacrileges we lament took place for the most part after that period; hundreds of frescoes, not merely of Giotto and those other elders of Christian Art, but of Gentile da Fabriano, Pietro della Francesca, Perugino and their compeers, were still existing, charming the eye, elevating the mind and warming the heart. Now alas! few comparatively and fading are the relics of those great and good men. While Dante's voice rings as clear as ever, communing with us as friend with friend, theirs is dying gradually away, fainter and fainter, like the farewell of a spirit. Flaking off the walls, uncared for and neglected save in a few rare instances, scarce one of their frescoes will survive the century.[24]

Ruskin was as dismayed by the 'restoration' as by the neglect. As early as 1845 he could write from Florence,[25] where scaffolding covered the Orsanmichele, that if the 'Devil [of restoration] . . . goes on at this rate . . . in ten years more there'll be nothing in the world – but eating houses and gambling houses, and worse'. In fact the most pessimistic of these various prophecies were not altogether fulfilled, but as we read Ruskin's accounts of his successive visits, which toll like a threnody for the destruction of all that was most beautiful in Italy, it is impossible not to feel that it was in this field, rather than in the increasing dispersal abroad of Italian paintings and sculpture, that the real losses were to be found.

Dispersal, however, continued apace. It has already been suggested, in reference to the French spoliation of Italy, that there was one whole area of Italian art that was treated with casual indifference by occupier and occupied alike. None of the legislative procedures of the *ancien régime* had envisaged the possibility that there would one day develop a serious taste for the acquisition of 'primitive art', though, in an extraordinarily precocious move, the Uffizi had, as early as the 1770s, begun not only to display some of the early paintings which formed part of the Medici heirlooms but actually to acquire others on the market. This, however, was essentially educational in intent, as were similar ventures by a few

imaginative private collectors. It was not until the disruption caused by the invasions that huge quantities of early Italian paintings began to leave the altars for which they had been painted (or the sacristies where they had been stored) and emerge into the shops of second-hand dealers, often to be broken up for the sake of their gold back-grounds, but sometimes to be collected (by the French especially) because they were cheap and nothing else was available as a result of the efficiency of the Musée authorities, or because, for the more scholarly-minded, they were instructive – though hardly beautiful. In Italy, where local historians had pioneered this approach, the ruling classes and influential collectors were paradoxically less responsive to the quality and importance of fourteenth- and fifteenth-century paintings than were those of France, Germany or England. It has already been pointed out that the Italian commissioners did not even bother in 1815 to take back those early pictures which Vivant-Denon had acquired for the Louvre – pictures which included Cimabue's *Madonna and Child with Angels*, Giotto's *Stigmatization of St Francis* and Fra Angelico's *Coronation of the Virgin* (all in the Louvre) – and as early as 1821 the Berlin Museum bought the huge collection of works by fifteenth-century Italian masters such as Andrea del Castagno (*Assumption of the Virgin*), Botticelli (*St Sebastian*) and Filippo Lippi (*Madonna and Child* – now in Washington) which an English timber merchant, Edward Solly, had with no effort extracted from Italy during much the same period. The Italians paid dearly for this neglect because it was during the nineteenth century that Italy was stripped of many of her finest masterpieces of this period.

In only one respect had the situation improved since before the deluge. The system of public museums which we have seen developing tentatively in Florence and Rome was, under the impact of the Musée Napoléon, enormously extended. Some were created by the French – the Brera, for example, in Milan, to which were brought many pictures from suppressed churches and monasteries – and others, the Vatican picture gallery among them, were built up after the end of the wars largely to accommodate paintings which came back from Paris, but which it was decided not to return to the churches from which they had been taken.

Once again, as so often in the past, the lead came from Rome. In 1802, under the immediate impact of the French plundering of the city, Pope Pius VII issued a remarkable decree in which, after naming the 'incomparable sculptor Canova' Ispettore delle Arti, he made the boldest attempt yet to keep full control of everything that still re-mained in Rome.[26] All the loopholes of previous legislation were

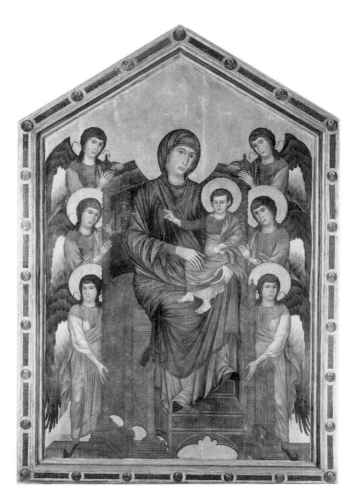

Plate 72 CIMABUE, *Madonna and Child with Angels*, Musée du Louvre. © Cliché Musées Nationaux, Paris.
Photo: Réunion des Musées Nationaux.

acknowledged and were now filled. No antiquities of any kind whatsoever, nor 'paintings on panel or canvas, produced by the classic artists working since the revival of the arts, nor works of interest to the arts themselves, the schools and scholarly study,' could be exported from the Papal States. And no persons at all 'possessing no matter what privilege, or honoured with any rank

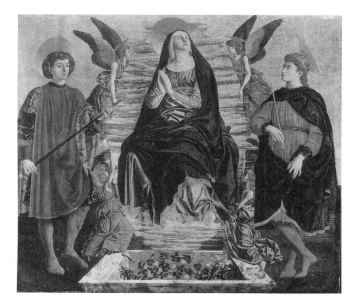

Plate 73 ANDREA DEL CASTAGNO, *Assumption of the Virgin*, Gemäldegalerie, Staatliche Museen Preussischer Kulturbesitz, Berlin. Photo: Jorg P. Anders.

whatever, not even the Most Reverend Titular Cardinals, Protectors of Churches or other specially privileged people' were allowed to grant export licences. No pictures could be removed from churches – 'not even for restoration on the spot or elsewhere, nor could they be moved for copying without the knowledge and permission of the Ispettore delle Belle Arti'. All private collectors were required to submit an exact list of their artistic possessions within one month, and their collections would thereafter be visited every year to check that nothing was missing. Foreigners living in Rome were subject to exactly the same restrictions on exports as were the local inhabitants, and for both groups alike sales of works of art could be made only within the city itself. An annual sum was set aside for purchases to be made for the papal museums, and the most stringent steps were taken to prevent destruction or damage of any kind to ancient monuments.

This decree should, in theory, have put an end, once and for all time, to every conceivable abuse. In fact it was followed almost

immediately by the long, hazardous journey to London of the finest
Titians and Raphaels left in Rome – as described on an earlier page.

In 1820, after the return from the Musée of the principal pictures
and antiquities in Rome, the Pope's decree was followed up by an
edict promulgated by the Cardinal Camerlengo Bartolomeo Pacca,
which repeated and amplified the decrees of 1802.[27] This was
probably the most effective ruling of its kind anywhere in Italy and,
as we shall see, it was still invoked as late as 1899 by an Italian
government which no longer recognized the authority of the pope
over the city of Rome – and which certainly had not respected
Cardinal Pacca's ideas about maintaining intact the fabric of its
buildings.

Nevertheless, from about 1845 onwards, these measures began to
be infringed in the most spectacular manner. In that year the huge
collection of pictures which had been formed by Napoleon's uncle
Cardinal Fesch was sold by auction. Lip-service was paid to the
papal decrees by indicating in the catalogue just which pictures were
said to have been brought into Rome from France (where the Car-
dinal had mostly resided before 1815) and which were not liable
– so it was claimed – to the embargo on exports. However, as virtu-
ally everything, whatever its provenance, quickly reached foreign
clients, even if actually acquired at the sale by dealers nominally
residing in Rome, this was little more than a gesture of good will,
and it cannot have been Cardinal Pacca's intention to let out of the
city paintings such as Mantegna's *Agony in the Garden* (London,
National Gallery) or Poussin's *Dance to the Music of Time* (London,
Wallace Collection). In 1856, another very important collection was
lost to Rome with the purchase by the fourth Duke of Northumber-
land of the pictures which had been collected by the painter Vincenzo
Camuccini. Most of these had been assembled (often in collaboration
with English dealers) during the chaotic years at the beginning of the
century, and Camuccini's collection was among those regularly in-
spected by the authorities to check that nothing went abroad.[28] Never-
theless he claimed that the pope refused to buy his greatest treasure,
The Feast of the Gods by Bellini and Titian (Washington, National
Gallery of Art), and other pictures, and this presumably gave him
(or his heirs) the right – during a very difficult time for the papacy
– to dispose of the entire collection.

But by far the most humiliating disaster of all was the loss, at
much the same time, of the incredible Campana collection, 'la più
ricca forse che sia sorta nel secolo decimonono', with its thousands
of archaeological treasures;[29] wonderful pieces of majolica; great

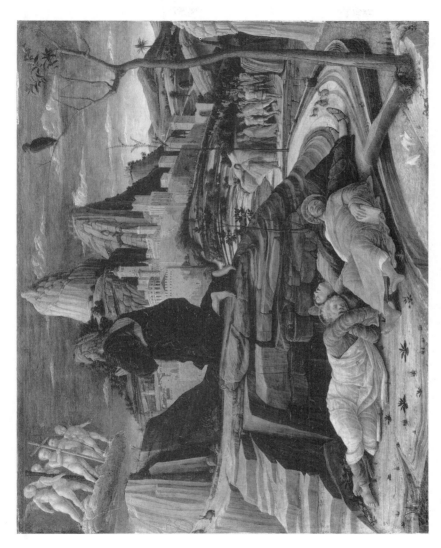

Plate 74 ANDREA MANTEGNA, *The Agony in the Garden*, reproduced by courtesy of the Trustees of the National Gallery, London.

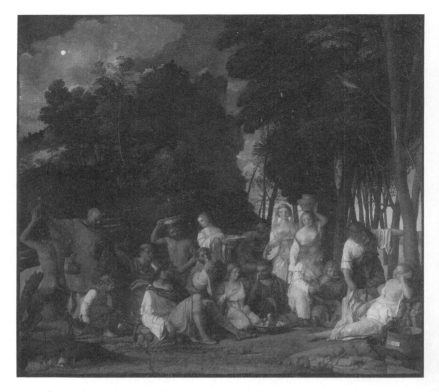

Plate 75 GIOVANNI BELLINI AND TITIAN, *The Feast of the Gods*,
1514, National Gallery of Art, Washington, Widener Collection.

paintings by Uccello (*Battle of San Romano* – Louvre), Justus van
Ghent (fourteen *Uomini illustri* from the studiolo of Federico da
Montefeltro in Urbino – Louvre), Botticelli (*Virgin and Child* – Petit
Palais, Avignon), among many others; sculptures by Donatello (*Christ
Supported by Angels* and *Christ Giving the Keys to St Peter* –
London, Victoria and Albert Museum), Luca della Robbia (the
roundels of the *Months* – London, Victoria and Albert Museum),
and many other masters. All this had been acquired by the insatiable
Marchese Giampietro Campana during his flourishing and fashion-
able years as director of the Monte di Pietà in Rome. When, after
some reckless dealings, the financial crash drew near in the middle
1850s, he tried in vain to sell off parts of his collection *en bloc*
(encouraged in this by the papal administration itself), though he

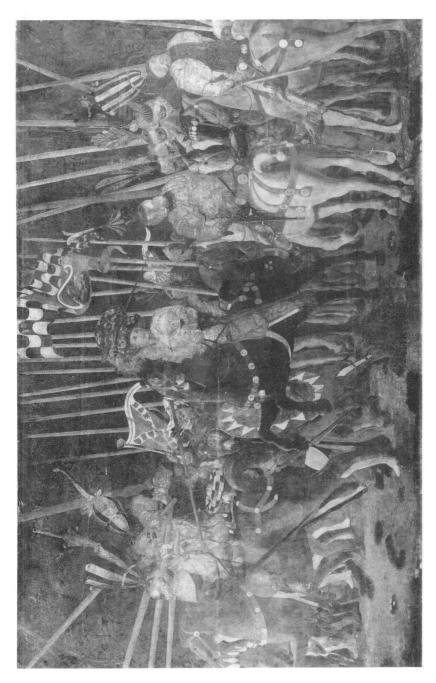

Plate 76 PAOLO UCCELLO, *Battle of San Romano*, Musée du Louvre. © Cliché Musées Nationaux, Paris. Photo: Réunion des Musées Nationaux.

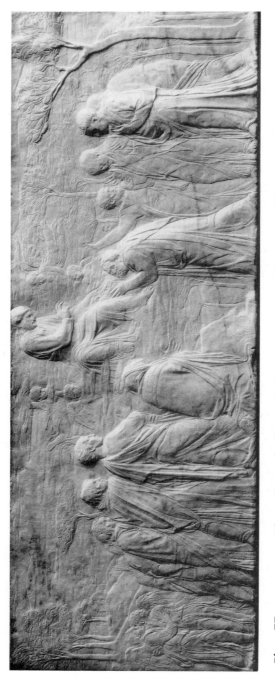

Plate 77 DONATELLO, *Christ Giving the Keys to St Peter*, by courtesy of the Board of Trustees of the Victoria and Albert Museum, London.

continued to collect and live in splendour until the last possible moment. When in 1857 he was arrested and then sentenced to twenty years' hard labour for fraudulent procedures – the sentence was soon afterwards reduced to exile from Rome – the collections were confiscated by the authorities to cover his debts. And then, in defiance of every regulation established by his own predecessors, the pope sold off the principal sections: the Greek vases, some statues and a series of frescoes (then attributed to Raphael) were acquired by the Tsar of Russia; much of the Renaissance sculpture and majolica went to the newly opened South Kensington Museum in London; the paintings were mostly bought by Napoleon III. During Campana's trial his supporters had actually opened his 'museum' to the public, for part of his defence rested on the (undoubted) services he had rendered to the cause of the arts in Rome: it is all the more incredible that Pope Pius IX now threw away an opportunity that would have been gratefully seized by so many of his more enlightened predecessors. The times were financially hard (they always are), and the authorities, who had known of Campana's malpractices long before they took any steps to putting an end to them, had to show the world how determined they were to remedy the situation. Nonetheless, no really adequate explanation has yet been offered of the dispersal of the Campana collection, and it makes a sad end to papal rule of the city in the one field where that rule had nearly always been beneficial.

But if papal laws could on occasion be broken by the popes themselves, few other Italian states had any worthwhile laws at all to regulate the export of their possessions. In some places the situation continued much as it had always done. Thus, in 1840, two hundred years after the Gonzaga in Mantua, a hundred years after the Este in Modena, the Duke of Lucca sent his picture collection to London to be auctioned. The cases quoted above are not strictly comparable, for the dynasty was a new one, and nearly all the pictures concerned had been either bought by the Duke himself or inherited from his mother. But although there was thus no long-standing connection with the city, such a total disregard by a ruler for his subjects was by now beginning to seem a little anachronistic, and whatever the moral issues at stake, Italy certainly lost another group of major pictures – by Honthorst (*Christ before Pilate* – London, National Gallery), by Poussin (*Massacre of the Innocents* – Chantilly), by Francesco Francia (*Virgin and Child with Two Saints* – London, National Gallery), and many others.

Elsewhere in Italy little was done to prevent the export of even the

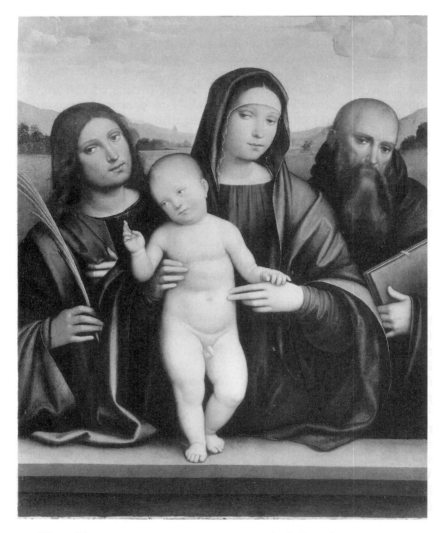

Plate 78 FRANCESCO FRANCIA, *Virgin and Child with Two Saints*, detail, reproduced by courtesy of the Trustees of the National Gallery, London.

most important pictures. In Tuscany a law had been passed in 1818 forbidding the alienation of works of art from religious establishments and certain other public institutions without special authority from the government.[30] In fact, this appears to have been enforced only once, when Charles Eastlake, director of the London National Gallery, was in 1855 refused permission to buy Ghirlandaio's *Madonna and Child with Archangels and Saints* (Uffizi)[31] despite the facts that the Congregazione dei Sacerdoti di Gesù Salvator, which owned the cloister of La Calza where the picture hung, was anxious to sell; that the Archbishop of Florence, acting for the pope, had no objection; and that the picture itself had been 'reduced by years of continual neglect to a condition nearly hopeless'. The incredulous indignation with which the government's decision was greeted in England and the assurance given by the Duca di Casigliano, Minister of Foreign Affairs, 'that notwithstanding any rule to the contrary every facility would in future be given for the exportation of pictures, not Church property, which the British Government might desire to purchase' show clearly enough what was the general practice, and a glance at the masterpieces of Tuscan fourteenth- and fifteenth-century painting still to be seen in London is enough to demonstrate that the duke kept his word. Indeed in 1857 the National Gallery was able to buy the Pollaiuolo *St Sebastian* from the Marchese Pucci on the grounds that, having been commissioned by his family in the fifteenth century, it was his private property to dispose of as he wanted, even though for nearly four hundred years it had hung in a chapel open to the public.

The Austrian rulers of Venice made a constant series of proclamations affirming their intention of preserving the city's main art treasures, but we may be forgiven for not taking these too seriously in view of the fact that the most famous single picture in private hands, Veronese's *Alexander and the Family of Darius*, was bought for the National Gallery in London with the full authorization of the imperial government in Vienna, and that the most famous single collection of pictures, which had been formed towards the end of the eighteenth century by Girolamo Manfrin, was available to anyone who chose to buy it *en bloc* or piece by piece (as many people did).

In 1859 the English collector and dealer W. B. Spence thought of leaving Florence where he had settled because he was so certain that the government of a united Italy, which was clearly about to emerge, would impose export restrictions on important works of art and thus put an end to his extremely lucrative and successful career.[32]

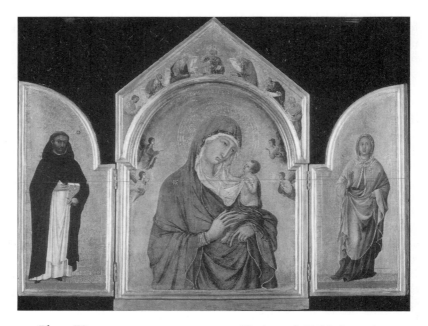

Plate 79 DUCCIO DI BUONINSEGNA, *Virgin and Child*, from the
triptych, *Virgin and Child with Saints*, reproduced by courtesy of the
Trustees of the National Gallery, London.

Within a year or two he discovered, to his enormous relief, that
there was no such danger and he resumed business.

It is true that in the new kingdom of Italy constant proposals were
being made for safeguarding the artistic heritage of Italy, but the
prevailing doctrine of free trade as constantly thwarted them. It is
ironical to find a liberal such as Giambattista Cavalcaselle, who had
fought for the cause of Italian unity, looking back wistfully to Car-
dinal Pacca's edict of 1820.[33] In 1875, as the first Ispettore generale
per la pitture e la scultura, Cavalcaselle was still trying, as he had
done years earlier in the company of Morelli, to have lists drawn up
of all paintings in public possession so as to prevent their dispersal;
he was also still trying to enforce his views on restoration: 'A paint-
ing that has deteriorated or become incomplete is of more value to
the scholar and the experienced spectator than a painting completed
or repainted by the restorer, which, in the end, is neither old nor
modern. This must be made clear to the public, who normally prefer
a completely repainted fresco to one at all damaged.'

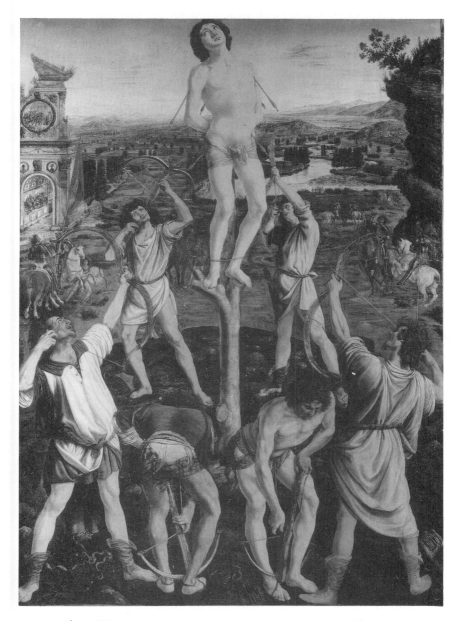

Plate 80 ANTONIO AND PIERO DEL POLLAIUOLO, *St Sebastian*,
reproduced by courtesy of the Trustees of the National Gallery,
London.

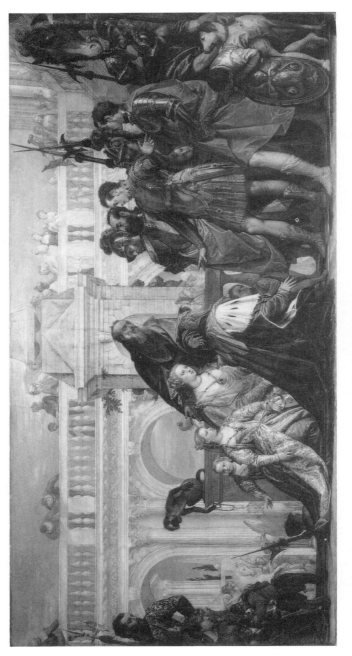

Plate 81 PAOLO VERONESE, *Alexander and the Family of Darius*, reproduced by courtesy of the Trustees of the National Gallery, London.

However, although very slowly legislation was being brought into operation to control some of the worst abuses to the Italian heritage (when those abuses were not being actually encouraged – such as the destruction of Villa Ludovisi in Rome, or the old centre of Florence), the government remained far more reluctant than ever the popes had been to interfere with the absolute rights of private owners. In 1875, for instance, Bode was very nearly able to buy for the Berlin Museum Giorgione's *Tempesta* from the Manfrin collection (just as Eastlake had bought for the National Gallery Veronese's *Alexander and the Family of Darius* from the Pisani, when the city was still under Austrian rule): it was only through the personal intervention of Bode's bitter enemy, the very influential Morelli (who himself helped to build up the collections of many an English friend),[34] that Prince Giovanelli was persuaded to buy the picture and the Italian government induced to forbid its export.[35] At the very end of the nineteenth century there were signs that the position was changing. Thus in 1899 the Government charged Prince Chigi with the illegal export of his Botticelli *Madonna of the Eucharist* (Gardner Museum, Boston), and in accordance with Cardinal Pacca's decree of seventy-nine years earlier he was fined the amount that he had received for the sale. After a series of appeals, however, the fine was reduced to one of ten lire . . .[36] But the case stimulated new legislation (though still in the teeth of powerful opposition), and in 1902 at last an entirely new legal framework was established, which though repeatedly modified since, still provides the fundamental background to the situation as it remains today. The most important aspect of the new laws was that they replaced the confusing inheritance of diverse traditions varying from region to region (and therefore liable to the most obvious abuse) with some sort of overall control.[37] Important pictures had to be registered with the authorities, even when they belonged to private owners, and in some cases their export was absolutely forbidden, while in others an export tax was enforced to discourage their sale abroad. Yet, even when the situation was quite clear, the law could be abused, as was explained by the minister answering a question in parliament about the scandalous export in 1907 of seven Van Dyck portraits from the Cattaneo collection in Genoa.[38] These, the minister explained, 'were not listed in the catalogue of works of the highest value, and could accordingly be sold in Italy'. But this was due not to negligence, but to the fact that the Cattaneo heirs had refused to let the inspectors see their pictures which they kept hidden in their palace, and in a free country

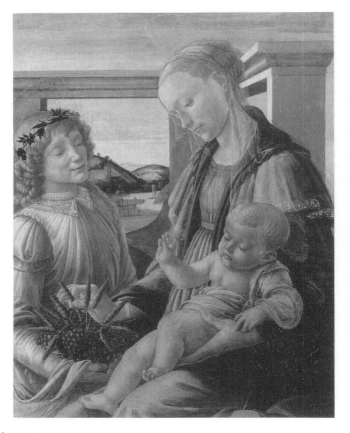

Plate 82 BOTTICELLI, *Madonna of the Eucharist*, Isabella Stewart Gardner Museum, Boston.

no steps could be taken to force them to open all the rooms. Nonetheless, the government prosecuted.

Later enactments gave the state the right to pre-empt works of art submitted for export licence at the (often fictitiously low) prices declared by the seller – and this has been responsible for some good bargains entering the Italian museums, and much saving of taxpayers' money. But neither abuses nor *causes célèbres* have been brought to an end.

In certain circumstances the state has been willing to make compromises. Thus in return for very great gifts to the nation, the heirs

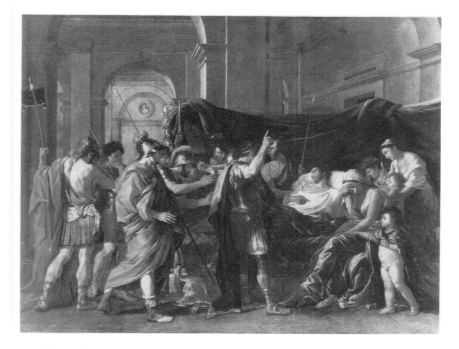

Plate 83 NICOLAS POUSSIN, *The Death of Germanicus*, Minneapolis
Institute of Arts.

to the wonderful Barberini collection were evidently given the right
to export, without special control, the other pictures in their posses-
sion – and this has led to the appearance in England and America
of some very fine seventeenth-century pictures during the last forty
or fifty years – Guercino's *Elijah Fed by Ravens* (London, Denis
Mahon collection), or (most remarkable of all) Poussin's *Death of
Germanicus* (Minneapolis Institute of Arts): this last, indeed, is a
picture so intimately linked with the history of Rome, from every
point of view, that one cannot but question the judgement of those
who were responsible for choosing what was to go and what to stay.
A somewhat similar arrangement appears to have been made with
the descendants of the collector and dealer Alessandro Contini-
Bonacossi, whose apparent wish to leave his entire collection to the
state 'could not be completely put into effect since the collection
incurred a two-thirds inheritance tax, the testator being permitted

to bequeath to his direct successors only a third of his personal estate'.[39] Moreover, many of the pictures had been temporarily imported into Italy and were not therefore subject to control. In the end the net result was a gift of superlative proportions and quality to the Florentine Museums – but also the appearance on the international market of some wonderful pictures (such as the Zurbarán *Still Life* – Norton Simon Collection), which had been in Italy for many years and which occasionally raise doubts as to the principles of selection.

It would take a moral philosopher rather than a historian to assess the merits of such cases – though Mussolini's deliberate waiving of the export laws in order to allow the Lancellotti family to sell to Hitler their great statue of the *Discobolus* presents fewer difficulties on this score.[40] There are a number of well-authenticated cases of such abuses during the Fascist period, though the most intriguing proposal of all never came to fruition. This was the suggestion made in 1941 by Prince Philip of Hesse, acting for the German government, that he should 'arrange the recovery of Italian works of art taken to France during the Napoleonic epoch. In return he asked for the suspension and a somewhat less rigid application of existing rules, as regarded export of works of art to Germany.' The ethical and artistic implications of such an arrangement cannot fail to stimulate the imagination. But the whole issue of an artistic heritage is complicated by the consideration of questions of this kind, even if on a smaller scale. As long ago as 1863 Cavalcaselle wrote[41] with some scorn of those who claimed 'that Italy has too many [works of art], that the whole world is now like a family, and other views of that sort', but – despite some flagrant abuses which have been chronicled in these pages – it would surely (in the past, if not today) have constituted a most misguided, as well as totally impractical, form of Italian 'patriotism' to try and prevent the departure of any masterpieces from the national territory. And it remains important to stress that the acquisition by great foreign museums of so many Italian works of art has been much less disastrous than many other blows which have hit the Italian heritage over the centuries – and continue to do so. One need only recall two of the most sensational thefts in recent years – the *Flagellation* by Piero della Francesca and Giorgione's Castelfranco altarpiece; and although these have fortunately been recovered, Caravaggio's magnificent *Nativity with San Francesco and San Lorenzo* from Palermo is still missing, to mention only the most important victim of innumerable thefts. The two world wars caused terrible havoc: Tiepolo's destroyed frescoes in the church

of the Scalzi in Venice and Mantegna's in the Eremitani in Padua must stand merely as symbols of far more numerous losses, among which some of the most painful have been inflicted by terrorist attacks apparently aimed at cultural targets. But, above all, there has been the persistent erosion of so much that has been spared from the acquisitive passion of the rich foreigner, from the thief and from the bomb. To many people the questions raised by this chapter may well seem irrelevant. The real problem that should perhaps be posed is how it has come about that a country which has produced the greatest artists in European civilization and which has, again and again, shown itself capable of demonstrating the most sensitive care in preserving and displaying the works of those artists has also been ready to deface so much that still remains under its control despite all the pressures which have been described in the preceding pages. Compared to the almost schizophrenic tendencies that might well be diagnosed by a full consideration of that problem, the 'loss' to a grateful and admiring world of pictures and sculptures belonging to the Gonzaga, Este or Borghese families may well seem trivial and easily bearable.

NOTES

1 R. Lanciani, *Storia degli scavi di Roma e notizie intorno le collezioni romane di antichità*, I (1902), p. 126.

2 L. Lalanne, 'Transport d'oeuvres d'art de Naples . . .', *Archives de l'Art Français*, 2 (1851–2), pp. 305–6.

3 Vasari, *Le vite con nuove annotazioni e commenti di Gaetano Milanesi* (Florence, 1906; reprint 1973), V, p. 50.

4 A. Emiliani, *Leggi, bandi e provvedimenti per la tutela dei beni artistici e culturali negli antichi stati italiani, 1571–1860* (Bologna, 1978), pp. 32ff.

5 For all this section concerning the Mantua sale see A. Luzio, *La Gallaria dei Gonzaga venduta all'Inghilterra nel 1627–28* (Rome, 1912; edizione anastatica, 1974), with special reference to quotations on pp. 144 and 154.

6 H. E. Wethey, *The Paintings of Titian*, III: *The Mythological and Historical Paintings* (London, 1975), pp. 43ff.

7 S. Savina-Branca, *Il collezionismo veneziano nel '600* (Padua, 1965), p. 64; E. K. Waterhouse, 'Paintings from Venice for Seventeenth Century England: Some Records of a Forgotten Transaction', *Italian Studies*, 7 (1952), pp. 21–2; C. Garas, 'Giorgione et Giorgionisme au XVIIe siècle', *Bulletin du Musée Hongrois des Beaux-Arts*, 25 (Budapest, 1964), pp. 51–80.

8 C. Burnet, *Some Letters containing an Account of what Seemed most Remarkable in Switzerland, Italy &c.* (Rotterdam, 1686), p. 246.

9 Emiliani, *Leggi*, p. 76.

10 *Correspondance des Directeurs de l'Académie de France à Rome avec les Surintendants des Bâtiments*, V (1895), pp. 348, 373, 396, 377; VI (1896), pp. 11, 35.

11 *Correspondance*, VII (1897), p. 480.

12 C. Pietrangeli, *Scavi e scoperte di antichità sotto il pontificato di Pio VI* (Rome, 1958), pp. 89–90.

13 A. Gotti, *Le gallerie di Firenze – relazione al Ministro della Pubblica Istruzione in Italia* (Florence, 1872), p. 134.

14 H. Posse, *Die Staatliche Gemäldegalerie zu Dresden, erste Abteilung* (Berlin and Dresden, 1929), pp. xvii–xviii.

15 M. de La Lande, *Voyage en Italie*, 2nd edn (Yverdon, 1787), I, p. 362.

16 F. Haskell, 'Some Collectors of Venetian Art at the End of the Eighteenth Century', in *Studies in Renaissance and Baroque Art presented to Anthony Blunt on his 60th Birthday* (London, 1967), pp. 173–8.

17 Emiliani, *Leggi*, pp. 160ff.

18 F. Boyer, *Le Monde des arts en Italie et la France de la Révolution et de l'Empire* (Turin, 1970), pp. 78–88.

19 Le Général Pommereul, *De l'art de voir dans les beaux-arts, traduit de l'italien de Milizia; suivi des institutions propres à les faire fleurir en France, et d'un état des objets d'arts dont ses musées ont été enrichis par la guerre de la liberté* (Paris, An 6 de la République), pp. 313–16.

20 C. Gould, *Trophy of Conquest: The Musée Napoléon and the Creation of the Louvre* (London, 1965), p. 112.

21 L. Cicognara, *Storia della scultura dal suo risorgimento in Italia sino al secolo XIX* (Venice, 1816), II, p. 166.

22 Letter from Miss Cornelia Knight, 29 February 1818, in Léon-G. Pélissier, *Le Portefeuille de la comtesse d'Albany* (Paris, 1902), p. 353.

23 M. Callcott, *Description of the Chapel of the Annunziata dell'Arena; or Giotto's Chapel in Padua* (London, 1835).

24 Lord Lindsay, *Sketches of the History of Christian Art* (London, 1847), III, p. 418.

25 *Ruskin in Italy: Letters to his Parents, 1845*, ed. Harold I. Shapiro (London, 1972), p. 89.

26 Emiliani, *Leggi*, pp. 110–25.

27 Ibid., pp. 130–45.

28 F. Beaucamp, *Le Peintre lillois Jean-Baptiste Wicar (1762–1834): son oeuvre et son temps* (Lille, 1939), II, p. 567; and C. Falconieri, *Vita di Vincenzo Camuccini* (Rome, 1875), p. 282.

29 *Dizionario biografico degli Italiani*, XVII (1974); M. Laclotte and E. Mognetti, *Avignon, Musée du Petit Palais: peinture italienne* (Paris, 1976); L. Vertova, 'A New Museum is Born', *Burlington Magazine* (1977), pp. 158–67.

30 Emiliani, *Leggi*, pp. 57–8.

31 D. Robertson, *Sir Charles Eastlake and the Victorian Art World* (Princeton, 1978), pp. 145–50, 164–6, 167–72.

32 J. Fleming, 'Art Dealing and the Risorgimento', *Burlington Magazine* (1979), pp. 492–508, 568–80.

33 L. Moretti, *G. B. Cavalcaselle. Disegni da antichi maestri* (Venice, 1973), p. 30.

34 J. Fleming, 'Art Dealing and the Risorgimento', part I, *Burlington Magazine* (1973), pp. 4–16.

35 A. Morassi, *Giorgione* (Milan, 1942), p. 85; and the entry on the *Tempesta* by Sandra Moschini Marconi in the catalogue *Giorgione a Venezia* (Venice, 1978).

36 P. Handy, *European and American Paintings in the Isabella Stewart Gardner Museum* (Boston, 1974), p. 38.

37 *L'Arte*, 1 (1898), pp. 203–6, and 6 (1903), pp. 222–3.

38 *Bollettino d'Arte*, 1 (1907), fasc. IV, p. 26.

39 M. Salmi, 'La donazione Contini-Bonacossi', *Bollettino d'Arte* (1967), pp. 222–32.

40 R. Siviero, *Second National Exhibition of the Works of Art recovered in Germany* (Florence, 1950).

41 Moretti, *Cavalcaselle*, p. 36.

FIVE

The Public Reception
of Art*

ANNA MARIA MURA

Audience and appreciation

The number of people who come into direct contact with art is,
however, quite restricted, both by the comparative rarity of aesthetic
talent – which is sometimes focused on particular areas in art – and
by the obstacles of social stratification. For certain strata of society
access to works of art and aesthetic training is limited. Nevertheless,
some effects of art reach even those people who have no direct con-
tact with it.[1]

THESE words, written by J. Mukařovský in 1936, set out with
definitive clarity the complexity of the tasks facing students
of the history of art who take a sociological approach with
an interest in the 'public'. We must remember that our job is not
merely to study the workings of direct economic relations (patron-
age, collecting, circles of diffusion etc., including the historical angle
taken by studies of a work's critical 'fortunes'), or the socio-cultural
stratifications actually involved – nor even the game of mutual
provocation between 'amateurs' in a certain elite and 'their' artists.
There is also a need (an urgent one, if only to redress the balance
of attention in the current state of study) to investigate the complex
interplay of mediation which, through historically identifiable channels
and mechanisms, conditions the way these wide-ranging effects

* Translated by Claire Dorey.

actually function. There is also a need to define what should be understood by the artistic 'text' in this respect at any given time in the consciousness of the concretely defined beholder, and to survey the wide spectrum of research into perceptual and socio-cultural mechanisms of consumption. Nor, obviously, can we afford to overlook the two very important areas of architecture and theatre and their point of convergence or intersection in the history of temporary backdrops and scenery created for display on public occasions and the various meaningful utterances which they conveyed.

Mukařovský used the influence of poetry on the development of the linguistic system as a macroscopic example of these indirect but crucial effects of art, but the visual sphere is full of its own examples. Take for instance the relationship between artistic norms and languages of graphic communication (from traffic signs to advertising, to mention a field characterized by connections with many other classes of activity),[2] or the idea of visual arts as a source of 'codifying devices' for behaviour.[3]

Moreover, a history of art as a history of its consumers (patrons, amateurs, beholders, users or addressees) ought necessarily to take into account this variety of different levels of user, so to speak, and try to identify the actual changing content of the entity labelled 'public' in the historical sources, or at any rate as it appeared to the consciousness of the art 'operative', though this obviously did not always coincide with the actual geography of real recipients. These levels were more likely to overlap where the 'public' is a homogeneous social group of amateurs, but the coincidence is much more problematic in the case of consumers of artistic texts whose function is primarily extra-aesthetic. This is the public studied in all those theoretical pieces about the strategy of images (for example the controversy between Bernardo di Chiaravalle and Suger, or the Counter-Reformation treatises, or modern advertising theories); but it is also the same public which is seen (already with potential consumer status) as the third group for whom the museum was intended in the famous passage from Diderot: '... therefore collections in which works of beauty are gathered together according to some kind of method eventually become like schools for the arts and for the nation, where lovers of art can pick up ideas, artists can make useful observations, and the public may gain some good first notions.'

In the end, what these different 'publics' have in common is the fact that in every case – regardless of the primary function of the object or activity of which they may be involuntary or inattentive addressees – they belong to that wider public or target of the work

of art which stems from its more general role in the mechanics of culture as non-genetic memory for a given social group, and therefore also from its being the 'model' of a particular type which can, as Yuri M. Lotman puts it, transmit to the consumer 'precisely the information he needs and which he is in some way prepared to assimilate'; as it adapts itself to the consumer the information 'also assimilates him to itself, thus predisposing him to assimilate the part of the message which he was previously unable to comprehend'.[4]

But there is another point to consider: at a certain moment in history (primarily in the wake of the socio-economic transformations which are generically referred to as the advent of industrial society), the problematics of the addressee and/or consumer take shape as a distinct historical phenomenon which comes to play a part in the history of art as an agent of change, with its own evolution and a considerable influence on cultural workers, especially artists, affecting their image of themselves, their plans and behaviour, and ultimately the works themselves.

As we follow the evolution of this phenomenon through from its first appearance to the present day, I think that we can distinguish three phases within it (though it remains to be seen whether such a simplifying and schematic device can ultimately be productive) and these each appear to be dominated by their respective central problems:

1 the relationship between the visual arts and popular education (from the founding of the great museums in the eighteenth century to the early battles for an 'independent' art);
2 the 'divorce' between artist and public (from the rejection of Impressionism to the emergence of the 'historical avant-gardes');
3 the new status of the public for the visual arts following the transition from mass audience to mass media audience.

The 'fortunes' of the beholder

What I intend to try to give here is not an accountant's report or balance sheet for the field of art-historical studies 'from the spectator's point of view',[5] but a brief exploration of some of the areas, or rather directions, of research which increasingly stand out from the changing map of current study as being conspicuously more problematic. This kind of research raises more questions than it answers, producing confrontations between different methodologies and clashes among approaches of diverse extraction.

Our first question might well be how the crucial but far from pain-less practicalities of interdisciplinarity actually function in this case. There is a constitutionally interdisciplinary condition for studies on the 'public' which dictates that they should necessarily compare results, share tools, look across at neighbouring disciplines, and transcend watertight categorizations.

Whereas the relationship between sociology and the history of art may in the past have seemed to be more a matter of mutual ignor-ance than of mutual encounter,[6] the saga of thematic intersections and methodological interference (further complicated by fairly well-concealed parallels) between art history and anthropology followed quite a different course, having no small influence on the theoretical development of the problematics of consumption.[7] There is a third and perhaps better-known point of contact: after an initially turbu-lent and notorious series of misunderstandings, the structures and tools used for looking at problems in psychoanalysis bore fruit which was certainly of interest for the study of mechanisms of consump-tion in the visual arts, and formed the basis of some important writings. The prime area for expansion for these findings seems to have been in work on the cinematographic audience.[8]

Nowadays we can perhaps see the risk – quite the opposite kind of risk to the tendency towards mutual isolation – in the not always profitable practice of unquestioningly adopting concepts borrowed from linguistics (such as, for example, the temptation to draw rather close analogies between phonemes and basic graphic units). Obvi-ously, transcending rigid categories should not be a licence to ignore with blithe abandon the specific conditions for the actual phenom-ena we are dealing with. Apart from anything else, it would make it impossible for us to reach the kind of reliable and specialized findings required of interdisciplinary research, which should seek first of all, as G. Mounin has said, to know 'what people are really doing when they look at a picture'.[9]

Also significant in the context of studies of the typology of culture is the emphasis on the distinction between methodologies appropri-ate to the study of models of natural language and those which can be used to investigate cultural and poetic models (primarily with a historical dimension, where we need better communication between structural and historico-sociological studies and methods).[10]

The problem of the addressee also occupies a clear and growing space in related disciplines, particularly in literary studies, where the idea of a 'history of literature that is also a history of readers and a typology of reading respectively' finds a field already rich with

existing contributions and increasingly stimulated by semiological influences.[11] The questions posed by the consumption of works from the past, the influence that addressees as 'producers of a system of expectations' can exercise over the sender, the decline of the system of 'genres' in a cultural context dominated by the mass media, are all examples of problems which crop up in both contexts with enough common features to justify the exchange of cognitive tools and to encourage the comparison of findings.[12]

It is also no accident that both J. Mukařovský and W. Benjamin – whose formulations and ideas (dating back to the late 1930s but substantially revived several decades later) comprise an essential part of the journey towards studying the public's point of view – use arguments relating in roughly equal proportions to the literary context and the territory of the visual arts.

Decodification and consumption of an inconstant object

We also find perhaps the most active interdisciplinary exchange (for example between psychoanalysis, neurophysiology and information theory) working precisely as exchanges in which the vital mechanism of consumption is investigated and analysed, and in this field art-historical studies often have much to contribute. I am thinking especially here of Gombrich's contribution to the theory of 'anticipation'[13] (further corroborated, on the art-historical plane, by the anti-inductivist approach of Popper). The cardinal points for him in explaining 'what people are really doing when they look at a picture' (or rather what particular groups of people do or did in looking at specific works of art) could in fact be summed up by these two key quotations: 'ambiguity is clearly the key to the whole problem of image reading'[14] and 'works of art only communicate meaning within an articulated tradition'.[15] There is no need to remind ourselves that, like Chomsky's 'mentalism', Gombrich's anti-inductivism aroused strong disagreement, and often misunderstanding.[16] One of the many merits of examining the role played by the formation of expectations in the decodification of the work is that it debunks the paternalistic error at the root of so many discussions of the supposed 'popularity' of 'masterpieces', and therefore of the relationship between the work of art and the social classes traditionally excluded from being its consumers. Although they are motivated, albeit rather crudely, by the best intentions, these attitudes are

half-truths, and are bound ultimately to throw the responsibility for not deciphering the work back on to the beholder. Such ideas were current and found particular favour in the inter-war period in the climate of the 'return to order'.[17]

One of the main areas of debate where the shift of critical interest to the world of the recipient seems to entail important consequences (particularly as it serves to alter the terms of old controversies by rendering them meaningless, thereby rescuing them from the rut in which they seemed to be stuck fast), concerns the influence of extra-aesthetic factors in the artistic experience, and brings to the old problem of the relationship between art and 'reality' and the newer but no less fraught problem of misunderstanding, the importance, for the consumer question, of areas that are marginal to art-historical 'tradition'. This is also one of the areas of study where recourse to Mukařovský's protosemiological viewpoint is most fruitful.

Reading between the lines of his theories, propounded in 1936 in his famous *Aesthetic Function, Norm and Value as Social Facts*, we can see real contact and intense exchange with the practice of avant-garde art and the theoretical reflections of the artists, who for the first forty years of the twentieth century wrestled with the problematics of recipient and consumer practically unaided. (It is even possible that Mukařovský derived the solidity and balance of his argument, avoiding the pitfalls of *Geistesgeschichte*, from this practice of familiarizing himself with the thematics of the 'avant-gardes', from Formalism to Surrealism, in their finest hours, such as – to name a few names – the episodes of Klee and Eisenstein.)

For the purposes of our discussion, we should simply recall that the emphasis on the dynamics of norms and functions and the treatment, in this light, of the relationship between extra-aesthetic factors and the aesthetic function organizing them[18] certainly form a pressure-point for the tools Mukařovský offers us, which in fact turn out to be particularly useful in dispelling the misunderstandings which for nearly a century have been at the root of the long-debated pseudo-problems of understanding how the work of art, considered as a constant quantity, relates to extra-aesthetic factors; in other words, to reality and to period. In fact the work of art 'is not a constant quantity: with every shift in time, space or social milieu there is a change in the prism of artistic tradition through which the work is perceived; the effect of these shifts also changes the aesthetic object which corresponds in the consciousness of the members of a given collectivity to the material artefact, the object created by the artist.'[19] Furthermore, the work is seen as a carrier (and, on the level of

consumption, given that the values brought to bear by the process of decodification are those of the consumer, as a mediator) of extra-aesthetic values, both in its 'contentistic' components and in its formal components;[20] the dividing line between the sphere of artistic creation and the extra-aesthetic sphere becomes blurred by the variety of functions; attention is switched to the – inevitable and necessary – tension between the system of values in the work and the value-system of the collective consumer. All these ideas are of direct interest to another important problematical crux, the debate (often confused by the emotive residue of old controversies) over the polarity between crystallized opposites such as elite art/popular art, art/kitsch, high art/folk art, fine art/minor arts. Many of these oppositions have meaning and validity only on the level of the beholder.[21]

The appeal for research centred around the problematics of consumption also came, and actively continues to come, from those interested in the altered conditions placed on the consumption of art by the new media: photography, cinema, television (and one could, if necessary, also include 'design' here).

Images 'functioning as something else'

Leaving aside the complex history of photography as a new means of translating and diffusing works of art, and its responsibility for the development of what has been called the 'imaginary' or fantasy museum', and also leaving aside for the moment the story of how workers in the figurative arts used it as one of their tools for a more advanced rendering of 'illusion',[22] we must first look at how photography, as the production and consumption of images that are, in a manner of speaking, 'original', immediately raised the problem of its own beholder, whose characteristics did not always coincide exactly with the kinds of 'public' inherited by the older – and ultimately competing – industries of the consumer image.

Baudelaire's famous tirade (as early as the 1859 Salon he was already putting the problem in terms of differentiated functions, crediting photography with extra-aesthetic functions only, and providing a perceptive and insightful inventory of these), coupled with the prohibitions and preventive censorship so hastily issued by centres of power,[23] even reactions such as the outdated arguments used by Charles Blanc when refusing photographers portrait licences ('How could a machine depict the soul?'); all these facts appear to be bound up with the trademark of photography's supposed 'objectivity',

which exists in fact precisely in so far as it exists as a fact in the consciousness of the beholder/consumer, and is connected with what Barthes, in his analysis of the rhetoric of the image, has called the 'real unreality' of photography, or the way it creates an illogical conjunction 'entre l'ici et l'autrefois' (between the present and the past). In fact, it connects with the ambiguity of an experience which, through the same image, can encompass the superimposition of two planes of 'reading': both as a document and as an image with a symbolic function (although, as Barthes says, the projective power of the image is weakened, as in psychological tests drawings are preferred to photographs).

From the daguerreotype to the hologram, therefore, as a replica of appearances obtained by mechanical means, photography has its own consumer area, and its own specific conditions of decodification, characterized by the fact that there is a possibility of forgery, an element of doubt as to whether the image is true or false (on the various levels of catalogue description, cutting, montage, special effects etc.), which could only be applied wrongly or inappropriately to other categories of physical image (barring some openly stated guarantee of 'fidelity'). This gives a more than adequate explanation for both the intervention of preventive censorship and later (but as it turned out rather premature) manipulations for power purposes.

This is also the place to mention the question of what type of status to accord, on the consumer level, to photographic images which followed precisely the 'humbly' extra-aesthetic directions listed by Baudelaire. His inventory is worth recalling: 'It should rapidly enrich the traveller's album and provide his eyes with the precision which his memory might lack, it should adorn the naturalist's library, enlarge microscopic animals, even provide information to reinforce the astronomer's hypotheses; finally, it should be secretary and note-book for anyone who has need in their profession of absolute material exactitude.'

We know how important subsequent developments in these specializations were for contemporary art history from the sender's point of view; they came to be among the factors determining visual habits, and suggested the beginnings of new ways to recast the relationship with nature as a 'process'. One example taken at random from the many possible could be the importance of the success that books of 'scientific' photographic images found with artists in the early decades of our own century, such as K. Nierendorf's *Urformen der Kunst*: from its hundred plates, Ozenfant took some of the photographs which illustrate his 1928 book, *Art*.

But what happens at the level of the addressee, for the mass public, the non-artist beholder?

Apart from the most obvious phenomenon of the 'reading' conventions which became common currency through the habit of instantly interpreting newspaper photos, we can suppose that 'fine' photographs of a scientific nature were also governed by the particular conditions of decodification we have looked at, as they spread to consumers beyond the narrow and exclusive specialist sphere. As the latest descendants of 'naturalia' (once displayed for visitors to *Wunderkammern* to marvel at and, before that, for the amazement of pilgrims between reliquaries at the sanctuaries), these photographic reproductions of a scientific nature (optical effects, microscope photography etc.), which were sold as postcards at the desk in the Science Museums, are actually the opposite – like a rival attraction (though to what extent remains to be established) to those souvenir postcard photographs of views which are 'aesthetically' manipulated in various ways, and which are to varying degrees behind the times compared with more popular artistic norms. (Such as postcards of Notre-Dame or the Eiffel Tower afflicted by spasms of psychedelia, to produce a sub-representational art form so paradigmatically kitsch that they must have been invented as textbook illustrations of the typology of kitsch as described by Umberto Eco. And these postcards are in turn the present-day descendants of a long tradition of products intended for mass consumption, including for example pictures on visiting cards, coloured by hand, showing gentlemen of respectable bourgeois society posed according to the conventions of late genre painting in the guise of common itinerant pedlars.)

The consumer of this type of image, which is linked in a sense to the history of attempts to find a way to render perfectly the illusion of reality – I referred to this earlier – (but in the autonomous direction about which Wierz was so enthusiastic), such a consumer has no use for a reading dependent on 'clues implicit in the authenticity of the photograph' and such a reading may indeed be quite alien.[24]

A history of photography's public should therefore probably follow two distinct lines of development, one of which, in terms of the demands it satisfies, runs closely parallel to the fortunes of 'three-dimensional paintings', and the taste for historical *trompe-l'oeil* (up to the level of the most dignified and celebrated Salon backdrops such as Couture's *The Romans of the Decadence*),[25] and this tradition comes across as having definite designs on the status of Art with a capital A. The second line, on the other hand, follows the prodigious growth of documentary and scientific photography and

was spurred on by the technical progress it helped to stimulate. One should also point out that it was this second line that gave rise to a renewal of connections with figurative arts in the traditional media (take for example the extraordinary success of magazines such as *Minotaure* or the nature of experiments such as Breton's idea of using photographic views in place of verbal descriptions in *Nadia*). The products of the first group, on the other hand, were later the object of an unusual rescue operation – along with material felt to be anti-artistic and likely to arouse aesthetic aversion – staged by the surrealists.

Another aspect of the advent of photography which is of interest in studying the addressee is of course its technical reproducibility: as an object in some sense typical of the process whereby, in Benjamin's phrase, 'the reproduced work of art becomes in ever increasing measure the reproduction of a work of art that is predisposed to reproducibility.' However, the process does not yet have the same validity and scope later enjoyed in the spheres of cinema and music, although it is true that – aside from the traditionally 'minor' status accorded to 'consumer' products (of any kind: informative, magical/ devotional, pornographic, propagandist, and so on) – there were also the constraints of market mechanisms which tend to keep alive in the public mind a mental association between uniqueness (or at least rarity) and value.

As for cinema, we must first identify an early period of theoretical contributions in which problems specific to the lack of a sound component were raised. A typical case is the debate, particularly lively in the field of Russian formalism – for example with B. Eichenbaum – over cinematographic metaphors, which depend for their comprehensibility on the spectator's degree of familiarity with the current verbal metaphors the author was attempting to visualize, and which were therefore often rather hackneyed. We must also consider how much the shared visual experience owed to the revelations made possible by particular artificial techniques, especially those which play on 'tense': which also, as Benjamin says, encourage convergence 'between the artistic use and the scientific use of photography'.

But for this discussion the basic themes are still those of comparison: as well as comparing notes with recipients and beholders in the theatre, we must also compare with recipients and beholders of the figurative arts. Benjamin isolates two agents which, in around 1900, transformed the management of 'cultural inheritance' (the 'weight of the treasures pressing on humanity'): technical reproduction of the work of art, and cinema. Along these dual lines he also suggests a

comparison between painting and cinema from the public's point of view, and here the diversity of conditions for cinematographic reception is mainly qualified on three levels: simultaneous observation by a large audience; the 'semi-specialist' status which cinematographic technique accords the ordinary spectator; and the 'shock effect' which clashes with the flow of free association. So for Benjamin a cinema audience will tend to receive or appraise 'in a state of inattention'. It might be interesting, at this point, to compare this with an opposite interpretation of the same kind of phenomena, from the point of view of an exponent. This is in fact Man Ray's statement explaining his reasons for abandoning film-making after a few attempts:

> A book, a picture, a sculpture, a drawing, a photograph, any concrete object, is always at our disposal. We can appreciate it or ignore it. Whereas a show put on for a number of people demands attention for the whole duration of the performance. The stimulus and approval we may get from such a showing necessarily depend on the mood of the moment and of the gathering. I prefer the permanent immobility of the static work, which allows me to draw my own conclusions, without being distracted by circumstances.[26]

Looking at this very detailed contrast of motivations (within practically the same area, in all its most important periods and events, if we think of the context of late Surrealism in which they are situated) one can only hope that there will be some progress in the study of the various modes of behaviour and rituals of cinematographic reception, hopefully – to quote an observation by C. Metz – some kind of 'socio-analytic typology of the different ways of attending a film screening'.[27]

One example of how timely such progress would be can be seen in the famous comparison, again from Benjamin, of the different ways in which Picasso and Chaplin were received by the masses (the comparison should take pride of place in a mental anthology of occasions where the name, or rather the 'case' of Picasso has been used as a symbolic, almost statutory, reference point in the discussion of the 'fortunes' of contemporary art on the mass level). It is worth recalling the whole passage:

> The technical reproducibility of the work of art modifies the masses' relationship with art. From an extremely reactionary relationship, for example in the case of Picasso, it becomes an extremely progressive relationship, for example in the case of Chaplin. Here the progressive attitude is marked by the fact that the enjoyment in seeing and reliving

connects directly with the attitude of competent judge . . . In the cinema the public's critical attitude and its attitude of pleasure coincide . . . The fact is precisely this, that painting cannot offer the work for simultaneous collective reception, which is something that architecture on the other hand has always managed to do, as the epic once did, and as film does today.[28]

What is at work here (and what Benjamin does not seem to take sufficient account of, even though it is in a sense implicit in his theory of an evaluative stance 'not involving the attention') is the likely influence of differing levels of expectation determining the audience's behaviour in advance. With painting this remains a condition of the presence of the signal 'great art', which the mass spectator would see as corresponding to an enduring and precise cliché which Picasso could not be made to fit into. Whereas for Chaplin and the cinema in general, which in those days still came under the heading of entertainment or show business, there was no corresponding level of expectation with a similar conditioning effect.[29]

In evaluating the importance for the effective enjoyment of the work of art of the reverential respect which disposes or conditions an audience to admire (or of its extreme, almost pathological, variant, which is the sanctifying 'aura'), we seem to have reached the nucleus of a quest which theoretical speculation about the beholder cannot afford to ignore – both on the level of the socio-political implications and on the level of investigations in the sphere of the psychology of perception – and there is no doubt that the natural arena for discussion of this problem is the history of the museum and the analysis of its public.

Mediating institutions

One of the best-publicized cries from contemporary art's turbulent critical self-management is certainly its call for the destruction of museums. However, in the time that has elapsed since the earliest intimations, we can see a definite shift in their actual target, or rather in the level on which the discussion is actually based. In its early formulations, still closely related to the meeting-point between Naturalism and Impressionism – for example in Camille Pissarro's famous outburst[30] – the target is without doubt the museum as a symbol of the excessively forceful power of suggestion (of sacred and sanctioned norms) which had evolved, during the nineteenth

century, out of the old educational practice which dictated that
young artists should assiduously study the works of the great mas-
ters as a short cut to training themselves to 'read and look into
nature',[31] and to make the right 'anticipations', but this had now
broken down into a misleading ritual, and was perceived as being
directly opposed to the need to be faithful to one's own age (an idea
of distant Romantic extraction, but which had grown up, with some
ambiguous implications, in the field of Naturalism); and thus it was
still perceived by Boccioni in 1911.[32] The 'museum', which it was
being suggested should be (metaphorically) burned at the stake, was
just a collection of distorted and intimidatory rules.

Let us instead jump ahead fifty years and choose an example
much closer to our own time, such as Dubuffet's letter to Paulhan
in 1945, after the latter was nominated to the council for museums.
We notice straight away that the discussion is no longer about crea-
tion (since the battle for the freedom to use all the 'historical cards'
had been won long ago, this was no longer an issue), but about
consumption: the museum is for the beholder.

> What you must do, my dear Jean, as soon as you take office as
> adviser to the museums, is to propose and see through as your first
> and only motion the abolition of museums. You will explain that the
> work of art makes no sense unless encountered individually by chance
> – the more imbued with charm for being imperfect or even a little
> shabby. Ask them if they would hope to encourage the development of
> amorous passions by displaying in national palaces twelve thousand
> people whom your eminent consistory had judged likely to inspire
> such passion. What would probably happen is that people would be
> more likely to go prowling around the ticket-sellers or collectors.[33]

What we see here is not just the beginnings of an appeal for
déculture (Dubuffet later played a part in the controversy over pol-
itical culture under this banner, in support of the 'horizontal pro-
liferation of creative thought', as he wrote in 1968). This shift of
interest was also in response to the fact that, in 1945, the museum
as institution was on trial. But which museum? Not the traditional
one-way museum where visitors follow a hierarchical itinerary, but
the temple of universal art, a place to compare masterpieces from all
ages and provenances. The problems of managing this museum for
the non-specialist visitor were much harder to solve than the problems
it had posed for the artists; but these problems were (eventually)
overcome at a crash by the voracious freedom of Picasso and friends.

The opening up of the museum (in its most prestigious sense, as

an institution guaranteeing the excellence and immortality of the objects on display) to contemporary masterpieces and to the art of geographical and/or historical areas which had previously been excluded from the 'tradition' was the result of a battle won largely on the strength of what one could call an exercise in 'counter-intimidation', but there could be no simple corresponding substitution of aesthetic norms. It was not really surprising that most of the theoretical ideas would, to various extents, end up being read in the illusory catch-all key of 'myth' (as Malraux points out). But to get a slightly more precise idea of what this might mean in terms of its demands on the ordinary visitor, we must return, to take one example from many, to that inexhaustible source provided by A. Ozenfant's curious book entitled *Art* (definitely with a capital A!) published in 1928 (translated as *Foundations of Modern Art*, London, 1931). Starting from the charismatic illusion of the masterpiece that speaks for itself, 'which acts like a force of nature', he introduced the famous metaphor – then technologically topical – of the radio set and 'tuning'. This operation was the beholder's responsibility (he should be 'trained' to shut out received ideas, particularly references to current visual experience – or the habit of 'comparing fiction with reality'), and he should expect it to bring not 'pleasure' but 'elevation'. Indeed, 'masterpieces are almost never pleasing' and 'it takes nobility to tolerate grandeur'. Comforted, so to speak, by these instructions the consumer would be able to approach the collection of all-time masterpieces on offer in the museum – with or without walls – (which had at the time recently been enriched by newly discovered prehistoric art). The new challenge thus in a sense concerns one aspect of the function of the museum for the general public, outlined from its beginnings.

The transformation of the collections in 'museums' open to the public during the eighteenth century took place – the story is well known – along differing lines (although these are certainly not sharply distinct from one another). Sometimes it was the dual purpose of training for the artists and delight for the 'amateur' public, broader but still select, which prevailed, and sometimes it was more markedly scientific and pedagogical aims (albeit in an art-historical sense). These orientations are also revealed by the presence or absence of obvious clues (labels),[34] and by the type of ordering. Controversies over these early museological problems are particularly instructive in studying the history of the beholder.[35]

As regards the wider public and its reactions in this first age of museums, the new significance these temples to the religion of art

take on seems also to bear some relation to problems of access, and
to the kind of preparation made by a high-profile distribution of
announcements, catalogues and iconographic collections. This is
expressed in the solemn stage-setting whose effects are symbolically
illustrated in Goethe's famous account of his first visit to the Gallery
in Dresden. It is worth rereading:

> The opening time of the gallery, impatiently awaited, arrived at last,
> and my admiration surpassed everything I had imagined. The magnifi-
> cent room . . . where a deep silence reigned, with its splendid cornices,
> recently gilded, the well-waxed parquet, all worked much more as
> spectacle than as a working studio, and made a solemn impression,
> quite unique, and more like the emotion one feels on entering the
> house of God, because of the fact that the decorations of several
> temples, all objects of adoration, were newly exhibited in this place,
> for the sacred purposes of art.

As for the whirlwind of change which overtook the spread of the
cult of art following the Great Revolution – still on the plane of
Enlightenment homage to the 'genius' of man, which was gradually
becoming a 'religion of humanity' – a number of studies have
anatomized it in almost every aspect of importance for the study of
the public. Some of the more significant aspects were the effects of
the great displacements of masterpieces around Europe between
Revolution and Restoration, and of the public ceremonies which
attended their arrivals and returns and acted in a sense as advertise-
ments; the idea of the museum as 'iconoclasm without destruction',
with the resultant split between symbolic value and aesthetic func-
tion in the artistic object; and the effect of introducing the general
public to a certain taste for historical evocations, which was of great
importance in nineteenth-century culture.

This is more or less where the first part of the intricate question
of the museum's duties towards contemporary art also fits in (though
I cannot go into it here). The problem sparked off debates which
involve the beholder in many of their implications, for example, the
historical circumstances where the museum functioned as a thresh-
old beyond which the 'consecration' effect operated; the significance
of unified or fragmented itineraries within museums of antique art;
or the series of transformations in the principal role of the museum:
as patronal protection, either supplementing or replacing commis-
sions for 'monumental' public purposes, simply as a document of a
process seen as evolutionary and hastily assimilated to the scientific
process, as a 'cultural centre' or a place for various levels of enterprise.

The problematics of this last function also overlap with the history of debates surrounding political culture, and in its dual interpretation as 'democratizing' and promoting 'creativity', also involves another theme, which we shall go into later: the birth and crisis of the idea of 'animation'.

On the one hand we have evidence of the success of the great retrospective exhibitions, the boom in museums of ancient and modern art, the crowds of devotees filing past loaned masterpieces as though on a conveyor belt, rationed to a few seconds each (against every prediction of Benjamin's regarding the decline of the 'aura'); on the other hand there is evidence from sociologists' research of an enduring numerical relationship between the socio-professional categories of museum users, which remains obstinately inverse to that of the working population. Such are the contrasting aspects of the problem facing cultural scholars who are, in various ways, responsible for this sector.

As for how this affects our discussion, the main aspects involved are therefore twofold: an urgent need to democratize the museums, and a need for research into the modalities of consumption on the part of the educated visitor. The material which it is logical to use as fuel for the problem, museological conference papers on the one hand, and sociological surveys of the museum-going public, which now proliferate, on the other, is sometimes consistent and sometimes contradictory. Comparing analyses from the sociological side with the evidence from art-historical sources, however, I think it is clear that any solution to the problem of widening effective enjoyment of museums among the sectors of the population who are traditionally excluded therefrom must be closely linked to a deeper awareness of the mechanisms of utilization by beholders/art lovers,[36] and the more we deepen our knowledge of the mechanism of reception as a form of activity, the more we will realize the importance of the function of critical mediation (either verbal or in the form of museum layout etc.). So the crux, the key point, is to decide whether the work can stand alone, in isolation, ineffable[37] or whether we should not rather bear in mind that, as Roberto Longhi has said, 'the work of art, from a vase by a Greek craftsman to the Sistine Chapel ceiling, is always an exquisitely "relative" masterpiece.'[38]

What it seems that the two mediating institutions, the museum and the critics, must now do is to put the ordinary, uninitiated spectator into the same position of participating in the findings of specialized research into this illuminating web of relations. This still leaves open the problem of evaluating the 'aura' in this context;

does familiarity or reverent distance create the best conditions for approaching a work of art? This question should in part be addressed to the psychologists of perception. We already have Gombrich's positive evaluation[39] of 'religious awe' as a condition for mental concentration and ultimately for the possibility of gaining enjoyment from going to see works of art; but of equal relevance is his insistence on the need to make the two functions of *prodesse* and *delectare* coincide once again for museum users, including the unprimed public. Remembering his own experience as a consumer, Gombrich casts doubt on the usefulness of restricting the number of objects on show in the hope of reducing the risks of confusion, and underlines how exhibiting masterpieces alongside works which allow comparison with the context of other products from which they are taken (a guiding principle for collections of the didactic type) is also important on the level of *delectare*, and therefore as an instrument for allowing the uninitiated viewer to discover this pleasure: 'unless the visitor can at least get a first inkling of that experience, he really has no reason ever to come again.'

So we are now at the opposite pole from the concept of the masterpiece which speaks for itself; 'tuning' here becomes a highly rational and controllable fact, or rather procedure, which can be taught and promoted by intervention on various levels. One factor is the extent to which codes and systems of classification dominate, but it is also important to exercise criteria for layout of a kind likely to favour a more educated consumer.

Ultimately this way of seeing the museum experience, based on valuing observation as an activity, paradoxically throws the responsibility for the lack of contact between art and the uninitiated public back on to the specialist – the museum curator, the critic, the cultural operative in short – instead of leaving it all on the shoulders of the beholder. From this point of view, the value of the wealth of iconographic and verbal information which inevitably accompanies the viewing of the work also takes on a similarly increased importance.

'We never see just the pictures, our vision is never pure vision . . . All those words in the museum to guide or confuse our journey!' as Butor wrote in a book which is still exemplary.[40] The experience of visiting a museum can in fact be seen as a paradigm of the whole gamut of degrees and possibilities of interference or interaction of the verbal code in the deciphering of the image: either under the pretext of information or critical persuasion (both on the level of memory and through the various didactic devices, from explanatory

labels to taped guides, to the audio-visual apparatus which Butor calls – no offence intended! – the juke-boxes of art history), or as interventions which are materially present, external or internal to the 'text'. This is where the problem also moves close to theoretical speculation about iconism, and to the extraordinary development of controversies in the semiological field, and partially overlaps with similar themes raised by the dual concept of verbal sign/iconic sign in a literary context.

'Connoisseurs' and 'non-connoisseurs'

And since we have mentioned the earth, we should mention the noble and miraculous artifice which was made of it . . . Pots were made from it in many ages by the most noble and skilled artists in ancient days. And on these pots . . . were carved and drawn all the generations of plants and leaves and flowers . . . so that connoisseurs were quite ravished by delight; and non-connoisseurs through ignorance gaining no delight from them, broke them and threw them away . . . And of these pots a half-dish came into my hands, on which were carved such natural and clever things, that connoisseurs, when they saw them, cried and swore aloud and were beside themselves and became almost stupid, and non-connoisseurs wanted to break it and throw it out. And when one of these pieces came into the hands of sculptors or draughtsmen or someone else who knew about these things, they held them like holy objects, marvelling that human nature could rise to such subtlety,

wrote Ristoro d'Arezzo in the late thirteenth century.[41]

Although the theoretical preoccupation and the practical necessity of clarifying the terms of the problem of the receiving end of art may take on the feel of a quest only in the late eighteenth century, it may nevertheless be possible and useful to trace a history of theoretical repercussions from this kind of interest in preceding centuries which can be calibrated on three main aspects: sporadic flashes of awareness of the existence of several categories of user – if not of addressee – for works of art; the rare traces and records of changes which occurred in the history of the modalities and rituals of consumption; and the contributions which can be found within the rich seam of art literature that constitutes the theoretical background to the long history of the 'strategy of images'.[42]

The consideration, or awareness at least, of different possible

reactions to the same work of art (reactions of either an aesthetic or an extra-aesthetic nature, up to and including total rejection) most often linked to a stratified hierarchy of social order, or to changes of period, seems for a certain time to be systematically and exclusively connected with a contrast between the knowledgeable and the ignorant, in the sense Ristoro used them.

Another sense, and a different historical dimension and hierarchical emphasis on 'ignorance' are found in the time-honoured distinction, occurring in various forms, which sees a contrast between the delight of the eyes and the satisfaction of the intellect, as when Boccaccio writes of Giotto that 'since he restored that art to light which for many centuries had lain buried under the errors of some who painted more to delight the eyes of the ignorant than to please the intellect of the wise, he can deservedly be called one of the lights of the glory of Florence' (the echo of the new 'intellectual' dimension of the beholder's duty strikes a chord here).[43]

Longer and richer in valencies with current problematics is the list of possible entries in an anthology on the strategy of images; and the age of the Counter-Reformation would certainly be one of the thickest chapters. Consider the level of awareness of the active role of the beholder in Paleotti's treatise discussing images 'introduced to serve the public good of the world', and divides them into 'sacred' and 'profane':

> But I now wish to advise the reader that these differences between sacred and profane images may be seen in two ways: first with regard to the figures themselves, then to the person looking at them, because it may be that an image, of its nature and because of its form, might justly be placed among the sacred, and that nonetheless the person seeing it will put it in the other category. This happens because the beholder has a very different concept in his imagination from the artist's, as in ancient time the brazen serpent made by Moses on God's orders was to some a sacred and mysterious thing, and to others an idol. So, of these images, one may, on the basis of its external surface, be held by one person as religious and sacred, by other perverse and wicked people as an idol, and by other fools as a profane painting fit only for entertainment, as the Holy Fathers warned in the Seventh Synod . . . Thus the same image will give rise to many differences, according to the various concepts that onlookers have of it, as it says in that scholastic motto, although with another meaning: *quod omne receptum habet se per modum recipientis et non recepti* (every percept is given its form by the perceiver, not by the object of perception).[44]

Education for art and education through art

In 1946 a survey promoted by *Lettres françaises* on the theme 'L'art et le public' was still asking the questions: 'Is there a divorce between art and the public? Does this divorce result from another divorce, between art and reality?' Apart from the obvious observation that this series of questions is evidence of the concerns of a precise historical period, it should be noted how the terms of the problem have not shifted far from where they had been planted and in a sense fixed in the late nineteenth century. The age of symbolism is confirmed as a key moment partly by this aspect of its treatment of the problem of the receiving end of art, as it adopts the character of the crisis and explicit expression of a process begun at least a century earlier, principally, of course, under the heading of changes in the socio-economic context connected with what is commonly understood by the simplifying phrase 'industrial revolution', and therefore with geographically very different patterns of development.

The origins of the process go back to the period where the appearance of new stratifications and differentiations among beholders gave rise to the emergence of the problem of the mass public in the figurative arts, in terms of aesthetic education. This education was seen as part of a more general picture of a plan for education *through* art (though free from the old religious aims and directed, at least for as long as it follows the path of the theories current in the eighteenth century, towards civic and political education), but also as meaning the education of the public *for* art, with the duties this entailed. This latter aspect was decidedly new, and it would be worth tracing the web of contradictory influences, evaluations and interpretations, which is marked by a tendency towards seeing the possession of an 'aesthetic education' more and more as an explicit means of distinguishing between mass audience and elite consumer. The early promotion of the general public to the role of judge of the quality of goods at industrial exhibitions certainly did not automatically guarantee entry to the sacred enclosure of the judges of art.[45]

It is worth observing here that the current reappraisal, in the light of our own cultural codes, of this first interest in the problem of the addressee as 'public' tends quite rightly to give a special place to one account – on the level of the theoretical survey (Baudelaire's supremely lucid and perceptive piece), and one sector of observation in the field of sociological research (the audience for the great universal exhibitions); also important is the growing interest in the

origins and development of the taste for illusionistic reconstructions
of reality (e.g. the importance of the first 'panoramas' and 'dioramas')
and its convergence, in terms of public appeal, with the elusive
juncture of realism and/or naturalism in the nineteenth-century sense.
The attention given to the great exhibitions also covers interest in
the adjoining field of the many other 'categories' of visual condition-
ing specific to the world of the big city (the so-called 'urban spectacle'),
which do not all come under the heading of art: architecture, cityscape,
signs, window displays and so on. This also raises the fascinating
theme of the history of town planning as the visualization of symbolic
functions.

If we can speak of fine art as a social frontier, and as an objective,
the state-organized public exhibition (and therefore, typically, the
Salon) is obviously likely to become the primary locus for assaults
on that frontier.

But it seems equally important to remember that public exhibi-
tions also came into being as sites for the consumption, if we may call
it that, of the products of the figurative arts as 'spectacle' (in accord-
ance with the first type of educational aims).

To get an idea of how, for example, an exhibition of works in
competition for a prize with a series of variations on the same theme
'functioned' in the early decades of the nineteenth century, as a
particular type of spectacle, one must reread one of the reviews
translated in Italy as part of the 'cultural policy' of the Antologia
group, which was progressive in its way. The reviewer saw in the
variety of the competitors' interpretations 'a certain piquancy which
excites curiosity and educates the spectator'.[46] The comparison with
the theatre (there are controversies relating to the legitimacy of the
comparison) is, at the time, the commonest key to a 'reading'; in the
Italian context (one may recall, staying with the Antologia, Benci's
quarrel with the *Kunstblatt* and the preference given to 'importing'
articles on the subject) this collides with the related question of the
rejection of mythological themes and allegorical procedures, which
solved – or posed – problems of cultural coding linked to the expan-
sion of the 'audience' beyond its traditional social contexts.[47]

Italian awareness of the problems raised by the new addressees
seems in fact to have arisen first within these groups of intellectuals
who were putting forward ideas for 'cultural policy' (whereas it
seems that artists became conscious of them only significantly later
in the century, and then only when the constantly spreading shift
from commission to acquisition, and the decline, dearth or invisibil-
ity of traditional institutions of 'protection' made it imperative for

them personally to take over the management of their own publicity for their work).

But in Italy as elsewhere, what marks the first phase, spanning almost the entire nineteenth century, is the primacy of the problem of educating the people. As Carlo Belgioioso wrote in a report from 1867:

> It is a question of educating the people (a subject on the agenda of every cultured group) to examine the conditions of the art of drawing: because its principles complement the modest level of education of the people, and its products go back to the people, to charm them and instruct them at public exhibitions.[48]

The specific context of this problem in Italy is clearly the pedagogism of the Risorgimento, used in the exercise so appositely described by G. Bollati as the 'engineering of Italian-ness';[49] and it suffered from all the old ambiguities surrounding the true extent of the term 'the people'. The figurative arts in Italy in the nineteenth century were naturally put to work to provide a 'patriotic' iconography, but had to tackle problems relating to the new conditions of diffusion and to the communicative validity of their codes. We still need to know more about their real effectiveness, their ability to reach the public, and how they functioned as self-interpreting models of the national project, compared with those provided by literature and melodrama.

Guided opinion

The objective centrality of France in the nineteenth century as a reference point for the whole of Europe in artistic matters justifies using the French model as an initial example. It has often been stressed how already in the eighteenth century there were large numbers of visitors coming to public exhibitions with no intention of buying, but simply out of 'curiosity'. But at the beginning of the nineteenth century (the zenith should probably be pinpointed to the time of the 'July monarchy'), the new and significant fact is not so much the exceptional affluence of the Salon audience (which was noticeable before, albeit to a lesser degree), as the echo it struck in print – an echo of shock mingled with pleasure: in the famous caricatures of Daumier, Traviès etc., and in the occasionally *brillant* descriptions of the epic 'crushes' at openings.

Part of the reason for the extraordinary success of the Salon was the fact that it confirmed, for the bourgeois audience, the possibility

of satisfying two pressing demands at the same time: on the one hand the desire for access to the enjoyment of 'great art' as a mediated form of possession, and this came to equal social advancement, reinforcing the illusion that one was a member of the elite of 'connoisseurs'; and on the other hand the dimension of the consumption of art (as packaged comfort or entertainment) matched by the pattern set in other forms of spectacle.

It should also be noted that the enjoyment and consumption of Salon art was made easier by the fact that appreciation was regulated by the fixed hierarchy of the 'genres', which was duly recognized and made known. Exact guidelines also made it easier to judge: for 'style' (and therefore for works at the top of the hierarchy, the allegorical, sacred and historical paintings which still comprised the most prestigious sector), the compulsory reference was provided by 'tradition' (necessarily unambiguous, by virtue of an awkward eclecticism – we need research to establish these parameters, and measure how far the consciousness of this category of addressees differed from the contemporary interpretations of the specialists). Then as regards what can still be gathered under the old heading of 'appropriateness', one could seek counsel from recourse to literary culture (here too it would be interesting to have a systematic survey of the various levels); and everyday experience was sufficient guidance in judging 'mimesis' in the strict sense: the pleasure of recognizing verisimilitude of detail was allowed for 'genre' paintings, even by those theorists who were keenest to assign reductive connotations to the taste for *trompe-l'œil*.[50]

As for the conditions governing the circulation of aesthetic norms and the evolution of circuits of diffusion, as the century progressed so did the importance of mediation and related socio-economic structures: the reproduction industry, important beyond the 'educational' plane and on the largely substitutive plane of mediated consumption (prints, multiple castings, and eventually photography), and more especially the proliferation and expansion of periodical publishing which used the verbal mediation of criticism to publicize controversies between movements and artists, which had previously been confined to privileged circles, beyond the realm of direct experience of the work and therefore beyond the possibility of seeing for oneself.

Nor is it anything new to observe that the extraordinary development of the Salon as a literary genre greatly influenced subsequent changes in the quality of observation: it saw itself as complementary to direct observation, if not quite replacing it, in directing the new forms of public interest in the figurative arts.

It is significant, moreover, that criticism which was negative, *brillant* or abrasive (or at least tried to be), had a precise role to play: the public's visits to the Salon also provided the satisfaction of seeing its own form of power over the artists confirmed, of exercising a right and a function recognized as pertaining to 'opinion', under the guidance of what Algarotti called the 'sound minds' of eighteenth-century tradition.

So who are the 'experts' on whom the bourgeois public modelled its opinions (always cultivating the illusion of independent judgement)? Besides the civil servants entrusted by the state with the acquisition of works – this was still the only form of consecration, as a prelude to inclusion in the museum – it was the critics and writers who nurtured the new genre of the Salons, particularly through the periodicals.

This is in fact the point at which the new figure of the art expert comes to the fore and takes centre stage as an adviser no longer principally to the patrons but to public opinion; a character whose responsibility for establishing 'official' art has been well emphasized; and it would not be hard to compile from the writings of such experts an anthology of the different ways in which the central notion of education for art was rejected in the course of the nineteenth century, with a variety of contrasting solutions on the very important theme of defining a basis for making art intelligible on a non-specialist level.

Finding a basis for the intelligibility of art in a common social inspiration (which most often simply translates into recommending contemporary subjects) seems to be the solution – rather a vague one, to be honest – put forward by champions of humanitarian art, who tend to predict for the vague near future a popular presence of art as 'a workaday language, within everybody's grasp'.

The two motifs which run through Thoré's criticism, according to Pontus Grate ('On the one hand the thrill of following the innovative artists . . . and on the other hand the desire to propound a human and social ideal which could lead the people to art') form a contradiction which will be very influential in the future (both in the immediate and longer term). But the typical example of the new expert figure is the powerful critic of the *Revue des Deux Mondes*, Gustave Planche, who sees the critic's duty, or rather his 'mission', as consisting precisely in educating the public. Using a tactic similar to one of the most successful models of modern-day advertising practice, Planche counterpoised the 'masses' against an intellectual elite of 'connoisseurs and philosophers', but he also declared

membership of the elite to be open to anybody, albeit under the guidance of 'experts' and in terms which narrowly limited the type of art which could be considered. Defining the bases for judgement as common sense, good taste, 'clear values' and comparison with masterpieces, Planche established a model outside which art did not exist, and this idealism, as Pontus Grate writes, went on 'gathering strength from its plundering of tradition, hiding behind respect for "finish", appealing to the cult of clear and intelligible content'.[51]

It was precisely within this context that the rift dividing 'official' art, with its own critics and public, from 'independent' art and groups in sympathy with the artists' reasoning, gradually widened. This rift no longer relates in any way to the old division between those who 'understood' and those who 'did not understand', which needed bridging in quite a different way.

The divorce between artist and public

One may therefore wonder what, in practice, were the modes of consumption and the levels of expectation for beholders of 'official' art in the years which saw the rejection of Impressionism, which is not only the first and classic example of a split between art and public, but was also a decisive event in the subsequent development of that phenomenon, because of the importance of the shock this rejection created in the consciousness of the next generation of artists (in whose experience it sometimes carried more weight than their own fascination with the new painting); and also because of the second shock of its subsequent rehabilitation – and this is particularly striking in the financial sphere, as the movement's bankability is established by its promotion to museum status – felt in its effect on the habits of later generations of beholders (and of potential buyers).

Let us turn to the causes of this rejection, which we should remember was just as disturbingly expressed by the wave of fakes from around 1890 onwards (which, on close inspection, did not adhere, even slightly or in modified form, to the new artistic norm, but actually distorted it so that most of the time the results were more of a contraband of the opposite style). To discover the causes we must answer a number of questions, the first of which concerns the principal and most striking reason put forward: that the image was hard to decipher. Though it was inevitable that such a differently conditioned audience as the general public of 1874 should have

problems here, it is harder to explain why this incomprehension persisted even after the works seem to have begun to be popular. This phenomenon relates to what Gombrich has called the 'climax of guided projection', which gave rise, as we know, to different interpretations and genealogies.[52] Another factor which should not be underestimated is that the public felt disoriented by the fact that in the works of the Impressionists, the traditional 'signposts' provided by the division into genres, each with its own suggestions for a particular treatment, which ultimately worked as a kind of user's handbook, were no longer valid.

Among the motivations for the hostility of certain sectors of the public one should also perhaps consider the influence of another kind of difficulty, even further removed from the 'text'. Namely the complexion that the work sometimes derives from the name of its author, in this case because of close friendships in the literary sphere; such as the nuance which, rather strangely, had helped to make Manet a leader in the mind of the right-thinking public; as J.-E. Blanche attests, 'he camped as captain by the barricades which were going up at the crossroads of symbolism and naturalism (with his lieutenants Zola and Mallarmé).' And again, 'we cannot now realize the amazement, the fury of a people who saw reproduced in a series of canvases – much brighter and more brilliant in colour, more startling than they are today, toned as they are by varnish and dirt – the engines, the smoke, the glazed halls of the Gare St Lazare.'[53] And so it seems that through mental association with literary Naturalists, there evolved a reaction which had much to do with the conflict between the system of extra-aesthetic values with which a group of addressees identified itself, and the system represented by the work, and this reaction should, in this case, be taken into account in examining the complex interactions, on the level of the audience, between literature and the figurative arts.

As far as the problematics of the addressee are concerned, the age of Symbolism coincides with two important facts: firstly, the conviction was growing among ordinary beholders as well as among artists (along the lines of a variously mediated revival of echoes of Schopenhauer's opposition between 'genius' and 'crowd'), that there was a state of separation, of estrangement, between art and life; and secondly, this happened in a Europe-wide climate where cultural processes that had been quite diverse, principally because of the varying degrees of influence of industrial development, were now converging in their results.

To take some examples, the gulf between Ruskin's critique of the

Crystal Palace in 1851, and J.-K. Huysmans and O. Mirbeau's enthusiasm for iron architecture (for example the Galérie des Machines) around 1889–90, is not of course just a question of dates, but the work of a profoundly different attitude to industrialization and the possible equations between scientific progress and artistic progress.

> One thing strikes me in this exhibition [wrote O. Mirbeau] and that is that the 'artistic' impression it makes is not produced by art, properly speaking, but by industry. While art pursues intimism or lingers over old formulae . . . still looking back at the past, industry marches forward, exploring the unknown, conquering new forms. This is typical. Industry is closer to modern beauty than art is because it is close to science.[54]

The reactions of the social idealists in England were quite different; there the myth of industry had already lost much of its lustre and, in the art world, nostalgia for the past was quite at home with progressive utopias. It is significant, at this point, to recall how Morris described the state of isolation of artists 'worthy of the name' in 1883:

> There is in the public today no real knowledge of art, and little love for it. Nothing save, at the best, certain vague prepossessions, which are but the phantom of that tradition which once bound artist and public together. Therefore the artists are obliged to express themselves, as it were, in a language not understanded of the people.[55]

We should now return to the situation in France, which at this period was still definitely paradigmatic. In the mid-nineteenth century the decisive phenomenon had been the absolute power of 'official' art, supported by a relatively unanimous public – although this unanimity was orchestrated by the great Salon critics, who in turn had links with the Academy, and was therefore less and less spontaneously motivated. This public 'consumed' the Salon as a spectacle and recognized itself in the 'clear values' exhibited by the prizewinning works, but the transformation of the market in the later decades not only brought the figure of the art dealer to the fore, as a new key figure, but also fragmented the single Salon and its audience.[56] At the same time, as we have mentioned, the notion of mutual estrangement between artist and society was publicized and propagated until it became part of the inherited collective consciousness, and the belief that art is institutionally separate from life,

something that 'cannot be understood', became a commonplace. On the other hand, it is hard to know to what extent the public was aware of the dichotomy which, although seemingly vague, sought to distinguish between artists according to the value they gave to the now central problem of the addressee. In the neo-Impressionist context (grouped around Seurat's 'set-piece' paintings, with Signac and Fénéon as its principal figures and therefore at least in part synonymous with what has been called the 'spirit of the *Revue Blanche*') the solution was conditioned by an interest in scientific aesthetics, and by the belief that new works have always had to struggle to introduce new languages. This was therefore a revival of the old idea of educating the public, but in the sense championed by Signac, of 'educating the eye'.[57] A case in point, and a classic example of the second approach, is the view of J.-K. Huysmans, who provided one of the period's most complete and popular illustrations of separateness as a value, in the much read *A Rebours* (translated as *Against the Grain*, New York, 1931):

> As the most beautiful melody becomes vulgar and unbearable as soon as the public begins to whistle it and the barrel-organs grind it out, so the work of art which cannot allow itself to leave artists indifferent, or to be censured by fools, and is not content with arousing the enthusiasm of the few, itself becomes, for the initiated, a banal profanation which is almost repulsive.

This translates, in the less subtle version by the leading spirit of the *Revue Wagnérienne*, T. de Wyzewa: 'The aesthetic value of a work of art is always in inverse proportion to the number of people who understand it.'

In the last two decades of the century artists in Italy also became aware of the 'public' as a problem, and of the need not so much for a theoretical response as for a strategy which could save them from divorce. It was no accident that it was the Divisionist milieu (brought closer to France by the Grubicy brothers' activism, not just in the sense of the mirage of the contract with Goupil) which produced the fairly important figure of Previati. It is principally significant because of the way the line of conduct, the 'strategy' chosen by Previati, differs from that proposed by Signac.

Although certainly representing only to a limited extent the emerging shape of their relationship with the public over those years in the minds of Italian artists in general, Previati's testimony nevertheless gives a well-circumstantiated idea of the importance of

Symbolism in Italy within circles exposed to a flood of information from outside official channels as well as from within. The wind from France, in these cases, and the ideas it brought (ideas revolving around the neo-Impressionist group and Fénéon, namely the 'spirit of the *Revue Blanche*'), focused attention principally on the phenomenon of the striking reversals of judgement by the critics and on how public favour towards movements introduced new norms. By this token, young 'innovators' seemed always to be on trial, possibly in the name of norms introduced by the 'innovators' of the previous generation which had finally been accepted.

The ideas which permeated the contradictory geography of literary and artistic Symbolism and gave it a false veneer of unity meant, among other things, that public favour was no longer seen as the prize in an artistic battle between rival norms laying claim to general validity (classicism and romanticism, 'academy' painting and naturalism, naturalism and symbolism); now the relationship between art and public was seen precisely as a series of rejections and acceptances. This new viewpoint had therefore already begun to influence the mechanism which traditionally regulated the way in which the successive different artistic norms were received (and consequently touched on links with the same process in other fields, particularly in the adjacent field of literature).

Signac, in his simplified 'reading' of the history of art in his century (an interpretation 'riddled with scientism', as Longhi would have said!), sees everything working towards the guiding illusion of neo-Impressionism, of progress in the rendering of maximum luminosity, and puts great emphasis on the period of adjustment necessary for the public eye to adapt to the new ways of seeing which artists put forward from time to time. In this light, the task of the 'innovators' is a matter of expressing the new norm with the greatest clarity and intransigence; the public must adapt, even if 'the same generation does not make the same effort of adjusting to a new way of seeing twice'. Inevitably, therefore, if the innovators stick to their guns, the public eye will have the means and the time to become educated and the vision of the few will once again become the vision of all.

To judge by the thoughts which can be extracted from his rather difficult letters to his brother, Previati's strategy is practically the reverse. The French example – which he always refers to, without naming names, as 'Luminism' – and the fascination with the scientific approach, both electrify and disturb Previati. What he seems most keen to avoid – is he thinking of the consequences, in the mind

of the artist, of the blunt incomprehension which met the work of the Impressionists, or is it the effect of its Italian aftermath closer to home? – is a head-on collision with the public and with other artists (public opinion, as he observed, follows their judgement).

If Signac's starting point is his belief that the public eye must be educated before it can accept innovation, Previati holds fast instead to the hope that true art will 'speak to all', and that therefore, if the artist is in full control of his own means of expression the work can be simultaneously 'new' and 'understood by all'. It is therefore the artist who must undertake to 'smooth out the intelligibility' of the work. Previati's diagnosis and strategy are both determined by a different – more docile? – image of tradition as a positive value which will soon, though not quite yet, be eclipsed, and above all by an entirely different situation and perspective as regards economic support. The impact of market forces is in fact quite clear in both his diagnosis and his strategy. In the French situation, the triumphant success of 'facile sub-Impressionism' at the Société Nationale, the proliferation of private galleries which were still not quite 'with the trend', a market generally full of risky attractions but also equipped with a fairly powerful distribution network aimed at a restricted but highly qualified collectorship (which could, as in the case of Impressionism, work in the long term as a guiding force) – all this gave artists a range of choices which were not all conditioned by the need to satisfy directly a public influenced by 'official' art, and were therefore free from the obligation to seek direct contact with and consensus from that public.

The situation in Italy as scanned in these letters is, by contrast, one where the public shows hardly any interest in the figurative arts. It was inevitable that there should be a desire to find out at whose door to lay the responsibility for that lack of interest. In 1891, commenting on the exhibition in the Brera, Previati delivered a fairly shrewd and dispirited judgement of current output, which was dominated by 'worn-out or too fashionable formulae',[58] and noticed a vacuum between artist and audience which he thought could be filled by the work of moderate 'innovators':

> It seems impossible, but you do not all see it [he wrote in a letter in January 1893] that the art which is generally produced is greeted with nothing but yawns and boredom, and the few chords which are still struck touch only worn-out nerves. And what of the throngs who flock to the theatres, and read borrowed books – in fact everything *living* that is printed – why do you think they close their eyes to paintings?[59]

But in a letter from March of the same year Previati goes on to
explain more fully his recent choices by justifying public embarrass-
ment in the face of the new, and comparing the hostility of the
moment with the success that masters of the past met with even
when they introduced innovation (something which those who did
not wish to throw 'tradition' to the dogs saw as further contradic-
tion of the comforting hypothesis of initial lack of success as proof
of value).[60]
 I think it is worth looking at a longer quotation:

> Our starting point, and there is no need to demonstrate this, is our
> awareness of the artistic period we are going through, which is dom-
> inated by the movement begun in France by the Luminists. Their
> theories found few militant followers in Italy, but did sow the seeds
> for that profound disturbance of beliefs which is the final step towards
> innovation. Whoever can find the missing link in the chain between
> forms which no longer ruffle public feelings and the bold abstractions
> of the Utopians who terrorize the public mind will be able to take art
> into that innovation. But the rejection of a principle which is held to
> be good . . . cannot come about while artists allow public opinion to
> decide whether they are appropriate, and manifestly contains the seeds
> of that decadence which is innate in man's conquests. But the links
> between what is new and what is an accepted formula must be im-
> mediately visible, so that everyone can easily judge the merits of the
> innovation . . . We must therefore follow the same procedure as artists
> of old, who did not reveal themselves in their first efforts or foist the
> products of their mature genius on an unprepared public which would
> have rejected them . . . The immediate welcome the public gave those
> artists was due in large part to the way they showed in their early
> works that they had taken the best from the art of masters who had
> gone before them, together with an element of innovation in an early
> stage of development which could be readily understood by the aver-
> age intelligence . . . What happens instead today is that the work artists
> are doing in order to win new esteem for pictorial art, that sense of
> stronger and truer reality of light effects which we are trying to get,
> is going on without the participation of the public in the gradual
> process of advancing study, and there actually seems to be some mad
> desire to make an entrance with the most abstruse results of this
> research as if to grab the limelight by force. Quite understandably, the
> public fails to comprehend any of it, and the sum of effort which the
> artists have put into these products is greater than normal energies,
> and so audience and artist battle it out to the death, always with the
> feeling that there is something missing here which could strike the
> chords of excitement without which art is a boring and deplorable
> occupation. Another persuasive thought is that one should apply

reasonableness to a work of art, just as the new expression of the effect of light is a distillation of the pictorial formulae prevailing in the public taste and the currently dominant artists; it does not use the *jolting* technique of the apostles of light, but takes formulae from works of art which are currently accepted. And of course the innovation element in painting does not follow exactly in the footsteps of developments imposed by literary taste.[61]

This diagnosis also helps to explain why Previati's programmatic, calculated accommodation of public taste is seen as a matter of the subject being the principal element to which the ordinary beholder was sensitive (in his letter there is much evidence that he thought the primacy of literary mediation very important in problems of contact with the public); and why, later still, the anecdotal, even 'literary' subject, did not have the same negative connotation in Italian 'avant-garde' circles as it still had in France throughout – and against the current of – the Symbolist revival. There is of course a story behind this: the most obvious and intriguing episode is undoubtedly Apollinaire's famous castigation of the Futurists as 'sentimental and puerile'.

The beholder and the avant-gardes: the limitations of victory

Whereas the eclipse of Symbolism, which marks the birth of the so-called 'historical avant-gardes', was generally felt by the artists as a time of clarification, of progress from a morass of doubts towards new certainties, the world of the addressee now seemed, on the contrary, to be fraught with every possible confusion.

It becomes all the more important here to speak not of one 'public', but of different 'publics' within the same 'macro-environment', and the most significant phenomenon here is possibly the growing tendency to transfer to the emerging media the type of demand which had hitherto been met by the figurative arts, within a context corresponding in part to that of the old Salon.[62]

In the cultural micro-environment – where public tends to overlap with 'clientele' – we see instead the emergence of the determining factor of large-scale collecting, particularly by Americans, which plays a large part in outlining the new face of mediation. The figure of the critic acquired an ambiguous but high-profile prestige role as adviser to the collector-patron, enhanced by the heroic aura of the

aesthetic crusader. Although it was eventually won behind closed
doors in private negotiations, the battle for contemporary art was
still fought, so to speak, on the streets. In fact it was already falling
into the pattern[63] where the role of 'opinion', in other words the
'non-paying public', is merely to amplify the publicity (be it favour-
able or otherwise) and therefore is also – if not principally – used
to create the *succès de scandale*. The classic example is the famous
American outcry over the Armory Show, but the earlier promotional
campaign for French post-Impressionist painting in England had
already ushered in an era of great confusion (starting with George
Moore's symbolic gaffe of mistaking Van Gogh for Cézanne in a
discourse in their defence). The very indiscriminateness of these
undertakings also had a remarkable effect on the strategies its de-
fenders are tempted or obliged to adopt: Cézanne, rather than being
understood or loved, became a name on a banner, or, for Roger Fry,
a discovery which could provide the key 'to explain the affinity
between all great works'.[64]

But amid such confusion, in the urgent and doubtless noble desire
to defeat the 'philistines' on the battlefield of commercial aggression
and to give the best artists oxygen and breathing space, too many
worthy supporters resorted to the disastrous loophole of the myth of
the absolute and splendidly isolated 'masterpiece', which speaks for
itself to all who are worthy. Meanwhile, observing the spread of a
less defeatist nature, the artists in particular began to turn their
attention to the problem of analysing the mechanisms of the actual
consumption of art.

One of the earliest such reflections concerns the idea of modalities
of 'reading' different from those typical of Western art (particularly
from the Renaissance onwards). When Matisse declared, with regard
to his own painting, that 'we must simply channel the beholder's
mind in such a way that he is held by the picture but able to think
about something quite other than the particular object we tried to
paint', he was merely proposing a relationship between beholder
and work where the beholder is expected to behave differently from
the way he would need to when exploring a 'Renaissance window',
even one translated into the instant photo-image of the 'slice of life'.
This relationship is, ultimately, closer to the kind we have in Sumerian
or Byzantine art than to what Gombrich calls the 'Greek miracle',
or Duthuit ascribes to the 'classical solstice'.[65]

This renewed respect for the importance of the beholder's ima-
gination in the mechanism of projection which precedes the forma-
tion of the image, as something foreseen by the artist during its

creation, is one of the basic themes of Klee's 'Jena Lecture'. But Klee also had thoughts on the temporality of the process of 'reading' the image[66] in terms of micromovements of the eyes, and these considerations anticipate the experimental findings of recent neurobiological studies of the apprehension and recognition of forms which seem to confirm Klee's observations on the hypothesis of a serial mechanism (through operations of scanning and montage), rather than the idea of total intake which had been put forward by Gestalt psychologists.[67]

As for Futurism, its contribution is naturally of great importance both in its breadth of resonance and in being such an early move towards the problems of mass communication, using the audience's hostility – as an element which intensifies the effects of a kind of art which seeks to work upon the beholder as an instrument of persuasion, in the context of the 'spectacularization of artistic experiences' and the 'integration of figurative work beyond the conventional genres', as Fossati wrote.[68]

'Something is wrong with the consumer'

What was it in the relationship between art and public that changed half-way through the century? A useful text to use as a starting point for a survey of a moment which also coincides with the emigration of art leadership from Paris to New York, is the article published in 1959 by R. Arnheim entitled *Form and the Consumer*.[69] Towards the end of the 1950s there was (not just in artistic circles) a qualified revival of interest in the problematics of consumption, and not only was the battle for contemporary art convincingly won on the level of what art sociologists call 'microenvironment', but the rupture with the general public also appears to have been settled, and contact re-established.

But, as Arnheim writes, 'something is wrong with the consumer.' The object of concern is not just the state of crisis in the consumption of contemporary art, but also anomalies in the 'reading' of the art of the past as proposed by its critics and advocates.

> Art has become incomprehensible. Perhaps nothing so much as this fact distinguishes art today from what it has been at any other place or time. Art has always been used, and thought of, as a means of interpreting the nature of world and life to human eyes and ears; but now the objects of art are apparently among the most puzzling implements man has ever made. Now it is they that need interpretation.

Not only are the paintings, the sculpture and the music of today incomprehensible to many, but even what, according to our experts, we are supposed to find in the art of the past no longer makes sense to the average person.

So it is the 'experts' who are on trial. The name taken as an example or as a scapegoat – in this case Roger Fry in a passage on Poussin – explains what may seem an arbitrary simplification of the complex moment of 'pure painting'. In certain environments and, as we have seen, in a way quite removed from the artists' own formulations, this *pure peinture* had certainly been received exclusively as something which could be reduced to the formula which Arnheim here puts in the dock, of art as 'the contemplation of formal relations'. As for the causes of what is 'wrong' with the consumer, besides the historical explanation (the excessive formalism of the mediation provided by critics engaged in the battle against sentimental anecdotalism and visual banality), Arnheim claims to identify, on the synchronic plane, two factors inherent to the current type of culture as being responsible for what he calls the inability 'to get beyond the shape': the absence of a dominant style, and a certain decline of 'symbolic power'.

Even 'granted that educated westerners have become capable of overcoming this obstacle (of shape) to a remarkable extent for almost any style that the history of art has brought forward anywhere', the price of this flexibility, he claims, is 'an extremely unstable sense of form. Having educated ourselves to perceive in any idiom, there is not set of shapes, arbitrary and wilful as it may be, which we cannot welcome, but, on the other hand, there is no longer any one idiom into which we slip completely.' Is this perhaps an old mythological temptation, a familiar nostalgia for the 'great ages' raising its head again? Besides, the second point also contains an echo of the problems of the 'prehistory' of the 'avant-gardes' that troubled the late nineteenth century, and which resurface here in the context of what can also be seen as a criticism of the solutions adopted by the artists of the early decades:

This philosophical and religious decline produces an opacity of the world of experience that is fatal to art because art relies on the world of experience as the carrier of ideas. When the world is no longer transparent . . . art becomes a technique for entertaining the senses. Unconscious symbolism, to which we have been running for salvation, is much too primitive to shoulder the task by itself.

In short, Arnheim challenges the concept of art as a *machine à sensations*, and deems its appeal to the unconscious, as in the surrealist solution, to be inadequate.

So, counter to the apparently happy ending of art and public reconciled seen in the economic success and new-found prestige and popularity of the museum, there has recently surfaced a feeling that what we have achieved is a broad diffusion of objects but no corresponding area where they are effectively appreciated. The case of Picasso is once again emblematic of this kind of observation: Arnheim cites the example of how a reproduction of *Guernica* can be used merely as a 'decorative pattern of formal relations'. In this sense Arnheim's argument falls into the range of contradicting reactions to 'formalism', although it takes up quite a different position from the more banal readings, distancing itself particularly by its focus on the plane of the consumer, basing its observations in the analysis of a certain new type of public or pseudo-public. His position is not however immune from a new myth, which one could call nostalgia for the public of the 'good old days' (like the exemplary Sicilian 'struck from the height of the apse by the fearful image of the blackbearded Pantocrator'). And he seeks its heirs in the present:

If it is true that what goes by the name of the aesthetic or critical attitude is often a device for escaping from the compelling call of art, then the TV audience, in the innocence of its full surrender to thrill, shudder and suspense, *is the only social group that functions as a genuine consumer of art*. This, indeed, is not far from being so. What better audience could a composer, performer, sculptor or poet want than one as fully devoted to his visions as television viewers are to the horrors and sweetness of their own fare? But we remember immediately that the television spectacle and its public are geared to each other by a community of style, interest and taste which does not now exist in the arts. It did exist in the past.

Having shown this nostalgia for the public of a bygone age, he thus seems to be proposing that we turn our attention to the public for the mass media.

These conclusions coincide strangely with a text from the same year, though from a rather different source and approach, which we may take as a second example of the general malaise. This is a short address on the theme of 'Artistic Education and Mass Communications', given by T. Maldonado at the Congrès International Extraordinaire des Critiques d'Art, in Brasilia.[70] Maldonado re-

ported on the 'widespread but unresolved' crisis facing the institutions in charge of artistic education, and the 'increasingly marked divorce between museum art and street *art*, between the tastes of the few and the tastes of the many'; and he observed that, as far as the 'man in the street' is concerned, 'his aesthetic, emotional and contemplative needs find satisfaction – whether real or artificial – in the infinite variety and the diverse modalities of mass communication' (in which 'there is certainly a vitality which the lover of "fine art" fails to perceive'). Like Arnheim, though not in quite the same way, Maldonado points the finger at the traditional mediators, the critics; and his hope is that 'in the most hidden fabric of mass communication there may be the seeds of protoforms of a new type of popular culture.'

'Deschooling' the spectator?

What did it mean to the beholder of the visual arts to take account of the mass media and of what was specifically new about them as 'social organizations for the specialized use of certain instruments and processes of communication . . . endowed with a structure, a function and an apparatus of internal communication which are entirely peculiar to them'?[71] How, in this context, on the theoretical plane, did the problematics of mass communication interfere with the question of the public for the visual arts? These seem to be the principal questions at this point, and in order to answer them we must first of all think along two different lines:

1 On the level of the means of expression (videotape, decor poster, comics etc.), and therefore of works produced and planned with a view not only to technical reproduction, but to diffusion through the new channels, which implies at least in part that they must have in mind a public subject to the mechanisms and conditioning – the laws of cultural diffusion – specific to the mass media.
2 On the level of artistic information, the diffusion of artistic products and culture.

With regard primarily, but not exclusively, to the first of these points, one of the most important consequences for artistic phenomena is connected with the greatly increased role of market censorship in these new conditions, together with the selective role played by the mass media. This is one more chapter, of particular interest for

our discussion, in the disturbing panorama of all the various ways in which censorship operates in the world of images, and we should examine it on a number of levels, as typology and as history. An example of this responsibility can be found in the recent boom in sales of home decor posters: a missed opportunity.[72] In studies of comics too the theorists have rightly focused their attention on establishing the influence of the mass media, in their capacity as organizations, on the content and ideologies conveyed, which 'are not just those of the scriptwriter, but more often those of the large distribution agencies'.[73]

One of the big problems on the agenda at this point obviously concerns the margin for critical control open to addressees from different socio-cultural strata, and the assessment of the degree of freedom which may depend on the fact that decodification is itself a form of activity.[74] Also relevant on this point are the controversies as to whether interpretations of this margin of freedom have perhaps been over-optimistic. Another typical example is the case of the manipulation achieved by inserting a fake audience into television shows.

On the plane of the diffusion and popularization of artistic culture, there are undoubtedly a wide variety of sociologically relevant aspects in problems related to the use of the mass media, but I think they fail to address the whole huge diversity of configuration, which seems also to be branching out into other kinds of change. In order to bring into focus the questions exercising the broad field of studies in the popularization of art, I think it may be useful at this point to take as a reference point the questions connoting the current state of the popularization of science. As Lotman and Uspenskij write in a recent piece despatched from the 'new frontier' of the typology of culture,

> The consciousness of the nineteenth century, where science and the spirit of criticism were substantially synonymous, while on the other hand the forms of life given by common sense and everyday experience seemed indestructible, was essentially constructed upon *doubt*. For the mass consciousness, to participate in science was to doubt and mistrust. A scientist was someone who entered critically into the sphere of mistrust.
>
> Moreover, the apparatus of science was relatively simple and accessible to an averagely cultured person. Mysteriousness was felt to be hostile to science ... while scientific knowledge was understood as that which can be verified (in principle by every human being). Nowadays a series of scientific revolutions has radically changed the idea

in the mass consciousness of the probable and the improbable . . . The more unlikely a thing is, the more it is to be expected, that is the more possible and close to science it is . . . The mechanism of science . . . has slipped irreparably from the control of the mass reader. Checking the accuracy of the theses of contemporary physics or the truth of para-doxical scientific ideas far removed from everyday experience is an undertaking that is beyond the reader's abilities. And that is not all: the idea of verifying what has already become an article of faith for others would land one with a reputation as backward, or unscientific. For the mass reader, being up to date with science means never being surprised and having faith.[75]

And for the mass beholder? It would certainly be simplistic to seek to trace a blindly analogous reversal of values in the way people commonly feel about art, but there are at least two points of contact which I think it is appropriate to consider.

In the nineteenth century the 'artistic', in the mass consciousness, was probably associated either with something comprehensible, or rather recognizable, in relation to the data of natural and everyday experience, or to something that conformed to a canon based on the secure values of the 'great art' of the past, a conformity guaranteed by the consensus of elite consumers. It was something which even an averagely cultured person must be able to enjoy, but there was still a nuance of privilege attached to its access (proof of a high degree of sensitivity in the consumer, a sensitivity 'above his station' even). In other words the equation was not just 'it looks like the model, therefore it is art', but 'it looks like the model and like the masters – according to the judgement and consensus of those privileged by their aesthetic education – therefore it is art.' The elite consumers were always the guarantors, although in the mass consciousness of the nineteenth century it must have seemed to be a matter of 'veri-fiability' against the double model of 'nature' and 'tradition' guided by one's own sensibility, which makes reference to everyday experi-ence, and by a more or less profound erudition, an asset within the reach of the averagely cultured audience.

If we then wish to ascertain what became of the 'artistic' in the mass consciousness of the twentieth century, I think that one would find a much less homogeneous range of answers than in the common attitude towards science. However, on the best-publicized, if not the most generalized of these levels, there has certainly been a reversal whereby the equation eventually becomes: 'no one understands it, it looks like nothing on earth, therefore it is art'; this is reinforced by another (which would seem to cast new doubt on the infallibility of

the experts): 'it doesn't sell, it is shocking, the critics don't like it, therefore the museums will take it.' All things considered, this is similar to the arguments often used by critics in the battle to impose avant-garde art in the early decades of the century, and we should not overlook the other, more consistent point of contact: the history of conscious attempts by artists and their supporters, throughout the course of the twentieth century and still to this day, to latch on to the new myth of the 'scientific'. This can be seen in the difference between the 'scientific aesthetics' of the nineteenth century (which are akin to the typical Renaissance relationship between art and science) and, in the opposite corner, the sequence which began with the equation between cubism and relativity.

On the level of their wider consequences, however, the new norms introduced from time to time by artistic movements at a high level spread through other channels: the field of satirical graphics, window displays, and especially the whole world of advertising, to take just a few instances.[76]

This leads us into the enormous arena commanded by 'design' for its critical and theoretical events with their many facets (beginning with those related to proxemics) which have hijacked all the main concerns in current management of the relationship between art (as a secondary modellizing system) and its users in the widest sense.[77]

Science of consumption and consumption of science: new developments for old tendencies

In the 1960s debates and interviews involving several people, and particularly 'round table' debates, acquired the status of a new 'genre', (somewhere between literature and entertainment), practically managed by the same mass media that, more often than not, provided the main subject for discussion.

Theoretical developments in the problematics of the addressee of the visual arts are also subject to this treatment, and this is where we can perhaps see the first signs of interest in the direction they were taking, with its twists and turns and new points of conflict, although of course the patterns would subsequently have to be checked on other levels, using other tools, given that – particularly with hindsight – many of these debates seem to be going round in circles, and are dictated by a rather backward viewpoint compared with contemporary events.

An important example (in both a good and a bad sense) is the

debate on the theme of 'Art and the Public' held at the close of the
Geneva Conference in 1967: the discussion appeared to be domin-
ated by the urgent need to analyse and explain (and almost to justify)
the extraordinary public success of the great celebratory exhibitions
of previous years (Chagall in Japan, Picasso and Tutankhamun in
Paris), along thematic lines centred around the ambiguity of the notion
of shock, the possibilities and implications for art of creating demand
by artificial means, the function of microgroups, etc.[78]

But if one must sit in judgement, the problem emerging in the
debate over the mass media in the second half of the 1960s is really
best set out, for example, at the Unesco-sponsored meetings in
Montreal in 1968 (involving 'official' operators) discussing ways to
'remedy the effects of the theoretical rift between communication
and culture'.[79] This shift of terms also plays a decisive role in influ-
encing the path taken by theoretical speculation on the question of
public and consumer over the next ten years.

Whereas the 1960s debate revolves around the problem of public
intervention largely as the spur 'to transform museums from temples
into cultural centres',[80] and therefore around the new type of me-
diation represented by the figure of the 'animator', if we lowered a
probe into the mass of corresponding documents from the following
decade a quite different climate would emerge, which can perhaps be
schematized into two partly complementary formulae: the crisis of
the 'animators', and the new sense of isolation which artists either
bemoan or parade, or both.[81]

Since the hypothetical democratization of art, obviously typified
by the illusory revolution of 'multiple' copies – sanctified by a sig-
nature and brought home to the 'microenvironment' by the expedi-
ent of paradoxically limited editions – had been frustrated by market
forces, the new register for theoretical speculation articulates instead
around the need to promote 'creativity' – a quest which is again not
entirely free from ambiguities, misunderstandings, and opportunities
for self-justification.[82]

Within the new wave of thought which artists gave to the problem
of the addressee, this translates into two main directions, both linked
to the quest for a new kind of relationship with the public (seeking
to avoid 'exclusion by definition'): first, the need to 'discover the
public outside the traditional context of art',[83] and secondly an in-
terest in inventing new rituals of participation aimed at arousing the
creativity of the beholder.

It is quite legitimate to wonder, however, whether this new revival
of institutional interest in controlling and organizing the consumption

of images rather than their production[84] should not be considered in relation to recent scientific interest in the complexity of that consumption as an activity.

Looking for signs and symptoms of something already present but not yet consciously registered at the level of the kind of documents we have hitherto been considering, I should like to risk putting forward at least two examples of the problematics of the consumer: one on the level of reactions from the general public, and the other from the laboratories of the most advanced theorists.

The sense of *déjà vu* one derives from reading press reactions to the 'striking' success in terms of crowd size at the second hologram exhibition at the Royal Academy in London in 1978 leads one to reflect on the endless possibilities for reincarnation of old 'publics', and also on the true nature of certain recurring phenomena. What we have here is a case of a technological advance being used – amid the usual distrust, protest and predictions of catastrophe from those working in the field – for the purposes of arousing feelings of an aesthetic nature (which 'fine minds' immediately seek to relegate to the subculture of entertainment).

On more elevated levels of research, it seems as though contamination and interaction between the 'two cultures' could also follow quite the reverse symmetry, as the extrapolation of how, in the future, studies on the artistic 'model' may be used to help perfect methods of transmitting scientific knowledge.[85]

NOTES

1 J. Mukařovský, *Aesthetic Function, Norm and Value as Social Facts* (1936), (Ann Arbor, 1970), p. 1.

2 I see the analysis of graphic language as one of the most promising avenues of research in the field of studies in the consumption of art, partly because it allows us to study the processes of decoding the image in a more simplified context, in laboratory conditions, as it were, as E. H. Gombrich has shown by his brilliant example. We must also consider the aspect of the relationship – on the recipient's level – between visual habits (systems of expectations) set up by the codes of graphic communication, and the decodification of painting. To take an intentional case – quite openly declared in the artist's theoretical writings – such as the presence of arrows in the works of Klee; a typical case, I would say, of a cut-in from current graphic convention, which Klee most often uses in order to direct and guide the eye over the picture, thus suggesting a modality for reading it.

3 An analysis of the exchange between theatre and painting in the cul-
 tural system of the early nineteenth century, when the 'assimilation of
 stage to painting gave rise to the specific "genre" of the "tableau
 vivant" as a spectacle in itself', is to be found in the essay by Yuri M.
 Lotman, 'La scena e la pittura come dispositivi codificatori del
 comportamento culturale nella Russia del primo Ottocento' (1973)
 (in Ju. M. Lotman and B. A. Uspenskij, *Tipologia della cultura*, Milan,
 1975, pp. 277–91).
4 Cf. *Tesi sull' 'arte come sistema secondario di modellizzazione'*, in Ju.
 M. Lotman and B. A. Uspenskij, *Semiotica e cultura* (Milan and Naples,
 1975). Lotman's approach, characteristically biased in favour of the
 spectator, provides useful tools for studying the public for art, starting
 from the same hypothesis of the artistic model – which, although quite
 distinct from them, shares features in common with the scientific and
 the ludic models, and can be used to study both the 'symbolic substitute'
 and the record of visual experience. The opposition between scientific
 model and artistic model in this context seems to me to be more
 fruitful than, for example, the opposition between presence and
 communication, given that what is of interest here is simply when –
 and how – a given text 'functions' as art.
5 For a recent authoritative appraisal of studies in this area, cf. E.
 Castelnuovo, 'Per una storia sociale dell'arte', *Paragone*, 313 (1976)
 and 323 (1977).
6 Mukařovský could still see this tendency in 1948: 'The theory of func-
 tions', he wrote, 'coupled with a semantics of art, is capable of estab-
 lishing an organic link between the so-called sociology of art and the
 study of artistic structure, spheres which have hitherto shown instead
 a tendency to mutual isolation' (*Il significato dell'estetica*, Turin, 1973,
 pp. 218–19). For the 'negative attitude of scholars towards a sociological
 perspective on art', see also F. Poli, *Produzione artistica e mercato*
 (Turin, 1975), p. 6.
7 For a basic account of the relationships between the two disciplines
 both in the European context and the American, cf. G. Previtali, 'Storia
 dell'arte o antropologia?' *Prospettiva*, 5 (1976) and G. Kubler, ibid.
8 Cf. Communications, 23 (1975) (devoted to *Psychanalyse et cinéma*).
9 Mounin's plea is to be found in his 1968 review of J. Bertin's *Sémiologie
 graphique*, which he liked precisely because Bertin's work on graphic
 communication did not succumb to the blandishments of conceptual
 borrowings from structural linguistics, but was based on 'structures
 specific to the graphic code, deduced from the way it functions'; cf. G.
 Mounin, *Introduction à la sémiologie* (Paris, 1971).
10 Ju. M. Lotman 'Metodi esatti nella scienza letteraria sovietica', *Strumenti
 Critici*, 1 (1967), is keen to define the limits of similarity between a
 typology of culture and 'a contemporary typology of languages'.
 Whereas natural language appears as a relatively simple system, the
 very complexity of any synchronic cross-section of cultural phenom-

ena and, even more so, of artistic phenomena, requires a deeper knowledge of the 'state preceding structure'. 'Models of natural language and models of culture, though together they comprise the whole system of humanity's non-genetically transmitted experience, are still profoundly different from each other. In natural language what "does the work", or functions as the means whereby information is passed on, and moulds the consciousness of the carrier of the language, is largely its cutting edge, its latest and current state. The history of language is useful to the researcher but not to the speaker. Culture, and particularly poetic culture, fulfils its own function of conservation in a completely different way: what "does the work" here is the whole historically formed system of codes. The synchronic cutting edge, freed from any link with previous structures, is quite unable to fulfil the function of preserving and passing on information. Therefore anyone who wishes to study culture, whether they favour structural methods or traditional methods, must become a historian.'

11 Maria Corti (*Introduction to Literary Semiotics*, Bloomington and London, 1978) emphasizes the point that 'the sociological and semiological points of view must intersect in the construction of a history of literature that is also a history of readers and a typology of reading respectively'; 'a history of literature that is to include addressees must be . . . a history of the readers, that is of the sociocultural context, as well as a typology of reading, as a decodification of the literary hypersign. These are two complementary aspects of research; in them the sociology of literature and semiology substitute for their furtive and occasional meetings, a legal union.' The book is packed with bibliographical information, and touches on many cases of possible interface with the area of figurative arts, particularly in the chapter on the addressee (in the three aspects of the addressee's relationship with the sender, with the work, and with other addressees); and on the theme of the evolution of literary genres.

12 Recent research into soap opera may perhaps help to clarify certain phenomena related to levels of expectation, including the case of some 'consumer' painting. The question might be whether a certain type of painting may have functioned, in a particular socio-cultural context, as a 'pleasure machine', to use Umberto Eco's phrase ('L'industria aristotelica', in *Cent'anni dopo* (*Almanacco Bompiani*, 1972)). This is not to say that the criterion put forward for the novel to distinguish between the 'problematic novel' and the 'consolatory novel' could be applied to painting without further qualification, but certainly as regards the consumer an analogy may be drawn (to include those 'incomplete mini-crises' which do not substantially contradict the current norm, as with certain 'chic' or 'flou' paintings). But, in the case of nineteenth-century painting, there is perhaps a good case for the hypothesis that deep down in the spectator's consciousness, 'the charismatic hero who possesses a power that the reader does not have' (and with whom the

reader does in fact identify to consoling effect), is in most cases a person whom the work makes us think of without actually showing him, in other words the artist whose 'genius' allows him to cross the sacred threshold of Art (with a capital A).

13 For the panoply of connotations and the growing importance of anticipation in the various disciplinary fields, see the entry by Massimo Piattelli Palmarini, in *Enciclopedia Einaudi* (Turin, 1977).

14 E. H. Gombrich, *Art and Illusion* (Oxford, 1960), p. 198.

15 *Idem, Meditations on a Hobby Horse* (Oxford, 1963), p. 100.

16 The impetus Gombrich gave to a re-examination of the history of art taking account of the 'beholder's share' (a reappraisal born out of his polemic against the cavalier attitude of the 'Geistesgeschichtliche Parallelen'), leads in two main directions. The first was certainly the analysis of the beholder's contribution to resolving the ambiguity of the image (as part of his campaign against the cliché of the 'innocent eye'); the second was his idea – of vital importance in studying the relationship between art and public – of integrating the study of art with the analysis of visual language as it exists 'beyond the sacred enclosure of art', for example the mechanisms which function in advertising graphics. Neither the idea nor the example were as obvious then as they are now.

17 In the literary context this suggestion has often been a target for Gramsci's critics. Cf. *Quaderni*, 17: 'Ungaretti wrote that his comrades in the trenches, who were "of the people", liked his poems, and it may be true: it was a particular kind of liking linked to the feeling that "difficult" (incomprehensible) poetry must be beautiful and that the author is a great man precisely because he is detached from the people and is incomprehensible: this was also what happened to Futurism and it is an aspect of the popular cult of intellectuals (who are in fact revered and despised at the same time).'

18 Cf. Mukařovský, *Il significato dell'estetica*, p. 74.

19 Ibid., p. 52.

20 Once only dwelt upon by the so-called 'historical avant-gardes' (consider the case of Eisenstein), formal components were again taken into consideration under different labels by the semiologists who adduce the help of psychoanalysis to question whether formal components are qualified to signify.

21 For the impossibility of relating the elusive and abused notion of 'elite' art to anything except the sphere of the beholder, cf. Q. Bell, 'Art and Elite', *Critical Enquiry* (September 1974), pp. 34–46.

22 I could give many other examples. For the Italian sphere the case of Michetti's photographic archive is worthy of note.

23 For some early Italian examples, cf. W. Settimelli, Appendix on photography in Italy, in J.-A. Keim, *Breve storia della fotografia* (Turin, 1976).

24 Cf. W. Benjamin, 'Piccola storia della fotografia', in *L'opera d'arte*

nell'epoca della sua riproducibilità tecnica (Turin, 1966), p. 77. The material for such an investigation is practically endless: of course there are a number of existing studies on the sociological history of photography where the abundance of material excited, if not always insight, then at least good will in its collectors; the study which one might feel was actually required would be a survey of the methods behind this research and gathering of material, or of the particular fetishes their authors worshipped and obeyed.

25 Regarding the 'mediated' consumption of Salon pictures (painted in the specific hope of winning prizes and acquisition by the state, and thus fulfilling an advertising and signposting function in the artist's career), one should recall that successful paintings could also function as texts – as musical 'scores' – which could be 'performed' as *tableaux vivants* at private parties, possibly under the direction of other artists. To give one example among many: Ugo Pesci (*Roma capitale*, 2nd edn, Florence, 1907) tells of a party during the Roman carnival of 1877 at the Palazzo Salviati during which, along with other *tableaux vivants* of Pompeii or a Moorish scene, Achille Vertunni 'staged' Delaroche's *Execution of Lady Jane Grey*.

26 Man Ray, 'Nota biografica', in *Oggetti d'affezione* (Turin, 1970), p. 271.

27 Christian Metz, *Le film de fiction et son spectateur*, Communications, 23 (1975), translated as 'The Fiction Film and its Spectator', in *Psychoanalysis and Cinema* (London, 1982), pp. 99–142. Recent studies on the cinema audience – using tools similar to those of psychoanalysis – have given results very different from those one might have expected. For example, the 'ingenuous' audience in the provincial auditorium, where people argue with the characters on screen, is simply following a ritual of cheering on the show, and would therefore seem to be less susceptible than the 'silent' public to perceptual transference.

28 Benjamin, *L'opera d'arte*, p. 38.

29 Besides, the cinema was born ready-labelled – and in some sense saved – by reductive interpretations which relegated it to the space of entertainment, and this was already true of its distant ancestors, the 'panorama' and the 'diorama'. Charles Blanc was able to say of these, in the second half of the nineteenth century, while theorizing about unity of gaze as characteristic of 'painting proper': 'Unity is thus essential to every spectacle which addresses the soul. If we are simply amusing the gaze with optical tricks and holding the beholder's curiosity on tenterhooks by giving him, in a series of different scenes, the pleasures of a momentary and material illusion, unity is then no longer necessary because the artist, instead of *conceiving* a painting, now has only to *contrive* a panorama' (*Grammaire des arts du dessin*, Paris, 1967, p. 536).

30 Pissarro's *boutade* was recorded thus by Cézanne in a letter of 1906: 'Yesterday I saw that valiant Marseillais Camoin, who came to show

me a photograph of a figure by the unfortunate Emile Bernard; we are
agreed on this point, that he is an intellectual constipated by recollec-
tions of museums, but who does look enough at nature, and that is the
great thing, to make himself free from the school and indeed from all
schools. So that Pissarro was not mistaken, though he went a little too
far, when he said that all the necropolises of art should be burned
down.'

31 The practice was ancient (think of Cennino Cennini's treatise), and
 was gradually reformulated until the period of the Enlightenment. For
 example, here is what Boullée wrote about the teaching of architec-
 ture: 'The teacher, having demonstrated to his pupils that the source
 of beauty is in nature and that it is from this well that they must draw
 water, must make this study as painless as possible. How so? By
 putting before their eyes the works of the great: it is by the knowledge
 they have gained that the students will begin to read and to look at
 nature' ('Réflexions sommaires sur l'art d'enseigner l'architecture', in
 Boullée, *Architecture. Essai sur l'art*, Paris, 1968. p. 171).

32 The call for the destruction of museums issued by the Futurists as part
 of a calculated, even solicited, provocation of the establishment audi-
 ence, was still seen by Boccioni within these parameters: cf. for exam-
 ple the text and notes for the Rome conference of 1911 (recently
 printed with some unpublished works) where the battle cry against
 museums is equated with the physical removal of 'antique statues'
 coinciding with, and as a function of, the birth of 'Christian art'. Thus
 we are still on the plane of the liberation of the artist from the con-
 ventions associated with a 'tradition' now felt to be in irreconcilable
 conflict with the 'spirit of the age'. As for the Italian public, the dis-
 appearance of the museums alone would not have been enough to
 shake it up; if traditional conventions were still dominant in official art
 then, according to Boccioni, the real culprit was lack of 'demand', in
 other words an audience which looked to art not for an answer to the
 challenges of the age but merely as a nostalgic refuge from the traumas
 of contemporary reality.

33 The letter, probably from September or October 1945, is published in
 Jean Paulhan à travers ses peintures (exhibition catalogue, 1974), p.
 95.

34 Cf. Algarotti's recommendations in favour of representation which
 includes its own explanation, without any need for captions or com-
 ments (*Saggio sopra la pittura*, 1762).

35 Not least of these is the Vienna controversy of 1875, between Mechel's
 belief that 'a great public collection is meant more for instruction than
 for passing pleasures', and the recriminations of von Rittershausen and
 friends who said that Mechel's museum was open to anyone intending
 to write a history of art, but no longer to the 'sensitive person'.

36 Unless we wish to create – or to perpetuate – a kind of hierarchy of
 first- and second-class beholders, where the second-class type of con-

sumer is still steered towards exclusively didactic ends and basically different by quality and not by degree, as is normal and inevitable, from the first-class type of consumer. Cf. the results of the survey by P. Bourdieu and A. Darbel published as *L'Amour de l'art. Les musées d'art européens et leur public* (Paris, 1969).

37 With regard to the public, the way the role of the 'creator' artist was understood according to the dictates of the part of the historical 'avant-gardes' most closely linked, despite appearances, to *fin-de-siècle* roots, can be exemplified, I think, by the opinions of the champion of 'Cercle et Carré', Michel Seuphor (*Le commerce de l'art*, Bruges, 1966, pp. 72 and 110). Having delegated to the professional critic the work of publicity, and to the beholder the onus to educate himself, the artist, Seuphor says, would be making a grave mistake if he thought about the people, the masses: 'His aim is to find in himself and for himself. He proposes, in the deepest counsel of his heart, and the whole of the people, one day, will meet there.' 'Every great work of art challenges the world. For the spirit which lives in the work is not measurable. Men will accept it sooner or later, if there is still some corner in them that is not dried up or mechanized.'

38 'The work never stands alone, it is always a relationship. To start with at least it is a relationship with another work of art. A work alone in the world would not be seen as a human product, but viewed with reverence and horror, as magic and taboo ... And so it is the sense of the possibility of a relationship which necessitates the critical response. This response does not just include the link between one work and other works, but between a work and the world, sociality, economics, religion, politics and whatever else' (R. Longhi, 'Proposte per una critica d'arte, *Paragone*, 1 (1950), p. 16.

39 E. H. Gombrich, 'The Museum, Past, Present and Future', *Critical Inquiry* (Spring 1977), pp. 449–70, an essay which began life in 1975 as an address to a conference of museologists.

40 Michel Butor, *Les mots dans la peinture* (Geneva, 1969).

41 Ristoro d'Arezzo, *La composizione del mondo colle sue cascioni*, critical edn by A. Morino (Florence, 1976), pp. 198–200.

42 On one point of the debate on the use of images that is deservedly one of the most famous and rich in valencies with current theoretical speculation, the 'polemic' between St Bernard and Suger de Saint Denis, see the famous essay by E. Panofsky, *Abbot Suger on the Abbey Church of St Denis* (Princeton, 1946), where he also focuses on the importance of Suger's text for the problematics of 'layout' (on the subject of ecclesiastical ritual as an aesthetic experience).

43 'Ignorance' is also regularly evoked as a term to explain a certain type of relationship – or rather absence of relationship – of the subordinate classes with art, which seems to be taken for granted in the late eighteenth century.

44 Further consequences of this position are seen in Paleotti's reasons

for claiming the superiority of images over books for the purpose of
'teaching the people to live well': the greater universality of the visual
code ('paintings are like a book open to the abilities of everyone, since
they are composed of a language common to all kinds of people, men,
women, children, adults, learned and ignorant, and can therefore be
understood, if the painter does not seek to distort them, by every
nation and every intellect, without other pedagogue or interpreter'); the
speed of consumption (since 'with the greatest swiftness, in a moment,
or rather at a glance, paintings can enable people at once; whereas the
learned know how much time and lamp-oil it takes to understand
things from books'); moreover, the image gives pleasure: 'and the most
important thing is that, while reading or knowledge cannot be acquired
from books without great effort and work and expense, images instruct
with great gentleness and recreation'; and it is more easily committed
to memory, more concentrated, which makes it the best means of per-
suasion: 'since we are bound to preach our law ... and to take every
opportunity to persuade others of it and to imprint it on their hearts,
what more efficient or more clear and enjoyable way could we find
than this method of the sacred image? which not only, as a hoisted flag
and an unfurled banner shows our law to all kinds of people every-
where, but also, like an eternal trumpet, shouts it out and inculcates
it in each person's senses?' (Gabriele Paleotti, 'Discorso intorno alle
immagini sacre e profane', in *Trattati d'arte del Cinquecento tra
manierismo e controriforma*, ed. Paola Barocchi, vol. II, Bari, 1961).

45 In the second half of the nineteenth century this is still documented by
a significant passage from the report on the Paris exhibition of 1855
published the following year by Prince Napoleon: 'Beauty cannot in
fact be appreciated by everyone as useful ... To judge a work of art
properly, one must have an instinct for beauty within oneself, be very
knowledgeable and trained to look at fine works by the masters; one
must, in a word, have an aesthetic education.' Cf. A. Abruzzese, *Arte
e pubblico nell'età del capitalismo* (Venice, 1976).

46 'Osservazioni sulla esposizione per il concorso al gran premio di scultura
distribuito dalla Accademia delle Belle Arti di Parigi il 28 settembre
1820', *Antologia*, 1 (1821). The exhibition comprised eight statues in
the round, and the theme was 'one of the best-chosen, Cain, after the
murder of Abel, hearing the Eternal One say: "The voice of thy brother's
blood crieth unto me from the ground. And now thou art cursed from
the earth, which hath opened her mouth to receive thy brother's blood
from thy hand."' The reviewer describes the different interpretations
in minute detail and remarks: 'In an exhibition of this kind we realize
with pleasure the various feelings which inspired the artists: when the
competitors have imagination (a talent found in abundance in our
young artists) this variety has a certain piquancy which excites the
curiosity and instructs the beholder. In this case, the subject offered a

series of situations and emotions, and there was no appropriate image which one or other of the emulators did not render.' So the audience has here a similar status to the theatre audience; and the 'text', the work, is *the temporarily assembled whole*, which can be appreciated according to different ways of behaviour and different rituals (to start with, over a period of time) in response to a demand which is different from that met by other traditional examples of works destined for 'public', if not collective, enjoyment, such as buildings, exterior decoration etc. This is a type of text whose antecedents it would be interesting to investigate, and which could probably be traced, in the Italian context, in the prehistory of public exhibitions.

47 From Benci's arguments in defence of the authorial/directorial capacities required of the painter if the 'story' is to be intelligible, complicated by the need to communicate that story in very concentrated form, there actually arose various types of coding problems ('Besides which everyone knows how much skill it takes to make good figures of the heroes of modern history, which can have great spirit, but have no picturesque qualities'); and yet painting was still inferior to the theatrical composition because, as another of the Frenchmen reviewed in *Antologia* says (Keratry and his *Lettere sull'esposizione del 1819*), painting is more imperfect 'in that it confines itself to a single moment, although it strives to let us imagine what preceded and followed it. Mostly the action is only hinted at; and is completed by the imagination or by the memory.'

48 Carlo Belgioioso, 'Sulle arti del disegno in Italia e l'Esposizione universale del 1867', *Rendiconti del Reale Istituto Lombardo di Scienze e Lettere*, Classe di lettere e scienze morali e politiche, 4 (1867), pp. 57–77.

49 G. Bollati, 'L'Italiano', in *Storia d'Italia Einaudi*, vol. I (Turin, 1972).

50 C. Blanc, *Grammaire des arts du dessin* (Paris, 1867).

51 Pontus Grate, *Deux critiques d'art de l'époque romantique* (Stockholm, 1959).

52 In his famous analysis of the 'beholder's share', E. H. Gombrich recalls how in Reynolds's time there was already awareness and acceptance of 'the pleasure in this game of reading brushstrokes', and he wrote that 'one wonders why the technique of the Impressionists struck the public as such a daring innovation. But Impressionism demanded much more than a reading of brushstrokes. There were a good many painters among the fashionable virtuosi of the nineteenth century, men like Boldini and Sargent, who drew more or less with a loaded brush and made the game of projecting sufficiently easy to be attractive' (*Art and Illusion*, p. 169).

53 J.-E. Blanche, *Manet* (Paris, 1924), pp. 47–8.

54 This passage, which appeared in an article in *Figaro* in 1890, is reprinted in the catalogue *Architectures. Paris 1848–1914*.

55 From a lecture given at the University of Oxford in 1883, in W. Morris, *On Art and Socialism. Essays and Lectures* (London, 1947), p. 135.

56 In 1890 many artists made a dramatic break with the Société des Artistes Français, under the leadership of Meissonnier, and founded the Société Nationale, known as the Société du Champ de Mars, with Puvis de Chavannes as its vice-president, while what had already become known as the Salon de Bouguereau had its headquarters on the Champs-Elysées. But in the previous decade the decline of the single Salon had already begun with a number of other initiatives (the Salon des Indépendants, Georges Petit's gallery, etc.).

57 P. Signac, *D'Eugène Delacroix au néo-Impressionisme* (Paris, 1899). 'It would be useless to draw up here a list of all the innovative painters who were censured in this century and whose own particular vision later triumphed. Such injustices, struggles and triumphs are the stuff of art history. Any new manifestation is challenged to begin with; then, slowly, we get used to it and accept it. We see the reasoning behind the treatment, the colour which aroused such horror seems powerful and harmonious. The unconscious education of the public and the critics is complete, to the point where they begin to see things in real life as the innovator chose to portray them: his formula, which they despised before, is now their criterion. And another original effort a few years later will be scoffed at in his name, until the day when it too will triumph. Each generation realizes its mistakes after the event with astonishment, and is prone to relapses.

'One generation never makes the effort necessary to take on a new way of seeing twice. Delacroix's detractors were forced to yield to his supporters. His supporters failed to understand the colourists who followed, the Impressionists. They in turn triumphed, and today lovers of Monet, Pissarro, Renoir, Guillaumin abuse the reputation for good taste that this choice has secured them to censure the neo-Impressionists.' This accurate assessment of Signac's was supported by his faith in the possibility of educating the eye of the public, beginning by teaching the laws of colour as preached by Chevreul and Rood.

58 Letter of 22 April 1891, published in the catalogue of the retrospective exhibition of Gaetano Previati (Ferrara, July–October 1969). After praising Segantini and Vittore Grubicy, Previati wrote: 'the rest, believe me, Beppo, is work, study, intelligence, effort, whatever you may call it but not art – there is none of the sincerity of a personal way of seeing reality and no courageous self-exposure – it is mostly imitation of trite or overly fashionable formulae and a general tendency to aim for glory by winning the approval of one's superiors or being acquired by some pseudo-patron.' Apart from the limitations of the confused cliché of 'sincerity', this is a clear insight into the uncomfortable choice between formulae which were felt to be obsolete and those whose commercial success could not make up for their inadequacy.

59 Letter of 11 January 1893.

60 But for the results of the myth of the misunderstood artist in the Tuscan environment, cf. Mimita Lamberti, 'Artisti e mercato: Il Giornale Artistico (1873–1874)', *Annali della Scuola Normale Superiore di Pisa*, 3rd series, vol. 7, 3 (1977).

61 Previati, letter of 18 March 1893, published in the catalogue of the anthological exhibition.

62 It may be interesting to observe the coincidences – for directly opposite reasons – between the subjects 'prohibited' by the regulations of the Rosicrucians and the promises of Méliès's advertising.

63 This mechanism is very well clarified by Poli, *Produzione artistica*, p. 118.

64 Cf W. Gaunt, *The Aesthetic Adventure* (London, 1945).

65 It is well known that Gombrich took part in the 'counter-incursion' into the field of psychology by historians of style in order to satisfy his 'curiosity as to the specific and unique functions of art which required the development of illusionistic means', and that the investigation of the link between form and function is seen, in his essays, as an assessment of the different modalities of consumption that the new function entails and demands. Although their evaluations are diametrically opposed, Gombrich's report on the art from before and after the 'Greek miracle' (i.e. the achievements of Greek illusionism) which escaped its influence ultimately coincides with Duthuit's 'readings'. Duthuit says that the 'classical solstice' interrupted the way art was, and was perceived, from the Sumerians, through Byzantium, and finally to the *Fauves* (for this thesis see particularly G. Duthuit, *Le feu des signes*, Geneva, 1962).

 (Gombrich on San Vitale): 'The gleam of the mosaics, the intense gaze of the emperor worshipping the divinity, the ceremonial dignity of the scene show the image has recovered something of the potency which it once had. But it owes its very strength to this direct contact with the beholder. It no longer waits to be wooed and interpreted, but seeks to awe him into submission ... This is the closest approach to pre-Greek conceptions to which art could attain after the Greek revolution' (*Art and Illusion*, p. 125).

66 One of his most complete pieces of writing on the subject is to be found in his *Schöpferische Konfession* (1920), where he considers the effect of the time factor both from the point of view of the artist and of the beholder: 'In Lessing's *Laocoon*, on which we wasted a certain amount of intellectual effort in our younger days, a good deal of fuss is made about the difference between temporal and spatial art. But on closer scrutiny the fuss turns out to be mere learned foolishness. For space itself is a temporal concept ... Does a picture come into being all at once? No, it is built up piece by piece ... And what about the beholder? Does he finish with a work all at once? (Often yes, unfortunately) ... The biblical story of Creation is a good parable for

motion. The work of art too is first of all genesis; it is never experienced purely as a result. A certain fire flares up, it is conducted through the hand, flows to the picture . . . What the beholder does is temporal too. The eye is so organized that it conveys the parts successively into the crucible of vision and in order to adjust itself to a new fragment, has to leave the old one. After a while the beholder, like the artist, stops and goes away. If it strikes him as worthwhile, again like the artist, he returns. In the work of art, paths are laid out for the beholder's eye, which gropes like a grazing beast (in music, as everyone knows, there are channels leading to the ear – in drama we have both varieties). The pictorial work springs from movement, it is itself fixated movement, and it is grasped in movement (eye muscles)' (P. Klee, *The Thinking Eye*, ed. J. Spiller, London, 1961).

67 Experiments have been conducted, using various systems, to record the paths traced by eye movements in the perception of an image. Besides the basic work by A. L. Yarbus of the Institute of Biophysics of the USSR Academy of Sciences, which analyses the journeys and the points where the attention is held during the observation of a work of art, we should also mention the studies carried out by researchers at the University of Berkeley on the sequential concept of visual intake and recognition (where the improved understanding of visual perception is influenced by studies on the computerized recognition of forms). And it is perhaps no accident that one of the figures used in studying scanning paths was a drawing by Klee (cf. D. Noton and L. Stark, 'I movimenti degli occhi e la percezione visiva', *Le Scienze*, 37 (1971), pp. 23–31.

68 P. Fossati, *La realtà attrezzata. Scena e spettacolo dei futuristi* (Turin, 1977).

69 R. Arnheim, *Towards a Psychology of Art* (London, 1966), pp. 7–16.

70 Cf. T. Maldonado, *Avanguardia e razionalità* (Turin, 1974), pp. 99–102.

71 Cf. Wilbur Schramm, *Mass Communication* (Urbana, Ill., 1970).

72 A study of the poster as a socio-aesthetic phenomenon is found in Christine de Rendinger's book *L'affiche d'intérieur: le poster* (Paris, 1976), which examines its genesis, market and 'social context'. After the initial phase where people collected original *affiches*, a first step towards the private context of 'this aesthetic branching off of the *affiche* [writes A. A. Moles in the preface] as it came off the street and into the home', the starting point for the phenomenon is shown to be small-scale collecting of posters as 'cultural trophies' linked to the spread of mass tourism, while the origins of the industrial side go back to the late 1960s.

73 Cf. M. Giacomorra, introduction to Pierre Fresnault-Deruelle, *Il linguaggio dei fumetti* [Paris, 1972] (Palermo, 1977), which refers in detail to the numerous studies by U. Eco devoted to this aspect. The dimension of the consumer is of paramount importance, in the context

of studies on the language of the comic, in relation to mechanisms for deciphering the image (for example the function of the borders, or the significance of the variation in size of the rectangle etc.). Another important topic which, as Giacomorra observes, is still partly unresolved, is that of the specific features of the comic in the context of interaction between iconic message and verbal message; when they are integrated, as here, the verbal message seems to function mainly as a guide to help the reader resolve the ambiguity of the iconic message.

74 Regarding the debate over the control of information (dominated by the two basic notions of the medium within a programming structure, and the process of communication in which both broadcaster and receiver play active roles), cf. Schramm, *Mass Communication*.

75 From the introduction by Ju. M. Lotman and B. A. Uspenskij to the volume *Ricerche semiotiche, nuove tendenze delle scienze umane nell'Urss* (Turin, 1973).

76 An early observation of the phenomenon of the use of metaphysical and surrealist painting within the context of advertising (and the predictable resistance in the Italian context), is found in the article by Ernst (Ernesto Treccani), illustrated with precise photographic evidence, in *Corrente* (then entitled *Vita Giovanile*), 1 (1938): 'It is hard to explain why Surrealism was so easily absorbed, but it is a fact that the unreal and dreamlike appearance, the strangeness of the composition, lends itself to practical application in advertising, which must be striking to the beholder, arresting the gaze of passers-by.' For an authoritative piece which was also, all things considered, well ahead of its time, cf. Leo Spitzer, 'American Advertising Explained as Popular Art', in *A Method of Interpreting Literature* (Ann Arbor, 1949).

77 For aspects of these events in Italy, and related theoretical thinking, cf. P. Fossati, *Il design in Italia* (Turin, 1972).

78 See the text of the debate on the theme 'L'art et le public', in various authors, *L'Art dans la société d'aujourd'hui. Textes des conférences et des entretiens organisés par les Rencontres Internationales de Genève* (1967).

79 Edgar Morin, 'Nouveaux courants dans l'étude des communications de masse', in various authors, *Essais sur les mass media et la culture* (Paris, 1971), which brings together texts by 'specialists in new forms of expression' and aims to 'contribute to the study of the impact of the growing use of image and sound on the evolution of modern societies', the subject of a round table meeting in Montreal in September 1968.

80 See G. Bechelloni, 'Le condizioni sociali della democratizzazione della cultura. Dal museotempio al museo–centro culturale', introductory note to the Italian translation of Pierre Bourdieu and Alain Darbel, *L'amore dell'arte*, I: *Musei d'arte europei e il loro pubblico* (Rimini, 1972).

81 On the importance of the animator's identity crisis, cf. Pierre Gaudibert, *Action culturelle. Intégration et/ou subversion*, 3rd edn (Paris, 1977).

In the new post-1968 interpretation, 'animation' could make its aim an attempt to ensure not so much that groups traditionally excluded possess the necessary codes and systems of classification to appreciate works of art, both past and contemporary (this was the aim of the previous 'democratizing' phase, which has been criticized from the immediate post-war period onwards and is nowadays judged 'in the best cases to be an active pedagogy creating a receptive audience which is both attentive and critical' and, in the worst cases 'cultural colonialism'), but more to ensure that they possess the right expressive means to take up the 'cultural initiative, understood as the ability to find responses to a situation, to preserve or affirm a cultural identity'.

82 For a critique of the 'demagogy of creativity' which is in danger of 'replacing the ideology of "Culture for all" with that of "Creativity for all"', see ibid., pp. 169–70.

83 As J.-L. Daval writes in his presentation of a survey which asked artists the question 'art for whom?': 'Today's creator has understood that he cannot rest content with being a model of liberalization for a society unable to receive his message, so esoteric has his language become and so socially compromised the use it is put to. Convinced that art has to do with life, he owes it to himself to scatter art in order to emphasize life. His testimony is likely to be all the more important for the fact that creativity is coming from traditionally unexpected quarters and imposing itself on the public without the "appellation controlée" of art' ('Art Actuel', *Skira Annuel*, 77).

84 A typical example is the paradoxical 'organized spontaneity' which marks certain aspects of the promotion and management of phenomena such as the Centre Beaubourg.

85 'Art is the most economical, compact method for storing and transmitting information. But art also has other properties wholly worthy of the attention of cyberneticians and perhaps, in time, of design engineers. Since it can concentrate a tremendous amount of information into the "area" of a very small text . . . an artistic text manifests yet another feature: it transmits different information to different readers, in proportion to each one's comprehension; it provides the reader with a language in which each successive portion of information may be assimilated with repeated reading. It behaves as a kind of living organism which has a feedback channel to the reader and thereby instructs him. The means by which this is achieved is of interest not only to those involved in the humanities. It is sufficient to conceive of a mechanism constructed analogously and issuing scientific information to understand that the disclosure of art's nature as a communication system can effect a revolution in methods of storage and transmission of information' (Ju. M. Lotman, *The Structure of the Artistic Text*, Ann Arbor, 1977, p. 23).

Index

Note: **Emboldened** references denote works illustrated